D0121099

An illustrated survey of

Picture Prices
at UK Auctions

2001-2005

2005 Edition

Editor: John Ainsley B.A., B.Ed., M.I.E.E.

An illustrated survey of

Picture Prices
at UK Auctions

2001-2005

2005 Edition

Editor: John Ainsley

First published in Great Britain in 2005 by
Antiques Information Services Ltd. Wallsend House,
P O Box 93, Broadstairs, Kent CT10 3YR
Telephone: 01843 862069
Fax: 01843 862014
E-mail: enquiries@antiques-info.co.uk

Further details about the Publishers may be found on our website at
www.antiques-info.co.uk

© Copyright 2005. All rights reserved.
No part of this work may be produced or used in any form or by any means,
either electronic or mechanical, including photocopying, recording or by any
information storage and retrieval system without the prior written permission
of the Publishers who are the copyright owners.

ISBN: 0-9546479-3-9
Whilst every care has been exercised in the compilation of this guide,
neither the Editor nor Publishers accept any liability for any financial
or other loss incurred by reliance placed on the information contained
in *Picture Prices at UK Auctions*.

Printed in the United Kingdom

Contents

Introduction

The Series

In December 2003, we published our pilot work *Pottery and Porcelain Prices at Auction.* This proved so successful that a *Series* was launched. *Furniture Prices at UK Auctions* published in 2004 and *Silver & Jewellery Prices at UK Auctions* followed in 2005. Now by popular request we present *Picture Prices at UK Auctions.* The *Series* will continue with new titles and we anticipate that each existing title will be updated with completely new information every three years.

Price Guides in General

Price guides have always followed the A-Z format, values being controlled by publishers and/or editors. Many, not all, fulfil more of an information role than function as price guides! The reasons are clear. The estimates they contain are bound to be influenced to some extent by the commercial considerations of their publishers. Much of our industry agrees that hyperbole operates. In some cases it can be argued that it is the price guides which are leading the market rather than the market leading the price guides! Values quoted, lacking an essential market context, always present in a real sale, such as condition, restoration etc are prone to reader misinterpretation and confusion, perceptions which we at *Antiques Information Services* are involved in having to correct. Frequently we have to inform owners that they are more likely to get say £50-£70 for their 'treasure' rather than the £150 or so quoted. Nor do many understand that every secondhand object is unique and its value subject to a measurable set of criteria.

It is therefore evident that estimates can never represent actual values. Using results from real sales, accompanied by the qualifications contained within the actual catalogue descriptions is a unique and ground-breaking development in the history of price guides. Readers of our new Series, even experts, dealers and auctioneers are now frequently referring to our books.

A New Rationale

Here are actual prices at auction from a mass of defined market situations representing the sales of 3,374 lots. These have been placed in 12 price bands and in actual price order in the price range £440,000 to £10. The price bands are arbitrary but provide a means of dividing the work into Sections which not only aid the analyses but provide a format to help the reader keep their bearings. These images have not only been chosen to represent the various price ranges but also to represent pictures from the last 500 years with examples from the sixteenth to the twenty-first centuries. The lots have been taken from sales occurring between 2001 and 2005, a credible four years. In this period fashions and even prices have changed and the book represents these changes.

The rationale is the rationale of the market. If you have used other price guides you will be aware of the difficulties. Their A-Z format is a weakness in itself, bearing no relationship to sales which is a straightforward matter of when an item was sold, where it sold and what it sold for! Here, the actual numeric price order, overseeing the price bands, representing the top to the bottom *is* the essential ingredient which aids a grasp of the fundamental elements which *are* the market. Here one can analyse the market in many ways. The reader can browse any price range, or, using the *Index*, it is possible to make, a market study of a particular category such as an artist or style, or theme. Each Section is preceded by an Editor's analysis. It is recommended this be studied with the images and the captions themselves. The analysis is not definitive and is unobtrusive: the subject is not a science. Analyses may follow numerous paths at various levels. Hence, the Editor's analysis is personalised around the Editor's interests and level of knowledge. Each reader will seek their own analyses based on their own knowledge and interests. For example, a specialist dealer may take a broad interest in prices or study pictures within his or her own price range. Alternatively collectors may concentrate on a particular artist or genre.

Auction Arithmetic

Buying at auction

Most auctions in the UK publish only their hammer prices. The final price paid by the buyer is a matter of a private invoice not usually disclosed to the press.

Auctions add on a buyer's premium dependent on the hammer price. You may pay 15% on top of a hammer price of say £1,000 but only 10% on a hammer price of £30,000. In addition there is VAT on the premium and in some cases VAT may be due on the hammer price as well, depending on the age and origin of the lot. We advise you add 15% to the hammer prices to gauge the approximate buying price. Auction catalogues will include the buyer's terms and conditions.

Selling at auction

The final cost to the vendor is again outside the public domain. There is a premium to pay which on average will be at least 10-15% of the hammer price. Then there is the VAT and there may be charges related to photographs, storage and even insurance. We suggest that if you use this price guide to gauge how much you would receive if you were to sell an item, that you subtract about 15% from the hammer price. This is an important market statement. The real buying price and the real selling price will actually vary by at least 30%. Again the auction catalogue will explain the terms and conditions relating to selling at auction. If the reader is in any doubt, auctions are always willing to explain their operations. And on viewing days, staff are usually on hand to offer information or advice on the lots themselves.

Picture Prices and the Market

The last 20 years

Before the picture price revolution reached its peak in the late 1980s, many people owned beautiful pictures. They hung on the walls of family homes, admired, enjoyed and even loved as works of art. Where are they now? As one auctioneer explained, 'When one sees the name, Monet or Picasso in the press with rows of zeros extending across the page, how do we now view such art? Should we always consider its investment potential or, should we buy for the love of the picture and the pleasure it will afford us over time?' Hopefully this discussion will present answers.

Following the peak came the slump. Again the interest of investors, dealers and collectors quickened after 1995. Now the art market has gradually regained its strength. Although many of the top prices for impressionist art in particular were recorded in those days, the first $100 million picture sold at auction only this year, (Picasso's *Garcon à la pipe*, 1905) at Sotheby's, New York, in May 2005.

Many auctioneers consider that art in general has been a good investment. Despite the slump, they argue, prices have remained stable if not rising in the past 20 years. The basis of this investment has been good Victorian and Edwardian pictures by known artists, particularly those with original frames and little or no restoration. Quality has always been the bench-mark, combined of course, with attractive subjects. Freshness to the market also drives prices. A steady rise over a long period does not mean that there have not been dips and recoveries in certain categories, such as Old Masters. And perhaps not every well known artist of the period has seen a rise. Many auctions are painting a mixed picture, suggesting the Victorian market in some sectors, might not have been such a reliable investment. Some report that the recent trend is for lesser artists to come down in value. This also may be true for better quality works. 'Robert H. Hammond who was selling for £2500-£4000 in the late 1980s and early 1990s has fallen to £1400-£1600', quotes one auction who also say that popular Victorian artists such as Sidney Richard Percy, William Mellor, Alfred Augustus Glendenning and Benjamin Williams Leader are fetching no more today than between 1989-1993. Another auction has suggested that, whereas 20 years ago the public were strongly buying Victorian landscapes and watercolours by artists such as the Stannard family, this market has fallen away. Today's buying public want different things, in line with the trend for white walls occupied by one stunning painting. They do not always share the taste of their parents or grandparents often selling what they have inherited and buying what they like.

Certainly, in general, dealers and collectors are much more choosy. Many auctioneers report that 'gone are the days' when merely decorative pictures by minor artists would easily sell. Dealers need to buy pictures they can sell quickly or to meet a request, rather than buying for stock. Despite the move towards modernism, most auctions report that good antique watercolours and oils with a known provenance are constantly attaining good prices. Local subjects and artists continue to prove popular, for example, Thames scenes in London or John Piper. Other recognisable subjects also remain sought after such as views of Venice, London and Rome and whilst well known still life artists are in demand, this category and portraiture have fallen away unless of course they are of children or pretty girls.

The last 4 years

Buyers are less intent on 'run-of-the-mill' Victorian genre and landscapes of the middle market. However, major Victorian pictures still command very high prices. We have seen one auction comment that Mellor hasn't made any 20-year headway, whilst another, local to Mellor and Royle see these artists as exceptions to middle market stagnation! Another auctioneer has seen the trend move towards only the very best, untouched paintings, with strong prices for the right material and indifference to lesser or minor works or artists which have either fallen in value or have become unsaleable.

It is being confirmed from many areas that younger collectors are entering the market and looking towards the 1930s and later English painters of the 1950s and 1960s. The contemporary Indian market is extremely strong with painters of the 1950s to 1970s such as Francis Newton Souza. The Irish market is also flourishing. In the west country an auction writes of excellent viewing and sale attendances at picture sales and sees their Region as a stronghold for twentieth century and contemporary artists, with a good local market and following. Many auctioneers have reported this category as 'extremely hot' or as 'blue chip'.

Russian art is showing a steady increase. Modern and contemporary prints seem to be doing well in the capital and this is also backed up by reports from northern England, where signed prints by artists such as Hirst, Hockney and Lowry are in demand. Alternatively, the general print market for etchings/lithographs etc is reported as poor except for a few very collectable artists such as Snaffles, Aldin, Dicksee, Eileen Soper, Walcott etc. Children, dogs, cats, good topographical scenes, help. An Arthur Wardle (1864-1949) oil on canvas depicting a terrier with her pups in an interior realised £11000 plus buyers' premium in September 2004.

In summary, the consensus is a noticeable move away from traditional Victorian and Edwardian landscapes etc by lesser artists. Modern British and contemporary art is thriving and is much more suited to modern interiors. And finally, local art, and even provincial schools back to c1800, providing, of course, they are untouched and

fresh to the market, are maintaining their appeal. Other more specific trends are worth a mention. The work of English Surrealists such a Eileen Agar is sought after. A newer trend is towards the Bomberg Group of the 1950s. Robert Lenkiewicz (1941-2002) the late Plymouth based artist has shown some frenzied results but is now settling down. Most of his paintings make £3000 to £10000. Exceptions: £35000 for *Self-Portrait in Hospital* and £29000 for *Anna Navas with Paper Lanterns*.

There is confusion over British drawings and works on paper. Probably the consensus is that the market is less dynamic than 10 years ago. Old Master paintings and drawings and modern art are selling. Popular are Francis Bacon, Lucien Freud, Damien Hirst and David Hockney who have recently set new price records.

Despite the recent buzz for contemporary art and the high figure paid for Jack Vettriano's 'The Singing Butler', in Scotland in 2004, 2005 offerings of his work failed to attract a bid near to their protective reserves. Safer are Old Master drawings/paintings, witness the recent £5.8 million paid for a preparatory drawing by the Florentine artist Andrea Del Sarto (1486-1530). The major seventeenth century painters are all performing well. Scottish auctions report interest in contemporary artists such as Peter Howson, John Bellamy, Ken Currie and Stephen Campbell.

The market continues to provoke intense interest. In 2004 Cheffins found a Rembrandt etching in a junk box at a charity for the homeless. It fetched £7000. Stroud Auctions quote the case of a family whose grandfather purchased an original Monet over 70 years ago. Recently, the painting, which cost the family nothing, was estimated at over $10 million. Market value and insurance costs forced them to sell. Gorringes sold a John William Godward for £440000 as the owner could no longer afford or justify the insurance risk. One of the most endearing stories is of the painting 'The Red Houses' by the Irish artist Norman Garston, one of the founders of the Newlyn School. This was saved from a skip and fetched a hammer price of £23000 in March 2004, at Thomas Mawer, in Lincoln. Shanklin Auctions sold four paintings, in the manner of Sir Peter Lely, (1608-1680) of the mistresses of Charles II for £35000. Clearly it is not only Old Masters which perform well!

Pitfalls in the market

One problem is the over-supply of poor quality oils and watercolours of little merit. Taste, fashion and opinion are constant operators waiting to trap the unwary. These subjective 'snakes-in-the-grass' can easily put a dent in your investment and if you have to sell at a loss don't expect the insurance company to pay up! If you are parting with a lot of money seek the opinion of several experts, unless, of course, you are one yourself! In summary be cautious following current trends led by investment money. 'In such a market bad examples sell for too much money', quotes one auctioneer. 'Buy the best of a lesser artist rather than the worst of a better'.

There is much over-restoration about. There are also forgeries and fakes, even of living painters! Buy from fine art auctions, or specialist galleries, or fine art fairs where rigorous efforts are usually made to confirm attributions, condition and so on. Modern giclée prints are also around. The term comes from the French 'gicler' meaning 'to spurt' or 'to squirt', a term used for high quality digital prints produced using an ink-jet printer. These are sometimes called Iris prints from the commercial name of one make of ink-jet printer. Laser prints are also a problem. On good paper these could easily pass for watercolours.

How to use this book

This book is an ideal browsing medium but it is recommended that both the full **Introduction** and the **Section Analyses** are read at an early stage. A significant part of this work is the lot descriptions. These conclude with colour-coded market information, viz: *where the lot was sold, when the lot was sold* and *what the lot was sold for*. In addition, whilst every effort has been made by the Editor to check out the attributions, there exists the unlikely possibility of error. Auction cataloguing is a difficult task and even specialists cannot know everything. However, great care is usually taken and 'labelling' is in most cases very accurate. Incidentally, many auctions will rescind a sale within a set period of the purchase if the buyer can show inaccuracies in the catalogue description. Disputes usually revolve around damaged, restored or misrepresented lots.

In some cases captions have been rationalised in order to solve editing requirements. Syntactical changes have been made and abbreviations used which did not occur in the original auction catalogue. And on occasions the Editor has used his discretion to omit descriptive detail which would be tedious and which would not materially influence the price. In all cases, the Editor has ensured that changes in meaning have not occurred and that the content of a caption remains true to the original version. Foreign spellings and name spellings also varied in the original catalogues. These have been standardised to ensure the integrity of the Indexing system.

Finally, the reader's attention is drawn to the *Glossary of Terms* and *Picture Index*. These are integral parts of this work. The *Index* has 4,500 cross-references and is colour-coded to aid fast searches. See also the *Appendices* for an explanation of cataloguing terms and practices associated with the sale of drawing, paintings and watercolours at auction, a list of the abbreviations and explanations used in the picture captions and a list of the auction houses who have contributed information to enable us to produce the Series.

The Editor wishes to thank the dozens of auctioneers up and down the country who have spared some of their very precious time to comment on the picture market and who have submitted invaluable material which has appeared in the Series so far. Their details can be found in Appendix 3.

Section I £10,000 +

The Dorothea Sharp at **64** encapsulates everything the market could want, and the title, *Children with a Dog on a Summers Day* makes an indelible statement about the period, the genre, the artist and the market.

The reader is advised to study the **Introduction** before launching into the analyses. Here the **Series** is given a context and includes a 2000 word essay relating to the market over 20 years and particularly in recent times.

Pictures fetching millions are not the subject of this work. Such occurrences are sensational and newsworthy but do not touch on the tens of thousands of dealers and collectors nationwide who need a mass of undiluted market information about the real market, rather than the narrow corridor of corporate and billionaire investment. John William Godward was included at **No. 1** because he represents, at about £½million, how ordinary people can no longer afford such art. The story is portrayed on page 6, and discusses also a Monet, lost to a family who could no longer afford the risk or the insurance.

All of the great collecting areas are represented here, with townscapes probably dominating. See **4**, **5** and **6**. Famous cities pepper the pages, at **16** Paris and opposite at **27** and **30**, London. Picture **25** sees our first Venice scene. See also **55**, **60** and **66** with San Marco at **93**. Incidentally our second townscape was a Lowry. A further Lowry, *A Lancashire Woman sitting down,* appears at **59**. More of women later.

A further popular theme is equestrian. The first, a large oil by John Emms appears at **3**, quickly followed by examples at **9**, **12** and **17**. The theme may be followed through to a James Pardon hunting scene at **70**. Indeed equestrian and canine subjects for example, are so common throughout this study that indexing particular categories proved pointless. See also **19**, **51**, **84** and **87**. **51** is a particularly charming Arthur Wardle (1864-1949) study of Jack Russells which fetched £16,500 in 2004. A further Arthur Wardle of a terrier and pups is discussed in the **Introduction** at £11,000 hammer.

Animal paintings are synonymous with the incomparable Henriette Ronner. (1821-1909 Dutch) Examples of her work can be found at **14** and **38**, and again on page 15, but see also page 114 where a 'circle of Henrietta Ronner' bearing the signature 'H. Ronner' sold for £400. Notice either the deliberate spelling error or cataloguing error! The reader may also wish to follow other women painters in this section and beyond. See for example **8**, **25**, **28**, **46**, **49**, **63** and **64**. Helen Allingham occurs only once as does Dorothea Sharp. (**63**, **64**) Both women were born in the high Victorian period, their lives straddling the turn of the century. This can be said of most of the women painters in this Section and many of the other artists. Circa 1850-1950 is a dominant period in art.

Seascapes occur surprisingly only five times, no more than still life, which according to the consensus of opinion has suffered a set back, except for important artists such as Clare. Examples of his work can be seen later. Harnett (1848-1892 American) top scores here with **No. 2**, a still life, *After the Hunt* at £200,000 hammer. The highest priced pen and ink drawing at £26,000 is a Chelsea street scene by another American, Whistler at **27**. Whistler 'works on paper' do not appear very often, the popular market being prints selling mainly in New York for prices anywhere from £2,000 up to £35,000. (August 2003 to August 2004) Also significant at **48** is a drawing of Samuel Taylor Coleridge which fetched £17,000 at Rupert Toovey in Sussex.

Famous names embrace old masters to contemporary artists. Already mentioned are Godward, Lowry and Harnett. Additionally there is Nash, Lely, Frost, Breanski, Hunt, Marcel Dyf and Munnings, (1878-1959) the latter a most charming oil on panel study of *The Delaney Boys* which fetched £30,000 hammer at Gorringes in March 2005. This provides an opportunity to introduce two of the most popular of all areas in art, that is, the study of women and of children. Examples commence at **1**. Women are also portrayed at **22**, the incredibly beautiful *Fresh Lavender* at **29** by William Henry Margetson and the Sophie Anderson study at **46**. See also **83**, **92**, **96** and **100**. Studies of children can be found at **23**, **24**, **49**, **56**, **64**, **79** and **82**. The Dorothea Sharp at **64** encapsulates everything the market could want, and the title, *Children with a Dog on a Summers Day* makes an indelible statement about the period, the artist and the market. According to *Art Sales Index*, appropriately, June 04 saw two Sharp paintings sell in London, both at £30,000, one entitled *Summer Day on the Cliffs* and the other *Daisy Pickers*! Earlier in 2004 Gorringes sold a William Marshall Brown study of children paddling for £12,000 (see **79**) entitled *Romping*. The market craves such paintings!

Now check out a number of pictures showing a range of social occasions. See **10**, **11**, **28**, **42**, **45**, **78**, **80** and **91**. Some are 'genre' paintings in the sense that they show scenes from daily life. These paintings embrace all social classes and were painted mainly during the late nineteenth and early twentieth century, except **78** and **80** which were probably earlier. Does this group represent a range of styles which defy fashion? Regardless of subject, good paintings sell well, a contention which has been echoed by many auctioneers.

Hammer Prices £440000 - £43000

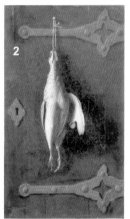

John William Godward (1858-1922), oil on canvas, 'A Cool Retreat' II, signed and dated lower right, 'J.W.Godward 1919', 21 x 40ins. Gorringes, Lewes. Mar 05. £440000.

William Michael Harnett, (1848-1892) oil on canvas, After the Hunt, signed, dated 1885, 18.25 x 10.75in. Gorringes, Lewes. Jun 02. £200000.

Large oil painting of the winners of the Dumfriesshire Hunt Point to Point in 1892, by John Emms. Dreweatt Neate, Newbury. May 02. £150000.

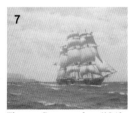

Cornelis Springer (1817-1891) Street scene in Makkum, Friesland, signed and dated 1873, oil on panel, 32 x 42cm. Sworders, Stansted Mountfitchet. Feb 03. £120000.

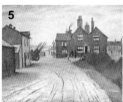

Oil painting of Old Houses (Arden Farm) by L S Lowry, 15in x 19in, on plywood, 1950. Stride & Son, Chichester. Feb 01. £98000.

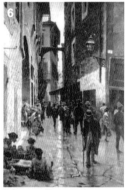

Telemaco Signorini's, an Italian street scene with numerous traders and other figures. Dreweatt Neate, Newbury. Feb 00. £87000.

Thomas Somerscales, (1842-1927) oil on canvas, Clipper ship off the Valparaiso Coast, Chile, signed and dated 1911, 26 x 39in. Gorringes, Lewes. Jul 01. £78000.

Minnie Agnes Cohen, (1864-1940) 'At the Capstan Bars', oil on canvas, monogrammed, 113 x 176cm, framed. Bristol Auction Rooms. Nov 03. £66000.

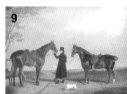

John Frederick Herring, Senr. (1795-1865), two hunters in a landscape, held by a groom with a terrier, oil on panel, signed and dated 1820 lower right, 55 x 76cm. Dreweatt Neate, Newbury. Apr 00. £62000.

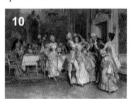

Arturo Ricci, 'The Toast', oil on canvas. Mellors & Kirk, Nottingham. Dec 02. £55000.

Walter Dendy Sadler RBA, (1854-1923) Old & Crusted, signed lower left 'W Dendy Sadler '88', oil on canvas, 85 x 120cm. Cheffins, Cambridge. Apr 04. £50000.

Heywood Hardy, ARWS, RPE (1843-1933) Drawing Covert signed lower left, oil on canvas, 90 x 120cm. Cheffins, Cambridge. Sep 03. £49000.

'Meg Roses', oil on canvas, signed Cecil Kennedy, (1905-1997), 49.5 x 59.5cm. Ambrose, Loughton. Jun 02. £49000.

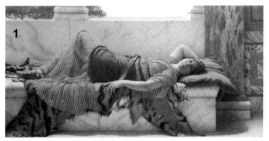

Henriette Ronner, oil on mahogany panel, study of three kittens, one asleep, signed, dated '96, 12.25 x 17.25in. Gorringes, Lewes. Jun 00. £49000.

Prices quoted are hammer and exclude the buyer's premium. Adding 15% will give approx. buying price.

Paul Nash (1889-1946), oil on canvas, Trees beside a pond, signed and dated (19)28, Ryman and Co. label verso, 30 x 25in. Gorringes, Lewes. Jun 01. £48000.

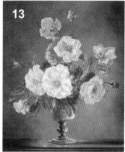

Edouard-Leon Cortes, (1882-1969) oil on canvas, 'Paris street scene'. Desmond Judd, Headcorn, Kent. Dec 03. £43000.

17

Heywood Hardy, At the Gate and Showing the Way. (2) Hamptons, Godalming. May 00. £39000.

18

Sir Peter Lely, oil on canvas, Double portrait of Sir John Rivers, 3rd Bart. and his wife, Lady Anne Rivers. Gorringes, Bexhill On Sea. Dec 04. £38000.

19

James Hardy Jnr. Guarding the Day's Bag, signed and dated (18)68, oil on canvas, 28 x 36in. Hamptons, Godalming. Feb 01. £36000.

20

Terry Frost, 1915-2003, Blue & Silver Quay, abstract in blue and grey, dark background, hardboard, 28 x14in, signed and inscribed to rear in plain grey frame. Canterbury Auc. Galleries, Kent. Apr 05. £35000.

21

William Michael Harnett, (1848-1892) oil on canvas, still life with fruit and a vase, monogrammed, signed verso and dated Munchen 1881, 4.5 x 3.5in. Gorringes, Lewes. Jan 02. £32000.

22

Oil on canvas by Vittorio Matteo Corcos, (1859-1933) Lady with kitten, 109.5cm x 61cm. Bristol Auction Rooms. Oct 01. £30000.

23

Cornelius Johnson, Charles II as the Prince of Wales, reverse with Thomas Agnew and Sons label, inscribed in a contemporary hand 'From the Duke of Hamilton's collection, oil on copper, 10 x 8.25in, 18thC giltwood frame. Hy. Duke & Son, Dorchester. Jun 03. £30000.

Hammer Prices £39000 - £25000

24

Sir Alfred James Munnings (1878-1959), oil on wooden panel, The Delaney Boys, signed, 13.5 x 20.5ins. Gorringes, Lewes. Mar 05. £30000.

25

Emma Ciardi (1879-1933), Italian, oil on canvas, Venice, signed, dated 1923, 1928, Fine Art Society label verso, 24ins. x 35.5ins. Gorringes, Lewes. Apr 02. £29000.

26

William Stewart MacGeorge, My Lady's Train, signed, 33.25 x 43.25, carved and gilt frame. Andrew Hartley, Ilkley. Dec 00. £27000.

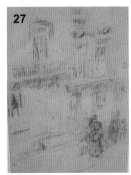

27

James Abbott McNeill Whistler, Street scene in Chelsea, pen and ink, with butterfly monogram, 15 x 10cm. Rosebery's, London. Mar 04. £26000.

28

Margaret Dovaston, (1884-1955) Tea at the Vicarage, signed lower left 'M Dovaston', oil on canvas, 49 x 67. Cheffins, Cambridge. Apr 04. £25000.

29

William Henry Margetson, oil on canvas, Fresh Lavender. Gorringes, Bexhill On Sea. Sep 04. £25000.

30

Attributed to Francis Smith, (fl. 1764-1778). Panoramic view of London with the Thames and St Pauls, oil on canvas, 29.5 x 49.5in. Woolley & Wallis, Salisbury. Apr 00. £25000.

Hammer Prices £24000 - £17000

Andrea Meldolla, called Lo Schiavone, (1510-1563) Mythological scene with Ceres, Pomona, Pan and other figures in a landscape, oil on panel, 27 x 84cm. Cheffins, Cambridge. Nov 04. £24000.

Archibald Thorburn, watercolour, Ptarmigan in the Highlands, 1922. Bearne's, Exeter. Mar 03. £22000.

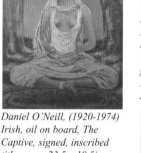

Daniel O'Neill, (1920-1974) Irish, oil on board, The Captive, signed, inscribed title verso, 23.5 x 19.5ins. Gorringes, Lewes. Apr 03. £21000.

Archibald Thorburn, watercolour, Grouse on a Moor. Bearne's, Exeter. Mar 03. £20000.

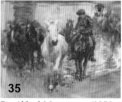

Sir Alfred Munnings, (1878-1959) watercolour, study for The Ford, signed A J Munnings, 10.5 x 12.5in. Gorringes, Lewes. Mar 03. £20000.

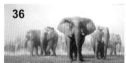

David Shepherd, (1931-) oil on canvas, Elephants, signed and dated '99, 20 x 40in. Gorringes, Lewes. Dec 03. £20000.

Anglo Dutch School, c1705, British men o'war in a stiff breeze, oil on canvas, 35 x 79.5in, contemporary carved giltwood frame. Hy. Duke & Son, Dorchester. Jun 03. £20000.

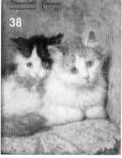

Henriette Ronner, oil on mahogany panel, Two Kittens on a Cushion, signed, dated (18)95, 8 x 6in. Gorringes, Lewes. Sep 00. £19500.

Harold Clayton's Flowers in a sculptural vase. Dreweatt Neate, Newbury. Feb 00. £19000.

Sidney Richard Percy, (1821-1886) oil on canvas, Near Llanwrst, North Wales, signed, 9 x 15in. Gorringes, Lewes. Jul 01. £19000.

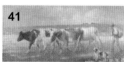

Fred Hall, (1860-1948) A Golden Evening, cattle and cowman with a dog in the Lambourn Valley, oil on canvas, signed lower left, 63.5 x 147.5cm. Dreweatt Neate, Newbury. Apr 00. £18500.

> The numbering system acts as a reader reference as well as linking to the Analysis of each section.

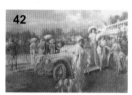

Arriving at the Polo Match, a watercolour by Fortunino Matania, 18 x 26.375in. Mervyn Carey, Tenterden. Oct 02. £18250.

Architectural ink drawing c1905 of Auchenebert House, Killearn by Charles Rennie Mackintosh. Phillips, Scotland. Dec 00. £18200.

Walter Hunt, oil on canvas, 'The Crofter's Farmyard', signed and dated 1903, signed verso, 49.3 x 75cm, framed. Bristol Auction Rooms. Oct 01. £18000.

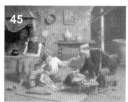

Eugenio Zampighi, (1859-1944) Italian, oil on canvas, 'The Hungry Turkey', signed, 25.5 x 33in. Gorringes, Lewes. Apr 02. £18000.

Sophie Anderson, (1823-1903) oil on canvas, Girl holding a basket and jasmine blossom, signed, 21 x 17in. Gorringes, Lewes. Jun 03. £18000.

John Hoskins, A Lady, signed and dated in gold i65i.iH., vellum, oval, 7.3 x 5.9cm, 19thC inscription on reverse, to the support 'John Hoskin 1651 commonwealth No = 17 E F'. Mellors & Kirk, Nottingham. Apr 03. £17500.

Charles Robert Leslie, pencil, charcoal and white chalk, portrait of Samuel Taylor Coleridge, inscribed, dated 'about 1820', 31.5 x 27cm. Rupert Toovey, Washington, Sussex. May 04. £17000.

Kate Perugini (1838-1929) Portrait of Dora, daughter of Anderson Critchett, FRCS, signed and dated 1892, oil on canvas, 45.5 x 24.5in. Clarke Gammon, Guildford. Dec 04. £16500.

Victorian sailing vessel, unsigned oil, believed to be of the Earl of Yarborough aboard his yacht Kestrel, 35 x 45cm. Stride & Son, Chichester. Aug 03. £16500.

Arthur Wardle, (1864-1949) Jack Russell and four pups in a barn interior, oil on canvas, signed lower left, 49.5 x 39cm. Wintertons Ltd, Lichfield. Mar 04. £16500.

Edgar Hunt, oil on canvas, Farmyard Friends, signed and dated 1907, 12 x 10in. Biddle & Webb, Birmingham. Jan 02. £16200.

Circle of Joos van Winghe, (1578-1654) Belshazzar's Feast, oil on panel, inscribed 'Mene Mene Tekel Upharsin' upper right, 142 x 196cm. Dreweatt Neate, Newbury. Apr 00. £16000.

Jesus Raphael Soto, 'Grand Relation Noir et Bleu', construction of meal and painted wood, signed, titled and dated 1965 verso, 150.8 x 100cm. Rosebery's, London. Mar 05. £16000.

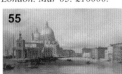

Carlo Grubacs, pair of oils on canvas, views of Venice, Vicars Bros. labels, verso, signed, 12 x 18in. Gorringes, Lewes. Jul 00. £15500.

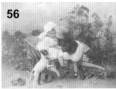

19thC British School, Love in a Barrow, oil on canvas, signed William Strutt, 32 x 42.5cm. Locke & England, Leamington Spa. Sep 02. £15000.

William Brooker, (1918-1983) oil on canvas, 'For Guiseppe Abbots 1836-68', inscribed top left corner, 40 x 50in. Gorringes, Bexhill. Feb 04. £14500.

Hammer Prices £16500 - £13500

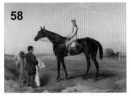

Harry Hall, (1814-1882) Study of the Racehorse 'Fisherman', ridden by Brusher Wells, oil on canvas, signed and dated 1857-8, 85.5 x 117cm. Rupert Toovey & Co, Washington, Sussex. Feb 03. £14500.

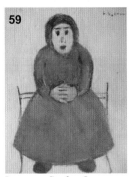

Lawrence Stephen Lowry R.A. 'A Lancashire woman sitting down', oil on panel, signed and dated 1961, 6.75 x 5.5in. Sworders, Stansted Mountfitchet. May 01. £14500.

Sunlit Venetian Canal Scene by 20thC artist Antoine Bouvard, signed, oil on canvas, 25 x 38in. Canterbury Auction Galleries, Kent. Oct 00. £14000.

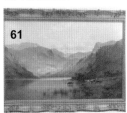

Alfred de Breanski's, 'The Hills of Callander', oil on canvas, 19 x 29.5in. Ewbank Auctioneers, Send, Surrey. Oct 02. £14000.

Albert Bierstadt, (1830-1902) American/German, oil on canvas, French nature study, monogrammed and dated 1878, 9.5 x 13.75ins. Gorringes, Lewes. Apr 05. £14000.

Helen Allingham R.W.S. 'Duke's Cottage'. Hamptons, Godalming. Sep 00. £14000.

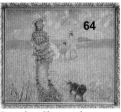

Dorothea Sharp, oil on canvas, Children with dog on a summers day, signed, 19.5 x 23in. Louis Taylor, Stoke on Trent. Jun 04. £14000.

Herbert Royle, Snowscene, Ullswater, signed, 35 x 49in, gilt frame. Andrew Hartley, Ilkley. Feb 02. £13500.

Henry, Venice by moonlight, oil on canvas, indistinctly signed lower left, 59 x 89cm. (flaking) Dreweatt Neate, Donnington. Nov 02. £13500.

67

Mark Senior, (1864-1927) oil on canvas, figures in a village square, signed and dated 1904, 20 x 24in, unframed. Gorringes, Lewes. Sep 03. £13500.

68

George Mousey Wheatley Atkinson, (1806-1884) oil on canvas, Cork & Liverpool, S.S. Co paddle steamer 'Ocean' off the coast of Cork, signed and dated 1841, 26 x 39in. Gorringes, Lewes. Jun 02. £13500.

69

Edgar Hunt, oil on canvas, doves and ducks by a basket and broom, signed and dated 1907, 12 x 10in. Biddle & Webb, Birmingham. Jan 02. £13200.

70

James Pardon, (fl 1800-1850) 'Will Staples, hunts-man to Lord Hill on a chest-nut hunter with pack of hounds', oil on canvas, signed and dated 1847, 31 x 39in. Halls Fine Art, Shrewsbury. Nov 04. £13000.

71

Attributed to Cornelis Springer, (1817-1891) oil on canvas, 'A busy quay side in old Dutch town', bears signature. Bristol Auction Rooms. Apr 02. £13000.

72

Charles Edward Dixon, (1872-1934) set of 4 water-colours heightened with body colour. London scenes, each signed and dated 1923, 31.2 x 51.8cm. Bristol Auction Rooms. Nov 01. £13000.

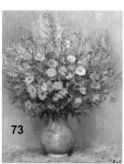

73

Marcel Dyf, (1899-1985) oil on canvas, 'Le Bouquet Emaillie', signed, 29 x 24ins. Gorringes, Lewes. Dec 04. £13000.

74

Keith Vaughan, gouache of The Wave, the sea splashing over a promenade, 1944, 34 x 26cm. Stride & Son, Chichester. Jan 05. £13000.

75

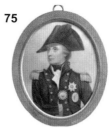

Large enamel portrait miniature of Admiral Lord Nelson by Henry Bone RA and dated 1812. Bearne's, Exeter. Jul 02. £12500.

76

Chinese School, 19thC, an Extensive View of Hong Kong, oil on canvas, some crazing, 52 x 97cm. Hampton & Littlewood, Exeter. Apr 04. £12100.

77

John Blair: St Andrews in Summer, watercolour, 10 x 14.5in, signed and inscribed St Andrews. Bob Gowland International Golf Auctions, Mickle Trafford. Jul 01. £12000.

78

Henry Perlee Parker HRSA, (1795-1873) Hell's Kitchen, oil on canvas, 19 x 48cm. Cheffins, Cambridge. Apr 04. £12000.

79

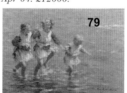

William Marshall Brown. (1863-1936) Oil on canvas, 'Romping', signed, original label verso, 10 x 14in. Gorringes, Lewes. Jan 04. £12000.

80

Edward John Cobbett, (1815-1899) oil on canvas, The Fern Gatherers, signed and dated 1859, 37.25 x 65.5in. Gorringes, Bexhill. Feb 04. £12000.

81

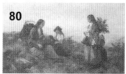

Sir Herbert James Gunn, oil on canvas, 'Figures by a rocky shore', signed, 18 x 24in. Great Western Auctions, Glasgow. Dec 01. £12000.

The illustrations are in descending price order. The price range is indicated at the top of each page.

82

Follower of Sir Henry Raeburn. Portraits of two brothers, dressed in highland costume, oil on canvas, 30 x 25in. Hamptons, Godalming. Oct 02. £12000.

83

Robert Gemmell Hutchison RSA RSW. (1855-1936) Mother and Child, signed 'Gemmell Hutchinson', oil on canvas, 78 x 64cm. Sworders, Stansted Mount-fitchet. Feb 04. £12000.

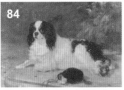

84

Treasured Possessions, King Charles spaniel reclining beside a crimson velvet purse, on canvas, signed with monogram (W.D.) lower right, dated 1884, 63 x 75cm. Wintertons Ltd, Lichfield. Sep 00. £11800.

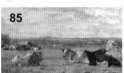

85

Nathaniel Hone, RHA (Irish, 1831-1917) Cattle Grazing, Malahide, signed with initials lower left 'NH' oil on canvas laid down on board 33 x 55cm. Cheffins, Cambridge. Feb 05. £11500.

86

Harold Clayton, a still life of roses and other flowers in a jug on a ledge, signed 'Harold Clayton', oil on canvas. Hamptons, Godalming. Apr 01. £11500.

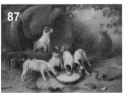

87

Walter Hunt, (1861-1941) Meal Time, with Jack Russell puppies, signed, indistinctly dated, 9.5 x 13.5in. (paint shrinkage) Neales, Nottingham. Jun 04. £11500.

88

Signed, oil on canvas by Edgar Hunt. Biddle & Webb, Birmingham. Apr 02. £11000.

89

Early 19thC view of the Cantonese port of Macao with sailing vessels in the foreground and buildings along the foreshore, gouache on canvas, 17.5 x 30in. Amersham Auction Rooms, Bucks. Aug 01. £11000.

90

Signed, oil on canvas by Edgar Hunt. Biddle & Webb, Birmingham. Apr 02. £11000.

91

William Strutt, (1823-1915) oil painting, The Prior's Feast, canvas 41 x 34in, signed, contemporary frame. Canterbury Auc. Galleries, Kent. Apr 01. £11000.

92

Marc-Aurele de Foy Suzor Cote, (1869-1937) Canadian, oil on canvas, portrait of a young lady, signed and dated Paris 2.7.1901, inscribed 'A Mademoiselle Eda Hughes, Te'moignage d'Admiration', 15.5 x 12.5in. Gorringes, Lewes. Apr 02. £11000.

93

Emma Ciardi, (1879-1933) Italian, Towards San Marco, oil on board, signed, dated 1928, Fine Art Society label verso, 15 x 20ins. Gorringes, Lewes. Apr 02. £11000.

94

Alfred de Breanski Senior, oil on canvas, Eagle Rock, Loch Lomond, signed, 24 x 36in. Gorringes, Lewes. Apr 00. £11000.

95

'The rain cloud, Careg Cenin, near Llandeilo' by David Cox O.W.S. (1783-1859), watercolour. Halls Fine Art Auctions, Shrewsbury. Nov 03. £11000.

19thC oil on wood of a young lady getting dressed in an attic bedroom, Ed. Frere. Stride & Son, Chichester. Mar 01. £11000.

96

97

A small pen, ink and wash drawing of a defeated boxer by Winston Churchill in his last year at Harrow School. Stride & Son, Chichester. Jun 00. £11000.

98

Henry Redmore, (1820-1887) oil painting, French Fishing Boats off Coast, canvas, 20 x 30in, signed and dated 1861. Canterbury Auc. Galleries, Kent. Oct 01. £10500.

99

One of a pair of oils on canvas by Henry Redmore, (1820-1887) 'A Busy Dutch Estuary Scene', signed and dated 1866, 12 x 20in, and 'An evening scene with Dutch hay barge in an estuary'. Halls Fine Art, Shrewsbury. Nov 04. £10500.

100

Fred Hall, (British 1860-1948) Portrait of a young peasant girl, oil on copper panel, signed lower right, 15.5 x 18.5cm. Fellows & Sons, Hockley, Birmingham. Oct 02. £10300.

101

Henry Redmore, (1820-1887) Shipping off the coast in a stormy sea and Shipping in a calm sea with a rowing boat and figures, oil, pair, one indistinctly signed, 13.5 x 20.25in, gilt frames. Dee, Atkinson & Harrison, Driffield. Feb 05. £10000.

Section II < £10,000 to £5,000

Compare Fortunino Matania's incredibly accomplished detail in *Arriving at the Polo Match* at **42** with his *Musical Soiree* at **117** which fetched less than half the price. It is not too difficult to see why.

Several landscapes fetched over £10,000 in Section I, notably Alfred de Breanski's *The Hills of Callendar* (**61**) and Herbert Royle's *Snowscene, Ullswater*. They didn't overwhelm the Section. Nor did seascapes. However, between £10,000 and £5,000 the picture changes dramatically with, getting on for 40 landscapes and about 15 seascapes. The collector or dealer could make a study of painters and the pictures commanding such price tags and include the continuing panorama of a further 15 townscapes gracing this Section. Studying a painter is best done through the ***Index***. Herbert Royle alone has about 20 entries, William Mellor almost as many. James McIntosh Patrick's, *April Snow, Craigowl, Angus*, at **113** appears only once.

There were very few pre nineteenth century pictures in Section I and the same applies here. At **128** is an 'after Lely' study of Lady Walpole of unknown date. At **135** is a 'circle of' Daniel Mytens, the seventeenth century Dutch artist, and at **157** is a charming study of *Nell Gwynn*, circle of Peter Lely. (1618-1680) Four such mistresses of Charles II were sold at this sale for a combined £35,000. See ***Introduction***. Lely also appears at **145** with a chalk portrait of Barbara Villers, Duchess of Cleveland. There are further early works at **165, 173, 198** and **230**. The eighteenth century only figures rarely in this Section. Still life paintings occur frequently here and throughout all sections and are too numerous to ***Index***. Gerald Cooper appears twice at **168** and **189**. Compare also the traditionalists with Mary Fedden (1973) at **119**. Check out Fedden's other works in the ***Index***. The range of still lifes are broad and include sporting, fish and books but surprisingly no game birds. Equestrian subjects are less common than in Section I with only six examples. Canine subjects are difficult to find. In the Editor's opinion the best of these is Edmund Bristow (1787-1876) *Pointers on a Heathland*, which fetched £7,500 hammer at Hamptons, Godalming in September 2002. There is also an attribution to the artist later, on page 40 at **513**. This analysis shows the ***Index*** at work. There is only one cat subject in this Section, being a further Henriette Ronner at **104**. This artist was studied in Section I. We apologise for the poor colour reproduction on the image. Subscribers to our Website at **www.antiques-info.co.uk** can view a good quality enlarged image of this subject and all other images in this work. Those interested in animalia in general can view further pictures at **143, 163, 194** and **247**, as well as the equestrian subjects mentioned earlier.

Returning to portraiture, the oil sketch at **108** of jockey Thomas Weston, by Irish artist Sir John Lavery, tells a story. It was about to be binned after being found on the floor in a house clearance in Lincoln. The building had been burgled four times since the owner's death, and the painting was about to be thrown away until spotted by the saleroom porter at Thomas Mawer of Lincoln, where it fetched £9,500 in April 2002. Why was the painting found in a house in Lincoln? Our research has shown that Thomas Weston was a leading jockey in the 1920s and 1930s. He won *The Derby* twice, *The Oaks* four times, the *2000* and *1000 Guineas* and *The St Leger* three times in 1923, 1928 and 1933. *The St Leger* is held at Doncaster. Lincoln, 40 miles away, also had a race-course. Perhaps the owner of the painting had a racing connection. How he acquired the painting will probably remain a mystery. (A further Sir John Lavery (1856-1941) oil can be found at **322** in Section III.)

To conclude the analysis the Editor will pick through the pages for areas of potential interest. At **105** is a charming study *Happy Thoughts*, by Edmund Blair Leighton. Also contrast the study of women in a garden by Henry John Yeend King at **110** with the same artist's study of a quayside scene at **142**. Compare Fortunino Matania's incredibly accomplished detail in *Arriving at the Polo Match* at **42** with his *Musical Soiree* at **117** which fetched less than half the price.

Here is charming portraiture, particularly of women and children. We have commented on Nell Gwynn at **157**, but see a further Sophie Anderson at **155** and a pre-Raphaelite girl at **159** by the same artist. Note also at **154** *...girl sat in a window* by Charles Baxter (1809-1879) and the John Charles Dollman study *Child knitting and kitten* at **212**. Their paintings sold in 2001 for £7,000 and £5,600 respectively. What are they worth today? Neither artist appears regularly at auction and neither appear to command these prices. A Baxter *Mother and Children beside the Sea*, admittedly smaller, fetched only £1,200 in July 2004 at Bonham's. Other pictures which interest the Editor are the Frederick Morgan (1856-1927) *Midday Rest* and the William Lee Hankey (1869-1952) at **176** - unfortunately the only example. There are several genre studies in this Section. See for example **109, 140, 180, 200, 210, 233** etc. I particularly like the watercolour at **200**. Thomas Waterman Wood (1825-1903) was an American, and sales of *Visit from the Landlord* and *Feeding Time* fetched £9,783 and £12,346 respectively including premium at recent London sales.

102

William Traies, A view of Exeter from Trews Wear with cattle and figures in foreground, 69 x 90cm. Bearne's, Exeter. Jul 03. £9800.

103

Abraham Hulk, pair, Fishing boats in harbour and A rowing boat coming ashore, signed, 19 x 29cm. Bearne's, Exeter. Jul 03. £9800.

104

Henriette Ronner, (1821-1909) 'Expectation' study of a blue eyed kitten, oil on board, signed, dated (18)93 ROI exhibition label verso, 4.24 x 3.75in. Gorringes, Lewes. Dec 01. £9600.

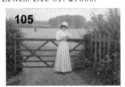

105

Edmund Blair Leighton, (1853-1922) unframed, oil on wooden panel, Happy Thoughts, signed and dated 1908, 10 x 14in. Gorringes, Lewes. Dec 03. £9500.

106

Edmund Blampied R.B. R.E. 1886-1966, oil on canvas, The Belgian Horse, signed and dated 1923 recto and entitled on a T & R Annan label verso, 20 x 27in. Great Western Auctions, Glasgow. Dec 01. £9500.

107

Alfred de Breanski Senior, (1852-1928) oil on canvas, Flowing to the Tay, signed and inscribed verso, 30 x 20in. Gorringes, Lewes. Jun 02. £9500.

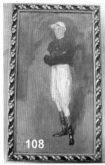

108

Oil sketch of jockey Thomas Weston by Irish artist Sir John Lavery. Thos Mawer & Son, Lincoln. Apr 02. £9500.

Artists or themes can be followed through the colour coded Index which contains over 4500 cross references.

109

Eugenio Zampighi, a pair, Interior Scenes with Figures, signed, 9.5 x 13.25in, gilt frames. Andrew Hartley, Ilkley. Apr 03. £9400.

110

Oil on canvas by H. J. Yeend King, 51 x 76cm. John Taylors, Louth. Nov 02. £9400.

111

Attributed to George Barret Jnr, Irish landscape, oil on canvas, indistinctly signed, 28.5 x 40.5in, gilt frame. Amersham Auction Rooms, Bucks. Mar 04. £9000.

112

Herbert Royle, busy haymaking scene in subtle evening light. A. Hartley, Ilkley. Dec 01. £9000.

113

James McIntosh Patrick, R.S.A. April Snow, Craigowl, Angus, signed, inscribed and dated 1949 on the reverse, 49 x 59cm. Bearne's, Exeter. Jul 03. £9000.

114

William Mellor (1851-1931) oil on canvas, On The Wharf, Bolton Woods, Yorkshire, signed and entitled verso, 20 x 30in. Gorringes, Lewes. Feb 01. £9000.

115

Thomas Rowlandson, (1756-1827) Pen, ink & watercolour, Dr. Syntax at the Auction, engraved 'Dr Syntax in Search of Consolation, 1820', 10.25 x 16.25in. Gorringes, Lewes. Apr 03. £9000.

116

Attributed to Van Os, Still life, oil on canvas, 30.5 x 22.5in. Clarke Gammon, Guildford. Apr 04. £9000.

117

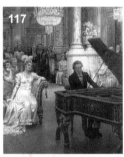

Fortunino Matania, Musical Soiree with Beethoven playing the pianoforte, oil on canvas, 20.5 x 17.5in. Mervyn Carey, Tenterden. Oct 02. £9000.

118

G Laeverenz. Two children playing with a ball of knitting wool beside a table. Stride & Son, Chichester. Mar 01. £9000.

119

Mary Fedden, 1973, still life, oil painting of fruit. Stride & Son, Chichester. Jan 05. £9000.

Hammer Prices £8800 - £8000

Adrien Joseph Verhoeven-Ball, (1824-1882) oil on canvas, 'Le Rubins du Village', signed, dated 1860, title verso, 36 x 45in, gilt gesso frame. Gorringes, Lewes. Dec 01. £8800.

William Henry Trood, Two Puppies and a Frog, signed, dated 1884, 11.5 x 15.5in, gilt frame. Andrew Hartley, Ilkley. Aug 02. £8750.

Dame Laura Knight, Off to sleep, signed Laura Johnson, 17.5 x 13.75in, stained frame. Andrew Hartley, Ilkley. Aug 01. £8600.

R. Poate, The Sailor's Return, Jack at Home, mid 19thC, 81.5 x 114.5cm. Rupert Toovey, Washington, Sussex. Nov 03. £8600.

Angeles Dubos, The Pet Bird, signed, dated 1869, oil on canvas, 45 x 55cm. Sworders, Stansted Mountfitchet. Feb 03. £8600.

Attributed to Robert Salmon, (1775-1844) American, oil on board, Perch Rock, Liverpool, indistinctly signed and dated, 9 x 11.5in. Gorringes, Lewes. Feb 01. £8500.

19thC Maltese School, pair of watercolours, Grand Harbour, Valetta, Malta, 14 x 21in. Gorringes, Lewes. Apr 04. £8500.

Henri de Toulouse-Lautrec (1864-1901) French Colour lithographic poster, Jane Avril, Imp. Chaix, 20 Rue Bergere, Paris Encres Lorilleux, and Depot Chez Kleinman, 8 Rue de la Victoire, 49 x 36 ins. Gorringes, Lewes. Apr 03. £8500.

After Lely, Lady Walpole before a classical building, oil on canvas,125 x 100cm, framed. Bristol Auction Rooms, Jun 02. £8400.

Thomas Bush Hardy, (1842-1897) watercolour, 'Deojozzi off the Ducal Palace, Venice', signed and dated 1882, 17.5 x 27in. Gorringes, Lewes. Mar 02. £8200.

Giuseppe Palizzi. Child goatherd with his animals. Stride & Son, Chichester. Mar 01. £8200.

John Opie R.A. Portrait of Colonel John Henderson, signed 'Opie', frame mounted with an inscribed plaque, 76 x 63cm. Sworders, Stansted Mountfitchet. Sep 03. £8200.

Sir George Clausen, RA (1852-1944) An Essex Village, signed, inscribed verso, oil on canvas 35.5 x 45cm. Sworders, Stansted Mountfitchet. Feb 05. £8200.

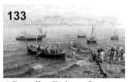

A Pratella. Fishing fleet in the Bay of Naples, canvas, signed lower right, bears black stencil mark RW306, label for G.M. Lotinga Ltd, 57 New Bond Street, London, listing title, artist and date of July 1958, 30 x 48cm. Wintertons Ltd, Lichfield. Jul 03. £8200.

Robert Gemmell Hutchison, (1855-1936) oil on canvas, seated boy blowing bubbles, signed, 26 x 21in. Gorringes, Lewes. Jan 02. £8000.

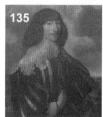

Circle of Daniel Mytens, pair, oils on canvas, portraits of George and Eleanor Chute. Gorringes, Bexhill On Sea. Sep 04. £8000.

Edward Seago, (1910-1974), Behind The Dunes, Sea Palling, oil on board, signed, 20in. x 30in. Halls Fine Art, Shrewsbury. Apr 05. £8000.

Oil painting of the Rialto Bridge, Venice by George Vivian, 23.5 x 41.5in. Mervyn Carey, Tenterden. Nov 03. £8000.

Attributed to Dutch School, mid 19thC, pair, oil on mahogany panels, 18 x 15cm, in manner of Koekek, unsigned. Richard Winterton, Burton on Trent, Staffs. Aug 04. £8000.

Portfolio of assorted water-colours, pencil drawings etc. Shanklin Auction Rooms, Isle of Wight. May 05. £8000.

Josef Kinzel, (1852-1925) A Tavern Interior, signed and dated Wien, 190?, oil on canvas, 63 x 76cm Sworders, Stansted Mountfitchet. Feb 05. £8000.

Albert Goodwin, (1845-1932) watercolour, Wells Cathedral, Children beside a lake, monogrammed, 14 x 20.5in. Gorringes, Lewes. Jan 03. £7800.

Henry John Yeend King, (1855-1924) oil on canvas, Fishing village with boy on the quayside, signed, 25.5 x 36.5ins. Gorringes, Lewes. Apr 03. £7500.

Juliette Peyrol Bonheur, French School, (1830-1891), A cockerel and chickens on a sunlit sandbank, oil on canvas, signed, dated 1863, 39in. x 51in. Halls Fine Art, Shrewsbury. Apr 05. £7500.

Edmund Bristow, (1787-1876) oil, Pointers on a Heathland. Hamptons, Godalming. Sep 02. £7500.

Small covered chalk portrait of Barbara Villers, Duchess of Cleveland by 17thC artist Sir Peter Lely, 22 x 16cm. Stride & Son, Chichester. Apr 04. £7500.

Johannes Hermanus Koekkoek, (1778-1851) oil on canvas, Dutch canal scene, signed, dated 1848, 43.7 x 57.7cm, framed. Bristol Auction Rooms, Bristol. Jan 02. £7400.

Herbert Royle, Manor Farm, Nesfield, signed, 15.5 x 19.5in, gilt frame. A. Hartley, Ilkley. Apr 04. £7200.

William Mellor, Cattle and Drover on a Woodland Path and River Landscape, a pair, 11.5 x 19.75in, gilt frames. Andrew Hartley, Ilkley. Oct 03. £7200.

After Francesco Zanin, 19thC, Italian overpainted print, St Marks Square, Venice, bears signature, 17 x 25in. Gorringes, Lewes. Sep 03. £7200.

William Page Atkinson Wells, Sunderland Point, near Morecambe, signed, 19.75 x 36.5in, gilt frame. A. Hartley, Ilkley. Jun 02. £7000.

Herbert Royle, Mill at Burley in Wharfedale, oil, signed, label verso, 19.75 x 23.5in, gilt frame. Andrew Hartley, Ilkley. Apr 05. £7000.

Herbert Royle, Starbottom in Wharfedale, oil, signed on board, inscribed verso, dated 1954, 19.75 x 23.75in, gilt frame. Andrew Hartley, Ilkley. Apr 05. £7000.

After Watts, oil on canvas, traveller on a lane, over-looking an extensive land-scape, 24 x 36in. Gorringes, Lewes. Apr 01. £7000.

Charles Baxter, (1809-1879) oil on canvas, Interior with girl sat at a window, signed, 17.5 x 13.5in. Gorringes, Lewes. Apr 01. £7000.

Sophie Anderson, (1823-1903) oil on canvas, Maiden holding orange blossom, signed, 14 x 12in. Gorringes, Lewes. Jun 03. £7000.

Benjamin Walter Spiers, (fl. 1875-1893), watercolour Family Relics, signed, dated 1877, 9.5 x 13.25ins. Gorringes, Lewes. Apr 02. £7000.

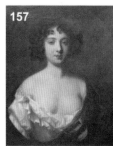

Circle of Peter Lely, oil on canvas, Nell Gwyn, mistress of Charles II, 75 x 60cm. Shanklin Auction Rooms, Isle of Wight. May 05. £7000.

Hammer Prices £7000 - £6500

158

Antique unsigned naive oil of a seated dog, 58 x 50cm. Stride & Son, Chichester. Mar 02. £7000.

159

Portrait of a pre-Raphaelite girl, S. Anderson, oil, indistinctly signed. Stride & Son, Chichester. Nov 03. £7000.

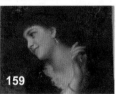

160

Frederick Morgan, (1856-1927) Midday Rest, signed and dated 1880, watercolour and bodycolour, 50 x 75cm Sworders, Stansted Mountfitchet. Feb 05. £7000.

161

Herbert Royle, Beamsley Beacon from Addingham, signed, oil on board, label verso, 20 x 24in, gilt frame. Andrew Hartley, Ilkley. Dec 03. £6800.

162

William Morris and Phillip Webb, watercolour, Sketches for a Shield, a pair, unsigned, 12.75 x 10.75in, mounted in a single ebonised frame. Andrew Hartley, Ilkley. Apr 04. £6800.

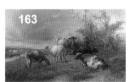

163

Thomas Sidney Cooper, RA (1803-1902) Canterbury Meadows, signed lower right 'T Sidney Cooper RA, 1827', oil on canvas, 50 x 75cm. Cheffins, Cambridge. Feb 05. £6800.

164

William Lee-Hankey, RWS, RI, ROI, RE (1869-1952) Brittany Harbour, signed lower left 'W Lee Hankey', oil on canvas, 60 x 72cm. Cheffins, Cambridge. Feb 05. £6800.

> The abbreviations following artist's names can be located in the Appendices.

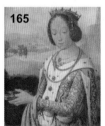

165

Early 16thC, Netherlandish School, oil on panel, half length portrait of a lady, a portrait of a gentleman verso, 11 x 9ins, tabernacle frame. Gorringes, Lewes. Oct 04. £6800.

166

Gerald Cooper, oil on canvas, signed and dated 1945, 75 x 62cm. R. Toovey, Washington. Apr 04. £6800.

167

Angelos Giallina. Pair of classical temple scenes, watercolours. Stride & Son, Chichester. Mar 04. £6800.

168

Gerald Cooper, (1898-1975) 'Flowers in a Vase, No 1', oil on canvas, signed, 25.5 x 24.5in. Halls Fine Art, Shrewsbury. Nov 04. £6750.

169

Oil painting by James Edwin Meadows, (1828-1888) oil on canvas, 16 x 26in, signed. Marilyn Swain Auctions, Grantham. Aug 01. £6600.

170

James E Meadows, 1850, a mid Victorian landscape, Return with the Harvest, oil, 24 x 41in. Stride & Son, Chichester. Nov 02. £6600.

171

William Mellor, Styborrow Crag, Ullswater, Westmorland, signed, inscribed verso, 17.25 x 13.5in, gilt frame. Andrew Hartley, Ilkley. Dec 01. £6500.

172

Henry Leonidas Rolfe, (1847-1881) on canvas, still life salmon and trout, signed, dated 1866, 19.5 x 29.5in, gilt frame. Dee Atkinson & Harrison, Driffield. Nov 04. £6500.

173

Attributed to Jean Baptiste Monnoyer, (1636-1699) oil on canvas, still life of flowers in a vase, upon a ledge, 30 x 38in. Gorringes, Lewes. Oct 01. £6500.

174

Circle of Frederick Marianus Krusemen, (1816-1882), oil on mahogany panel, Winter landscape with figures, signed, dated 1847, 19.5 x 25.5in. Gorringes, Lewes. Jul 02. £6500.

175

William Thornley, one of a pair of coastal scenes, St Michael's Mount, Cornwall, oil painting. Hamptons, Godalming. May 01. £6500.

176

William Lee-Hankey, (1869-1952) oil on canvas, Low Tide, Concarneau, signed, 61 x 75cm, framed. Lots Road, Chelsea. Nov 02. £6500.

177

Edward Lear, Kaer es Saad, water buffaloes beside river with building and palm trees, watercolour, initialled 1854, 9 x 20cm. Stride & Son, Chichester. Jul 03. £6500.

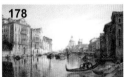

178

Arthur Perigal, The Grand Canal Venice, Looking Towards Santa Maria Della Salute, signed, inscribed A Perigal R.P.S. Venice 1872, 28 x 44.25in, gilt frame. Andrew Hartley, Ilkley. Aug 01. £6400.

179

Jessie Marion King, (Exh 1901-1940) Illustration of 'Idleness' from 'The Romaunt of the Rose' by Chaucer, pen and ink on vellum with gilt highlights, signed, 27 x 14cm. Cheffins, Cambridge. Nov 01. £6400.

180

Walter Langley (1852-1922) watercolour, fisherman's wife carrying a basket, a girl on a stairway beyond, signed and dated 1882, 14.25ins. x 7.5ins. Gorringes, Lewes. Apr 02. £6400.

181

Herbert Royle, A Hay Meadow by the Wharfe, signed, 11.5 x 15.75in, gilt frame. Andrew Hartley, Ilkley. Oct 01. £6400.

182

John L Wimbush, (d1914), oil on canvas, 'A Bolt from the Blue', signed, 74.7 x 100.7cm, framed and glazed. Bristol Auction Rooms, Bristol. Sep 01. £6400.

183

William Henry Hamilton Trood, (1848-1899), pair of oils on canvas, Two terriers pulling a cracker with other dogs looking on, signed, 9 x 12 ins. Gorringes, Lewes. Mar 05. £6400.

184

John Wood, Algernon Graves & Boydell Graves, one of a pair of oval quarter length portraits, one signed & dated 1847, inscribed verso, 22 x 18in. Sitters were members of the poet Robert Graves family. Sworders, Stansted Mountfitchet. Dec 01. £6400.

185

William Mellor, View near Goathland, Whitby, Yorkshire, signed, inscribed verso, oil, gilt frame, 29.5 x 49.5in. Andrew Hartley, Ilkley. Jun 03. £6250.

Hammer Prices £6500 - £6000

186

19thC Italian, After Raphael, Madonna della Sicciola, unsigned roundel, 28in wide, canvas inscribed verso 'Creste Bicchi Copio Ottobre 1888, E Pieraccini Inspettou della R Galleria', wax seal, 56 x 45in. Andrew Hartley, Ilkley. Feb 01. £6200.

187

Robert Alexander Hillingford (1825-1904), oil on canvas, The Battle of Waterloo, signed, inscribed verso, 19.25 x 29.5ins. Gorringes, Lewes. Apr 03. £6200.

188

Edward William Cooke, RA (1811-1880) The Molo, Venice, signed, oil on canvas 29 x 44cm. Sworders, Stansted Mountfitchet. Feb 05. £6200.

189

Gerald Cooper, (1898-1975) Bowl of peonies, flags and other flowers, signed, oil on board, 29.5 x 24.5in. Clarke Gammon, Guildford. Apr 04. £6000.

190

Herbert Royle, Haymaking at Nesfield, Ilkley, signed, 19.5 x 23.5in, gilt frame. Andrew Hartley, Ilkley. Oct 02. £6000.

191

Duncan Grant, (1885-1978) Still life with fruit, oil on canvas, signed and dated '70, 60 x 75cm. Cheffins, Cambridge. Jun 01. £6000.

192

John Warkup Swift (1815-1869), oil on canvas Men-o-War and other vessels in heavy water, signed and dated 1845, 19.75 x 29.5in. Dee, Atkinson & Harrison, Driffield. Feb 01. £6000.

193

Frank William Scarbrough, watercolour drawings, pair; The Tower Bridge, London and Blackwall Reach, London. Gorringes, Bexhill On Sea. Dec 04. £6000.

194

Thomas Sidney Cooper, (1803-1902) oil on canvas, Highland landscape with sheep grazing, signed and dated 1852, 31.5 x 41.25ins. Gorringes, Lewes. Apr 03. £6000.

Hammer Prices £6000 - £5600

195

199

203

208

Henry John Boddington, Children playing in a river, in a wooded landscape, signed and dated 1845, oil on canvas, 43 x 32.5cm. Henry Adams, Chichester. Jul 02. £6000.

Henry John Sylvester Stannard, RBA, Hay Making near Wantage, signed H. Sylvester Stannard, watercolour, 19.5 x 29.5in. Hamptons, Godalming. Oct 02. £6000.

George Turner, A scene Knowles Hills, Derbyshire, oil on canvas, signed lower right and signed, titled and dated 1887 verso, 50 x 75cm. Wintertons Ltd, Lichfield. Nov 02. £5800.

Sir George Clausen, RA, RWS, RI (1852-1944) Storm Clouds Gathering, signed lower right 'G Clausen', oil on canvas, 62 x 75cm. Cheffins, Cambridge. Feb 05. £5600.

196

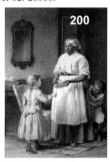

200

204

209

R Stone, one of four Hunting Scenes. Mellors & Kirk, Nottingham. Feb 03. £6000.

T. W. Wood, signed watercolour on paper, study of a 19thC interior with figure of a young girl before a householder and her daughter, 16.75 x 11.25in. Biddle & Webb, Birmingham. Mar 04. £5800.

Georgian chenille work and watercolour panel depicting a father teaching his son to write & mother lace making in a cottage landscape, 12 x 17ins Gorringes, Lewes. Mar 02. £5750.

Gerald Cooper, (1898-1975) Still life, signed, reverse dated 19.6.67, oil on board, 19.5 x 15.5in. Clarke Gammon, Guildford. Jun 02. £5600.

197

Fresh to the market paintings perform better than those which have been in and out of auction.

205

Camille Souter, Irish School 20thC, untitled abstract composition in red, blue, brown and black, oil on paper, signed, inscribed 'Dublin', dated '57, 34.5 x 23.3cm, unframed. Rosebery's, London. Sep 04. £6000.

201

Herbert Royle, Bolton Abbey Yorkshire, signed, 15.5 x 23.5in, gilt frame. A. Hartley, Ilkley. Aug 01. £5600.

206

Frederick Goodall, (1822-1904), oil on panel, The Opium Bazaar, Cairo, signed and dated 1863, artist's and Agnew's labels verso, 16 x 24ins. Gorringes, Lewes. Oct 04. £5800.

Richard Eurich, In the Dockyard, signed and dated 1935, 31.5 x 23in, stained frame. Andrew Hartley, Ilkley. Aug 04. £5600.

210

Frederick William Elwell, (1870-1958) oil on hardboard, 'Maids with pigeons' at the window of the Bar House kitchen, Beverley, signed, 19 x 15in. Dee, Atkinson & Harrison, Driffield. Aug 01. £5600.

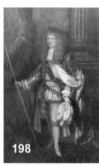

198

202

207

211

Circle of Cornelis van Jonson, oil on canvas, James Butler, 1st Duke of Ormonde, 103 x 67cm. Shanklin Auction Rooms, Isle of Wight. May 05. £6000.

French, style of Jean Baptiste Monnoyer, (1636-1699) oil on canvas, still life of flowers in a vase, 28 x 24ins. Gorringes, Lewes. Apr 02. £5800.

Richard Bankes Harraden, (1778-1862) The New Building - St John's College, Cambridge, oil on canvas, title inscribed verso, 34 x 50cm. Cheffins, Cambridge. Dec 01. £5600.

William Lionel Wyllie, (1851-1931), The Thames, St Pauls beyond, signed, watercolour, 13 x 9.25in. Gorringes, Lewes. Feb 01. £5600.

212

John Charles Dollman, (1851-1934) watercolour, Child knitting and kitten, on a doorstep, signed, 26.5 x 19.5in. Gorringes, Lewes. Apr 01. £5600.

213

Follower of George Chinnery (1774 - 1852), oil on canvas, Chinaman with a pot-bellied pig, 9 x 7 ins. Gorringes, Lewes. Oct 04. £5600.

214

Marcel Dyf, 20thC, oil, The Garden. Stride & Son, Chichester. Nov 02. £5600.

215

Herbert Royle, Morning in Spring, Nesfield Woods, signed on board, 19.5 x 23.5in gilt frame. A. Hartley, Ilkley. Dec 01. £5500.

216

Herbert Royle, Cattle and Drover at Nesfield, near Ilkley, signed, 11.5 x 15.5in, framed. Andrew Hartley, Ilkley. Oct 04. £5500.

217

Charles Edward Dixon, Tower Bridge from The Pool, watercolour, signed, dated '15, 33.5 x 78.5cm. Bearne's, Exeter. Jul 03. £5500.

218

Frank Wheatley, (1747-1801) Ruth and Boaz, oil on canvas, signed and dated 1790, 125 x 100cm. Cheffins, Cambridge. Mar 01. £5500.

219

Attributed to James Stark, (1794-1859) View in Windsor Great Park, signed, reverse inscribed and dated 1845, oil on canvas, 17.5 x 23.5in. Clarke Gammon, Guildford. Apr 04. £5500.

220

Henry Leonidas Rolfe, (1847-1881) on canvas, still life salmon and trout, signed and dated 1866, 17.5 x 29.5in, gilt frame Dee Atkinson & Harrison, Driffield. Nov 04. £5500.

221

J W Carmichael, (1800-1868) oil on canvas, a Naval Cutter, a 3 decker and other vessels possibly off Plymouth, signed, dated 1854, 16 x 26in. Dee, Atkinson & Harrison, Driffield. Feb 01. £5500.

222

William Henry Mander, mountainous river land-scape, oil on canvas, label 'Wales by W.H.Mander, exhibition picture price 30 guineas', signed, dated '96, 23.5 x 35.5in, framed. Fieldings, Stourbridge. Apr 05. £5500.

223

Harrington Bird (1846-1936) watercolour, Arab mare and foal, Bedouin encampment beyond, signed, 15 x 19.5in. Gorringes, Lewes. Sep 03. £5500.

224

Attributed to Andrea Soldi, (1703-1771) Italian, Portrait of a gentleman, oil on canvas, signed, dated 1735, 14.5 x 12.25ins. Gorringes, Lewes. Apr 05. £5500.

225

Marcel Dyf, (1899-1985) oil on canvas, 'Village de Plouharnel, Bretagne', 44 x 54cm. John Taylors, Louth. Nov 03. £5500.

226

Kilchurn Castle, signed David Farquharson 1881. Stride & Son, Chichester. Mar 01. £5500.

227

Follower of Canaletto, Figures promenading by an Italianate palace by a river, oil on canvas, 71.3 x 91.8cm, unframed. Rosebery's, London. Mar 05. £5500.

228

Oil painting of a young boy with game, signed 'J Hardy', dated 1881, not original frame, 38 x 30cm. Richard Winterton, Burton on Trent. Apr 05. £5400.

229

Pauline Bewick, (Irish, b.1935) A Hand-Bound Book of Watercolours of an Evening at Le Gavroche, 8 April 1989: nine watercolour sketches, all inscribed, and five pen and ink sketches on the reverse each 29 x 39cm. Cheffins, Cambridge. Feb 05. £5400.

230

Attributed to Frans Francken the Younger, (1581-1642) Flemish, oil on panel, The Adoration of the Magi, 24 x 19in. Gorringes, Lewes. Apr 01. £5400.

Hammer Prices £5300 - £5000

John Sell Cotman, (1782-1842) Leigh High Woods, watercolour, 12.5 x 18.5in, verso inscribed in pencil 'Leigh High Woods, Clifton, Revd J Bulwer in the foreground'. Neales, Nottingham. Jun 04. £5300.

Watercolour of a scene in Connemara by Percy French, 9.5 x 13.5in. Mervyn Carey, Tenterden. Oct 04. £5200.

Arthur Verey's 'Dinner Time in the Hop Garden', oil, exhibited at the Royal Academy in 1881. Canterbury Auc. Galleries, Kent. Jun 02. £5200.

The Hon. Marion Saumarez, (1885-1978) Madame Breakwell, oil on canvas, 180 x 112cm. Cheffins, Cambridge. Feb 04. £5200.

Paul Jones, 19thC British, a pair, Scottish highland scenes, oils, signed, dated 1868, relined canvases, 8 x 12in, gilt moulded frames. Canterbury Auc. Galleries, Kent. Aug 03. £5200.

Henry Calvert, oil on canvas, signed and dated 1863. Shanklin Auction Rooms, Isle of Wight. May 05. £5200.

Markey Robinson, (Irish School, 1917-1999) 'Country Road', oil on board, signed, 18 x 24in. Halls Fine Art, Shrewsbury. Nov 04. £5100.

Herbert Royle, Ferries in Dock, Western Isles, Scotland, signed, unfinished landscape of Beamsley, verso, 23.5 x 19.75in, gilt frame. Andrew Hartley, Ilkley. Oct 04. £5000.

Terrick Williams, A Wet Evening, St Ives, signed, 38 x 29cm. Bearne's, Exeter. Jul 03. £5000.

G Corelli, a pair of oils on wooden panels, Fishing boats on the Mediterranean coast, one signed, 11 x 18.5in. Gorringes, Lewes. Mar 03. £5000.

Christopher Wood, (1901-1930) Charcoal & sanguine chalk, Two figures dancing, from the series 'The Dancers' 23.5 x 18.5in. Gorringes, Bexhill. May 04. £5000.

Circle of Sir William Beechey (1753-1839) Oil on canvas, 'The Vaughan Boys', 25 x 30.5 ins. Gorringes, Lewes. Mar 03. £5000.

James Clarke, A log wagon at a ford, a pair. Hamptons, Godalming. Feb 02. £5000.

19thC English School, Three children and a rocking horse, watercolour, 33 x 38cm. Henry Adams, Chichester. Jul 02. £5000.

18thC French School, The Muse, oil on canvas, 75 x 94cm, framed. Lots Road, Chelsea. Feb 03. £5000.

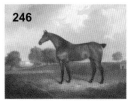

Henry Barnard Chalon, A Favourite Hunter in the Grounds of Casewick Hall. Mellors & Kirk, Nottingham. Dec 02. £5000.

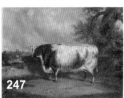

Richard Whitford, A Prize Shorthorn Bull in a Land-scape, signed, dated 1876, inscribed Animal Painter to the Queen, 52 x 76.5cm, sold with a plaster model of a bull and an EPNS bull's hoof inkwell, lid engraved. Mellors & Kirk, Nottingham. Jun 03. £5000.

Provenance is an important market factor which can bare positively on results achieved at auction.

Oil on copper after Watteau, tentatively attributed to J P Hackert depicting a flower carnival, 20 x 27in. Stride & Son, Chichester. Apr 02. £5000.

Still life oil, Harold Clayton, 39 x 43cm. Stride & Son, Chichester. Sep 04. £5000.

Section III < £5,000 to £3,000

Is the charming Haynes King (1831-1904) interior of two ladies reading a newspaper, which fetched £3,000 hammer at Gorringes, Lewes in April 2001, the same painting which sold for £4,000, entitled *Reading the News* at Bonhams in March 2004?

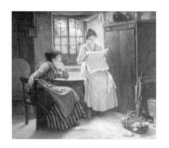

Whilst the price bands chosen are arbitrary they do tell a story. The number of images in each Section reflect the number of auctions submissions. Section II contained 148 images compared to 101 in Section I. In other words, our statistics suggests approximately 47% more sales between £5,000 and £10,000 than in the over £10,000 range. In this Section, 208 images suggests that there are about 41% more sales than in Section II. Later, although Section IV, is similar to Section III, there will be a dramatic increase in sales in Section V, when prices fall below £2,000. These statistics are tedious and will only briefly occupy future analyses. Those wishing to study correlations may be able to apply to them, some practical use.

This Section is dominated by landscapes, seascapes and townscapes. Royle and Mellor dominate but this is only because a Yorkshire auction submits many images from sales. Edward Seago (1910-1974) appears again at **260** with a wonderful example *The March Mill*, and at **377**. Follow this artist through the **Index**. Seago was a prolific artist whose paintings, particularly in London, fetch much more. Exceptionally his painting *Derby Day* fetched £280,000 at Christie's in May 2004. Normally we associate Sir William Russell Flint with nudity but see a French harbour scene watercolour at **279**, which fetched £4,400 hammer at Cheffins, Cambridge in February 2005. A typical Breanski, *Perthshire Lock* appears at **294** followed at **295** by a pair of lithographs of the *Canterbury and Whitstable Railway*, signed by Robert Stephenson. The print theme can be pursued on the same page at **299** and **300**, where two limited edition Lowry prints each fetched £4,200. There are further examples in this Section, the last at **407** by Henry de Toulouse-Lautrec. See also Marcel Dyf landscapes at **277** and **399**. More of this artist later. Also of interest is the John Piper (1903-1992) gouache, watercolour and ink at **303**. See also Ken Howard at **448**. Earlier paintings from say, the seventeenth and eighteenth centuries are poorly represented but see **265**, **349**, **354**, **350**, **351**, **365**, **388**. A John Riley (1646-1691) portrait of Mr John Marriott at **414**, which sold for £3,200 hammer at Gorringes, Bexhill in December 2004, appears to be the same painting which sold in July 2004 at Sotheby's, London, for £1,500. This information was gleaned from the 2005 Edition of Hislop's **Art Sales Index**.

Portraiture is quite well represented. The reader can easily browse the Section seeking examples. Beneath the traditional 'dragoon guard' at **269** don't miss the

'Anachronistic Bratby' (1928-1992) at **270** or the John Everett Millais at **324**. See also the Marcell Dyf at **386** and the Leonard Campbell Taylor at **424**. The John Banting (1902-1972) portrait at **380** and £3,500 is rare and unusual. This artist reached £11,000 for 'Abstract Masks' at Christie's in 2003. (not in this volume) Equestrian pictures hardly appear and canine portraiture is also poorly represented. There are a considerable selection of farm animals and some wildlife. See particularly a Colin Burns oil of pheasants and a woodcock at **392** and the Charles Frederick Tunnicliffe (1901-1979) *Waiting for the Ebb* which sold at Canterbury Auction Galleries, Kent for £4,400 hammer in April 2004.

Here are a further selection of women and children portraits at **272**, **304**, **307**, **315**, **345**, **386**, **422**, **423**, **432**, **438**, **440**, **441**, **442**, **443** and **445**. The Bertha Newman (fl.1876-1904) *Meadow of Flowers*, which sold at Halls Fine Art, Shrewsbury in April 2005 for £4,500 hammer is the 'desirable' market right up to date. See also the Marcel Dyf at **386** and the William Lee Hankey at **422**. Compare also the genre style of Johannes Weiland at **307**, *Preparing the Meal* with the John Mcghie (1867-1952) portrait of *The Mussel Girl* at **445**. See also the Hon. Marion Saumarez (1885-1978) portrait of Ellen Griffiths at **438**, also **441**, **442** and **443**, the latter a particularly charming Haynes King (1831-1904) interior of two ladies reading a newspaper. This fetched £3,000 hammer at Gorringes, Lewes in April 2001. Is this the same painting which sold for £4,000, entitled *Reading the News* at Bonhams in March 2004?

Nudes are now beginning to appear in this price range. See the Sergei Marshenkov, *Nude in Red* at **331**, **(361)** and the Marshennikov, *Nude in Gold* at **385**. Note the comments in the **Introduction** about the emergence of twentieth century and contemporary Russian art. Readers interested in abstract or twentieth century or contemporary artists have a number of examples to follow in this Section. See for example **448** and **449**. Or see **329**, **371**, **378** and **380**, the latter already mentioned. Irish art appears in these examples and Irish artists or Irish themes can be followed at **267**, **313**, **322**, **360**, **372**, **379** and **449**. My pick of this Section is the compelling Charles Edward Dixon riverscape, *London Bridge*, a watercolour which brings the very desirable 'Thames scene' (in 1915) gloriously to life. This picture represents an art theme which seems impervious to fashion and should prove a certain and sound investment. See the discussion on fashion in the **Introduction**.

Hammer Prices £4900 - £4600

250

Frank Wootton, large oil on canvas study, 'Cley Mill, Norfolk'. Humberts incl. Tayler & Fletcher, Andoversford. Oct 04. £4900.

251

19thC Italian School, Sixteen topographical views, each inscribed, watercolour and gouache, 3.75 x 5.5in, mounted in four frames. Clarke Gammon Wellers, Guildford. Feb 05. £4800.

252

Colin Graeme, (British fl 1858-1910) a pair, oil on canvas, one signed lower left, the other lower right, 495 x 39.5cm. Fellows & Sons, Hockley, Birmingham, Oct 02. £4800.

253

James Randolph Jackson (1882-1975) Australian oil on canvas, Marley Beach, Sidney, signed, 16 x 20 ins. Gorringes, Lewes. Jan 04. £4800.

254

Thomas Sidney Cooper, In the Meadows. Mellors & Kirk, Nottingham. Dec 02. £4800.

255

Terrick Williams, (1860-1936) oil on canvas, 'The Church Door, Honfleur', signed, dated 1900, 12ins. x 18ins. Gorringes, Lewes. Apr 02. £4800.

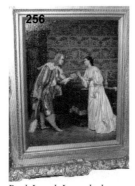
256

Paul Joseph Leyendecker, (b1842) The Gift Box, oil on canvas, signed, dated 'Paris 1871', 34 x 26cm, framed. Lots Road Auctions, Chelsea. Nov 02. £4800.

257

Edwin Douglas, (1848-1914) Highland sheep in mountainous landscape, signed lower left, oil on canvas, in original gilt frame, 19.5 x 23.5in. Peter Wilson, Nantwich. Feb 02. £4800.

258

John E Tennant, (1796-1872) Romantic highland scene, signed, dated 1843, oil on canvas, 83 x 152cm. Sworders, Stansted Mountfitchet. Jun 03. £4800.

259

Horace van Ruith, (1839-1923), 'The Reading Lesson' young, possibly Turkish girl & companions, oil on artist's board, 38.5 x 28.5cm, signed, labels verso. Ambrose, Loughton. Apr 02. £4700.

260

Edward Seago, 'The Marsh Mill, signed, watercolour, 33 x 50cm. Sworders, Stansted Mountfitchet. Nov 04. £4700.

261

Keith Vaughan, (1912-1974) gouache 'Study for Group of Bathers', outlines of four standing figures, 3.5 x 6in, signed in full and dated '57, modern gilt frame, glazed. Canterbury Auc. Galleries, Kent. Jun 05. £4700.

262

Herbert Royle, Scottish Old Alligin Pier Loch Torridon with Beinn Alligin beyond, oil, signed, 17.5 x 23.25in, painted and gilded frame. Andrew Hartley, Ilkley. Dec 03. £4600.

263

Colin Middleton, Fishing Village, boat and seagulls in the foreground, signed on board, 12.5 x 29.5in, stained frame. Andrew Hartley, Ilkley. Dec 04. £4600.

264

Herbert Royle, Burnsall, in Wharfedale, signed on board, label verso, 12.5 x 16.5in, gilt frame. Andrew Hartley, Ilkley. Apr 04. £4600.

265

17thC Dutch School, oil on canvas, family beside a cottage with cattle, sheep & goats, riverscape beyond, 29 x 24.5in. Gorringes, Lewes. Jun 02. £4600.

Most auction catalogues carry an explantation of the terminology used in descriptions. See Appendices.

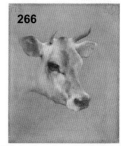
266

Edwin Douglas, (1848-1914) oil on canvas laid on board, portrait of 'Old Iris, The Lawbrook Pet', a Jersey cow, monogrammed, 12 x 10in. Gorringes, Lewes. Jan 04. £4600.

267

Percy French, (1854-1920) Irish watercolour, Girl and ducks beside a lough, signed and dated '13, 6.5 x 9.75in. Gorringes, Lewes. Mar 04. £4600.

268

John Ruskin, (1819-1900) watercolour, Alpine Scene, Switzerland, signed in pencil, 5.25 x 9.75ins. Gorringes, Lewes. Apr 03. £4600.

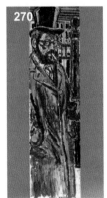

269

Charles Jagger of Bath, painting on ivory of Charles De Laet Waldo-Sibthorp, Captain of the 4th Dragoon Guard. Thos Mawer & Son, Lincoln. Apr 02. £4600.

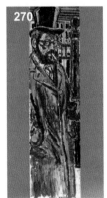

270

John Bratby, (1928-1992) oil, 'Anachronistic Bratby', three quarter length self portrait, 54 x 15in, signed, inscribed, dated Nov. ii 1960. Canterbury Auc. Galleries, Kent. Apr 02. £4500.

271

Oliver Clare, (British 1853-1927) pair, still life study, oil on artists' board, signed lower right, 24 x 17cm. Fellows & Sons, Hockley, B'ham. Oct 02. £4500.

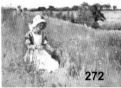

272

Bertha Newcombe, (fl.1876-1904), Meadow of Flowers, oil on canvas, signed, dated 1884, 16 x 20in. Halls Fine Art, Shrewsbury. Apr 05. £4500.

273

Harold Clayton, Still life, oil, 39 x 43cm. Strides, Chichester. Sep 04. £4500.

274

John A Lomax, The Geographer, signed on board, 13.25 x 11.25in, gilt frame. Andrew Hartley, Ilkley. Aug 01. £4400.

275

John Morris, a pair, Cattle in a farmyard and Workhorses in a farmyard, signed, 15.75 x 23.5in, gilt frame. Andrew Hartley, Ilkley. Jun 01. £4400.

276

Herbert Royle, Autumn on the Wharfe, Bolton Abbey, signed, 15.5 x 23.5in, gilt frame. Andrew Hartley, Ilkley. Aug 01. £4400.

277

Marcel Dyf, French landscape, oil, signed, 23.25 x 28.25in, painted and gilded frame. Andrew Hartley, Ilkley. Dec 03. £4400.

278

Charles Frederick Tunnicliffe (1901-1979) Waiting for the Ebb, 20 oyster catchers and 4 ringed plovers on stony beach, watercolour, signed in black to corner, painted frame, glazed, 14 x 26in. Canterbury Auc.Galleries, Kent. Apr 04. £4400.

279

Sir William Russell Flint, RA, PPRWA, RSW (1880-1969) French Harbour signed lower left 'W Russell Flint' watercolour, 24 x 33cm. Cheffins, Cambridge. Feb 05. £4400.

280

James Salt, oil on canvas, Santa Maria Della Salute, 17 x 31in. Clevedon Salerooms, Bristol. Nov 01. £4400.

281

Cecil Maguire, (1930-) oil on board, Dividing the Catch, signed, 24 x 19in. Gorringes, Lewes. Mar 04. £4400.

282

Samuel John Lamorna Birch (1869-1955) Road beside the Seine, oil on canvas, signed, dated Paris 1896, 15.5 x 12.5ins. Gorringes, Lewes. Apr 03. £4400.

283

Alfred William Hunt (1830-1896), watercolour, View of Harlech Castle, 1867 Paris Universal Exhibition label verso, 13 x 20.5ins, gilt gesso frame. Gorringes, Lewes. Oct 02. £4400.

284

Attributed to James Stark, (1794-1859) oil on canvas, 43 x 58cm. Rupert Toovey & Co, Washington, Sussex. Aug 03. £4400.

285

Thomas Baker, Back of Haddon Hall, oil. Wintertons Ltd, Bakewell. Jun 02. £4400.

286

Herbert Royle, Nesfield Woods in snow with figures and sheep, oil, signed, 19.5 x 15.5in, painted frame. Andrew Hartley, Ilkley. Apr 05. £4300.

287

Amadeo Preziosi, (1816-1882) Italian, watercolour, Carpet seller in an Arab market, signed and dated 1850, 12 x 16in. Gorringes, Lewes. Mar 01. £4300.

288

Pompeo Massani (1850-1920) The Rival Suitors, signed 'P Massani, Firenze', oil on canvas, 56 x 40cm. Sworders, Stansted Mountfitchet. Feb 05. £4300.

289

Giovanni Grubacs, Rialto Bridge, Venice, signed 'G Grubacs', re-lined, framed, 20.5 x 20.5in.? Tring Market Auctions, Herts. Apr 05. £4300.

290

E Verboekhoven, sheep and lambs in a byre. Stride & Son, Chichester. Mar 01. £4250.

291

William Mellor, On the River Llugwy, North Wales, oil, signed, inscribed verso, 11.5 x 17.5in, gilt frame. Andrew Hartley, Ilkley. Apr 01. £4200.

292

William Mellor, On the Wharfe, Bolton Woods, signed, 11.5 x 17.75in, gilt frame. Andrew Hartley, Ilkley. Dec 02. £4200.

293

Frederico-Maria Eder Y gattens, (fl 1858-1880) Spanish country landscape, 20 x 27in, signed 'Eder Sevilla '83', gilt frame. Canterbury Auc. Galleries, Kent. Oct 02. £4200.

294

Alfred Fontville de Breanski, Perthshire Loch, signed, 20 x 30in, gilt frame. A. Hartley, Ilkley. Apr 05. £4200.

295

Thomas Mann Baynes, one of a pair of coloured lithographs showing the opening of the Canterbury and Whitstable Railway, May 3rd 1830, signed by Robert Stephenson himself. Canterbury Auc. Galleries, Kent. Nov 02. £4200.

296

Indian Company School. Fine album of 27 Company School watercolours of Indian occupations, crafts and trades, Patna, c1820-1840, each 17 x 13cm. Cheffins, Cambridge. Jul 02. £4200.

297

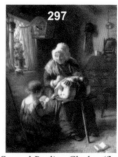

Samuel Barling Clarke, (fl 1852-1878)) The reading lesson, signed, oil on canvas, 17.5 x 13.5in. Clarke Gammon, Guildford. Apr 01. £4200.

298

Henry Scott Tuke RA RWS, watercolour, Shipping in a Mediterranean Harbour, signed and dated 1904, 9.5 x 13.5in. Clevedon Salerooms, Bristol. Mar 01. £4200.

299

L. S. Lowry. Limited edition print 41/75, Figures in a Street, Church in background, 62 x 97cm, together with another, park with river, buildings and figures. D M Nesbit & Company, Southsea. Jun 03. £4200.

300

L. S. Lowry. Ltd edition print 41/75, Figures in a Street, Church in background, 62 x 97cm, together with another, park with river, buildings and figures. D M Nesbit & Company, Southsea. Jun 03. £4200.

301

Herbert Menzies Marshall, (1841-1913) watercolour, Waterloo Bridge, signed and dated 1907, 19 x 26ins. Gorringes, East Sussex. Mar 02. £4200.

302

Glyn Philpot, (1884-1937), oil on canvas, Dahlias, 1933, initialled, AEB label verso, 24 x 20ins. Gorringes, Lewes. Mar 05. £4200.

303

John Piper, (1903-1992) 'Bedwelty', gouache, water-colour and ink, signed and titled, 15 x 21.5in. Halls Fine Art, Shrewsbury. Apr 05. £4200.

Ensure you never hang your watercolours etc in direct or reflected sunlight. Fading seriously affects value.

304

Basil Nightingale, Young girl holding bouquet to foal by a stile, titled 'Do you like Butter' and 'The artist's daughter Miss Florence Nightingale and the race-horse Spate when a foal', charcoal and watercolour on brown paper, signed Basil N, 54 x 74cm. Locke & England, Leaming-ton Spa. May 03. £4200.

305

Yuri Matushevski, (1930-1999), 'Blue Winter', 1957, oil on board, signed, 48 x 60cm, framed. Lots Road Auctions, Chelsea. Dec 04. £4200.

306

Anglo-Chinese School, 19thC European and American residences along a busy waterfront; paint on paper, 15 x 27.2cm, and with one other Anglo Chinese painting depicting shipping by fortified harbour entrance, 14.2x27cm. (2) Rosebery's, London. Dec 04. £4200.

307

Johannes Weiland, Preparing the Meal, signed and dated, framed, 19 x 15in. Tring Market Auctions, Herts. Jul 04. £4200.

308

George Turner, The Evening Hour, oil on canvas, signed lower left, titled and signed verso, 16 x 24in. Wintertons Ltd, Bakewell. Feb 02. £4200.

309

Kate Gray, St Patricks Day, signed and dated 1911, 24 x 19.5in, gilt frame. A. Hartley, Ilkley. Apr 02. £4100.

Hammer Prices £4200 - £4000

310

Oliver Clare, (British 1853-1927) a pair, still life, oil on artists' board, both signed lower right, 23 x 14cm. Fellows & Sons, Hockley, Birmingham. Oct 02. £4100.

311

William Mellor, Thornton Ghyll, Ingleton, signed, inscribed verso, 15.5 x 23.5in, gilt frame. A. Hartley, Ilkley. Aug 01. £4000.

312

William Mellor, On the Lledr, North Wales, signed, inscribed verso, 11.25 x 17.5in, gilt frame. A. Hartley, Ilkley. Dec 01. £4000.

313

Thomas Rose Miles, Trout Fishing on the Ballanahinch Connemara, signed and inscribed verso, 10 x 15.75in, gilt frame, a pair. Andrew Hartley, Ilkley. Aug 03. £4000.

314

Herbert Royle, Boats on a Loch, Camus Terach, Ross-shire, oil, signed, inscribed verso, 11.5 x 15.75in, gilt frame. Andrew Hartley, Ilkley. Dec 03. £4000.

315

Ernest Higgins Rigg, portrait of the Artists Daughter at the piano, signed, 29.75 x 24.5in, gilt frame. A. Hartley, Ilkley. Apr 04. £4000.

316

Herbert Royle, Dean Farm, Nesfield, signed, 17.5 x 14in, gilt frame. Andrew Hartley, Ilkley. Aug 04. £4000.

317

Indian Company School, Collection of 43 Company School watercolours of Indian occupations, crafts and trades, Patna, c1820-1840, each 17 x 13cm. Cheffins, Cambridge. Jul 02. £4000.

318

Herbert Royle, (1870-1958), oil on board, Hay cart in a cornfield, signed, 8 x 10ins. Gorringes, Lewes. Oct 04. £4000.

Hammer Prices £4000 - £3900

319

Charles Edward Dixon, London Bridge, watercolour, signed, inscribed and dated 1915, 33.5 x 78.5cm. Bearne's, Exeter. Jul 03. £4000.

320

Duncan Grant, (1885-1978) oil on canvas, Firle Park, signed, 24 x 29ins. Gorringes, Lewes. Sep 04. £4000.

321

Angelos Giallina, (1857-1939) Greek watercolour, View of the coast of Corfu, signed, 15.5 x 28ins. Gorringes, Lewes. Jan 04. £4000.

322

Sir John Lavery, (1856-1941) oil on artist board, Portrait of Arabella, Duchess of Marlborough, signed, 14 x 10ins. Gorringes, Lewes. Apr 03. £4000.

323

Albert Goodwin, (1845-1932) 'Folkestone', oil on card, signed and inscribed, 10 x 14.5ins. Gorringes, Lewes. Apr 03. £4000.

324

Sir John Everett Millais, (1829-1896) 'Portrait of Stanley Leighton M.P., FSA, of Sweeney Hall, Oswestry', long bust length, oil on canvas, signed with monogram and dated 1896, 28in x 23in. Halls Fine Art, Shrewsbury. Apr 05. £4000.

325

Bonomi Edward Warren, (19thC), pair, 'An Extensive Summer Landscape with Figures Haymaking', and 'Two Girls with Children Playing', watercolours, signed and dated 1836/7, 80 x 132cm. (2) Hampton & Littlewood, Exeter. Jul 04. £4000.

326

Attributed to Kerstiaen De Keuninck, (1560-1630) Aeneas Carrying his Father from Troy, oil on canvas, 33.5 x 59in, framed. Lots Road Auctions, Chelsea. Apr 01. £4000.

327

Attributed to H Shayer, oil painting, 23.5 x 30in. Marilyn Swain Auctions, Grantham. Aug 01. £4000.

328

Pair of Regency sand prints, in the style of James Ward, 'A Lion resting in his lair' and a 'Tiger lying by a tree', both with glass eyes, contemporary gilt frames, 30 x 35cms wide. Rosebery's, London. Dec 04. £4000.

> Frames and mounts should enhance your picture. Empathy, rather than fashion should dictate your choice.

329

Camille Souter, Irish School 20thC, Abstract composition, gouache on newspaper, signed and dated August '57, 54 x 35cm. (unframed) Rosebery's, London. Sep 04. £4000.

330

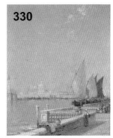

Arthur Meadows, (1843-1907) oil on canvas, Venice from the Public Gardens, 56 x 43cm. Rupert Toovey & Co, Washington, Sussex. Mar 03. £4000.

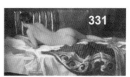

331

Sergei Marshenkov, Nude in Red, oil on canvas, 55 x 90, signed, framed. Lots Road Auctions, Chelsea. Jun 04. £4000.

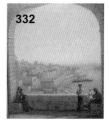

332

G Gianni, Italian artist, oil painting of Malta, group of figures and a monk on a stone balcony overlooking the harbour, 1883, 9 x 7in. Stride & Son, Chichester. Mar 03. £4000.

333

Monogram JnC. Seven sheep in a snowy landscape, on board, monogrammed lower right, 19 x 30cm. Wintertons Ltd, Lichfield. Jul 02. £4000.

334

Edward Morland Lewis, (1903-1941), Clock Tower, view of a quay with boats, oil on canvas, 18 x 22in, signed 'M. Lewis', black, gilt moulded, painted frame. Canterbury Auc. Galleries, Kent. Apr 05. £3900.

335

John Thomas Peele (1822-1897) oil on canvas, Mother and child feeding chickens in a farmyard, signed and dated 1883, 22 x 34in. Gorringes, Lewes. Sep 02. £3900.

336

Charles Edward Dixon, off Gravesend, signed, dated '03, watercolour, 27 x 79cm. Henry Adams, Chichester. Sep 02. £3900.

337

George Wetherill, View of Whitby, signed, 4.75 x 8.25in, gilt frame. A. Hartley, Ilkley. Jun 01. £3800.

338

John Wilson Carmichael, Scarborough, initialled and dated 1819, 12.25 x 18.5in, gilt frame. Andrew Hartley, Ilkley. Dec 04. £3800.

339

William Louis Desanges, a pair of life size portraits of an Officer of the 17th Lancers, together with his wife, oil on canvas, 226 x 130cm. D M Nesbit & Co, Southsea. Sep 03. £3800.

340

Robert Watson, (19/20thC) study of sheep and lambs, signed and dated 1900, 23.5 x 35.5in, gilt frame. Dee Atkinson & Harrison, Driffield. Jul 04. £3800.

341

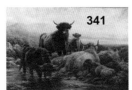

Robert Watson, (19/20thC) Highland Cattle with calves watering, signed, dated 1900, 23.5 x 35.5in, gilt frame. Dee Atkinson & Harrison, Driffield. Jul 04. £3800.

342

Attributed to Juan de Arellano, (1614-1676) Spanish, oil on canvas, still life, flowers in a classical terracotta vase, 37 x 30in, carved giltwood frame. Gorringes, Lewes. Apr 01. £3800.

343

Theodore Hines, (fl.1876-1889) oil on canvas, On The Lockay, Killin, N.B., signed, 20 x 30in. Gorringes, Lewes. Mar 04. £3800.

344

Angelos Giallina, (1857-1939) Greek watercolour, Fishing boat off the coast of Corfu, signed, 15.5 x 28.5ins. Gorringes, Lewes. Jan 04. £3800.

345

Alesandro Ossani, Street Children, signed and dated 1877, oil on board, 25 x 34cm. Sworders, Stansted Mountfitchet. Feb 03. £3800.

346

Rowland Hilder, (1905-1993) oil on artist board, Shoreham Valley, signed, 20 x 30 ins. together with a letter from the artist regarding this work. Gorringes, Lewes. Sep 04. £3800.

347

Sir Alfred Munnings, (1878-1959) oil on canvas, Woodland landscape with pond in foreground, signed and indistinctly dated, 22 x 16ins, Gorringes, Lewes. Mar 03. £3800.

348

19thC Continental School, oil on canvas, Still life of grapes, pomegranates and a melon, 36 x 27ins Gorringes, Lewes. Apr 02. £3800.

349

Follower of Frans Franck II, (1581-1642) Flemish, pair of oils on copper panels, Moses beside the Red Sea & Woman laying tribute before a warrior, 20 x 15.5ins. Gorringes, Lewes. Apr 05. £3800.

350

Follower of Philips Wouverman, (1619-1668) Country Feast with landscape and figures beyond, oil on canvas, 42 x 60cm, framed. Lots Road Auctions, Chelsea. Jul 02. £3800.

351

Henrietta Maia, follower of Van Dyck, late 17thC, oil, 78 x 40cm. Lots Road Auctions, Chelsea. Mar 03. £3800.

352

After Landseer, Shoeing, study of a blacksmith's shop, on canvas, 141 x 110.5cm. Wintertons Ltd, Lichfield. Jan 03. £3800.

Hammer Prices £3800 - £3600

353

19thC English Provincial School, Lancashire Hock-Hoofed Longhorn bullock and a companion study of a heifer of the same breed, oil on board. (2) Rosebery's, London. Mar 02. £3800.

354

Thomas Rowlandson, (1756-1827) A Gaming Party, pen, ink and watercolour, 10.5 x 18cm. Sworders, Stansted Mountfitchet. Feb 05. £3800.

355

George Gregory, HMS Victory, 100 guns, in Portsmouth Harbour, oil on canvas, signed, dated 1883, 21.5 x 39.5in, gilt frame. Amersham Auction Rooms, Bucks. Aug 02. £3700.

356

Eugene Boudin, (1824-1898) French pastel, sketch of two dogs, initialled, 5 x 7in. Gorringes, Lewes. Jun 03. £3700.

357

Henry Garland, pair of oil paintings of Highland Cattle, oils on canvas, signed, dated 1897 and 1898, 24 x 20in. Marilyn Swain Auctions, Grantham. Aug 01. £3700.

358

George Turner, scene at Milton Derbyshire, signed, dated '91, signed and dated again and inscribed with the title and artists's address Barrow on Trent near Derby verso, 51 x 76.5cm, unframed. Mellors & Kirk, Nottingham. Apr 03. £3700.

359

John Mulcaster Carrick, a pair, Abbot's Cliff, Folkestone. Mervyn Carey, Tenterden. May 01. £3700.

360

J H Campbell 1804, a pair, titled 'Ireland's eye taken from Baldoyle Co. Dublin' and 'View of St. Valeri Co. Wicklow' and 'Shankhill from Killcrony', signed, dated, trimmed and remounted, 7 x 9.5in. Tring Market Auctions, Herts. May 02. £3700.

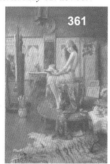

361

William A. Breakspeare, (1856-1914) oil on wooden panel, Artist in studio painting his model as Salome, signed, 18 x 14ins. Gorringes, Lewes. Dec 02. £3600.

362

William Mellor, On the River Wharfe, Yorkshire, oil, signed, inscribed verso, 11.5 x 17.5in, gilt frame. Andrew Hartley, Ilkley. Apr 01. £3600.

363

Herbert Royle, Moorland Scene with Figure, Horse and Cart, signed, on board, 11.5 x 15.5in, gilt frame. Andrew Hartley, Ilkley. Aug 02. £3600.

Ensure your watercolours etc are mounted on acid free boards. Have old pictures checked out by a framer.

364

English School (18thC) Neo-classical Wall Panel surmounted by Bacchus, with swags of flowers and garrya husks, crossed thyrsae, putti in terracotta cameos, and amorini in an arch below, oil on canvas, 235 x 173cm. Cheffins, Cambridge. Feb 05. £3600.

365

Edward Bawden, (1903-1989) screen print, 'Lindsell Church', signed and dated 1960, 32/40, 24 x 61ins. Gorringes, Lewes. Apr 03. £3600.

366

Frank Bramley, (1857-1915) oil on canvas, 'Hollyhocks', label verso, 39 x 33ins. Gorringes, Lewes. Jan 05. £3600.

367

Pair of oils on canvas, studies of dalmatians, signed and dated 1915, 12 x 15in. Gorringes, Bexhill. Dec 01. £3600.

368

Julian Olzzon, oil on canvas, Waves breaking on the shore, signed, 24 x 30in. Gorringes, Lewes. Apr 01. £3600.

369

Clarkson Stanfield, (1793-1867) watercolour, The Great Tor, Oxwich Bat, Gower Coast, dated under mount 1847, inscribed 'To J.Penrice Esq. with C.Stanfield's Compliments', 6.5 x 13.25ins. Gorringes, Lewes. Dec 04. £3600.

370

374

William Gunning King, (1859-1940), 'Feeding the calves', a pair of oils on canvas, signed, dated 1912, 17 x 18in, and companion 'A shepherd with ewes'. Halls Fine Art, Shrewsbury. Nov 04. £3600.

19thC Continental School, The Muck Spreader, indistinctly signed, 52 x 84cm. Locke & England, Leamington Spa. Jan 03. £3600.

378

Albert Gleizes, Three seated female figures, pencil watercolour and gouached, signed (twice), 50.4 x 55.5cm, unframed. Rosebery's, London. Sep 04. £3600.

382

Eugen Jettel, (1845-1901) A Garden, signed and dated Paris '90, oil on panel, 35 x 27cm. Sworders, Stansted Mountfitchet. Feb 05. £3500.

371

375

Early 19thC British School. Portrait of a young girl in a landscape, oil on canvas, 118 x 74cm. Wintertons Ltd, Lichfield. Sep 03. £3600.

379

Edward Morland Lewis, (1903-1943) Irish Town, street scene by a bridge, oil on canvas, 24 x 20in, signed in red 'M Lewis', gilt moulded frame. Canterbury Auction Galleries, Kent. Apr 05. £3500.

383

John Bellany, R.A. Fisherwoman with a cockerel, oil on canvas, signed and dated '95 on stretcher, 100.7 x 76cm, unframed. Rosebery's, London. Dec 03. £3600.

376

Ernest Walbourn, Highland Cattle by a Loch, oil, signed, 49.5 x 74.5cm. Mellors & Kirk, Nottingham. Jun 03. £3600.

380

Tom Scott, RSA (1854-1927) watercolour, 'Spring Morning, Bowden Burn', signed and dated '96, label verso, 19 x 14ins. Gorringes, Lewes. Apr 03. £3500.

372

377

Henry Robertson Craig, (Irish 1916-1984) In the Tuileries Gardens, oil on canvas, signed, framed, 60 x 50cm. Lots Road Auctions, Chelsea. Feb 03. £3600.

Edward Seago, (1910-1974) watercolour, The Lock at Liedschendam, 34 x 51.5cm. Rupert Toovey, Washington, Sussex. Apr 03. £3600.

John Banting, (1902-1972), Portrait, oil on board, 55 x 40cm, in original frame. Dreweatt Neate, Donnington. Nov 02. £3500.

381

384

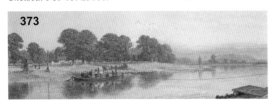

373

William Wilde. Wilford Ferry and Gunthorpe Ferry Nottinghamshire, one of a pair, both signed and dated 1862. Mellors & Kirk, Nottingham. Feb 03. £3600.

Herbert Royle, Harvest Time in Wharfedale, signed, label verso, 19.5 x 23.5in, gilt frame. Andrew Hartley, Ilkley. Jun 02. £3500.

David Emil Joseph de Noter, (1825-1875) Belgian, oil on wooden panel, still life of a bowl of raspberries with a flagon of wine, tomatoes and a basket of flowers in the background, signed, 12.75 x 9.25ins. Gorringes, Lewes. Apr 02. £3500.

Hammer Prices £3500 - £3400

385

Sergei Marshennikov, 'Nude in Gold', oil on canvas, signed, 46cm x 90cm, framed. Lots Road Auctions, Chelsea. Dec 04. £3500.

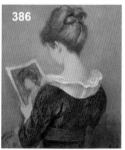

386

Marcel Dyf, 20thC, oil, Portrait of a girl. Stride & Son, Chichester. Nov 02. £3500.

387

William Mellor, On the Wharfe, Bolton Woods and Waterfall Ingleton Force, a pair, both signed and dated May '28th '98, 11.75 x 8in, gilt frames. Andrew Hartley, Ilkley. Feb 05. £3500.

388

Thomas Rowlandson, (1756-1827) pen, ink and watercolour, Darning the Sock, signed, 10.5 x 8.25ins. Gorringes, Lewes. Apr 03. £3400.

389

William Kay Blacklock, The Artist and his Wife sketching on a river bank, signed, 10 x 13.5in, gilt frame. A. Hartley, Ilkley. Apr 02. £3400.

390

William Mellor, On the Lledr, North Wales, signed, inscribed verso, 155.25 x 25.25in, gilt frame. Andrew Hartley, Ilkley. Dec 01. £3400.

391

In the manner of T S Cooper, oil on canvas, Cattle in a Landscape, 24 x 36in. Clevedon Salerooms, Bristol. Mar 01. £3400.

392

Colin Burns, (1944-) oil on canvas, Cock and Hen Pheasant and a Woodcock in the Snow, signed, 19.5 x 29.5in. Dee, Atkinson & Harrison, Driffield. Aug 04. £3400.

393

Frederick John Widgery, (1861-1942) Flooded Water Meadows on the River Exe, oil on canvas, signed, 36 x 74cm. Hampton & Littlewood, Exeter. Apr 04. £3400.

394

Joseph Thors, (fl.1863-1900) oil on canvas, figures and cottage in an extensive landscape, monogrammed, 10 x 16in. Gorringes, Lewes. Feb 01. £3400.

395

18thC Dutch School, oil on canvas, Equestrian figures on a woodland lane with manor houses beyond, 40 x 54in. Gorringes, Lewes. Apr 01. £3400.

396

T. Edwards, (19thC) oil on canvas, 'Ware Reform Festival, 25th July 1832', inscribed verso, 22 x 27in. Gorringes, Lewes. Jul 04. £3400.

397

Curtius Victor Clemens Grolig, A busy quayside with an artist sketching, signed and dated 1830, 41 x 50.5cm. Mellors & Kirk, Nottingham. Apr 03. £3400.

398

Maurice Levis, (1860-1940) oil on cradled panel, La ferme au bord du ruisseau, signed, label verso, 6.25 x 9.25in. Gorringes, Bexhill. Sep 03. £3400.

399

Marcel Dyf, 20thC, oil, French village in Provence. Stride & Son, Chichester. Nov 02. £3400.

400

Attributed to Conradyn Cunaeus, (1828-1895) Dutch oil on panel, Waiting for their master, signed, 18.5 x 25.5ins. Gorringes, Lewes. Apr 03. £3400.

401

Albert Goodwin, (1845-1932) oil on card, 'Venice', signed and inscribed, 9.25 x 14.5ins. Gorringes, Lewes. Apr 03. £3400.

402

Carl Friedrich Werner, (1808-1894), Middle Eastern riverside scene, watercolour, signed and date 'C. Werner, F.1871', 6 x 9in, framed. Lots Road Auctions, Chelsea. Feb 01. £3400.

403

Angelos Giallina, (1857-1939) Greek watercolour, Corfu coastline, signed, 15.5 x 29ins. Gorringes, Lewes. Jan 04. £3400.

404

Georgina Lara, Rustic Farm, late 19thC, oil on canvas, signed, 22 x 34.5cm. Rupert Toovey & Co, Washington, Sussex. Oct 03. £3400.

405

Alexander M Rossi. Afternoon on the river, oil on canvas, signed, 16 x 20in. Sworders, Stansted Mountfitchet. May 01. £3300.

406

18thC Italian School. Madonna and child, relined canvas, 33 x 43in, moulded frame. Canterbury Auction Galleries, Kent. Apr 05. £3300.

407

Henri de Toulouse-Lautrec, lithographic poster in two sheets, Reine de Joie par Victor Joze, printed by Edward Ancourt & Cie Paris, 136 x 92cm. D M Nesbit & Company, Southsea. Jun 03. £3300.

408

Charles Jones RCA, (1836-1892) Sheep on a bank, signed with a monogram and dated 1871, 12 x 16in and companion, Sheep in a meadow, a pair. Halls Fine Art Auctions, Shrewsbury. Apr 04. £3300.

409

Oliver Clare, (1853-1927) Still life of apples, plums and gooseberries on a mossy bank, on canvas, signed, 46 x 38cm, unframed. David Duggleby, Scarborough. Apr 02. £3250.

410

Herbert Royle, Village Street Scene, oil, signed oval, 14.25 x 17.5in, gilt frame. Andrew Hartley, Ilkley. Dec 03. £3200.

411

Cecil Kennedy, (1905-1997) 'Roses', signed, oil on canvas, 49.2 x 39.2cm, framed. Bristol Auction Rooms. Jun 03. £3200.

412

Herbert Royle, Scottish Loch from over the Haunted Glen of Mary Rose, signed, label verso, 19.5 x 23.5in, gilt frame. Andrew Hartley, Ilkley. Oct 03. £3200.

413

19thC primitive oil on canvas, Mount Austin Barracks, 16 x 22in. Clevedon Salerooms, Bristol. Nov 01. £3200.

Condiiton, rarity, provenance and fashion are the key market operators currently dictating values.

414

John Riley, oil on canvas, Portrait of Mr John Marriott of Alscot Park. Gorringes, Bexhill On Sea. Dec 04. £3200.

415

Henry B Wimbush, (fl.1881-1904) pair of watercolours, figure beside watermill and girl walking by a stream, signed, 16 x 11.5in. Gorringes, Bexhill. Oct 01. £3200.

416

John Piper, (1903-1992) Brighton street scene, watercolour and ink, signed, dated 1939, Leicester Galleries label, 16 x 22in. Gorringes, Lewes. Jan 02. £3200.

417

George Armfield, (fl.1840-1875), oil on canvas, Three terriers at a rabbit hole, signed, 43cm x 53.5cm. Gorringes, Bexhill. Mar 05. £3200.

418

George Houston R.S.W. R.S.A. 1869-1947, an oil on canvas 'Spring Snows, Loch Fyne', signed recto, a T & R Annan label to the reverse. Great Western Auctions, Glasgow. Dec 01. £3200.

419

Sir Sidney Robert Nolan, Burke and Wills V, synthetic polymer paint on hardboard, 56 x 65cm. Henry Adams, Chichester. Jan 03. £3200.

420

Charles Rowbotham, (1856-1921), pair of watercolours, View of Naples from the hills, and Italian lake scene, signed, one dated 1881, 10.5 x 21in. Gorringes, Lewes. Mar 01. £3200.

Hammer Prices £3200 - £3000

421

Attributed to Johann-Ernst Heinsius, (1740-1812), pair of half length portraits, oil on canvas, 31 x 24in, framed. Lots Road Auctions, Chelsea. Feb 01. £3200.

422

William Lee Hankey, (1869-1952) On the Stile, water-colour, signed, 34 x 24cm, framed. Lots Road Auctions, Chelsea. May 01. £3200.

423

George Goodwin Kilburne, Tea Time. Mellors & Kirk, Nottingham. Dec 02. £3200.

424

Leonard Campbell Taylor, Portrait of Guy Kortright in a mountainous landscape, signed, oil on canvas, 76 x 91cm. Sworders, Stansted Mountfitchet. Mar 03. £3200.

425

Benjamin William Leader, RA (1831-1923) A River Scene with figures in a boat, signed and dated 1878, oil on canvas 31 x 46cm. Sworders, Stansted Mountfitchet. Feb 05. £3200.

426

David Payne, (Exhib 1882-1891). 'A Derbyshire Lane', two figures resting, signed lower right, signed/inscribed on the reverse, 63.5 x 105cm. Wintertons Ltd, Lichfield. Mar 04. £3200.

427

William Thornley, Low Tide Ramsgate and Shipping off Margate, a pair, one signed, 34 x 27cm. Mellors & Kirk, Nottingham. Apr 03. £3200.

428

Edward Morland Lewis, (1903-1941) Chelsea Street, view looking down from upper floor to street, 4 storey house opposite, oil on canvas, 24 x 14in, unsigned, painted, moulded frame. Canterbury Auc. Galleries, Kent. Apr 05. £3100.

429

Harry Mitton Wilson, Beach scene at low tide with numerous figures, signed, oil on panel, 10 x 15in. Sworders, Stansted Mountfitchet. May 01. £3100.

430

George Stainton, marine oil painting of a Quiet Evening, galleons at anchor by the coast. Stride & Son, Chichester. Apr 02. £3100.

431

Vicat Cole, Fisherman on a river in the highlands, signed with monogram and dated 1887 lower right, 75 x 59cm. Wintertons Ltd, Lichfield. May 02. £3100.

432

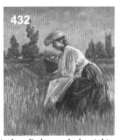

Arthur Delaney, lady picking poppies, Mottram-in-Longdendale, signed, oils, 28.5 x 25.5cm. Dockree's, Manchester. Jun 01. £3050.

433

R. Stubbs, a pair of Dorset Coastal Scenes, signed and dated 1866/69, 10.5 x 19.5in, gilt frame. Andrew Hartley, Ilkley. Aug 02. £3000.

434

Reginald Brundrit, View of Wensleydale, signed, exhibition labels verso, 30 x 40in, gilt frame. Andrew Hartley, Ilkley. Apr 04. £3000.

435

Benjamin Williams Leader, Mountain River Scene with Figures beneath a Tree, signed, 30 x 20in, gilt frame. Andrew Hartley, Ilkley. Feb 05. £3000.

436

Edward Seago 1910-1974, 'Evening, River Bure', 8.5 x 11.25in, signed in pencil, gilt frame and glazed. Canterbury Auc. Galleries, Kent. Apr 05. £3000.

437

Edward Morland Lewis, (1903-1943) 'St Valery-en-Caux', oil on canvas, 16 x 20in, unsigned painted/moulded frame, inscribed on rear of frame 'Frame Makers - Green & Stone Ltd, 258 Kings Road, Chelsea'. Canterbury Auc. Galleries, Kent. Apr 05. £3000.

438

The Hon. Marion Saumarez, (1885-1978) Portrait of Ellen Griffiths, Madam Breakwell, oil on canvas, 90 x 71cm. Cheffins, Cambridge. Feb 04. £3000.

Wilfrid Gabriel de Glehn, RA, RP, NEAC (1870-1951) Elms at Grantchester, oil on canvas, 63 x 76cm. Cheffins, Cambridge. Feb 05. £3000.

Sir Daniel Macnee FRSA, mid 19thC, oil on canvas, portrait of a young boy, signed, 49 x 39in. Clevedon Salerooms, Bristol. Mar 01. £3000.

Prices quoted are hammer and exclude the buyer's premium. Adding 15% will give approx. buying price.

Thomas Morris, oil on canvas, Portrait of a young lady wearing a red turban, inscribed verso and dated 1809, 24 x 20in. Gorringes, Lewes. Mar 01. £3000.

18thC School, pair of oils on canvas, half length portraits of a gentleman and his wife, 30 x 25in. Gorringes, Lewes. Oct 02. £3000.

Haynes King, (1831-1904) oil on canvas, Cottage interior with ladies reading a newspaper, signed, 14 x 18in. Gorringes, Lewes. Apr 01. £3000.

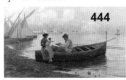

G. Amadio, oil on canvas, Neopolitan coastal scene with young fisherman seated in a boat with mother and child, signed, 60 x 100cm. Clevedon Salerooms, Bristol. Feb 05. £3000.

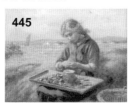

John McGhie, (1867-1952) oil on canvas, The Mussel Girl, signed, 20 x 26in, gilt gesso frame. Gorringes, Lewes. Jan 03. £3000.

Edward Seago, (1910-1974) oil on board, Pevensey Castle, signed, 18 x 25ins. Gorringes, Lewes. Dec 04. £3000.

Engleheart, miniature, young gentleman wearing a black coat etc. Gorringes, Bexhill On Sea. Dec 04. £3000.

Hammer Price £3000

Ken Howard, (1932-), oil on board, St Michaels Mount, signed, 9.5 x 7.5ins. Gorringes, Lewes. Mar 05. £3000.

Brian Ballard, (Irish b1943) Irises, oil on canvas, signed, 44 x 57cm, framed. Lots Road Auctions, Chelsea. Feb 03. £3000.

Arthur Spooner, The Pool Evening, signed, signed again and inscribed verso, canvas-board, 29 x 34cm. Mellors & Kirk, Nottingham. Apr 03. £3000.

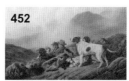

A. Wheeler of Hanwell, oil on canvas, signed and dated '86, 15 x 24.5in. Louis Taylor, Stoke on Trent. Jun 03. £3000.

William P. Hollyer, (1834-1922) Lunch Time, signed lower right, oil on canvas, framed, 19.75 x 29in. Peter Wilson, Nantwich. Nov 01. £3000.

William Mellor, (1851-1931) The Woodlands Glade, signed lower right, oil on canvas, relined, 70 x 90cm, framed. Peter Wilson, Nantwich. Jul 02. £3000.

Bernard Finegan Gribble. (exhib 1891-1940) St Marks Square, Venice, signed, oil on canvas, 86 x 112cm. Sworders, Stansted Mountfitchet. Feb 04. £3000.

W. Knox, The arrival of a merchant ship, with gondolas and Venice beyond, on canvas, signed lower left, 23 x 35in. Wintertons Ltd, Lichfield. Mar 01. £3000.

P Vervoe, (1822-1913) Offloading trade, a Dutch river scene, monogrammed PV to sail, signed lower left, oil on board, 90 x 71cm. Wintertons Ltd, Lichfield. May 03. £3000.

Karl Girardet, (1813-1871) Swiss oil on canvas, Lake scene with figures ploughing, and a shepherd, signed, 21 x 34.5ins. Gorringes, Lewes. Jan 04. £3000.

The novice reader may well be surprised at the values that often attach to pictures of horses. It is the same with dogs and cats. This price range now introduces original Louis Wain cat cartoons starting at £2,600 hammer.

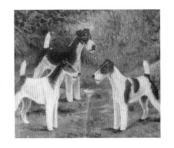

Whilst about a 100 of the images in this Section are land, sea or townscapes, there is a substantial movement in other categories between £2,000 and £3,000. These will be discussed later. Views worthy of mention are as follows. At **467** is Thomas Bush Hardy, one of the most prolific Victorian painters. Hislop's **Art Sales Index** lists about a 100 sales of his works in the year August 2003 to August 2004. This fine Venice scene at £2,800 is above the average for his work. See the **Index** for other examples. The Section is rich with famous landscape artists. See the water colourist Henry Sylvester Stannard at **613** and a rare Walter Goodin harbour view at **611**. Twentieth century artists also abound. See for example the Brian Shields, Lowry style. townscape at **608** or the Frank Wootton (1914-1998) London view of the Royal Exchange at **643**, which appears to date from the mid twentieth century. Notable seascapes are the William Lionel Wyllie at **535** or the unusual and compelling view from Brighton Pier at **530**. See also the unforgettable Norman Wilkinson, *Rounding the Mark* at **482** which sold for £2,700 hammer at Bristol Auction Rooms in September 2001. Several of Wilkinson's paintings sold in 2003/2004 for £5,000-£6,000. How much would this sell for today?

There has been a dramatic rise in portraiture in this Section. At least 20% of lots represent this category with a smattering of the usual seventeenth and eighteenth centuries included. Within this group is the opportunity to study women and children, for example **488**, **489**, **500**, **519**, **527**, **538**, **574**, and **577**, with children at **460**, **469**, **585**, **600**, **617**, **631** and **660**. Outstanding examples are the Lidderdale (1831-95) portrait of a girl at **488** and the Ralph Peacock (1868-1946) at **500**. See also the Pre-Raphaelite study at **527**. Compare this with **159** and the rather poor watercolour at **3335**. Is it possible to recognise the Pre-Raphaelite influence in other works that are not identified in the captions? There are fine portraits of children in this Section. See for example the continental school portrait of a young girl at **631** and the William Dacres Adams double portrait at **660**. This artist has little or no form so is difficult to assess without much further study. The same applies to **628**, the study of a grandmother and children - good enough to have raised £2,000 hammer at Gorringes in April 2001. See also Charles Rossiter (1827-1890) *Washing Baby* (**612**) which fetched £2,100 at the same auction in the same year. Are these paintings fashionable enough to have proved a sound investment in the last four years? Do

they have the same appeal, say, as the Bertha Newcombe at **272**? And how do we assess the value of an H. Pistor pair of paintings. (**538**) again sold in 2001? This picture also tells a story about the three occupants of the boat. Still life is again poorly represented, although an Oliver Clare at **492** fetched an amazing £2,700 hammer at Wintertons in May 2001. See also **491**, **521**, **526**, a rarer example of wild orchids and ferns by Marion Chase (1844-1905), **557**, an album of botanical watercolours, **621**, yellow roses and white lilac, and **637**, a Teresa Hegg (fl.1872-93) watercolour which fetched £2,000. There are a number of equestrian studies at **464**, **473**, **480**, **534**, **559**, **652** and **658**. The novice reader may well be surprised at the values that often attach to pictures of horses. It is the same with dogs and cats. Start at **484** and **485**. See the incredibly accomplished **494**, (**513**, **554**, **595**), and the perky **602** (the essence of terriers) and **614**, the oil on zinc portrait of *Comrade* by Edwin Douglas (1848-1914). The price range of this selection is £2,700-£2,100. Amazing? Yes, but the £2,100 paid for *Comrade* is only the artist's median price. *Waiting for Master* sold for £22,000 at Christie's, South Kensington on 23rd November 2003. (not illustrated here) And what about cats? See Louis Wain, *The Spill* at **509** and £2,600. See also **548**, the French artist Leon Charles Huber (1858-1928). This is top of the range for this artist but he has fetched more on at least two occasions in recent years. See now Louis Wain again at **550**, *Rats, Rats, I'm sick of 'Em* and a further French artist A A Brunel de Neuville at **592**, *Trois Petits Chats.* (Three Little Cats)

Now we can study about a dozen or so drawings or pen and inks. Start with **487**, an H M Bateman, First World War cartoon. This is at the top of his range. See also **475** and **504**. Thomas Rowlandson (1756-1827) was an extremely prolific draughtsman. *An Eye on the Will* at **532** and £2,500 is about his average which ranges from £250 to £17,000. See also **552**, an Edward Lear (1812-1888) at **569**, and Rowlandsons at **618**, **619** and **623**.

Other possible themes to follow are genre paintings, abstracts, nudity and even prints. The William Breakspeare (1856-1914) *Nymph* at **503**, selling for £2,600 hammer is the pick of nudity. Whilst there is nothing demure about this nymph, there is a sensuous innocence and grace which defies any sensuality suggested by the full frontal nudity. Readers are advised to read the **Introduction**, the previous Section Analyses and to study the **Index** which points up dozens of themes which may be followed.

Herbert Royle, Springtime, The Dene, Nesfield, oil, signed, 19 x 23.5in. Andrew Hartley, Ilkley. Apr 05. £2900.

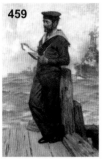

Arthur David McCormick, RBA, RI, ROI, (1860-1943) oil on canvas, A Sailor reading on a quayside - HMS Invincible, 174.2 x 100.4cm, framed. (Full length portrait of the famous Players 'Navy Cut' sailor. Bristol Auction Rooms. May 02. £2900.

19thC oil on canvas, young girl with flowers, unsigned, 21 x 15in. Gorringes, Bexhill. Feb 01. £2900.

Jonathan Richardson, (1665-1745), oil on canvas, Portrait of Sir Francis Page Kt, one of the Justices of the King's Bench, 1733, 51 x 45in, and an engraving of the sitter. Gorringes, Lewes. Oct 04. £2900.

William Hoggatt, (1880-1961) watercolour, The Hyacinth Wood, Bailrigg, signed, original label verso, 17.5 x 23.5in. Gorringes, Lewes. Jan 04. £2900.

Warren Williams, (1863-1941) On the Afon Llugwy with Moel Siabod in the background, watercolour, signed, 48 x 72cm. Byrne's, Chester. Oct 03. £2900.

Mid 19thC Spanish School, equestrian study of a coach horse in a stable yard, oil on canvas, indistinctly signed and dated 1844, 22 x 28in, gilt frame. Amersham Auction Rooms, Bucks. Mar 04. £2800.

Georgina Lara, Figures on Horseback and a Horse and Cart before a Cottage, oil, signed, 9.75 x 15.25in, gilt frame. Andrew Hartley, Ilkley. Apr 01. £2800.

William Mellor, (1851-1931) Waterfall in the Yorkshire Dales, signed lower right 'William Mellor', oil on canvas, 57 x 87cm. Cheffins, Cambridge. Feb 05. £2800.

Thomas Bush Hardy, On the Riva di Schiavoni, Venice, signed and inscribed, 8.5 x 27.5in, gilt frame. Andrew Hartley, Ilkley. Apr 04. £2800.

L Ward, 19thC, oil on canvas, The Paddle Steamer 'Vivid' in Hull colours weathering the storm, a lightship close by, signed 'L Ward. Hull', 24 x 36in. Dee, Atkinson & Harrison, Driffield. Feb 01. £2800.

The numbering system acts as a reader reference as well as linking to the Analysis of each section.

Circle of Sir David Wilkie (1785 - 1841), oil on canvas, Portrait of a young lady, wearing a red cape, 30 x 25in. Gorringes, Lewes. Oct 04. £2800.

G. O. Owen, late 19th/20thC, Portrait of a religious cleric, watercolour, signed lower right and dated, possibly (18)98, 49 x 70cm. Fellows & Sons, Hockley, Birmingham. Oct 02. £2800.

John Piper, (1903-1992) gouache and ink, Arundel Terrace, Kemp Town, signed, 1940 Leicester Gallery Exhibition label verso, 14 x 18.5in. Gorringes, Lewes. Mar 02. £2800.

James Lambert Sr., (1725-1788) Lewes Artist, oil on canvas, Cattle beside a barn with landscape beyond, 22 x 26in. Gorringes, Lewes. Mar 01. £2800.

19thC Hungarian School, oil on canvas, Hungarian cavalrymen, 26 x 20in. Lots Road Auctions, Chelsea. Jul 01. £2800.

Jacob Maris, (1837-1899) Boats on a canal, Holland, signed, oil on canvas, 49 x 70cm. Sworders, Stansted Mountfitchet. Feb 05. £2800.

Hammer Prices £2800 - £2700

475

Pedro Pruna, North African soldiers, pen, black ink and wash, signed, 35 x 25cm, together with 14 other pen, ink and watercolour studies of figures by the same hand most signed and inscribed. unframed. Rosebery's, London. Sep 04. £2800.

476

Alfred Augustus Glendening, oil on canvas, signed, dated '96, 39 x 29cm. Rupert Toovey & Co, Washington, Sussex. Jul 04. £2800.

477

Donald McIntyre, RCA, Evening Sun, Porthdinllaen, signed, oil on board, 40 x 50cm. Sworders, Stansted Mountfitchet. Mar 04. £2800.

478

Charles Jones, (1836-1892) Oil on wooden artists board. Sheep on a hillside, monogrammed, 7 x 9in. Gorringes, Lewes. Dec 02. £2700.

479

David Fulton, Presweep(?) Farm, Early Springtime, signed, inscribed verso, 17.75 x 29in, gilt frame. Andrew Hartley, Ilkley. Aug 01. £2700.

480

John Sanderson Wells, a pair of oils on canvas, each 29.8 x 44.8cm. Bristol Auction Rooms. Oct 01. £2700.

481

18thC French School, shepherd and shepherdess tending their flock, oil on canvas, 31 x 49cm. Henry Adams, Chichester. Jul 02. £2700.

482

Norman Wilkinson, 1878-1971, oil on canvas board, 'Rounding the Mark'. Bristol Auction Rooms. Sep 01. £2700.

483

Beatrice Parsons, (1870-1955) watercolour, The Rose Garden, Buxted Rectory, Sussex, 10.5 x 8in, signed, contemporary gilt frame, glazed. Canterbury Auction Galleries. Feb 04. £2700.

484

Vincent de Vos. (1829-1875) The Dispute, signed bottom left, indistinct label verso, oil on board, 27.2 x 35.7cm. Sworders, Stansted Mountfitchet. Feb 04. £2700.

485

Alfred Wheeler, (1852-1932) Study of the head of three fox hounds, oil on board, 10 x 16in, signed, dated 1899, oak frame, glazed. Canterbury Auc. Galleries, Kent. Apr 04. £2700.

486

Pietro Psaier (b.1939) and Andy Warhol (American, 1928-1987), Little Habana, Miami, Florida 1977, signed, mixed media, oil & silkscreen, 90 x 152cm. Cheffins, Cambridge. Feb 04. £2700.

487

H. M. Bateman, The Demand WWI cartoon drawing of figures queuing for a bus, pen and ink, signed, dated 1917, 37 x 28cm. Stride & Son, Chichester. Jul 03. £2700.

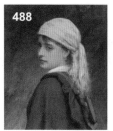

488

Charles Sillem Lidderdale, portrait of a girl, monogrammed, oil on board, 48 x 40cm. Sworders, Stansted Mountfitchet. Dec 02. £2700.

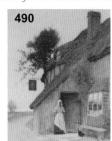

489

American Provincial School, 19thC, a pair of naive family portraits, oil on board, 25 x 19in, burr maple frames. Sworders, Stansted Mountfitchet. Jul 01. £2700.

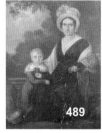

490

Arthur Claude Strachan, a pair, The Village Inn, watercolour, both signed, 25.5 x 17cm. Sworders, Stansted Mountfitchet. Oct 02. £2700.

491

Circle of Gasparo Lopez, a pair, Still lifes of flowers in ornate maiolica vases, oil on canvas 71 x 48cm. Sworders, Stansted Mountfitchet. Nov 04. £2700.

Oliver Clare. Sill life studies of fruit, on a mossy bank, signed lower right, a pair, 6 x 8.75in. Wintertons Ltd, Lichfield. May 01. £2700.

Herbert Royle, Beamsley Beacon from Addingham in Spring, signed on board, inscribed verso, dated 1957, 11.5 x 15.5in, gilt frame. Andrew Hartley, Ilkley. Dec 04. £2600.

Arthur Alfred Davis (English, fl.1877-1889) Breast High signed lower left 'Arthur A Davis '89', inscribed with title on the reverse, oil on canvas, 90 x 59cm Cheffins, Cambridge. Feb 05. £2600.

River Greta, near Barnard Castle by William Mellor, oil on canvas. Wintertons Ltd, Bakewell. Mar 05. £2600.

Frank H Mason, (1876-1965) watercolour, The Customs House, Venice, busy harbour scene with Venice to the background, 9.5 x 28.25in, signed in full. Canterbury Auction Galleries, Kent. Oct 01. £2600.

John Banting, (1902-1972), Spring, abstract, oil on board, signed, dated 1930 lower right, 55 x 40cm, original white frame Dreweatt Neate, Donnington. Nov 02. £2600.

Henry Sylvester Stannard, (British 1870-1951) Rural landscape, watercolour heightened in white, signed lower left, 48 x 35.5cm. Fellows & Sons, Hockley, Birmingham. Oct 02. £2600.

The illustrations are in descending price order. The price range is indicated at the top of each page.

Attributed to Thomas Hickey, (1741-1824), oil on canvas, half length portrait of a lady, oval, 10 x 8in. Gorringes, Lewes. Feb 01. £2600.

Ralph Peacock, (1868-1946) oil on canvas, portrait of Monica, signed, inscribed verso, 18 x 15in. Gorringes, Lewes. Apr 02. £2600.

Claude Cardon, (fl. 1892-1920) oil on canvas, Farmyard scene, label verso, 19 x 29in. Gorringes, Bexhill. Sep 03. £2600.

Reinhold Nagele, (1884-1972) German, tempera, Lake Constance, study of rooftops verso, signed, dated 1935, 14 x 19.5in. Gorringes, Lewes. Oct 04. £2600.

William A Breakspeare, (1856-1914), oil on canvas, Nymph with a butterfly and a dove, signed and dated 1877, 32 x 15in. Gorringes, Lewes. Mar 05. £2600.

Early 19thC English School, folio of 17 pencil and 11 monochrome watercolour sketches, Italian topography incl. Near Puzzuli, entitled and dated c1824, largest 12.5 x 18.75 ins. Gorringes, Lewes. Mar 04. £2600.

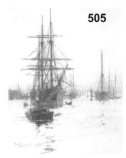

Charles Edward Dixon, (1872-1934) watercolour with bodycolour, 'Moonrise', signed, 19.75 x 15.5in. Gorringes, Lewes. Apr 03. £2600.

Attributed to Sir Henry Raeburn, (1756-1823) oil on canvas, portrait of John Grant, 30 x 25in. Gorringes, Lewes. Mar 03. £2600.

Circle of Antonio Calza, (1653-1725) A Cavalry Engagement between Turks and Saracens, oil on canvas, oval, 21.5 x 27.5in, framed. Lots Road Auctions, Chelsea. Apr 01. £2600.

Hammer Prices £2600 - £2500

Manner of Pieter Lely, Portrait of a Lady, oil on canvas, 122 x 100cm, gilt frame. Lots Road Auctions, Chelsea. May 05. £2600.

Louis Wain, The Spill, watercolour, signed, 28.5 x 21.5cm, original Raphael Tuck & Sons label to reverse. Marilyn Swain Auctions, Grantham. Dec 03. £2600.

19thC English School, full length portrait of a young lady, oil on canvas, 38.25 x 25.25in, modern gilt frame. Morphets, Harrogate, N Yorks. Feb 01. £2600.

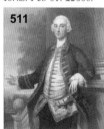

Circle of Thomas Hudson, Portrait of a gentleman, oil on canvas, 127 x 102cm. Sworders, Stansted Mountfitchet. Dec 03. £2600.

Maurice Lévis, On the Loire, late 19thC, oil on panel, signed, dated '94, 21 x 31.5cm. Rupert Toovey & Co, Washington, Sussex. Oct 03. £2600.

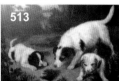

Attributed to Edmond Bristow, rural scene depicting a terrier and 2 puppies, oil on canvas, 25 x 30in. Amersham Auction Rooms, Bucks. Apr 01. £2500.

Charles Martin Hardie, Spring Blossom, oil, signed, 29.5 x 39.25in, stained frame. Andrew Hartley, Ilkley. Apr 01. £2500.

George Turner, On the Conway, North Wales, unsigned, old label verso, 15 x 25.5in, gilt frame. Andrew Hartley, Ilkley. Aug 01. £2500.

William Mellor, On the Ledr and On the Llowy, North Wales, oils, signed pair, 17.5 x 13.5in, gilt frames. Andrew Hartley, Ilkley. Apr 05. £2500.

English School 19thC, Malta, watercolour, 25 x 35cm. Bearne's, Exeter. Jul 03. £2500.

Kenneth Newton, (1933-1984) oil painting, The Allotment, canvas 50 x 40in, early work of a garden on Richmond Hill 1957/58. Canterbury Auc. Galleries, Kent. Apr 02. £2500.

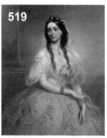

Richard Buckner, three quarter length portrait of Mrs C Stoughton, exhibited at the Royal Academy in 1861, oil, 50 x 40in. Canterbury Auc. Galleries, Kent. Jun 02. £2500.

William Brooker, (1918-1983), Hotel Bedroom, oil, nude woman climbing out of bed, board 13 x 10in, signed in red 'Brooker', dated '50, painted, moulded swept frame. Canterbury Auction Galleries. Apr 05. £2500.

Bennett Oakes, Flowers and Red Currants, signed and dated '86, oil on board, 13.5 x 17.5in. Clarke Gammon, Guildford. Feb 02. £2500.

Feliks Topolski, (1907-1989), The Studio, with Jan Stevenson, Yuki, Desmond Morris, Lady Diana Cooper and Lady Windlesham, oil, 244 x 151cm. Dreweatt Neate, Donnington. Nov 02. £2500.

Artists or themes can be followed through the colour coded Index which contains over 4500 cross references.

18thC Chinese School, reverse painting on glass and mirrored picture of a lakeside landscape, 17.5 x 29in, Hogarth framed and glazed, Qianlong period, paint loss to tree and figure of child, mirror marked. Canterbury Auc. Galleries, Kent. Apr 05. £2500.

Attributed to Guercino Lapira, (fl 1839-1870) gouache, View of the Bay of Naples with figures in the foreground, Vesuvius beyond, 10 x 15.5in. Gorringes, Lewes. Mar 01. £2500.

525

Johan Scherrewitz, (1868-1951) Dutch, oil on board, Milking Time, signed, 20 x 14ins, acanthus decorated glazed gilt frame. Gorringes, Lewes. Apr 03. £2500.

526

Marian Chase, (1844-1905) watercolour, Wild orchid and ferns, signed and dated 1884, 12.75 x 9.25in. Gorringes, Lewes. Jan 03. £2500.

527

Pre-Raphaelite School, early 20thC, 'Spring', watercolour, signed with initials E D S, dated '04, 12.5 x 7in. Halls Fine Art, Shrewsbury. Nov 04. £2500.

528

Sir Joshua Reynolds, oil on canvas, Portrait of John Cranch Esq. in profile, 30.5 x 25in. Gorringes, Lewes. Oct 04. £2500.

529

Arthur Joseph Meadows, (1843-1907) oil on canvas, 'Saumur on the Loire', signed and dated 1884, 10 x 14in. Gorringes, Lewes. Jul 04. £2500.

530

Albert Goodwin, (1845-1932) oil on board, 'The Lifeboat, from the old chain pier, Brighton', signed and titled, 17 x 19in. Gorringes, Lewes. Jul 04. £2500.

531

Louis Verboeckhoven, (1802-1889) Belgian, oil on canvas, fishing boats on a choppy sea, signed and dated 1831, 20 x 25in. Gorringes, Lewes. Mar 01. £2500.

532

Thomas Rowlandson, (1756-1827) pen, ink and water-colour, An Eye on the Will, signed,11.5 x 9in. Gorringes, Lewes. Apr 03. £2500.

533

Walter Williams, oil on canvas, Field of Corn, 44.5 x 64.5in. Thos Mawer & Son, Lincoln. Nov 02. £2500.

534

English School, Huntsman holding his horse, oil on canvas, 23 x 28in. Sworders, Stansted Mount-fitchet. Apr 01. £2500.

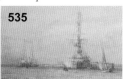

535

William Lionel Wyllie, R.A., R.W.S. (1851-1931) Warships in the Solent, signed, water-colour, 28 x 45cm. Sworders, Stansted Mount-fitchet. Jul 03. £2500.

536

Walter Williams, oil on canvas, English country landscape, re-lined and re-framed, 44.5 x 64.5cm. Thos Mawer & Son, Lincoln. Nov 02. £2500.

537

David Bates, 'The Carters', dog, horses, carts and a man digging on a country lane, signed and dated 1910 lower right. Wintertons Ltd, Lichfield. Sep 01. £2500.

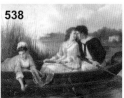

538

H. Pistor, Family boating on a loch and companion study of young lovers & chaperone picking water lilies, on relined canvas, signed, 38 x 50cm. Wintertons Ltd, Lichfield. Dec 01. £2500.

539

Late 19thC Oriental school, Middle Eastern street vendors with children talking to two men, on canvas, 97 x 71cm. Wintertons Ltd, Lichfield. Mar 03. £2500.

540

George Goodwin Kilburne, The Novice, Interior with Card Players, signed, 14 x 20.5in, gilt frame. A. Hartley, Ilkley. Apr 02. £2400.

541

William Fraser Garden, (1856-1921), the river bank, watercolour, signed and dated '90 and a companion, a pair, 28 x 20cm. Cheffins, Cambridge. Jun 01. £2400.

542

Cicely Mary Barker, Fairy Music, watercolour, 11.5 x 9in. Ewbank Auctioneers, Send, Surrey. Oct 02. £2400.

Hammer Prices £2400

543

G Hamilton Constantine, (1875-1967) Up the Hill and The Hay Field, a pair, rural landscape with working shires, watercolours, signed, titled, 18 x 26cm. Byrne's, Chester. Oct 03. £2400.

544

T Gotch, oil on canvas, River landscape, signed, 22.5 x 34.5in. Gorringes, Lewes. Mar 01. £2400.

545

Frederick John Widgery, (1861-1942) gouache, Belstone Moors, Dartmoor, signed and inscribed, 19.5 x 29.5in. Gorringes, Bexhill. May 02. £2400.

546

Adam Buck, (1759-1833) watercolour, The Piano Lesson, signed and dated 1800, 16 x 16.5in. Gorringes, Bexhill. May 04. £2400.

547

Edward Wilkins Waite, (fl1878-1927), oil on wooden panel, Poultry and cart on a village lane, signed, 10 x 14in. Gorringes, Lewes. Apr 04. £2400.

548

Leon Charles Huber, (1858-1928), oil on canvas, interior scene with playful kittens and a Louis XV style commode, signed, dated 1926, 44 x 36.5cm. Gorringes, Bexhill. Mar 05. £2400.

549

Attributed to Benjamin West, (1738-1820), oil on canvas, Cain and Abel, 20 x 15in. Gorringes, Lewes. Mar 05. £2400.

550

Louis Wain, (1860-1939) ink and bodycolour, 'Rats, Rats, I'm Sick of 'Em', signed, 10.75 x 8in. Gorringes, Lewes. Apr 05. £2400.

551

Andrew Robertson, portrait miniature of Maria Travers, c1810, oval 3in, gilt metal mount on green plush base. Halls Fine Art Auctions, Shrewsbury. Nov 03. £2400.

552

Leonard Baskin, Nine Animal Studies, pen, black ink & wash, one signed and dated 1983, 17 x 125cm, and some signed/dated, unframed. (9) Rosebery's, London. Sep 04. £2400.

553

French School, 18thC, elegant young woman, coloured chalks, 21 x 17.5in. Hy. Duke & Son, Dorchester. Jun 03. £2400.

554

Louis Robert Heyrauld, oil on canvas, signed and dated 1851, 71 x 61cm. Rupert Toovey & Co, Washington, Sussex. Dec 03. £2400.

555

Circle of Anton Kozakiewicz, The Surprise Visit, oil on panel, bears signature, 25 x 18cm. Rosebery's, London. Mar 04. £2400.

556

John Nash, RA, Ash Grove, Firle Park, Sussex, signed and dated 1957, watercolour, 33 x 43cm. Henry Adams, Chichester. Jan 03. £2400.

557

Early 19thC British Album of Watercolours, containing approx 48 botanical studies, many inscribed, some dated 1804, various sized, album 52 x 31cm. Rosebery's, London. Mar 05. £2400.

558

French School, early 20thC, 'L'Hopital Chaumont-en-Vexin', pencil & watercolour, signed with monogram and dated 1916, 20 x 27.5cm. Rosebery's, London. Dec 04. £2400.

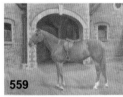

559

Florence Mabel Hollams, (1877-1963) Chestnut Hunter outside Mickleham Hall Stables, Surrey, oil on canvas, signed and dated '53, 45 x 60cm. Rupert Toovey & Co, Washington, Sussex. Dec 02. £2400.

560

Claude Strachan, Spring, watercolour. Wintertons Ltd, Bakewell. Mar 05. £2400.

561

Tristram Hillier, Canete 1971, signed, dated, framed and glazed, 14 x 16in. Tring Market Auctions, Herts. Nov 02. £2400.

562

Fergus O'Ryan RHA, 'Sunlight & Shadow', park scene with people seated near a pond, oil on board, 36cm x 30.5cm, incised signature, label verso Avondale Bird Avenue, Clonskea, Dublin. Ambrose, Loughton. Apr 02. £2300.

The abbreviations following artist's names can be located in the Appendices.

563

W Howard, Dutch quay scene, sailing craft, figures and buildings, oil on canvas, signed, 30 x 50in, gilt frame. Amersham Auction Rooms, Bucks. Mar 03. £2300.

564

Max Todt, (1847-1890) oil on mahogany panel, Standard Bearer, signed, framed, 25.4 x 17.8cm. Bristol Auction Rooms. Apr 02. £2300.

565

Attributed to John Varley, (1781-1842) Chiswick Reach on the Thames, 5.5 x 8.25in, watercolour, unsigned. Canterbury Auc. Galleries, Kent. Apr 03. £2300.

566

Edward Morland Lewis, (1903-1943) Watermill and buildings reflected in a mill pond, oil, canvas 20 x 24in, signed in black, painted moulded frame. Canterbury Auc. Galleries, Kent. Apr 05. £2300.

567

William Watt Milne, (1873-1951) St Ives bridge with the boatyard to the foreground, oil on canvas, signed, 26 x 36cm. Cheffins, Cambridge. Apr 01. £2300.

568

Louis Bentabole, (1820-1880) Fishing boats and figures on a rocky beach, signed, dated '56, oil on panel, 10.5 x 16in. Clarke Gammon, Guildford. Apr 01. £2300.

569

Edward Lear, (1812-1888) watercolour and ink, Wady Wadan, inscribed and dated 1899, 3.25 x 9in. Gorringes, Lewes. Oct 02. £2300.

570

Thomas Smythe, Ipswich School, (1825-1906), watercolour, Suffolk Horse Drawn Ploughing Match, signed, 18 x 32in, framed and glazed. Diamond Mills & Co, Felixstowe. Dec 04. £2300.

571

Samuel John Lamorna Birch, (1869-1955) oil on board, The Lizard River, Cornwall, signed, 9.5 x 13.5in. Gorringes, Lewes. Apr 01. £2300.

572

Hendrik Barend Koekkoek, (1849-1909) one of a pair of oils on canvas, Winter and Summer, each signed, 7.5 x 11.5in. Gorringes, Bexhill. Oct 02. £2300.

573

Samuel Palmer, (1805-1881), etching, Lonely Tower, signed in pencil, stamped 16 in the margin, 190 x 252mm. Gorringes, Lewes. Sep 04. £2300.

574

Early 20thC American School, Portrait of a Lady, oil on board, indistinctly signed, 58 x 48cm, giltwood frame. Lots Road Auctions, Chelsea. Dec 03. £2300.

575

Harry Fidler, oil, Shepherd and sheep, 9.75 x 11.5in. Louis Taylor, Stoke on Trent. Dec 02. £2300.

576

Harry Fidler, oil on canvas. Louis Taylor, Stoke on Trent. Mar 03. £2300.

577

Flora MacDonald Reid, Confidences, oil on canvas. Mervyn Carey, Tenterden. Feb 02. £2300.

578

James Paterson, Chatham Heath, watercolour, signed, inscribed on artists own label, verso, 2 Bedford Road, Edinburgh. Rosebery's, London. Jun 03. £2300.

Hammer Prices £2300 - £2200

579

Charles Morris Snr, series of three paintings, on canvas, a moonlight riverscape, a millhouse and a cottage, signed, framed, each 11.5 x 9.5in. Tring Market Auctions, Herts. Sep 02. £2300.

580

E Niezky Mchn, young lady on a balcony, signed, oil on panel, 36 x 25cm. Sworders, Stansted Mountfitchet. Dec 02. £2300.

581

George Turner, signed and dated 1901, oil on board, shepherd with flock on a country lane, written verso 'near Idridgehay, Derbyshire', 31 x 41cm. Thos Mawer & Son, Lincoln. Sep 04. £2300.

582

G Armfield, Terriers in a barn and companion study of three terriers watching a rat in a cage, on canvas, signed lower left, 28.5 x 38.5cm. (2) Wintertons Ltd, Lichfield. Jan 04. £2300.

583

William Meadows, Grand Canal, Venice, signed, 11.75 x 23.5in, gilt frame Andrew Hartley, Ilkley. Feb 01. £2200.

584

William Mellor, Near Birk Crag, Harrogate, signed, inscribed verso, 17.75 x 11,5in, gilt frame. A. Hartley, Ilkley. Apr 03. £2200.

585

Alexander M Rossi, oil on canvas, an urchin boy studying a photograph, 54.5 x 44cm. Bristol Auction Rooms. Jan 03. £2200.

586

V Feneck, (Maltese) four unframed watercolours, Il Vescoso di Malta, 7.5 x 6.25in, Signora Maltese, 9 x 6.25in, Il Commendatore dell'Artigliera, 7.5 x 6.5in and Il Gonfaloniere della Vittoria, 7.5 x 6.25in, all signed. Gorringes, Lewes. Apr 01. £2200.

587

A Calp,(?) oil on canvas, cattle and sheep by a pond before a cottage, indistinctly signed, 20 x 24.25in. Gorringes, Bexhill. Feb 03. £2200.

588

Frank Wootton, (1911-1998) oil on board, 'Winter sunshine, Bo-Peep Farm', signed, 20 x 24in. Gorringes, Lewes. Jul 04. £2200.

589

Attributed to Nathaniel Hone (1718 - 1784), oil on canvas, Portrait of Lady Jane Clifford, 30 x 25 in. Gorringes, Lewes. Oct 04. £2200.

590

Ronald Ossory Dunlop, (1894-1973) oil on canvas, 'Autumn Glow in the Arundel Woods', signed, exh. R.A. 1954, 28 x 36in. Gorringes, Lewes. Dec 04. £2200.

591

Edward Duncan, (1803-1882) watercolour, Fishing Lugger off the Mumbles, signed and dated 1873, 9 x 14.25in. Gorringes, Lewes. Dec 04. £2200.

592

A.A. Brunel de Neuville, 19thC, French, oil on mahogany panel, Trois Petits Chats, signed, paper label verso. 8.5 x 10.5in. Gorringes, Lewes. Dec 02. £2200.

593

D Havell and J Bluck, one of ten hand coloured aquatints, published London by William Miller 1808-1809, 47 x 64cm. Henry Adams, Chichester. Jul 02. £2200.

594

19thC reverse glass painting, Le Grand A'miral Nelson', 22.5 x 30in. Humberts inc Tayler & Fletcher, Andoversford. Jun 04. £2200.

595

Follower of David De Koninck, (1636-1699) Dead Game with Dog and Cat, oil and canvas, 27.5 x 38in, framed. Lots Road Auctions, Chelsea. Apr 01. £2200.

596

Pierre de Clausade, Summer Clouds over the Loure, oil painting. Mervyn Carey, Tenterden. Jul 02. £2200.

597

Early 19thC European School, Portrait of a Lady, oil on canvas, laid to board, 79 x 49cm. Lots Road, Chelsea. Dec 02. £2200.

598

19thC Orientalist School, The Carpet Seller, watercolour, signed Raggi, 52 x 36cm, unframed. Lots Road, Chelsea. Feb 03. £2200.

> Fresh to the market paintings perform better than those which have been in and out of auction.

599

Portrait of Louis Napoleon, Prince Imperial of France, oil on canvas, 23.5 x 35in, gilt frame. Wallis & Wallis, Lewes. Mar 02. £2200.

600

Mid 19thC Sporting School, a young cricketer, oil on panel, unsigned, 38 x 28cm. Richard Winterton, Burton on Trent. Feb 04. £2200.

601

James Watterson Herald, Shepherd and his flock at dusk, watercolour and bodycolour with touches of white chalk, signed, 17.2 x 24.8cm. Rosebery's, London. Mar 02. £2200.

602

F T Daws '32, oil on canvas, three terriers in a landscape named 'Cobblers Lady, Simons Dimple, Little Miss Dimple', signed, dated, 38 x 49cm, framed. Thos Mawer, Lincoln. Feb 03. £2200.

603

William George Robb, oil on canvas, Frisking Light in Frolick, early 20thC, signed, 50 x 60cm. Rupert Toovey & Co, Washington, Sussex. Dec 03. £2200.

604

George Pyne, Interior of a library in a house, possibly in Oxford, pencil and watercolour heightened with white, 20 x 30cm. Mellors & Kirk, Nottingham. Apr 03. £2200.

605

Edward Armfield, Unwanted Attention, and After the Day's Shoot, oils on canvas, a pair, both signed, 45.5 x 54cm. Rosebery's, London. Mar 05. £2200.

606

A W Bayes, (1832-1909) oil painting. Richard Williams, Pershore. Sep 01. £2150.

607

William Meadows, Venice, Showing the Campanile, Piazzetta, Doge's Palace and Bridge of Sighs, signed, 11.5 x 23in, gilt frame. A. Hartley, Ilkley. Aug 01. £2100.

608

BRAAQ (Brian Shields), The Old Bag Won't Serve Me, oil, signed on board, dated '79, inscribed verso, 11.25 x 15in, gilt frame. Andrew Hartley, Ilkley. Apr 05. £2100.

609

Late 19thC Chinese School, painted and appliqué ship portrait, SS Topaze of London, 17.5 x 31.25in, gilt frame, glazed. Canterbury Auc. Galleries, Kent. Aug 02. £2100.

610

Edward Le Bas, (1904-1966) Fishing Boats, Martiques, harbour scene, oil on canvas, 11 x 18in, signed in red, painted and moulded frame. Canterbury Auc. Galleries, Kent. Apr 05. £2100.

611

Walter Goodin, (1907-1992) Bridlington Harbour with fishing boats and figures, signed on board, 23.25 x 29.25in, painted frame. Dee Atkinson & Harrison, Driffield. Jul 04. £2100.

612

Charles Rossiter, (1827-1890) 'Washing Baby', oil on canvas, signed, Fine Art Society label verso, 10 x 8in. Gorringes, Lewes. Jul 01. £2100.

613

Henry Sylvester Stannard, (1870-1951) watercolour, Thatched cottage beside a stream, signed, 9 x 13in. Gorringes, Lewes. Mar 01. £2100.

614

Edwin Douglas, (1848-1914) oil on zinc panel, Portrait of 'Comrade', favourite hound of the Surrey Union Hunt Master, with two 1876/77 Meet Cards inserted into the cut mouth, 14.5 x 11.5in, casement frame. Gorringes, Lewes. Jan 04. £2100.

Hammer Prices £2100 - £2000

624

Walter Stuart Lloyd, RBA, (fl 1875-1929) At the Ferry, water-colour, signed and dated 1903, 16 x 39in. Halls Fine Art Auctions, Shrewsbury. Nov 03. £2100.

615

Luigi M Galea (1847-1917) Maltese oil on board, Valetta harbour, signed, 9 x 21.5in. Gorringes, Lewes. Mar 04. £2100.

616

Roy Petley, (1951-), oil on board, Coastal landscape with children on jetty, signed, 12 x 18in. Gorringes, Lewes. Oct 04. £2100.

620

Yuri Matushevski, Violet Winter, 1960, oil on board, 50 x 70cm, signed, framed. Lots Road Auctions, Chelsea. Jun 04. £2100.

625

J. O. Hume, oil, Moonlit Scottish landscape with loch to foreground and cattle watering. Wintertons Ltd, Lichfield. Nov 03. £2100.

626

After Henry Scott Tuke, RA, RWS (1859-1929), oil on canvas, Summer Evening, 53 x 64cm, framed. Bristol Auction Rooms. Jan 02. £2050.

629

William Mellor, On the Nidd, Knaresborough, oil, signed, inscribed verso, 7.5 x 11.5in, gilt frame. Andrew Hartley, Ilkley. Apr 01. £2000.

617

Leonard Poyet, (1798-1873) oil on canvas, Portrait of William, Anne and Emily Burkinyoung, signed, 18 x 20in. Gorringes, Lewes. Apr 03. £2100.

621

Yellow roses and white lilac on a ledge, gouache on paper laid down on board, signed, 51.7 x 71.5cm, unframed. Rosebery's, London. Sep 03. £2100.

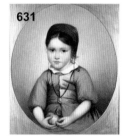
630

William Mellor, Mountain Stream, Nr Capel Curig, North Wales, signed, inscribed verso, 7.5 x 11.5in, gilt frame. Andrew Hartley, Ilkley. Apr 01. £2000.

618

622

19thC European, portrait miniature of a lady, oval, gilt metal mount within ebonized frame, 7 x 5.8cm, and 19thC English portrait miniature of a gentleman. Rosebery's, London. Mar 05. £2100.

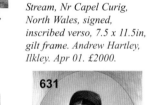
627

William E Pimm, oil on canvas, girl droving 4 cows, 107 x 137cm. John Taylors, Louth. Nov 03. £2050.

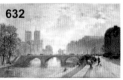
631

Continental School, Portrait of a Young Girl holding an Apple, half length, unsigned oval, 24 x 19.75in, gilt frame. Andrew Hartley, Ilkley. Aug 04. £2000.

Thomas Rowlandson, (1756-1827) pen, ink and water-colour Evolution of Man, 7 x 6in. Gorringes, Lewes. Apr 03. £2100.

619

Thomas Rowlandson, (1756-1827) pen, ink and water-colour, Dr. Syntax admires the buxom daughter, signed, 3.5 x 5.25in. Gorringes, Lewes. Apr 03. £2100.

623

Thomas Rowlandson, (1756-1827) Gaming Club, signed and dated 1820, pen, ink and watercolour, 14.5 x 24cm. Sworders, Stansted Mount-fitchet. Feb 05. £2100.

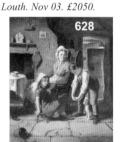
628

J Wells Smith, (fl 1870-1875) oil on canvas, Cottage interior with grandmother watching children playing, monogrammed, 19.5 x 15.5in. Gorringes, Lewes. Apr 01. £2000.

632

Charles Ernest Cundall, RA, RWS (1890-1971) oil on canvas, Early Morning, Paris, signed, label verso, 39.2 x 67.4cm, framed. Bristol Auction Rooms, Bristol. Apr 02. £2000.

633

Nathaniel Hone, RHA (Irish, 1831-1917) The Rocks of Kilkee, oil on canvas, 29 x 37cm. Cheffins, Cambridge. Feb 05. £2000.

634

William Anslow Thornley, (English, d.1898) Harbour Scene at Sunset and Harbour Scene by Moonlight, one signed 'W Thornley', oil on canvas 34 x 29cm, a pair. Cheffins, Cambridge. Feb 05. £2000.

Provenance is an important market factor which can bare positively on results achieved at auction.

635

Hermann Herzog, (1832-1932) Figure and goats, mountain torrent & buildings beyond, signed, dated 1870, oil on panel, 8.75 x 13in. Clarke Gammon Wellers, Guildford. Apr 05. £2000.

636

Adolf Seel, (1829-1907) watercolour, Arabian Baths Scene, signed, dated 1873, 23.5 x 18in. Dee, Atkinson & Harrison, Driffield. Aug 04. £2000.

637

Teresa Hegg, (fl 1872-93) watercolour, still life of roses and blossom, signed, 14.5 x 21.25in. Gorringes, Bexhill. Dec 01. £2000.

638

John Ferneley Jnr, (1815-1862) oil on canvas, artist and his family, in a drawing room, 25 x 30in. Gorringes, Lewes. Mar 02. £2000.

639

John Bellany, oil on canvas, The Artist and his Wife, signed verso, unframed, 36.5 x 36.5in. Gorringes, Lewes. Apr 01. £2000.

640

F. Sartorius, (fl.1799-1808), oil on canvas, Brig and dismasted vessel at sea, signed and dated 180..., 18 x 28in. Gorringes, Lewes. Apr 05. £2000.

641

Terrick Williams, (1860-1936) oil on wooden panel, On the Lagoon, Venice, signed, 7 x 9in. Gorringes, Lewes. Oct 02. £2000.

Hammer Price £2000

642

Alfred de Breanski, oil on canvas, River View at Sunset, 19 x 26.5in, signed. Gorringes, Bexhill. Dec 02. £2000.

643

Frank Wootton, (1914-1998) gouache, Royal Exchange, signed, 19.5 x 24.5in. Gorringes, Lewes. Jul 03. £2000.

644

Henry Bone, RA, after Annibale Carrachi, circular miniature, A self portrait of the artist as a young man. Gorringes, Bexhill On Sea. Dec 04. £2000.

645

Georges Robin, oil on canvas, La Riviere L'Aumance, signed, 22 x 18in. Gorringes, Lewes. Jul 01. £2000.

646

John Nixon, (1760-1818) watercolour, View of the Thames from Maidenhead Bridge, 15 x 22in. Gorringes, Lewes. Dec 04. £2000.

647

18thC English School, oil on canvas, portrait of a lady, wearing pearls and holding floral garlands, 30 x 23.5in. Gorringes, Lewes. Dec 04. £2000.

648

Attributed to Cornelius van Poelenburg, oil on canvas, Diana and Actaoen. Gorringes, Bexhill On Sea. Dec 04. £2000.

649

Julius Caesar Ibbetson, (1759-1817) watercolour. Losing her calf. 11.5 x 15.5in. Gorringes, Lewes. Dec 02. £2000.

650

19thC English School, Shipping on the River Thames off Greenwich, oil on panel, 27 x 42cm. Henry Adams, Chichester. Sep 02. £2000.

651

Henry Pierce Bone, miniature of James II, on enamel. Gorringes, Bexhill On Sea. Dec 04. £2000.

Hammer Price £2000

Jan van Chelminski, (1851-1925) Polish, oil on wooden panel, Cavalryman accepting a drink at the roadside, signed, 11 x 8.5in. Gorringes, Lewes. Apr 03. £2000.

Thomas Rowlandson, (1756-1827) pen, ink and watercolour, Tripe & Trollebobs, signed, 7 x 8.75in. Gorringes, Lewes. Apr 03. £2000.

Percy Dixon, (1862-1924) watercolour, 'Among the tumbled fragments of the hills', signed, Royal Institute of Painters exhibition label verso, 26 x 40in. Gorringes, Lewes. Mar 03. £2000.

George Engleheart, Gentleman, 4.8 x 3.8cm, in gold slide and a 19thC Elizabethan revival gem set frame. Mellors & Kirk, Nottingham. Apr 03. £2000.

David Bates, Welsh cottage near Talgarth, path through the wood, a pair, both signed. Mellors & Kirk, Nottingham. Feb 03. £2000.

After Fra Bartolomeo, (1472-1517), Italian, oil on canvas, La Depositione, 37. x 49in, Florentine giltwood frame. Gorringes, Lewes. Apr 02. £2000.

Thomas Weaver, (1774-1843), oil on canvas, Penelope, chestnut mare in a wooded landscape with a lake in the distance, signed, 62 x 75cm. Gorringes, Bexhill. Mar 05. £2000.

Mather Brown, (1761-1831) Portrait of a lady, oil on canvas, signed, 30 x 25in. Halls Fine Art Auctions, Shrewsbury. Oct 03. £2000.

William Dacres Adams. double portrait of young girls beneath a tree in parkland, signed, dated 1904, 68 x 144cm. Mellors & Kirk, Nottingham. Sep 03. £2000.

John Anthony Park, (1880-1962) oil on canvas, Street scene, Mousehole, signed, 20 x 24in, unframed. Gorringes, East Sussex. Mar 02. £2000.

Italian micro-mosaic plaque of Pliny's doves, 19thC, within a copper mount, 5.2 x 7.5cm. Gorringes, Bexhill. Mar 05. £2000.

Elizabeth Frink, Three running figures with a dog, signed '81, pencil sketch, 68 x 98cm. Henry Adams, Chichester. Jan 03. £2000.

Yuri Matushevski, Crispy Winter, 1961, oil on board, 60 x 80cm, signed, framed. Lots Road Auctions, Chelsea. Jun 04. £2000.

Thomas Baker, oil on canvas, Distant View of Coventry. Locke & England, Leamington Spa. Nov 02. £2000.

Yuri Matushevski, Grandeur, 1962, oil on board, 60 x 80cm, signed, framed. Lots Road Auctions, Chelsea. Jun 04. £2000.

William Walcott, c1940, oil, barges on Thames, 21 x 30in. Stride & Son, Chichester. Oct 02. £2000.

William H Chambers, 'Homeward Bound, at anchor off Hartlepool' and 'Shipping Stacking Offshore', a pair, signed and dated '81, oil on canvas, one with label for The Bray Art Gallery and Museum, exh. Summer 1922, 44 x 59cm. Sworders, Stansted Mountfitchet. Nov 04. £2000.

Lowry apparently drew the picture of *Old Berwick* on the reverse of a Senior Service cigarette packet whilst in a taxi going to, or from, the railway station, and gave it to the driver. Here at **674** is the most expensive cigarette packet in history fetching a staggering £1,900 plus premium!

Twice as many paintings sell at provincial auctions within the £1,000-£2,000 range than within the previous £2,000-£3,000 Section. In previous sections landscapes have dominated. Now there has been a sea change. From the coastal watercolours of George Wetherill (1810-1890) **740**, the beautiful *Connemara* at **764**, the atmospheric Thornley at **790**, Breanski at **809**, several W L Wyllie's and a cluster of Bush Hardy's, through to the conclusion, the reader is treated to an 'armada' of seascapes. They don't end here. Nor do townscapes let us down. There are at least twenty and the first at **674** has a story attached. Lowry apparently drew this picture of *Old Berwick* on the reverse of a Senior Service cigarette packet whilst in a taxi going to, or from, the railway station, and gave it to the driver. Here is the most expensive cigarette packet in history fetching £1,900 plus premium at Biddle and Webb, Birmingham, in February 2001! What is it worth today with such a story attached? And, where is it now? In these pages are townscapes of Bridlington at **679**, Florence at **680**, Skipton, Yorkshire at **760**, Hull, Dedham, Bruge, Paris, London at **891**, and much more. The reader should also note William MacTaggarts (1903-81) watercolour, *Glimpse of Florence*, (**935**) exhibited in 1955, (the only example here) and not miss the L S Lowry, *Industrial Panorama* lithograph at **938**, which fetched £1,200 hammer at Lots Road Auctions, Chelsea in December 2001. Subscribers to our Web Services can check out the values of Lowry prints on our website at **www.antiques-info.co.uk**, as well as viewing all images at a larger size. Landscapes have been discussed in earlier Sections but here there are about a further sixty examples, commencing with the small but incredibly accomplished Herbert Royle, *Beamsley Beacon in Winter* at **670** which recently sold at Andrew Hartley, Ilkley in April 2005, for £1,950 hammer. It is after all, small.

Portraits are prolific with women and children appearing more than 50 times. These subjects have been discussed in detail earlier but the Editor can't help drawing the readers' attention to some outstanding paintings. See, for example, *Young Girl Knitting in Interior* at **737**. *Le Ruban D'Or*, at **748** and the Scottish artist John Crawford Wintour at **768**. See also Italian children at **804**, James Green (1771-1834) at **888** and the *Andromache* portrait at **917** or *Portrait of Marie* at **928**. However, this is to overlook the Gordon King watercolour of Marilyn Monroe at **846**. See also nudity at **890**, the Percy Buckman (b.1865) watercolour *A Study in*

Clay, a J Bogdanovici's semi nude at **1024** and the sensuous Sheila Tiffin's (1952-) *Girl Undressing before a Mirror* at **1051**, not forgetting the Sergei Marshenkov *Reclining Nude* at **1054**. The Herbert Horwitz pair of *Classical Maidens* at **1045** are probably a rare find and are highly decorative at only 17 x 9 inches.

Still life are thin. The pick of these and probably more a botanical study is at **722**, where an Edward Bawden (1930-1988) pencil and watercolour *Oleandar*, fetched £1,800 at Sworders, Essex in February 2003. I like the John Sherrin (1819-1896) still life of a pineapple and three plums, **979**, which sold for £1,100 hammer in 2002. Of course, the Bawden watercolour is large at 64 x 47cms, although nowhere near the incredible screen print of his, which readers may recall at **365**, which fetched £3,600 at Gorringes, Lewes in 2003. Prints can also be found at **747, 780, 812, 845, 1048** and **1059**.

Equestrian interest is well served here even though a number of the lots are donkeys! Browse for these and for a good selection of wild life. Start at **716** and **717**. Canine subjects are well represented commencing at **685** with *Portraits of Spaniels* by Colin Graeme, dated 1902. Remember Graeme also has an earlier example at **252** and £4,800! See also **729, 777, 786, 789, 808**, and the fine John Arnold Wheeler (1821-1903) portrait of a Jack Russell at **895**, also **967** and the lively Jack Russell's at **968**. Only one cat picture graces these pages, again by a woman artist, Agnes M Cowieson (fl.1882-1940) *Braw Lads* which recently fetched £1,400 (April 2005) at Gorringes, this typically the price paid for her work.

There is a good selection of genre with modernists and abstract art. Mary Fedden can be seen at **686** and **757**. Other examples may be traced through the *Index*. John Bellany at **750** and Frederick Cayley Robinson's *Memories* at **993**, should also interest those following twentieth century art. See also Ivan Rabuzin (1919-) at **710** and Peter Sedgley's *Blue Nimbus* at **949**. Finally, it is worth mentioning the Kate Greenaway (1846-1901) at **713** and the Walt Disney (Studio) of *Bambi* on celluloid at **739**. Our first sporting picture appears at **676** with *Tennis Player* by Septimus Edwin Scott. (1879-1962) Another theme might be that of drawings, pen and ink or chalk. Check out **690-692, 711, 745, 800, 817, 822, 903, 946** and **1019**, including more Rowlandson examples and an Edward Lear, whose first example appeared at **177** for £6,500 and whose final example appears later at **1729** for £420. This shows the usefulness of the *Index* in providing a price range for a particular artist.

Hammer Prices £1950 - £1900

669

English School, oil, Portrait of a Gentleman, unsigned, 18thC, 30 x 24in, contemporary carved gilt frame, attributed to H Rigand. Andrew Hartley, Ilkley. Oct 04. £1950.

670

Herbert Royle, Beamsley Beacon in Winter, oil, signed, on board, 11.75 x 15.75in, white frame. Andrew Hartley, Ilkley. Apr 05. £1950.

671

Charles Thomas Bale, (c1840-c1923) Still Life Study of Fruit and Dead Game, a pair, oil on canvas, relined, 44.5 x 35cm, framed. Peter Wilson, Nantwich. Jul 02. £1950.

672

Samuel John Lamorna Birch, RA, RWS (1869-1955) The Heart of Cornwall, signed and inscribed verso, watercolour, 44.5 x 60cm. Sworders, Stansted Mountfitchet. Feb 05. £1950.

673

Kershaw Schofield, A Garden Vista, signed, 33.5 x 43.5in, stained frame. A. Hartley, Ilkley. Feb 01. £1900.

674

Lowry drawing bearing the signature L. S. Lowry and entitled 'Old Berwick' in pencil on the reverse of a Senior Service cigarette packet. Biddle & Webb, Birmingham. Feb 01. £1900.

675

Watercolour by Anthony Copley Fielding (1787-1855) of Bolton Abbey from the river. Bristol Auction Rooms, Bristol. Sep 01. £1900.

676

Oil on canvas by Septimus Edwin Scott, 1879-1962 entitled 'Tennis Player', 100 x 136cm. Bristol Auction Rooms. Oct 01. £1900.

677

Thomas Sherwood La Fontaine, (b1915) oil on canvas, 'Impromptu', signed, 85 x 131cm. Bristol Auction Rooms. Jan 03. £1900.

678

Harry Becker, (1865-1928) Two Trees, oil on board, 16 x 13in, lined and gilt frame. Canterbury Auc. Galleries, Kent. Feb 04. £1900.

679

Walter Goodin, (1907-1992), oil on board, Bridlington Harbour, signed, dated 58, 23.5 x 29.5in. Dee, Atkinson & Harrison, Driffield. Aug 01. £1900.

680

Thomas Miles Richardson, 1813-1890, View overlooking Florence, watercolour and pencil, 16.25 x 23.5in. Gorringes, Lewes. Oct 01. £1900.

681

Henry Ryland, (1868-1924) watercolour, Classical maidens beckoning to a shepherd boy, signed, dated 1905, 21 x 29in. Gorringes, Lewes. Apr 01. £1900.

682

Samuel John Lamorna Birch, (1869-1955) oil on board, Cornish cove, signed, 9.5 x 13.5in. Gorringes, Lewes. Apr 01. £1900.

683

H K The Bejewelled Head Dress, signed indistinctly, 72 x 53cm. Mellors & Kirk, Nottingham. Sep 03. £1900.

684

19thC Italian School, oils on canvas, a pair, Shipping in Venetian Lagoon, indistinctly signed, giltwood frames, 6.5 x 10in. Gorringes, Bexhill. May 04. £1900.

685

Colin Graeme, Portraits of spaniels, a pair, oil on board, both signed, dated 1902 on frame, 19 x 13.8cm, matching oak moulding frames. (2) Rosebery's, London. Dec 03. £1900.

686

Mary Fedden, (1915-) watercolour, Still life of a lemon and blue flower, signed and dated 1982, 6.75 x 4.75in. Gorringes, Lewes. Dec 04. £1900.

687

Carlton Alfred Smith, oil on canvas, Awake and Asleep. Gorringes, Bexhill On Sea. Sep 04. £1900.

688

Johannes Jacobus Paling, Cottage interior with a cobbler, his wife and child, oil on canvas, signed, 22 x 28in. Sworders, Stansted Mountfitchet. Jul 01. £1900.

689

Archibald Thorburn, (1860-1935) watercolour, Little Gull, signed, 6.5 x 9in. Gorringes, Lewes. Apr 03. £1900.

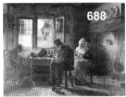

690

Thomas Rowlandson, (1756-1827) pen, ink and watercolour, Every Age has its Comforts-Gin and Snuf, signed, dated 1823, 11 x 9in. Gorringes, Lewes. Apr 03. £1900.

691

Thomas Rowlandson, (1756-1827) pen, ink and watercolour, Music at Home, 5.75 x 9.25in. Gorringes, Lewes. Apr 03. £1900.

692

Edward Lear, (1812-1888) pencil and ink, 'Mount Voltine, from near Minervino, O sand! O wind!' inscribed, dated 22. Sept. 1847, c/36, 11.5 x 18in. Gorringes, Lewes. Mar 03. £1900.

693

William Watt Milne, (fl.1900-15), oil on canvas, Landscape with figures in a boat and on a footbridge, signed, 16 x 20in. Gorringes, Lewes. Mar 05. £1900.

Most auction catalogues carry an explantation of the terminology used in descriptions. See Appendices.

694

Follower of Sir William Beechey, Portrait of an Admiral seated half-length in full dress uniform, holding a sword, oil on canvas, 90 x 71cm. Rosebery's, London. Sep 04. £1900.

695

18thC British School, portrait of Oliver Cromwell, oil on canvas, 45 x 36cm, within an oval raised mount with oak panel, 144 x 141cm. Locke & England, Leamington Spa. Sep 02. £1900.

696

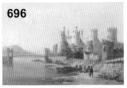

W Dommerson, View of Conway Castle, oil on canvas. Locke & England, Leamington Spa. Nov 02. £1900.

697

Arthur Moulton Foweraker, watercolour, signed. Biddle & Webb, Birmingham. Apr 02. £1880.

698

George Graham, Wooded River Scene with Cattle, signed, dated 1914, 27.5 x 35.5in, gilt frame. A. Hartley, Ilkley. Aug 01. £1850.

699

Joseph Thors, Rural scene with figures approaching a yard, oil, signed, 8.5 x 11.5in, gilt frame. A. Hartley, Ilkley. Jun 03. £1850.

700

Miss Ruth Hobson, (Exh 1909-13) watercolour, Fairies beside a meadow, initialled and dated 1910, Allied Artists Assoc. label verso, 16 x 21in. Gorringes, Lewes. Jan 02. £1850.

Hammer Prices £1900 - £1800

701

A Beaumont, Male quintet, oil on canvas, signed, dated 1854, inscribed 'Painted for B Shaw', and 'Presented to Benjamin Shaw as a testimony of friendship, by William Barker 1850', 34 x 44in. Sworders, Stansted Mountfitchet. Apr 01. £1850.

702

David Fulton, Children on a Rocky Shore, signed, 16.5 x 20.75in, gilt frame. Andrew Hartley, Ilkley. Apr 01. £1800.

703

Luigi Busetto, Venetian Scenes, a pair, signed and inscribed verso, 4.75 x 6.75in, gilt frames. Andrew Hartley, Ilkley. Jun 02. £1800.

704

Stanley Royle, (1888-1961) oil on board, 'The Windmill, Winter', signed, J Bennett of Glasgow label verso, dated (19)30, 12 x 16in. Gorringes, Lewes. Dec 01. £1800.

705

Samuel Phillips Jackson, (1830-1904) watercolour, Hulk and wreckers off Plymouth, signed and dated 1851, 12 x 18in. Gorringes, Lewes. Apr 01. £1800.

Hammer Price £1800

706

Pair of presentation miniatures of the Marquis and Marchioness of Antrim by William Singleton, c1780. Halls Fine Art, Shrewsbury. Nov 04. £1800.

707

Charles West Cope, (1811-1890) oil on board, Fireside Thoughts, exhibited at the Royal Academy 1848, 14.5 x 11.5in. Gorringes, Lewes. Apr 01. £1800.

708

Ludwig Papini(?), Crowded market scene in ruins in Rome, watercolour, signed, inscribed 'Rom', dated 1856, 67.2 x 53.2cm, unframed. Rosebery's, London. Dec 04. £1800.

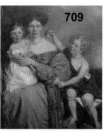

709

Attributed to John Rogers Herbert, (1810-1890) oil on canvas, Elizabeth Lady Mellor and her two elder children, 50 x 40.5in, carved giltwood frame. Gorringes, Bexhill. Oct 02. £1800.

710

Ivan Rabuzin, (1919-) Croatian, oil on canvas, The Village called Big Flower, 1960, signed monogram and dated 1960, 26.5 x 35.5in. Gorringes, Bexhill. Feb 04. £1800.

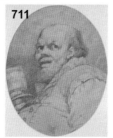

711

John Hamilton Mortimer, Falstaff, pen and black ink on laid, oval mount, 33.2 x 26cm. Rosebery's, London. Sep 02. £1800.

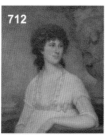

712

Attributed to Sir William Beechy, oil on canvas, portrait of Miss Elizabeth Wentworth. Gorringes, Bexhill. Sep 04. £1800.

713

Kate Greenaway, (1846-1901) oil on board, Girl in a doorway carrying a basket of eggs, initialled, 6.5 x 4.5in. Gorringes, Lewes. Apr 03. £1800.

714

Thomas Danby, (1818-1886), watercolour, Italian lake scene with a boat and figures on the shore, signed, dated 1869, 17 x 26in. Gorringes, Lewes. Apr 02. £1800.

715

Late 18th/19thC Chinese School, figures on a terrace, oil on canvas, 28 x 49cm, framed. Lots Road Auctions, Chelsea. Dec 03. £1800.

716

A. Simonetti (19th-20thC Italian), The Centre of Attention, oil on canvas, signed, dated 1870, 68 x 40cm. Hampton & Littlewood, Exeter. Apr 04. £1800.

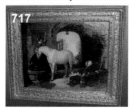

717

Watering the Horses, oil painting in the manner of Frank Moss Bennett, (1874-1953). Lots Road Auctions, Chelsea. Sep 03. £1800.

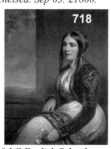

718

19thC English School, Portrait of a seated young woman, oil on canvas, 89 x 67cm. Henry Adams, Chichester. Jul 02. £1800.

719

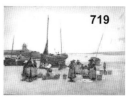

Robert Weir Allan, (1851-1942) On the Cornish Coast, watercolour, signed, 37 x 52cm, framed. Lots Road, Chelsea. May 02. £1800.

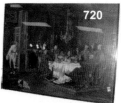

720

Sofy Asscher, 20thC, Toasting the Chef, oil on canvas, after Francois Brunery, (1849-1926) signed, 175 x 230cm, framed. Lots Road Auctions, Chelsea. Nov 02. £1800.

Ensure you never hang your watercolours etc in direct or reflected sunlight. Fading seriously affects value.

721

Sir Samuel Luke Fildes, (1843-1927), Portrait of Sir George Sutton, oil on canvas, signed, 132 x 100cm, framed. Lots Road Auctions, Chelsea. May 05. £1800.

722

Edward Bawden RA, (1903-1988) Oleander, signed, inscribed and dated 1988 in pencil, watercolour, 64 x 47cm. Sworders, Stansted Mountfitchet. Feb 03. £1800.

723

Hubert Coop, Shore scene with fisherfolk landing the catch, signed, framed and glazed, 13.5 x 19.5in. Tring Market Auctions, Herts. Sep 02. £1800.

724

19thC Primitive School, pair, Still lifes with spring onions and cucumbers, parsnips and beans, oil on board, each 7 x 10in, mahogany frames. Canterbury Auc. Galleries, Kent. Mar 05. £1750.

725

Albert Goodwin, 'Cley, Norfolk', watercolour, signed & inscribed, 9.5 x 14.5in. Sworders, Stansted Mount-fitchet. Mar 01. £1780.

726

Arthur J Stark, Travelling family resting by woodside, signed, 23.5 x 19.5in, gilt frame. Andrew Hartley, Ilkley. Oct 01. £1750.

727

Robert Watson, Highland Scene with cattle and drover, signed, dated 1890, 29.5 x 24.5in, gilt frame. A. Hartley, Ilkley. Jun 02. £1750.

728

Edwin Buttery, s.d. 1882, oil on canvas, English country landscape, 44.5 x 80.5cm. Thos Mawer & Son, Lincoln. Nov 02. £1750.

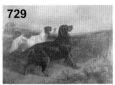

729

Colin Graeme, oil on canvas, English Pointer and Gordon Setter, signed lower left, 30 x 40cm, gilt frame. T. Mawer, Lincoln. Feb 03. £1750.

730

Ernest Higgins Rigg, Govilon South Wales, Turkey chasing a Rooster round a Milk Can, signed, on board, inscribed verso, 15.75 x 12.75in, gilt frame. Andrew Hartley, Ilkley. Feb 02. £1700.

731

J.H. 1899, oil on canvas, triple portrait study of three gentleman, 'Three Wise Men of Killarny', 9.75 x 17.5in. Biddle & Webb, Birmingham. Feb 04. £1700.

732

19thC Continental School, Italian lake scene, unsigned, oil on canvas, 13 x 18.5in, gilt moulded frame, glazed. Canterbury Auc. Galleries, Kent. Dec 03. £1700.

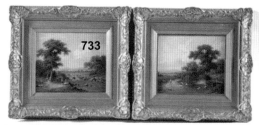

733

Pair of gilt framed oils by E. Beddington. Brettells Auctions, Newport, Shropshire. Sep 04. £1700.

734

William Miller Frazer, oil on canvas 'On the Struan', 20 x 30in. Clevedon Salerooms, Bristol. Nov 01. £1700.

735

Late 19thC Chinese School, Botanical studies, water-colours on rice paper, 7.5 x 10.5in, set of ten. Clarke Gammon Wellers, Guildford. Feb 05. £1700.

736

William Roxby Beverly, (1814-1889) watercolour, fishing boats off the coast, signed, dated 1864, 18 x 28.5in. Gorringes, Lewes. Feb 01. £1700.

737

Oil painting, William Eadie 'Young girl knitting in interior', 59.5 x 44cm, signed, dated 1888. Boldon Auction Galleries, Tyne & Wear. Sep 04. £1700.

738

The Hon. Marion Saumarez, (1885-1978) The Old Monk, oil on canvas, 63 x 52cm. Cheffins, Cambridge. Feb 04. £1700.

739

Walter Disney (Studio), Bambi, gouache on celluloid, 1942, 8.5 x 11.5in. Clarke Gammon, Guildford. Jun 03. £1700.

740

George Weatherill (1810-1890) watercolour, Figures unloading a beached ship, 3.5 x 4.75in. Gorringes, Lewes. Apr 03. £1700.

741

William Lee-Hankey, (1869-1952) oil on canvas, Portrait of a young lady, signed, 36 x 28in. Gorringes, Lewes. Jan 03. £1700.

Lady William Russell (?), oil on canvas, interior of Lady Russell's Drawing Room at Carlsbad (1844-45), inscribed verso, 11.5 x 11.75in. Gorringes, Bexhill. Sep 03. £1700.

Ettore Roesler Franz, (1845-1907) watercolour, Flight of stone steps, Villa d'Este, signed and inscribed Roma, 30 x 12.5in. Gorringes, Bexhill. May 04. £1700.

Frank Wootton, (1911-1998) oil on canvas, Looking across the Cuckmere Valle', signed, 20 x 24.5in. Gorringes, Lewes. Jan 04. £1700.

Elinor Mary Monsell, (Darwin) Exh.1899-1929. sepia chalk, Gwen John sketching at an easel, leaf from a sketchbook, Slade 1895, 8.5 x 6.25in. Gorringes, Lewes. Jul 04. £1700.

English Primitive School, early 19thC, 'Portrait of a little girl with her pet dog', oil on canvas, 17 x 14in. Halls Fine Art Auctions, Shrewsbury. Feb 04. £1700.

Alberto Giacometti, (1901-1966) Lady with Flowers, lithograph, signed by artist, 60 x 50cm, hors commerce, framed. Lots Road Auctions, Chelsea. Dec 03. £1700.

Elizabeth Westbrook, 'Le Ruban D'or, oil on canvas, signed with initials, dated 1872, 44.5 x 34.5cm. Rosebery's, London. Jun 04. £1700.

Attributed to Adam Fils, The sail & steamship 'Bayswater' heading out to sea, oil on canvas, signed 'T.E.G.V. Adam, Rouen, 1886(?), 62.5 x 92cm. Rosebery's, London. Dec 04. £1700.

John Bellany, R.A. 'Portseton', oil on canvas, signed, titled on the stretcher, 90.6 x 121.7cm, unframed. Rosebery's, London. Mar 04. £1700.

G.H.A. Binckes(?), Dulwich School, oil on canvas, signed, c1887, 40 x 56cm, framed. Lots Road Auctions, Chelsea. Oct 02. £1700.

Portrait of Admiral Coligny, oil on canvas, 47 x 38cm. Lots Road Auctions, Chelsea. Sep 03. £1700.

George Bunn, Sailboats in a Stiff Breeze, a pair, signed and dated '96, 22.5 x 31in, gilt frames. Andrew Hartley, Ilkley. Oct 01. £1650.

Ernest Herbert Whydale (of Royston), The Runaway, signed, oil on canvas board 37 x 56cm. Sworders, Stansted Mountfitchet. Nov 04. £1650.

English School, oil, Portrait of a Young Cavalier, half length, indistinctly signed, dated 1649, 23.5 x 19in, ebonised frame. A. Hartley, Ilkley. Oct 04. £1650.

Alfred Heaton Cooper, (1864-1929) watercolour, a View in the Lake District, 14.75 x 21.25in, signed in full and dated 1910. (?) Canterbury Auc. Galleries, Kent. Dec 01. £1650.

Mary Fedden, (1915-) watercolour, Two Figures, signed and dated 1975, 8.25 x 7in. Gorringes, Lewes. Dec 04. £1650.

Abel Hold, (1815-1891), oils on canvas, Birds nests with eggs, signed and dated 1876, 10in x 12in, a pair. Dee, Atkinson & Harrison, Driffield. Feb 01. £1600.

759

H. Redmore, river scene with a figure in a boat, signed and dated 1858, 16.75 x 23.5in, gilt frame. Andrew Hartley, Ilkley. Dec 01. £1600.

760

Herbert Royle, Canal Scene, Skipton, oil, signed on board, 11.25 x 15.5in, gilt frame. Andrew Hartley, Ilkley. Apr 05. £1600.

761

19thC Continental School, oil on wooden panel, game and fruit sellers at a market, 21.5 x 18in. Gorringes, Lewes. Feb 01. £1600.

762

Wright Barker, Cunning Boy in Stable with 'Joe' Goode, oil, signed and dated '95, 22 x 30in, gilt frame. A. Hartley, Ilkley. Apr 05. £1600.

763

Neapolitan School, (19thC) Set of three, market scenes and musicians, watercolours, 27 x 40cm. (3) Cheffins, Cambridge. Apr 01. £1600.

764

Edward Louis Lawrenson, (b.1868) Connemara signed lower left 'E L Lawrenson', oil on board, 31 x 42cm. Cheffins, Cambridge. Feb 05. £1600.

765

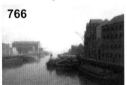

William Lionel Wylie, RA (1851-1931) HMS Victory fire a salute in Portsmouth harbour, etching signed in pencil, 21 x 49cm. D M Nesbit & Company, Southsea. Sep 03. £1600.

766

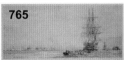

Walter Goodin, (1907-1992) oil on board, Towards the Humber, signed and dated 1981, 21 x 29.25in. Dee, Atkinson & Harrison, Driffield. Sep 02. £1600.

767

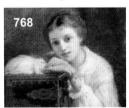

Charles Collins, RBA, oil painting on canvas, Coastal scene with estuary and cattle, 24 x 36in. Denhams, Warnham. May 04. £1600.

768

John Crawford Wintour, (Scottish, 1825-1882), Portrait of a Girl, oil on canvas, signed with monogram, dated 1869, 19 x 24in, framed. Lots Road Auctions, Chelsea. Apr 01. £1600.

769

After Morland, pair of oils on canvas, Vegetable Seller and a Hop Picker, 11 x 10in, one unframed. Gorringes, Lewes. Feb 01. £1600.

770

Edward Seago, (1910-1974) 'Ice Cliff near Base 'F', Grahamland', watercolour, 27 x 37cm. Sworders, Stansted Mountfitchet. Feb 05. £1600.

Frames and mounts should enhance your picture. Empathy, rather than fashion should dictate your choice.

771

William Hemsley, (1819-1906) oil on wooden panel, Porridge, signed, 6.5 x 5.25in. Gorringes, Lewes. Jun 03. £1600.

772

John Minton, (1917-1957), The Bullfighter, watercolour, signed, dated 1949 top right, 36.5 x 27cm. Dreweatt Neate, Donnington. Nov 02. £1600.

773

Frank Wootton, oil on board, Ponies in the rain, Winford Hill, signed, 15.5 x 23.5in. Gorringes, Lewes. Feb 01. £1600.

774

Frederick James Aldridge, (1850-1933) watercolour, Pool of London, signed, Ex Summerfield Collection, 20 x 27in. Gorringes, Lewes. Apr 01. £1600.

775

Colin Hunter, RA. (1841-1904) oil on canvas board, Pennyween, Fifeshire, signed and dated 1899, glazed gilt frame, 11.5 x 15.5in. Gorringes, Bexhill. Feb 04. £1600.

776

W. Knox, Gondolas on the Grand Canal, Venice, on canvas, signed lower left, 20 x 23in wide. Wintertons Ltd, Lichfield. Mar 01. £1600.

777

Attributed to John Wootton, oil on canvas, A Favourite Spaniel, 20 x 24in. Gorringes, Lewes. Oct 04. £1600.

Hammer Prices £1600 - £1500

778

Frederick F J Goff, pair of watercolours, London scenes. Gorringes, Bexhill On Sea. Sep 04. £1600.

779

Henry Sylvester Stannard, watercolour drawing, In a Bedfordshire Lane at Flitton. Gorringes, Bexhill On Sea. Dec 04. £1600.

780

Georges Braque, (1882-1963) French colour lithograph, L'Oiseau multicolore, signed in pencil, inscribed and numbered 107/200, 10 x 19.25in. Gorringes, Lewes. Jul 04. £1600.

781

19thC Neapolitan School, gouache, Fishermen working at day break, dated 1879, 18 x 25in. Gorringes, Lewes. Mar 03. £1600.

782

Ernest Higgins Rigg, (1868-1947), oil on board, Coastal landscape at sunset with ducks and haystacks in the foreground, signed, 12 x 15.5in. Gorringes, Lewes. Oct 02. £1600.

783

John Henry Dell, Stack Yard and another, a pair, monogrammed on panel, dated '67, 7 x 6in, gilt frames. Andrew Hartley, Ilkley. Jun 01. £1550.

784

Owen Bowen, Thatched Farmstead, signed, dated '94, 21.75 x 29.25in, gilt frame. Andrew Hartley, Ilkley. Aug 01. £1550.

785

H R Hall, Highland Cattle at a Moorland tarn Perthshire oil on canvas, inscribed verso, 24 x 36in. Sworders, Stansted Mountfitchet. Apr 01. £1550.

786

Pair Crown Devon plaques painted by R. Hinton, each depicting setters chasing game, 23 x 17.5cm. John Taylors, Louth. Sep 04. £1520.

787

Arthur Croft (born 1828. fl1868-1893) watercolour, Monaco and Monte Carlo from Cape St. Martin, panoramic view, 11.25 x 38in, signed in full, gilt moulded frame and glazed. Canterbury Auction Galleries, Kent. Feb 04. £1500.

788

Benjamin Williams Leader, On the Llugwy Below Capel Curig, oil, signed, 19.5 x 24in, gilt frame. A. Hartley, Ilkley. Apr 01. £1500.

789

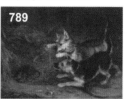

Alexander Forbes, Terriers Ratting, signed and dated 1839, 23 x 29in, gilt frame. Andrew Hartley, Ilkley. Aug 02. £1500.

790

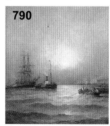

William Anslow Thornley, (English, d.1898) Sunset with Shipping at Low Tide signed lower right 'W Thornley', oil on canvas 24 x 40cm. Cheffins, Cambridge. Feb 05. £1500.

791

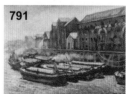

James Neal, Boats docked, River Hull, signed on board, 14.25 x 19in, painted frame. Dee Atkinson & Harrison, Driffield. Nov 04. £1500.

792

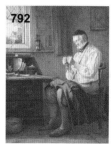

Henry Terry, (fl 1879-1910) interior scene, Threading the Needle, signed, unframed, 16.75 x 12.5in. Dee Atkinson & Harrison, Driffield. Mar 04. £1500.

793

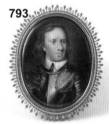

Portrait miniature of Oliver Cromwell, by W. Essex (British, 1784-1869), in battle armour, reverse inscribed 'Oliver Cromwell from an original miniature in the British Museum by S.Cooper 1656', and 'W.Essex Pinxt. Enamel painter to H.R.H the Princess Augusta. July 1832', decorative gilt metal frame, miniature height 2.75in. Fellows, Birmingham. Jul 03. £1500.

794

Frederikus-Jacobus Duchatel, (19thC) Dutch watercolour, Dutch estuary with fishing boats and windmills, signed, 16 x 24.5in. Gorringes, Lewes. Feb 01. £1500.

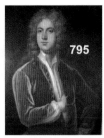

795

Late 18/19thC School, half length portrait of a gentleman in a flowing wig. Thos. Mawer & Son, Lincoln. Mar 04. £1500.

796

19thC English School, oil on canvas, Clipper at sea with sailors furling the topsail, 23.5 x 35.5in. Gorringes, Lewes. Mar 01. £1500.

797

William Dobell, Australian School (1899-1970), New Guinea Tribesmen, gouache, signed, 6 x 9.5in. Halls Fine Art Auctions, Shrewsbury. Apr 04. £1500.

798

William Lionel Wyllie, watercolour, HMS Victory and other vessels, in entrance to Portsmouth Harbour, signed, 15 x 27cm. Henry Adams, Chichester. Sep 02. £1500.

799

Thomas Bush Hardy, (1842-1897) watercolour, fishing boats on the Thames?, signed, 13 x 19in. Gorringes, Bexhill. May 02. £1500.

800

John Spencer Churchill, The Retreat to Dunkirk, May 1940, signed, dated 30 May '40 and inscribed as title and The Beaches HQ, First Corps B.E.F., pen, ink and grey wash, 31.5 x 44.5cm. Mellors & Kirk, Nottingham. Apr 03. £1500.

801

Manner of David Roberts, watercolour, Balkan figures seated beside classical ruins, 28 x 20in. Gorringes, Lewes. Oct 04. £1500.

> Ensure your watercolours etc are mounted on acid free boards. Have old pictures checked out by a framer.

802

Constant Kozovinc, Slovenian School mid 20thC, Troika in a winter woodland with figures and cottages, oil on canvas on board, signed, and inscribed 'Russie', 32 x 39.4cm. Rosebery's, London. Dec 04. £1500.

803

William Roberts, (1895-1980) oil on canvas, Portrait of a lady, signed, 20 x 16in. Gorringes, Lewes. Jan 04. £1500.

Hammer Price £1500

804

A. Bonifazi, 19thC, pair of oils on wooden panels, portraits of Italian children, signed, one dated '73, 8.5 x 6.75in. Gorringes, Lewes. Apr 04. £1500.

805

Clarkson Stanfield, (1793-1867), oil on canvas, Fishing boats putting out to sea, a tower beyond, signed, dated 1864, 16 x 27in. Gorringes, Lewes. Oct 04. £1500.

806

H.W.B. Davis RA, Cattle in a riverside meadow, on canvas, signed lower right, frame bears stencil mark '94SRZ', 50 x 75cm. Wintertons Ltd, Lichfield. Sep 02. £1500.

807

Frederick James Aldridge, (1850-1933) watercolour, Shipping on the Thames, signed, Ex Philip Aldridge Collection, artist's grandson, 20 x 29in. Gorringes, Lewes. Apr 01. £1500.

808

Samuel John Carter, (1835-1892) oil on canvas, Puppy with a toy rattle, signed and dated 1867, 12 x 14in, gilt gesso frame. Gorringes, Lewes. Dec 04. £1500.

809

Gustave de Breanski, (c1856-1898) 19thC, oil on canvas, fishing vessels offshore, panel signed, 74 x 49.5cm, narrow oak frame. Lambert & Foster, Tenterden. Jun 03. £1500.

810

Albert Goodwin, (1845-1932) watercolour, The School Playground, Dedham, signed and dated 1923, 10 x 14.5in. Gorringes, Lewes. Dec 04. £1500.

811

F Mabel Hollams, 'Sam', study of a dark brown hunter, signed, dated '37, oil on panel, 34 x 45cm Henry Adams, Chichester. Jan 03. £1500.

812

Georges Braque, (1882-1963) French colour lithograph, Le Grand Oiseau gris, signed in pencil, inscribed, numbered 30/95, 14.75 x 41.25in. Gorringes, Lewes. Jul 04. £1500.

813

James Bolivar Manson, (1879-1945) oil on canvas, Marigolds in a vase, signed, 18 x 14in. Gorringes, Lewes. Sep 04. £1500.

Hammer Price £1500

I Clark? One of a pair of hunting scenes, on canvas, signed, framed, 15 x 23in. Tring Market Auctions, Herts. Sep 02. £1500.

Marianne Harriette Robilliard, (Exh. 1908-20) oil on canvas, Passing Storm, this picture was the winner of the Turner Gold Medal and Scholarship at the Royal Academy 1907, 48 x 36in. together with two related photographs. Gorringes, Lewes. Jul 04. £1500.

19thC English School, a three deck, three masted war ship running for shelter in a continental port, watercolour drawing, unsigned, 36cm x 52cm. Thos. Mawer & Son, Lincoln. Mar 04. £1500.

Thomas Rowlandson, (1756-1827) pen, ink and water-colour, The Conducted Tour, 12 x 9in. Gorringes, Lewes. Apr 03. £1500.

58 *Picture Prices*

Circle of Philip Mercier, (18thC) Pierrot and Harlequin, oil on canvas, 91 x 72cm. Sworders, Stansted Mountfitchet. Feb 05. £1500.

William Thornley, (19th/ 20thC) oil on canvas, Fishing boats off the coast, signed, 10 x 16in. Gorringes, Lewes. Mar 03. £1500.

Charles Hunt 77, Babes in the wood, signed, the frame titled, re-lined, 24.5 x 29in. Tring Market Auctions, Herts. Apr 05. £1500.

Paul Jones, (19thC) oil on board, ghillies, spaniels and ponies in a landscape, signed and dated 1878, 6 x 8in. Gorringes, Lewes. Apr 02. £1500.

Edward Lear, (1812-1888) ink and watercolour, Konitza, Albania, inscribed and dated 16 April 1857, 4.75 x 7.5in. Gorringes, Lewes. Jun 03. £1500.

F Mabel Hollams, `Henry', study of a bay hunter, signed, oil on panel, 22 x 29cm Henry Adams, Chichester. Jan 03. £1500.

Henry Charles Fox, A Frosty Morning, watercolour, signed and dated 1890, 62 x 98cm. Rupert Toovey, Washington, Sussex. Oct 03. £1500.

Jesus Raphael Soto, untitled, construction of wood and rubber cord, 120.5 x 121.2cm. Rosebery's, London. Mar 05. £1500.

Alfred Bennett, (19th C) oil on canvas, On the Ouse, near Lewes, signed, dated Nr. Lewes '90, 16 x 24in. Gorringes, Lewes. Jun 03. £1500.

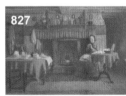

H Spernon Tozer, (1864-c1938), watercolour, Supper's Ready, interior scene with woman sewing and a table made ready for supper, signed, dated 1906, 21cm x 29.5cm. Gorringes, Bexhill. Mar 05. £1500.

Carl Werner, Chapel in the House of Caiaphas, signed, indistinctly dated, inscribed verso, watercolour, 50 x 35cm. Sworders, Stansted Mountfitchet. Nov 04. £1500.

H J Harvey, Old Friends, interior study of a seated peasant woman preparing vegetables, a black cat at her feet, on canvas, signed lower right, 30 x 22.5in. Wintertons Ltd, Lichfield. Jul 01. £1500.

Robert Antoine Muller, (fl.1872-1881), oil on canvas, Young girl holding a wicker basket full of balloons, signed, 49.5 x 37cm. Gorringes, Bexhill. Mar 05. £1500.

Robert Taylor Carson, (1919-) oil on canvas, 'Day Dreaming', signed, 20 x 16in. Gorringes, Lewes. Mar 05. £1500.

832

George Edward Lodge, eagle perched on a rocky outcrop, signed, oil on canvas, 28 x 42cm. Henry Adams, Chichester. Jan 03. £1500.

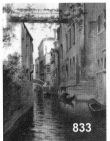

833

Prosdoci(m)ni (b1852), Venetian backwater with idle gondolas beneath ivy clad bridge, and with companion, Venetian market with fruit seller, watercolours, white moulded glazed frames, 41.5 x 26cm. (2) Locke & England, Leamington Spa. Mar 05. £1500.

> Condiiton, rarity, provenance and fashion are the key market operators currently dictating values.

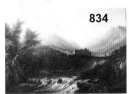

834

Follower of Robert Carver, (1730-1791), Cattle in a Mountainous Landscape, oil on canvas, 19 x 27in, framed. Lots Road Auctions, Chelsea. Apr 01. £1500.

835

Oscar Ricciardi, Busy market square in Naples, oil on panel, signed, 18.7 x 9.5cm, together with two other oils on panels by the same hand. Rosebery's, London. Sep 02. £1500.

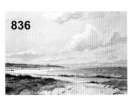

836

David West, Coastal scene viewed from the shore, watercolour, signed, 9 x 15in, glazed gilded frame. Amersham Auction Rooms, Bucks. Jun 01. £1450.

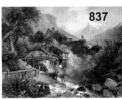

837

J D Harding, Alpine Village, signed and dated 1861, 18 x 25in, gilt frame. A. Hartley, Ilkley. Feb 01. £1450.

838

T F Cordeux, Extensive Harbour Scene, signed, 23.25 x 47.5in, gilt frame. Andrew Hartley, Ilkley. Jun 01. £1450.

839

After Anthony Van Dyke, Portrait of Ferdinand of Spain, 19thC, 43 x 38.25in, unframed. Andrew Hartley, Ilkley. Jun 02. £1450.

840

Tom Lloyd, watercolour, signed and dated 1898, 7 x 13.25in. Louis Taylor, Stoke on Trent. Sep 03. £1450.

841

B. W. Leader, View at Bettws Y Coed, North Wales, oil, signed, dated 1896, 19.5 x 29.5in, gilt frame. A. Hartley, Ilkley. Aug 04. £1450.

842

J Kinnaird, His First Day's Fishing, signed, 36.25 x 28in, gilt frame. A. Hartley, Ilkley. Feb 05. £1450.

843

Eugene Pechaubes, (1890-1967) French, pair of oils on canvas, 'Le Tremblay, 1931, 2eme Prix Herod', signed, 9.5. x 15.5in. Gorringes, Lewes. Apr 02. £1450.

844

William Pratt, Seaward Thoughts, oil on canvas, signed and dated, 40 x 29cm. Locke & England, Leamington Spa. Sep 02. £1450.

845

After Snaffles, Two prints, 'An Irish Yawner' and 'The Wissendine Brook runs deep and wide', hunting scenes, signed in pencil, gilt frames, glazed, 65 x 46cm. Locke & England, Leamington Spa. Mar 05. £1450.

846

Gordon King, portrait of Marilyn Monroe, watercolour, signed, 49.8 x 67.5cm. Rosebery's, London. Mar 02. £1450.

847

Peter De Wint, Whitby Abbey, Yorkshire, black and white chalk and watercolour on brown paper, 23.5 x 36.5cm. Thos Mawer & Son, Lincoln. Nov 02. £1450.

848

Unsigned, on panel, Italian School, peasant woman and a cattle and sheep drover on a path before a ruined temple at sunset, framed, 10 x 14in. Tring Market Auctions, Herts. Mar 02. £1450.

849

Carel Weight, (1908-1997) oil on board, Figures on a beach, signed, 7.5 x 17in. Gorringes, Lewes. Jul 04. £1400.

850

After Allan Ramsey, George III, formal portrait, oil on canvas, glazed, moulded gilt gesso frame, surmounted by a crown, 29.5 x 19.5in. Amersham Auction Rooms, Bucks. Feb 02. £1400.

851

William Lee Hankey, Alms Houses, Bruges, signed, original Art Nouveau gilt frame, 14.25 x 10.5in. Andrew Hartley, Ilkley. Aug 02. £1400.

852

Harry Sutton Palmer, watercolour, Collecting Peat, signed, dated 1873, 11 x 15in, gilt frame. A. Hartley, Ilkley. Oct 04. £1400.

853

Sir Hubert von Herkomer, RA, RWS, CVO (1849-1914) Bread & Sunshine, inscribed and titled on reverse 'Hubert Herkomer, No. 1, Bread and Sunshine', watercolour on ivorine, 10 x 7cm. Cheffins, Cambridge. Feb 05. £1400.

854

Frederick John Widgery, Amicombe Hill, Dartmoor, gouache, signed/described, 50 x 74.5cm. Bearne's, Exeter. Jul 03. £1400.

855

Zieellinus, oil on copper panel, Holy Family within a floral cartouche, 7 x 6in. Gorringes, Lewes. Jul 04. £1400.

856

William Anslow Thornley, (English, d.1898) A Steam Tug Towing a Three-Masted Sailing Ship into Harbour, Ramsgate signed lower left 'W Thornley', oil on canvas 34 x 29cm. Cheffins, Cambridge. Feb 05. £1400.

857

Warren Williams, (1863-1918) Figures on the beach Cemaes Bay, signed, 13.5 x 20.75in, gilt frame. Dee Atkinson & Harrison, Driffield. Nov 04. £1400.

858

George Gregory, (1849-1938) oil on canvas, Hulk and other shipping in harbour, signed and dated 1898, 13 x 20in. Gorringes, Lewes. Mar 04. £1400.

859

Norbert Joseph Horgnies, 19thC, Belgian unframed oil on canvas, Boys selling fish at a doorway, signed, 19.5 x 14.75in. Gorringes, Lewes. Mar 03. £1400.

860

Henry J Kinnaird, (fl.1880-1908) oil on canvas, Cornstalks in a field, extensive landscape beyond, signed, 18 x 32in. Gorringes, Lewes. Jan 04. £1400.

861

Tom Robertson, (1850 - 1947) oil on canvas, Fishing boats on a calm sea, signed, 28 x 36in. Gorringes, Lewes. Jul 04. £1400.

862

Archibald Thorburn, (1860-1935) watercolour, Ivory Gull, signed, 6.5 x 9in. Gorringes, Lewes. Apr 03. £1400.

863

Hely Augustus Morton Smith (1862-1941) oil on canvas, Sailing ship at sea,43 x 66in. Acanthus carved giltwood frame. Gorringes, Lewes. Apr 03. £1400.

864

Paul Maze, Sailing boats off Madeira, signed, pastel, 36 x 53cm. Henry Adams, Chichester. Sep 02. £1400.

865

Jacob Bornfriend, (1904-1974) oil on canvas, still life of fruit on a table, signed, 20 x 40in. Gorringes, Lewes. Apr 03. £1400.

866

Attributed to Karl Kaufmann, (1843-1901) View of Trieste, oil on canvas, signed 'F. P. Marzelli' (prob. pseudonym for Kaufmann), 41 x 17in, framed. Lots Road Auctions, Chelsea. Apr 01. £1400.

867

Giuseppe Pitto, (1857-1928) Italian, oil on canvas, The Fruit Market, signed, 19 x 26.75in. Gorringes, Lewes. Apr 03. £1400.

868

William H. Parkinson, (fl.1892-1898), oil on canvas, gardener tending a bonfire, signed and dated 1892, 14 x 10in, gilt gesso frame. Gorringes, Lewes. Oct 02. £1400.

869

Agnes M. Cowieson, (fl1882-1940), oil on canvas, 'Braw Lads' - two cats, signed, 14 x 18in. Gorringes, Lewes. Apr 05. £1400.

870

James Jas Stinton, (1870-1961) male and female pheasant eating seed, signed lower left, watercolour, framed, 9.5 x 14.5in. Peter Wilson, Nantwich. Nov 01. £1400.

Prices quoted are hammer and exclude the buyer's premium. Adding 15% will give approx. buying price.

871

Hermann Schmiechen, Bacchus, oil on canvas, signed, inscribed in pencil, dated 1915 on stretcher, 76.5 x 56.5cm. Rosebery's, London. Sep 04. £1400.

872

Alexander Nasmyth, (1758-1840) Portrait of Mrs Scott of Duninald, in a white dress in a landscape, oil on canvas, 102 x 76cm Sworders, Stansted Mountfitchet. Feb 05. £1400.

873

William Cook '73, pair of watercolour drawings in oval mounts, fishermen coming ashore to a beach beneath cliffs and figures and a rider before a watermill, 39.5 x 32cm, one monogrammed and dated. Thos Mawer & Son, Lincoln. Sep 04. £1400.

874

Charles Rowbotham, Near Swanage, coastal landscape with children and terrier on cliff top, yachts and steamer to distance, signed, indistinctly dated 1889 lower right, titled verso, 23.5 x 46.5cm. Wintertons Ltd, Lichfield. Mar 02. £1400.

875

Small late 18thC view of a racehorse and jockey, oil on canvas. Wintertons Ltd, Lichfield. Nov 04. £1400.

876

William Woodhouse, Canal Scene with barge and figures, signed, 10 x 13.75in, gilt frame. Andrew Hartley, Ilkley. Aug 02. £1350.

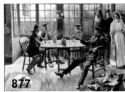

877

Watercolour by Tom Browne (1872-1910) entitled 'Yarns'. Bristol Auction Rooms, Bristol. Sep 01. £1350.

878

Vernon de Beauvoir Ward, (1905-1985) oil on canvas, Swans on a lake, signed, 67.3 x 52.3cm. Bristol Auction Rooms. Dec 01. £1350.

879

George Jones, (1786-1869) 'Notre Dame - La Grande, Poitiers', view of the market square, cathedral to background, oil, mahogany panel 30 x 27in, apparently unsigned, modern gilt frame. Canterbury Auc. Galleries, Kent. Apr 05. £1350.

880

Kenneth Webb (1927-) watercolour, Irish landscape, signed, Bell Gallery label verso, 15.5 x 23in. Gorringes, Lewes. Oct 02. £1350.

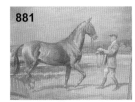

881

Equestrian portrait of 'Cufflink' and trainer George Harris by Molly Latham (c1900-1988), in the manner of Munnings, painted in 1959. Richard Winterton Auctioneers, Burton on Trent, Staffs. Jul 04. £1350.

882

Joseph Hughes Clayton, (?-1929) Rural village coastal scene, signed lower right, watercolour, framed 12 x 22in. Peter Wilson, Nantwich. Nov 01. £1350.

883

Sidney Watson, Highland Cattle, grazing on a Scottish mountainside, oil on canvas, signed and dated 1907, original gilt gesso glazed frame, 40 x 50cm. D M Nesbit & Company, Southsea. May 03. £1320.

884

Charles Pears, Lands End, signed, 19.5 x 29.5in, gilt frame. Andrew Hartley, Ilkley. Aug 02. £1300.

885

Henry Sylvester Stannard, watercolour, Landscape with Haymakers in the distance, signed, 9.75 x 13.75in, gilt frame. Andrew Hartley, Ilkley. Jun 04. £1300.

886

19thC Italian micro mosaic panel of Pliny's doves, mounted in gilt frame, 2.25in. Gorringes, Lewes. Dec 04. £1300.

Hammer Price £1300

887

Ronald Ossory Dunlop, (1894-1973) oil on canvas, Landscape with figure and cow, signed, 25 x 30in. Gorringes, Lewes. Sep 04. £1300.

888

James Green, (1771-1834) Portrait of Miss Mary Higgins of Turvey Abbey, Bedfordshire, oil on canvas, 76 x 64cm, gilded acanthus leaf moulded frame. Cheffins, Cambridge. Feb 05. £1300.

889

Frederick William Elwell, A.R.A., (1870-1958), oil on wood panel, 'Sun Baths' Riva Lake of Garda, signed and dated 1930, 11.5 x 15.5in. Dee, Atkinson & Harrison, Driffield. Feb 01. £1300.

890

Percy Buckman (born 1865) watercolour, A Study in Clay, signed, labels verso, 21 x 14in. Gorringes, Lewes. Feb 01. £1300.

891

Oil painting of Covent Garden market, prob. 100 year old copy of an earlier painting. Stride & Son, Chichester. Jul 04. £1300.

892

Herbert Dircksee, etching, Leopard on a tree trunk, dated 1920, signed in pencil, 17 x 26.5in. Gorringes, Lewes. Mar 01. £1300.

893

Frederick Richard Pickersgill. (fl. 1818-1853) Young mother with child in a country landscape, signed with initials F.R.P. RA, oil on panel, 36 x 51cm. Sworders, Stansted Mountfitchet. Feb 04. £1300.

894

G. C. Kerr, after J. K. Meadows, oil on canvas, Mounts Bay, Cornwall, signed, 30 x 50in, gilt gesso frame. Gorringes, Lewes. Oct 02. £1300.

895

John Arnold Wheeler, (1821-1903) oil on artist board, Portrait of a Jack Russell terrier, signed, 7 x 9in, unframed. Gorringes, Lewes. Jan 03. £1300.

896

J Gilbert, 1825, oil painting, signed and dated, 15.5 x 22in. Tring Market Auctions, Herts. Jan 02. £1300.

897

Mary Fedden, (1915-) watercolour, Partridge in a field, signed, 3.5 x 9in Gorringes, Lewes. Dec 04. £1300.

898

Simon Bussy, (1868-1954) 'Shama', signed, pastel, 28 x 23cm, exhibited at The Leicester Galleries, June-July 1939, No 29. Sworders, Stansted Mountfitchet. Feb 05. £1300.

899

English School, c1600, oil on wooden panel, portrait of a bearded gentleman, inscribed Anno Aetat, 20.5 x 16.5in. Gorringes, Lewes. Apr 02. £1300.

900

William Lionel Wyllie, three unframed etchings, The Battle of Trafalgar, signed in pencil, 7.75 x 15.75in. Gorringes, Lewes. Dec 04. £1300.

901

17thC English School, oil on canvas, Portrait of Agnes Thomson. Gorringes, Bexhill On Sea. Sep 04. £1300.

902

John Holland Snr, (fl.1831-1879) oil on canvas, 'Isle of Sark, Channel Islands', with lobstermen on the shore, signed, 12 x 18in. Gorringes, Lewes. Jul 04. £1300.

903

Thomas Rowlandson, (1756-1827) pen, ink and water-colour, 'Reverendissimo Viro-Wm.Huntingdon', inscribed by the artist, 7.25 x 6in. Gorringes, Lewes. Apr 03. £1300.

904

D Simone, gouache, Steam yacht 'Ravenska', Vesuvius beyond, signed and dated 1911, 16 x 26in. Gorringes, Lewes. Mar 03. £1300.

905

English School, 19thC, a pair, Badger baiting, oil on canvas, 13 x 15.75in. Clarke Gammon, Guildford. Oct 02. £1300.

906

William Langley, Highland cattle on the banks of a loch, oil on canvas, 12 x 20in and companion, Highland cattle on a track. (2) Halls Fine Art Auctions, Shrewsbury. Dec 03. £1300.

907

F C Bourne, Hong Kong 'from a painting by a Chinese artist'. Hamptons, Godalming. Nov 01. £1300.

908

Circle of Henry Redmore, (1820-1887) oil on canvas, 30.5 x 41cm. Rupert Toovey & Co, Washington, Sussex. Aug 03. £1300.

The numbering system acts as a reader reference as well as linking to the Analysis of each section.

909

Attributed to James Peel, (1811-1906) oil on canvas, 44 x 64cm. Rupert Toovey & Co, Washington, Sussex. Aug 03. £1300.

910

English School, c1840, Huntsman and his mount, oil on canvas, 63 x 76cm. Sworders, Stansted Mountfitchet. Feb 05. £1300.

911

Charles Taylor, merchant sailing vessel on choppy seas approaching a harbour, watercolour, signed, 60 x 12in, glazed light oak frame. Amersham Auction Rooms, Bucks. Jun 01. £1250.

912

John Ernest Aitken, Fairweather Haven, signed, 13 x 19.5in, gilt frame. A. Hartley, Ilkley. Jun 02. £1250.

913

A. W. Redgate, Hemmington, Leicestershire, oil, signed, inscribed verso, 11.25 x 17.5in, gilt frame. A. Hartley, Ilkley. Dec 03. £1250.

914

Stanley Royle, Windmill and Cottages at Sunrise, signed, 18.25 x 13.5in, gilt frame. Andrew Hartley, Ilkley. Oct 04. £1250.

915

Charles Johnson Payne, 'Snaffles', 'Bon Voyage', 'Le Poilu', 'Yi Hai-Indian Cavalry (B.E.F.)' and 'Jock (KR)', set of four coloured prints, 17 x 13.5in, gilt frame. Andrew Hartley, Ilkley. Feb 05. £1250.

Hammer Prices £1300 - £1250

916

After Paul Sandby, Windsor terrace looking eastward, Windsor terrace looking westward, Windsor from Eton, hand-coloured aquatints, each 30 x 45cm. (3) Sworders, Stansted Mountfitchet. Nov 04. £1250

917

In the style of Carlo Dolci, Andromache Mourning Over The Ashes of Werther, signed, re-lined, framed, 28 x 22in. Tring Market Auctions, Herts. Apr 05. £1250.

918

19thC Chinese School Merchants weighing tea chests, watercolour, 12 x 9.75in. Gorringes, Lewes. Apr 03. £1250.

919

19thC oil on canvas of a young boy eating a bowl of porridge, panel 48 x 62cm, gilt frame. Lambert & Foster, Tenterden. Jan 05. £1250.

920

John (James) Wilson Carmichael, (1800-1868), Shipping passing in an open sea, watercolour, signed, 56 x 79cm. Bristol Auction Rooms. Jul 02. £1250.

921

Anthony Gross, (1905-1984) ink and watercolour, 'The Tow-path, Putney', signed, 1947 Leicester galleries label verso, 14.5 x 21in. Gorringes, Lewes. Jan 04. £1250.

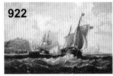

922

John Callow, Off Scarborough, signed and dated 1840, 21 x 28.25in, gilt frame. Andrew Hartley, Ilkley. Dec 04. £1250.

923

Robert Taylor Carson, (born 1919) Sailing ships beside a quay and a mountainous coast, signed, oil on board, 52 x 62cm. Sworders, Stansted Mountfitchet. Feb 04. £1250.

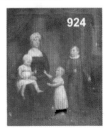

924

English School, c1830, Mother and her three children in an interior, oil on canvas. Sworders, Stansted Mountfitchet. Nov 04. £1250.

Hammer Prices £1250 - £1200

925

Portrait miniature of a gentleman, c1790, in red frock jacket, on ivory, within a gold bracelet clasp, 4cm high. Wintertons Ltd, Lichfield. Nov 02. £1250.

926

One of two oil paintings by Ernest Walbourn, (fl 1897-1904), poor condition, lacking frames, 24 x 36in. Canterbury Auc. Galleries, Kent. Jan 01. £1200.

927

19thC Indian School, 2 pairs of miniatures, Muhammad Shahjehan (1592-1666), Mumtaz Mahal (m.1612-d.1632), Maharaja Ranjit Singh (1780-1839), and Mahtab Kaur, on ivory, 2.5 x 2in, on papier mache panels, one other pair, Muhammad Shahjehan and his wife. Canterbury Auc. Galleries, Kent. Apr 05. £1200.

928

The Hon. Marion Saumarez, (1885-1978) Portrait of Marie, oil on canvas, 63 x 52cm. Cheffins, Cambridge. Feb 04. £1200.

929

Richard Bankes Harraden, (1778-1862), Great St Mary's Church, Downing College, Trinity Hall, Ruined Chapel, Dining Hall, sepia wash over pencil, each 10 x 15cm. (5) Cheffins, Cambridge. Feb 04. £1200.

930

Edward Irvine Halliday, PRBA, PRP, (British, b.1902) Mr & Mrs Edward Halliday and Miss Charlotte Halliday at home, signed lower right, 'Edward I Halliday 1958', oil on canvas, 120 x 78cm. Cheffins, Cambridge. Feb 05. £1200.

931

M. Earnshaw, portrait of two girls with a terrier, signed, pastel, 27 x 22.5in. Clarke Gammon, Guildford. Apr 04. £1200.

932

William Callow, (1812-1908), watercolour, A View of Dieppe from the sea, signed, dated 1896, 12.75 x 18.75in, (Leger & Son label) Gorringes, Lewes. Jun 01. £1200.

933

George Chambers Snr, (1803-1840) watercolour, Shipping at the mouth of the Thames, signed, 10.5 x 16.5in. Gorringes, Lewes. Mar 01. £1200.

934

Matthys Quispel, (1805-1858) Dutch, oil on oak panel, Horse, cow and goats in open landscape, signed, 6.25 x 8.5in. Gorringes, Lewes. Apr 01. £1200.

935

William MacTaggart, (1903-1981) watercolour, Glimpse of Florence, 1955 Scottish Art Council Exhibition label verso, 17.5 x 22in. Gorringes, Lewes. Apr 01. £1200.

936

Albert G Stevens, (Exh 1903-1922) watercolour, Scotch Fishing Boat at Whitby, signed, dated 1912, 10 x 14in. Gorringes, Lewes. Apr 01. £1200.

937

George Fiddes Watt, (1873-1960) Frigates, a paddle steamer and rowing boats in harbour, oil on canvas, signed and dated (18)91, 9 x 17in. Gorringes, Lewes. Apr 01. £1200.

938

L S Lowry, 'Industrial Panorama' lithograph. Lots Road Auctions, Chelsea. Dec 01. £1200.

939

Cockerels and Exotic Birds, in manner of Hondecoeter, works from the studios of Miguel Canals. Lots Road, Chelsea. Sep 03. £1200.

The illustrations are in descending price order. The price range is indicated at the top of each page.

940

18thC Continental School. 'Hugo Crotius', oil on copper, mounted and framed as oval, titled to the image, 14 x 11.5in. Wintertons Ltd, Lichfield. May 01. £1200.

941

Late 18th/early 19thC Spanish Colonial feather mosaic and gilt paper picture of the crowned & enthroned Madonna and the Infant Christ, 46 x 33cm. Rupert Toovey & Co, Washington, Sussex. Jan 03. £1200.

942

19thC French School pastel, Portrait of a lady, 28 x 33in, florentine frame. Gorringes, Lewes. Apr 04. £1200.

943

Mary Fedden, (1915-) watercolour, Sheep in a landscape, signed and dated 1981, 4 x 8.5in. Gorringes, Lewes. Dec 04. £1200.

944

James Bolivar Manson, (1879-1945) oil on canvas, Still life of flowers, signed, c1919/20, 24 x 20in. Gorringes, Lewes. Sep 04. £1200.

945

Kate Greenaway, ink and watercolour, Putting on their Sunday best, mother and two children. Gorringes, Bexhill On Sea. Dec 04. £1200.

946

Thomas Rowlandson, (1756-1827) Death and The Maiden, pen, ink and watercolour, signed, 5 x 8in. Gorringes, Lewes. Apr 03. £1200.

947

Anatoly Shapovalov, 'Lacing up the Ballet Shoe', oil on canvas, signed, 101.5 x 67cm, framed. Lots Road, Chelsea. Dec 04. £1200.

948

Archibald Thorburn, (1860-1935) watercolour, 'Black Tern', signed, 6.25 x 9in. Gorringes, Lewes. Apr 03. £1200.

949

Peter Sedgley, Blue Nimbus, mixed technique on paper, signed and dated '67 in pencil, 24.7 x 24.7cm, with one other similar work on paper titled 'Red Planet' by the same hand, signed and dated 1967, 24.7 x 24.7cm, bear inscribed exh. labels on the reverse. (2) Rosebery's, London. Sep 04. £1200.

950

Benjamin Williams Leader, (1831-1923) oil on canvas, Figures and pine trees in an open landscape, signed and dated 1907, 10 x 8in, gilt gesso frame. Gorringes, Lewes. Oct 02. £1200.

Hammer Price £1200

951

Thomas Bush Hardy, watercolour, coastal scene, signed and dated 1890, together with companion picture. 6 x 11.75in. Louis Taylor, Stoke on Trent. Sep 03. £1200.

952

Archibald Thorburn, (1860-1935) watercolour, Common Gull, signed, 5.75 x 8.75in. Gorringes, Lewes. Apr 03. £1200.

953

Charles Knight, (1901-1990) watercolour, Mousehole, Cornwall, 10.5 x 15.5in. Gorringes, Lewes. Apr 03. £1200.

954

Charles Knight, (1901-1990) watercolour, The Long Pool on the Lyn, signed, 15 x 21in. Gorringes, Lewes. Apr 03. £1200.

955

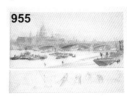

William Lionel Wyllie, (1851-1931) monochrome watercolour and pencil, View of the Thames and St Pauls, a study for the drypoint, 7 x 13.75 in, and a pencil study of a boat and figures, signed, 2.75 x 13.75in, framed as one. Gorringes, Lewes. Apr 03. £1200.

956

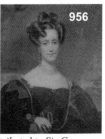

Attributed to Sir George Hayter, (1792-1871) oil on canvas, Portrait of Elizabeth Grant, half length, wearing a blue dress and elaborate drop earrings, 30 x 25in. Gorringes, Lewes. Mar 03. £1200.

957

Frederick Hines, (Exh. 1880-97) watercolour, Harvesting by moonlight, signed, 22 x 15.5in. Gorringes, Lewes. Mar 03. £1200.

958

Max Schodl (1834-1921) oil on wooden panel, an antique clock, glasses and book on a table, signed and dated 1912, 9.5ins x 7.5in. Gorringes, Bexhill. Mar 02. £1200.

Hammer Price £1200 - £1100

959

Peter Howson, (1958-) oil on canvas, Moonlit figure, 40 x 30in. Gorringes, Lewes. Jun 03. £1200.

960

Thomas Bush Hardy, (1842-1897), watercolour, 'A Hazy Morning, Off Treport', signed and dated 1879, 12.5 x 19.25in. Gorringes, Lewes. Mar 05. £1200.

961

K Mayer, Portraits of a Brother and Sister Depicted Seated, each in white dress, signed pair, 19 x 13in, gilt frames. Andrew Hartley, Ilkley. Apr 01. £1150.

962

Clifford Montague, (Exh 1885-93) Pair of oils on canvas, 'Dutch Boats Drying the Sails' and 'On a French River', both signed, titled verso, 34.2 x 59.5cm, framed. Bristol Auction Rooms. Dec 02. £1150.

963

William Kay Blacklock, The Harbour Mouth, Polperro, Cornwall, signed, inscribed verso, dated 1923, 10.5 x 15.25in, gilt frame. Andrew Hartley, Ilkley. Aug 02. £1150.

964

Lilian Stannard, watercolour on paper, a view of a summer cottage garden, signed, 13.25 x 9.5in. Biddle & Webb, Birmingham. Jan 04. £1150.

965

Arthur Moulton Foweraker, signed watercolour on paper, 'The Convent of Incamatia', 10 x 13.5in. Biddle & Webb, Birmingham. Jan 04. £1150.

966

Portrait miniature of David Garrick, by W Essex (British, 1784-1869), after Gainsborough, reverse inscribed 'Garrick the greatest of British actors excelled both in tragedy and comedy. Died 1779. He was buried in Westminster Abbey', and 'Painted by W.Essex, Enamel painter to Her Majesty & Prince Albert 1856, after Gainsborough', ebonised frame, miniature 3.75in high. Fellows, Birmingham. Jul 03. £1150.

967

Two wire-haired terriers ratting in the corner of a barn, oil painting attributed to George Armfield, (fl 1840-1875) canvas 10 x 16in, moulded oak frame. Canterbury Auc. Galleries, Kent. Feb 02. £1150.

968

19thC School, Jack Russell with 2 puppies playing, 17 x 21in, oil on canvas, unsigned, gilt moulded, swept frame, later over-painted. Canterbury Auc. Galleries, Kent. Feb 04. £1150.

969

Circle of Edward Lear, On the River Nile, pen & brown ink, bears signature, title, date and dedication 'for Emma Constance Fairburn', 11 x 17cm and with one other similar pen & ink study titled 'Campagna de Roma', also with signature date and dedication. (2) Rosebery's, London. Dec 04. £1150.

970

George vicat Cole RA (1833-1893) oil on canvas, landscape with horse, cart and figures on a woodland track, signed monograms, 1879, 18.75 x 17.75in. Gorringes, Bexhill. Oct 01. £1150.

971

Harden Sidney Melville, three horses pulling a log, oil on canvas, 20 x 27in. Canterbury Auc. Galleries, Kent. Jun 02. £1150.

972

Circle of Atkinson Grimshaw, autumnal street scene, woman gazing at a distant house, oil on canvas, signature, 17.5 x 24in, glazed moulded gilt frame. Amersham Auction Rooms, Bucks. Apr 04. £1100.

> Artists or themes can be followed through the colour coded Index which contains over 4500 cross references.

973

David Shepherd, Ode to the English Elm, signed, 15.25 x 19 .5in, gilt frame Andrew Hartley, Ilkley. Feb 05. £1100.

974

19thC Italian School after Raphael, (1483-1520) Madonna della Sedia, oil, relined canvas 15.5in square, in Florentine gilt mirror, frame 29.5 x 25.5in. Canterbury Auc. Galleries, Kent. Feb 04. £1100.

Erwin Eichinger, (19thC) Austrian, oil on board 'The Epicure', signed, 10.5 x 8.75ins. Gorringes, Lewes. Apr 02. £1100.

George Edward Lodge, (1860-1954) Kestrel watercolour and body colour, signed, 22 x 30cm, Rowland Ward label verso. Cheffins, Cambridge. Dec 01. £1100.

Henry Moore of Hull, (fl.1872-1899) A ketch storming along in a still breeze, signed, 9.25 x 13.25in, gilt frame. Dee Atkinson & Harrison, Driffield. Nov 04. £1100.

Walter Goodin, oil on hardboard, Bridlington Harbour. Dee, Atkinson & Harrison, Driffield. Apr 01. £1100.

John Sherrin, (1819-1896) watercolour, Still life of a pineapple & 3 plums, signed, 11.5 x 12.5in. Gorringes, Lewes. Jan 02. £1100.

Adelaide Claxton, Oriental Interior. Mellors & Kirk, Nottingham. Dec 02. £1100.

Henry Howard, oil on panel, portrait of a young girl wearing white dress, half length, inscribed verso, 7 x 5.5in. Gorringes, Lewes. Feb 01. £1100.

Follower of William Collins, (1788-1847) oil on canvas, Coastal landscape with fisherfolk on the shore and beached fishing boats, signed and dated 1850, 16.5 x 24.5in. Gorringes, Lewes. Mar 01. £1100.

Portrait miniature of Shakespeare, by W. Essex (British, 1784-1869), signed, dated 1849, reverse inscribed 'Shakspeare after the Chandos picture. Painted by W. Essex. Enamel painter to Her Majesty & H.R.H Prince Albert 1849', and with the quote 'We may have another Milton, but never another Shakespeare.' S. Rogers Esq. to W.E., gilt metal and wood frame bearing attribution, miniature 3.75in high. Fellows, Birmingham. Jul 03. £1100.

Louis Van Staaten, Dordrecht, signed, oil, 29 x 23cm. Locke & England, Leamington Spa. Sep 03. £1100.

Gustav Dore, (1832-1883) French, watercolour, Angels around a cathedral dome, 12 x 10in. Gorringes, Lewes. Mar 01. £1100.

Erwin Eichinger, (18thC) Austrian, oil on board, smiling gentleman holding a hand of cards, signed, 10 x 7.5in. Gorringes, Lewes. Apr 02. £1100.

Wilhelm Kray, (1828-1889) German, oil on canvas, mother and children on the coast, Capri beyond, signed inscribed Roma and dated 1873, 15.5 x 27.5in. Gorringes, Bexhill. Feb 04. £1100.

John Burr, (1831-1893) oil on canvas, Gentleman at a window wearing a smoking cap and holding a newspaper, signed, 26 x 20in. Gorringes, Lewes. Apr 01. £1100.

19thC Italian School, four sur-porte panels, with oval oil on canvas neo-classical scenes. Lots Road Auctions, Chelsea. Jun 02. £1100.

Sonia Delaunay, (1885-1979) one of 2 unframed gouache textile designs, signed in pencil and dated (19)55, 6 x 8in & 10 x 10in. Gorringes, Lewes. Apr 01. £1100.

Hammer Price £1100

991

Preparatory study for Panel decoration at Chelsea Town Hall by Alexander Jamieson (1873-1937), oil on canvas, with the Chelsea luminaries Whistler, George Eliot, Rossetti, Carlyle, Wellington and Turner, 65 x 92cm. Lots Road Auctions, Chelsea. Dec 02. £1100.

992

Erling Enger, (1899-1990) oil on canvas, coniferous woodland landscape, signed and dated '57, 32 x 39in. Gorringes, Bexhill. Dec 02. £1100.

993

Frederick Cayley Robinson, (1862-1927), oil on board, 'Memories', Leicester Galleries 1929 Exhibition label, 6 x 7.5 in. Gorringes, Lewes. Oct 04. £1100.

994

Andre Vignoles, (1920-) French, oil on canvas, Fleurs de Printemps, signed, dated '57, 22 x 13in. Gorringes, Lewes. Mar 04. £1100.

995

School of Joshua Reynolds, oil on canvas, Portrait of a boy holding a bow and arrow, 30 x 25in. Gorringes, Lewes. Jan 04. £1100.

996

Thomas Shotter Boys, (1803-74) The Doge's Palace, Venice, Early Morning, watercolour, 7 x 9.5in. Gorringes, Lewes. Dec 04. £1100.

997

Highland lake scene, oil on canvas, Alfred Fontville de Breanski, (d.1893), 60 x 91cm. Lots Road Auctions, Chelsea. May 03. £1100.

998

P. Jones, (19thC) oil on canvas, 'A Quiet Rest', signed and dated 1882, 12 x 18in. Gorringes, Lewes. Sep 04. £1100.

999

Archibald Thorburn, (1860-1935) watercolour, Great Shearwater, signed initials, 5.75 x 9in. Gorringes, Lewes. Apr 03. £1100.

1000

William Heaton Cooper, Feeding chickens in a high-land farm, signed, water-colour, 27 x 37.5cm. Rosebery's, London. Mar 05. £1100.

1001

Tom Robertson, (1850-1947) oil on board, 'A Syrian Coaster', signed, 8 x 10in. Gorringes, Lewes. Jul 04. £1100.

1002

Frederick Waters Watts, Hampstead Heath, pencil and watercolour heightened with white, 27 x 22.5cm. Mellors & Kirk, Nottingham. Apr 03. £1100.

1003

Thomas Bush Hardy, fishing boat on a beach, signed and inscribed, watercolour, 13 x 19in. Sworders, Stansted Mountfitchet. Jul 01. £1100.

1004

Charles Knight, (1901-1990) watercolour, Chancellors Ridge, Glencoe, signed,16.5 x 25.5in. Gorringes, Lewes. Apr 03. £1100.

1005

Molly M Latham, (c1900-1987) oil on canvas, Foxhunter, portrait of a horse, signed and dated 1952, 25 x 30in. Gorringes, Lewes. Apr 03. £1100.

1006

Bernard Dunstan. Girl at Tea, board, 7.5 x 18.5cm. Mellors & Kirk, Nottingham. Apr 03. £1100.

> The abbreviations following artist's names can be located in the Appendices.

1007

19thC French School, oil on canvas, portrait of a muse with floral garlanded hair and bird on a ribbon, 24.5 x 20in, unframed. Gorringes, Lewes. Oct 02. £1100.

1008

Erwin Eichinger (19thC) Austrian, oil on board, 'A glass of wine', signed, 10.5 x 8in. Gorringes, Lewes. Apr 02. £1100.

1009

George Sheringham, (1884-1937) oil on board,
'A Hampstead Holiday', signed, 6 x 14in.
Gorringes, Lewes. Jan 05. £1100.

1010

Giuseppe Giardiello, Figures
and beached vessels on a
beach with Naples in the
distance, oil on canvas laid
down on board, signed, 49 x
67cm. Rosebery's, London.
Sep 02. £1100.

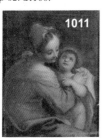

1011

19thC Italian School, oil on
zinc panel, Madonna and
child, 6.5 x 4.75 in, gilt gesso
frame. Gorringes, Lewes.
Jul 03. £1100.

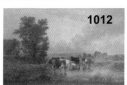

1012

W G Meadows, a pair, oils
on canvas, 'Cows standing in
a pool' and 'Cattle drinking
in a pastoral scene', signed,
59 x 105cm. Gorringes,
Bexhill. Mar 05. £1100.

1013

G.H.A. Binckes(?), Dulwich
Park, oil on canvas, signed,
dated 1887, 40 x 56cm,
framed. Lots Road Auctions,
Chelsea. Oct 02. £1100.

1014

Alfred Vickers, (1786-1868)
East Anglian landscape, oil
on panel, signed, 22 x 45cm,
framed. Lots Road Auctions,
Chelsea. Sep 02. £1100.

1015

Letitia Marion Hamilton,
Purple and Gold, signed with
initials, panel, 12 x 17cm,
Rowley Gallery silvered
frame. Mellors & Kirk,
Nottingham. Apr 03. £1100.

1016

Robert Johnson, 'At Leura',
Blue Mountains, New South
Wales, inscribed verso, 'The
Seddon Galleries, Melbourne',
signed, oil on board, 35 x
43cm. Sworders, Stansted
Mountfitchet. Nov 04. £1100.

1017

School of Jan Van Kessel,
Exotic birds in an orna-
mental Arcadian garden, oil
on canvas, laid down, 37.2 x
49cm. Rosebery's, London.
Sep 04. £1100.

1018

William Heaton Cooper,
Tranquil highland loch
scene, watercolour, signed,
36 x 54.2cm. Rosebery's,
London. Mar 05. £1100.

1019

Thomas Rowlandson, (1756-
1827) A Village Market,
signed, dated 1790, pen, ink
and watercolour, 17.5 x
23.5cm. Sworders, Stansted
Mountfitchet. Feb 05. £1100.

1020

Frank H. Mason, A Fishing
Fleet, signed, framed and
glazed, 12.5 x 13.5in.
Tring Market Auctions,
Herts. Jul 04. £1100.

1021

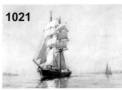

Watercolour by Samuel John
Milton Brown, (1873-1963),
entitled Summer Haze.
Bristol Auction Rooms,
Bristol. Sep 01. £1050.

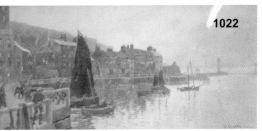

1022

William Matthison, Views of Whitby Harbour, watercolours,
a pair, both signed, 25 x 53cm.
Rosebery's, London. Sep 02. £1050.

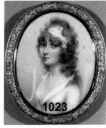

1023

18thC School, miniature
portrait of Mrs David
Wedderburne, unsigned oval
on ivory, 2.75 x 2.25in, gilt
metal floral cast surround,
reverse inscribed and dated
1787. Andrew Hartley, Ilkley.
Apr 01. £1050.

1024

J. Bogdanovici, Portrait of a
semi-nude female, seated
before a fire, oil on canvas,
signed, 68 x 48cm, unframed.
Hampton & Littlewood,
Exeter. Jul 04. £1050.

1025

Rosa Muller, (fl 1861-1901)
watercolour, Grove Park,
Gower, S Wales, children and
ducks on the river, signed,
33.5 x 52.8cm, framed and
glazed. Bristol Auction
Rooms. May 02. £1050.

Hammer Prices £1050 - £1000

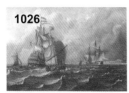

1026

Oil on canvas by Louis Berboeckhoven, 1802-1889, of Dutch shipping under sail, 39 x 54.4cm. Bristol Auction Rooms. Oct 01. £1050.

1027

James Watson, (19th/20thC British) Coastal view (thought to be of North Yorkshire), oil on canvas, 12 x 24in, signed and dated '04, modern gilt moulded frame. Canterbury Auc. Galleries, Kent. Aug 03. £1050.

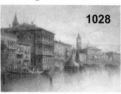

1028

Carlo Chiostri, The Grand Canal, Venice, oil on canvas, signed, 72.5 x 98.5cm. Rosebery's, London. Sep 02. £1050.

1029

Charles Greville Morris, (born 1861 - fl1886-1894) watercolour, The Primrose Pickers, country landscape with two children, 7.75in x 12.5in, signed monogram & 1890 to lower right corner, modern gilt frame, glazed. Canterbury Auc. Galleries, Kent. Apr 04. £1050.

1030

W E Atkins, watercolours, Portsmouth Harbour, a pair, 57 x 24cm, foxed. (2) Crows, Dorking. Jun 03. £1050.

1031

Watercolour of fishing boats signed Frank Rousse 1899, an artist who specialised in painting scenes at Whitby in Yorkshire. Stride & Son, Chichester. May 02. £1050.

1032

Carl Heuser, oil on panel, portrait of an old man with pipe, 12 x 15cm. Crows, Dorking. Apr 04. £1050.

1033

Henry Scott Tuke R.A., Baroque in Evening Light, Falmouth, signed and dated '93, watercolour 10.5 x 17.5cm. Sworders, Stansted Mountfitchet. Nov 04. £1050.

1034

Frederick Whitehead, oil painting. Hogben Auctions, Folkestone. Jul 03. £1050.

1035

Italian School after Guardi, oil on old panel, street scene, framed, 38 x 27cm. Richard Winterton, Burton on Trent, Staffs. Feb 04. £1050.

1036

After Andries Both, The Poor Painter, oil on canvas, 113 x 96.8cm. Rosebery's, London. Sep 02. £1050.

1037

Snaffles, two artist's proof coloured prints, 'A National Candidate', racehorse with jockey up, and 'The Timber Merchant', hunting scene, 18 x 17in, signed in pencil, ebonised frames and glazed Canterbury Auc. Galleries, Kent. Apr 05. £1050.

> Fresh to the market paintings perform better than those which have been in and out of auction.

1038

17thC English School, portrait of a gentleman, old label verso Robert Williamson, Sunnybank, Ripon and stencilled (auction house?) No. 221AR 69 x 54cm. Thos. Mawer & Son, Lincoln. Mar 04. £1050.

1039

H Gresley, Monsal Dale, Derbyshire, signed lower right, titled in pencil to the mount, 11 x 15in. Wintertons Ltd, Lichfield. May 01. £1050.

1040

Richard Marshall, (1944-) Summer on the beach at Scarborough, oil on board, signed, 19 x 24cm. David Duggleby, Scarborough. Jul 03. £1020.

1041

George Paul Chalmers, oil on canvas, bank of trees, unsigned, paper label to reverse, framed, 19.5 x 35.5in. Tring Mkt Auctions, Herts. Apr 05. £1020.

1042

Dominic Michael Serres, Tintern Abbey and River Scene, a pair, watercolour, unsigned, 17.25 x 23.25in, gilt frames. Andrew Hartley, Ilkley. Dec 04. £1000.

1043

After Michael Brown. Open Championship St Andrews 1895, photogravure, 13.5 x 27.5in. Bob Gowland International Golf Auctions, Mickle Trafford. Jul 01. £1000.

1044

Arthur Wardle, (1864-1947) oil on canvas board, Portrait of a Jack Russell, signed with presentation 'To Winnie', 13.5 x 9in. Gorringes, Lewes. Jan 05. £1000.

1045

Herbert Horwitz, Classical Maidens, a pair, signed, 17 x 9in, gilt frames. A. Hartley, Ilkley. Apr 05. £1000.

1046

Attributed to Edward Williams, (1782-1855) Wooded river landscape with figures fishing and walking on a path, oil on panel, 14 x 12in. Clarke Gammon, Guildford. Jun 02. £1000.

1047

Mabel Gear, 20thC oil on canvas entitled 'Vanity of the Vanities', signed, 24.5 x 29.5in. Dee, Atkinson & Harrison, Driffield. Apr 01. £1000.

1048

Louis Icart, drypoint etching, two ladies seated on a bed with a pierrot puppet, signed in pencil, L'Estampe Moderne 1922, 14.5 x 19in. Gorringes, Lewes. Feb 01. £1000.

1049

James Kay. The Clyde, Glasgow, signed and indistinctly dated, pastels, 17 x 28cm. Dockree's, Manchester. Jun 01. £1000.

1050

Stanley Roy Badmin, (1906-1989), Ink and watercolour, 'Addington Church', signed and dated 1931, 20cm x 23cm. Gorringes, Bexhill. Mar 05. £1000.

1051

Sheila Tiffin, (1952-), Girl undressing before a mirror, oil on canvas, signed, dated 1989, 24 x 20in. Gorringes, Lewes. Mar 05. £1000.

1052

John Brett, Sussex Coastal Landscape, off Newhaven at sunset, oil on board, 120 x 180cm. Henry Adams, Chichester. Sep 02. £1000.

1053

R. Mainella, Venice (1858-1907), Life on the Legunes, label verso, watercolours, a pair, each 15.5 x 32cm. Hobbs Parker, Ashford. Nov 04. £1000.

Hammer Price £1000

1054

Sergei Marshenkov, oil on canvas, Reclining Nude, 45 x 65cm, signed, framed. Lots Road Auctions, Chelsea. Jun 04. £1000.

1055

Yuri Matushevski, Forest Pond, 1969, oil on board, 40 x 50cm, signed, framed. Lots Road Auctions, Chelsea. Jun 04. £1000.

1056

Anatoly Shapovalov, 'Ballet Class', oil on canvas, signed, 76 x 121.5cm, framed. Lots Road Auctions, Chelsea. Dec 04. £1000.

1057

W. Kay Blacklock, watercolour, signed, 8.25 x 11in. Louis Taylor, Stoke on Trent. Mar 03. £1000.

1058

Charles Rowbotham, On the Italian Coast, signed, dated 1891, pencil & watercolour, 24 x 19cm. Mellors & Kirk, Nottingham. Jun 03. £1000.

1059

Claude Flight, (1881-1955) Swinging Boats, signed by artist in pencil and edition no. 42/50, sepia ink on oriental tissue paper, framed, 8.5 x 11in. Peter Wilson, Nantwich. Nov 01. £1000.

1060

Oil portrait of a 'stunner' by William Faed. Richard Winterton, Burton on Trent, Staffs. Mar 02. £1000.

1061

Sidney Cooper, watercolour, seated horned cow and sheep grazing beside a puddle with a thundercloud overhead. Richard Winterton, Burton on Trent. Aug 02. £1000.

1062

English School, early 19thC, portrait of a lady, unsigned, 145 x 110cm, contemporary gilt fillet frame. (hole repair) Richard Winterton, Burton on Trent. Feb 04. £1000.

Section VI < £1,000 to £750

Buy a painting first, then an artist. As one auctioneer puts it, it is usually better to buy a good painting by a lesser artist than a poor painting by a well known artist. That is not to say that this painting is poor, rather that it lacks charisma.

For the first time prices have fallen to under £1,000, the range in auction jargon known as 'the high hundreds'. Even so, most of the buyers will have paid more than a £1,000 with added premium. Two hundred and eleven lots have been chosen to represent this price range and all categories of art are represented from the uncertain date of 'After Albrecht Durer' at **1178** to the many examples of modernism in these pages.

At least half of the lots are landscapes, seascapes or townscapes. Take the fine Bertram Priestman landscape at **1114**. This artist has reached £2,500 where the size was 28 x 36 inches. Here, this modest, less than 9 x 13 inch painting has fetched a comparatively high £900! Now look at the Vilhelm Karl Ferdinand Arneson (1865-1948), a much more prolific artist at **1106**. This painting has realised about half of what his paintings of this size might fetch. Never buy an artist. Buy a painting first, then an artist. As one auctioneer puts it, it is usually better to buy a good painting by a lesser artist than a poor painting by a well known artist, not that this painting is poor, rather that it lacks charisma. Remember the compelling Charles Edward Dixon riverscape *London Bridge*, which was discussed in the Section III Analysis? **(310)** See also **1216** where a small Thames scene only 7.5 x 9.5 inches fetched £800. It is likely that all such pictures will always be in demand and although the advice is always to buy what you like, this painting should also prove a sound investment. Staying on townscapes, there are a few Lowry's in this Section around the £800 mark, but of course, you don't get originals at this price. Even the Lowry drawn on the back of a Senior Service cigarette packet fetched £1,900! **(674).** See also **1158, 1183, 1185, 1199** and **1251**. There are enough Lowry's in these pages to assess prices. Check out the **Index**. There are also a number of other highly priced prints in this Section. See **1075, 1099, 1115, 1118, 1137,** and **1215**. Worth noting are the Whitstable advertising cards at **1099**, boosted no doubt by local interest, having sold at Canterbury Auction Galleries, only a few miles away for £940 hammer in August 2001. More noticeable still is the Elizabeth Frink (1930-1993) lithograph at **1137**, a virtually illegible scribble which recently raised £900 hammer at Gorringes, Lewes in April 2005. Let us dip into Hislop's *Art Sales Index 2005* for a check on the form of this artist. Her prints alone start at £2,200 and her works on paper reach to £13,000, whilst her 3-D work goes to £110,000 with a median of £28,000! Other examples of

Elizabeth Frink's work can be found on page 48 at **663** and later**.** Was the £2,000 paid for the pencil sketch *Three Running Figures*, a good investment?

There are very few early paintings, perhaps only **1067, 1157, 1178** and **1204**. Those interested in the modernist art of the twentieth century have much to study, and should chart its incredible rise in fortune through the *Introduction*, if they have not already done so. For the novice, this is essential, or the whole market context of the analyses is weakened. Check out Charles Sims at **1109** and £900. This artist has recently fetched as much as £6,800 hammer. See also **1112, 1113** and **1125**, the latter a desirable small picture of about 7 x 14 inches, called *French Gouache* which fetched £900. This French artist has recently fetched over £64,000 and works on paper have reached £9,000. Move on to **1188** and **1189**. Ziegler (1903-) is or was actually a British painter. Follow on to **1203**. Eugene Corneau (1894-1976) was a French painter of the same period, Charles Walter Simpson (1885-1971) **(1221)** was also a modest talent producing quite a number of good paintings such as *Ducks Resting*. In the same vein see Edward Wolfe, RA, (1897-1982) at **1250**. This modest painting on paper seems to have fetched well above his median. His oils are different having recently achieved up to £6,500. There are many twentieth century artists in this Section. Portraits of women, discussed in every previous Section, continues starting with Marilyn Monroe at **1063**. Browse the pages but note particularly **1119, 1133, 1142, 1151, 1153, 1212, 1242** and **1244**. The latter, David Woodlock (1842-1929) can go to £2,500 for works on paper - *A Path through the Woods* is well above his median. All of his works are round about this size.

Still life is present, but there is little to excite the imagination, except perhaps for *Two Mackerel on a Platter* at **1145**, which make a change from the usual herring! There are good equestrian studies, dogs and wild life including a Louis Wain cat at **1085**. There is a Wardle at **1064**, *Study of an English Pointer*. Remember the first Wardle which fetched £16,500 at **51**? Amongst the wild life at **1271** is a James Stinton (1870-1961) watercolour of pheasants, more usually seen on Worcester porcelain. Amongst the pen and inks and drawings etc, the Elizabeth Frink example apart, at **1256** is a Kate Greenaway (1846-1901) sketch which fetched £750. There are several more examples. Check the **Index**. This artist has fetched £7,000 recently for a pencil water-colour, this from Hislop's *Art Sales Index*.

1063

Gordon King, composite portraits of Marilyn Monroe, oil on canvas, signed, 71.2 x 91.5cm. Rosebery's, London. Mar 02. £980.

1064

Arthur Wardle, RI, RBC (1864-1949) A Study of an English Pointer signed lower right 'Arthur Wardle', pencil and chalk, 25 x 34cm. Cheffins, Cambridge. Feb 05. £980.

1065

Watercolour by J F Herring Jnr. Kivell & Sons, Bude. Dec 02. £960.

1066

Frank Rousse, (fl 1897-1914) The Fish Pier, Scarborough with boats in the foreground, signed, 10 x 13.5in. David Duggleby, Scarborough. Apr 01. £960.

1067

Mid 18thC English School. Three quarter length portrait of a seated lady, on canvas, 116 x 96cm, some later re-painting to centre of picture. Wintertons Ltd, Lichfield. May 02. £950.

1068

Henry J Kinnard, watercolour, On the Itchen, Hampshire, signed lower right, titled lower left, 18.5 x 27.5cm. Wintertons Ltd, Lichfield. May 03. £950.

1069

Alexander Rosell, (1859-1922) Time to depart, rustic interior with fisherman's farewell to wife and daughter, signed lower right, oil on canvas, 66 x 52cm. Wintertons Ltd, Lichfield. May 03. £950.

1070

Donald A Paton, (Edward Horace Thompson: 1866-1949) a pair, 'Looking towards the Pass of Killiecrankie' and 'In the Trossachs, looking toward Ben Venue', watercolours, signed. W & H Peacock, Bedford. Jul 03. £950.

1071

H B Willis 75, a plough team at rest, signed, dated, framed and glazed, 15.5 x 25.5in. Tring Market Auctions, Herts. May 02. £950.

Hammer Prices £980 - £950

1072

P J Freyburg, Essex land-scape, on canvas, signed, framed, 27.5 x 35.5in. Tring Market Auctions, Herts. Sep 02. £950.

1073

A Kingfisher, watercolour, bodycolour, framed, signed lower right, 12 x 9in. Sworders, Stansted Mountfitchet. Oct 01. £950.

1074

Charles Edmond Rene His, (1877-1960) Farmhouse by the Stream, signed, dated verso 27/11/59, oil on canvas, 31.5 x 44.5cm. Sworders, Stansted Mountfitchet. Apr 05. £950.

1075

After Raoul Dufy, Parisian street scene, lithograph printed in colours, signed within the plate, 76 x 52cm, and ten other colour litho-graphs after the same hand, unframed. Rosebery's, London. Mar 05. £950.

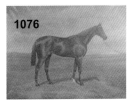

1076

C. H. Clark, 'Pretty Polly', oil on canvas, signed and inscribed, 18 x 24in. Sworders, Stansted Mountfitchet. Apr 01. £950.

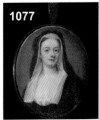

1077

Christian Friedrich Zincke, A Lady, in black dress, enamel, 4.8 x 4cm, gold frame. Mellors & Kirk, Nottingham. Apr 03. £950.

1078

19thC British School, oil on canvas, portrait of a gentle-man. Lots Road Auctions, Chelsea. May 03. £950.

1079

Anatoly Shapovalov, 'Late August', oil on canvas, signed, 75cm x 103cm, framed. Lots Road Auctions, Chelsea. Dec 04. £950.

1080

After Pether, Astrologer in his study, working by candle-light, oil on panel, 30 x 37cm. Henry Adams, Chichester. Jan 03. £950.

Hammer Prices £950 - £940

1081

William Francis Longstaff, (1879-1953) Australian, watercolour, The Royal Exchange, signed, 20 x 28.5in. Gorringes, Lewes. Mar 01. £950.

1082

Alan Fearnley, L.M.S. Black Five2 Locomotive No. 5552 Coming out of the Station, signed and dated 1978, 23.5 x 29.5in, stained and gilt frame. Andrew Hartley, Ilkley. Aug 04. £950.

1083

W St Clair Simmons, (Exh 1880-1917) watercolour, Washing Clothes in a Stream, signed, inscribed St Raphael, 11 x 8.25in. Gorringes, Lewes. Mar 04. £950.

1084

Mary Fedden, (1915-) watercolour, White flower and seeds, signed and dated 1982, 9 x 5in. Gorringes, Lewes. Dec 04. £950.

1085

Louis Wain, (1860-1939) Miss Fluffy, red chalk, c1915, 23 x 18cm. Cheffins, Cambridge. Dec 01. £950.

1086

19thC Italian School, set of 12 pen/chalk topographical views of Rome, mono-grammed BR, largest 12 x 18.5in, in a folio. Gorringes, Lewes. Apr 01. £950.

1087

Richard Westall, The White Lady and two other illustra-tions to Sir Walter Scott's 'Monastery', a set of three, pencil and watercolour, 4.75 x 3.75in, gilt frames. Andrew Hartley, Ilkley. Apr 01. £950

1088

Oval portrait miniature of Louis Philippe, by W. Essex (British, 1784-1869), after Dubufe, reverse inscribed 'Louis Philippe from the original picture painted at Claremont in 1849 by Dubufe', and 'Painted by W.Essex 1851. Enamel painter in Ordinary to Her Majesty & H.R.H. Prince Albert', gilt metal frame, miniature 4in high. Fellows, Birmingham. Jul 03. £950.

1089

Edward Wesson, (1910-1983) watercolour, View form St Aubins of St Helier, Jersey, signed, 13 x 19in. Gorringes, Lewes. Jan 04. £950.

1090

Tom Robertson (1850-1947) oil on board, 'On the beach - Valery sur Somme', signed, 10 x 12in. Gorringes, Lewes. Jul 04. £950.

1091

Attributed to John Hoppner, (1758-1810) oil on canvas, Portrait of a lady in a white dress, 30 x 25in. Gorringes, Lewes. Dec 02. £950.

1092

Carl Ferdinand Hurten, (1818-?) German, oil on canvas, still life of chrysan-themums, signed, 22 x 16in. Gorringes, Lewes. Apr 02. £950.

1093

Walter Goodin, (1907-1992), oil on board, Strand on the Green, signed, 23 x 29in. Dee, Atkinson & Harrison, Driffield. Aug 01. £950.

1094

Cecil Aldin, (1870-1935) pen and ink on ivorine, study of a Highland terrier, signed, 4 x 5in. Gorringes, Lewes. Sep 03. £950.

1095

Ronald Ossary Dunlop, oil, boats, 15 x 20in. Clevedon Salerooms, Bristol. Sep 01. £950.

1096

Attributed to J W Bottomley, 1816-1900, highland scene with 4 ghillies, pony and gun dogs sorting the day's shoot. 14 x 20in, signed, dated 1855. Canterbury Auc. Galleries, Kent. Apr 05. £950.

1097

Joseph Mellor, Figure on a Woodland Path, oil, signed, 17.25 x 13.25in, gilt frame. Andrew Hartley, Ilkley. Dec 03. £950.

1098

Rowland Emett, (1906-1990) pen & ink, 'Mumbling Magna Wings for Victory Week', 10.5 x 13in, signed. Gorringes, Lewes. Mar 03. £940.

1099

The larger (14 x 19in) of two cards advertising The Seasalter & Ham Oyster Fishery Company Limited. Canterbury Auc. Galleries, Kent. Aug 01. £940.

1100

Frederick William Booty, Haddon Hall, Derbyshire, signed and dated 1918, 20 x 33in, gilt frame. A. Hartley, Ilkley. Jun 01. £940.

1101

C... Heuser, (19/20thC) A Tyrolean smoking a pipe, signed top right, oil on panel 16.5 x 10.5cm Sworders, Stansted Mountfitchet. Feb 05. £920.

1102

English School, early 19thC, shoulder length portrait of Tom Lefroy, on ivory, 8 x 6cm, and tinted photograph of Sir Robert Peel. Rosebery's, London. Sep 02. £920.

1103

William Linton, Isle of San Guilio, Lake Orta, oil, named on reverse, framed, 17 x 41in. Tring Market Auctions, Herts. Nov 03. £900.

1104

Honor C Appleton, (1879-1951) one of three unframed watercolours, Child with fairies and two similar unfinished illustrations, signed, 8 x 6.5in. Gorringes, Lewes. Mar 03. £920.

1105

A Vickers, an Italian canal scene, signed, framed, 7.5 x 15in. Tring Market Auctions, Herts. Mar 03. £900.

1106

Wilhelm Karl Ferdinend Arnesen, (1865-1948) The Merchantman 'Swordfish' off Copenhagen, signed, dated 1938, oil on canvas, 47.5 x 73.5cm. Sworders, Stansted Mountfitchet. Sep 03. £900.

1107

D. M. Anderson, watercolour, The Grand Harbour, Malta, initialled, Modern Gallery label verso, dated 1909, 12 x 21in. Gorringes, Lewes. Jul 02. £900.

Hammer Prices £940 - £900

1108

Follower of Thomas Lawrence, Portrait of a naval officer, quarter length, oil on canvas, 75.2 x 82.3cm. Rosebery's, London. Mar 02. £900.

1109

Charles Sims, R.A., The Creation, tempera and oil on canvas, 76.2 x 50.5cm. Rosebery's, London. Sep 02. £900.

Provenance is an important market factor which can bare positively on results achieved at auction.

1110

Style of Fragonard, (19thC) oil on canvas, The Young Suitor. Gorringes, Bexhill On Sea. Sep 04. £900.

1111

De Simone, (19thC) Italian gouache, Steam Yacht Zoraide with Vesuvius beyond, signed, 16 x 23.5in. Gorringes, Lewes. Jan 04. £900.

1112

Bernard Meadows, four studies for sculpture, pencil watercolour heightened with white, each signed and dated '59, in shared mount, 26 x 21.2cm each. Rosebery's, London. Sep 02. £900.

1113

Kenneth Hall, Floral still life, brush, black ink and watercolour, signed, 50.7 x 35.7cm, unframed. Rosebery's, London. Sep 04. £900.

1114

Bertram Priestman RA, ROI, NEAC (1868-1951) An October Afternoon, Walberswick Church, Suffolk, signed lower left 'B Priestman '20'', oil on board, 24 x 34cm. Cheffins, Cambridge. Apr 05. £900.

1115

Louis Icart, drypoint etching, two ladies seated on a bed with a red fan and a monkey holding a mask, signed in pencil, L'Estampe Moderne 1922, oval, 14.5 x 19in. Gorringes, Lewes. Feb 01. £900.

Hammer Price £900

Circle of Joseph Teal Cooper, A Still Life of Pomegranates, Grapes and Roses, oil on canvas, laid onto canvas, 52 x 94cm. Sworders, Stansted Mountfitchet. Nov 04. £900.

Colin Graeme, portrait of retrievers, a pair, oils on board, both signed and dated 1902, 18.5 x 13.5cm, matching oak moulded frames. Rosebery's, London. Mar 05. £900.

Raphael Soyer, American 20thC, Lady looking in the mirror, etching, signed in pencil, 24.7 x 19.7cm, and 12 other etchings of figure subjects by the same hand, all signed in pencil, unframed. Rosebery's, London. Mar 05. £900.

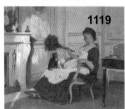

Joseph Caraud, A Well Earned Rest. Mellors & Kirk, Nottingham. Dec 02. £900.

Paul-Elie Gernez, (1888-1948) 'Deauville, La Plage', pencil and watercolour, signed, 29 x 45cm, framed. Lots Road Auctions, Chelsea. Dec 03. £900.

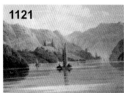

John Varley, Mountainous lakeland landscape, signed and dated 1810, watercolour, 24 x 33cm. Locke & England, Leamington Spa. Sep 03. £900.

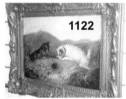

Oil on canvas of two terriers 'Rabbiting', signed H. A. Langlois. 24 x 34cm. John Taylors, Louth. Nov 03. £900.

Framed watercolour/gouache depicting the Austrian Tyrol, signed John Macwhirter, 41 x 61cm. John Taylors, Louth. Nov 04. £900.

William Pratt, (1855-1936) Figures holding banners gathered in a town square, oil on canvas, signed, dated 1892, 12 x 16in. Gorringes, Lewes. Apr 03. £900.

Leopold Survage, (1879-1968) French Gouache, Dancing figures, signed in pencil, with studio stamp, 7.25 x 14.75in. Gorringes, Lewes. Mar 03. £900.

James Stephen Gresley, Cattle watering on the Wharfe, near Barden Tower, watercolour, signed and dated 1901, 10.25 x 13.5in, gilt frame. Andrew Hartley, Ilkley. Dec 03. £900.

Henry Terry, Interior with seated gentleman threading a needle, watercolour, signed, 16.25 x 12.25in, stained frame. Andrew Hartley, Ilkley. Dec 04. £900.

Clement Lambert, (1854-1924), oil on canvas, Clearing Mist, signed, label verso, 30 x 50in. Gorringes, Lewes. Jun 01. £900.

Anthony Vandyke Copley Fielding, (1787-1855) watercolour, Coastal landscape with fisherman beneath cliffs, signed and dated 1806, 10 x 14.5in. Gorringes, Lewes. Mar 01. £900.

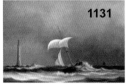

19thC English School, Ship portrait, three masted sailing ship in half sail in choppy sea, canvas 20 x 30in, unsigned in ebonised and gilt moulded frame, paint flaking from canvas around edge. Canterbury Auc. Galleries, Kent. Aug 02. £900.

> Most auction catalogues carry an explantation of the terminology used in descriptions. See Appendices.

Tim Thompson, (born 1951), A Dutch Packet off the Eddystone Lighthouse, Dutch boat in choppy sea with lighthouse and two ships, oil, canvas 24 x 36in, signed in full, gilt moulded frame. Canterbury Auc.Galleries, Kent. Apr 05. £900.

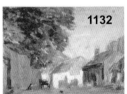

Philip Wilson Steer, (1860-1942) watercolour, Cottages, trees and a cart, Williamson Art Gallery 1951 and Bury Art Gallery 1954 exhibition labels verso, 7.75 x 10in. Gorringes, Bexhill. Mar 02. £900.

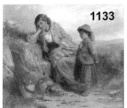

1133

R. Kemp, 19thC, oil on board, Mother and child beside a spring, signed, 14 x 16in. Gorringes, Lewes. Apr 04. £900.

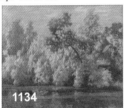

1134

Robert Noble, (1857-1917) oil on canvas, Riverside trees, church beyond, signed and dated '96, 20 x 24in. Gorringes, Lewes. Jun 03. £900.

1135

Robert Gallon, (1845-1925), oil on board, 'On the Llugwy', 18.5 x 29cm. Gorringes, Bexhill. Mar 05. £900.

1136

Neville Sotheby Pitcher, (Exh1907-39), oil on canvas, Frigate escorting cargo ships at sea, signed, 25 x 30in. Gorringes, Lewes. Mar 05. £900.

1137

Elizabeth Frink, (1930-93), lithograph, 'Horse and Rider IV', signed in pencil, 27/70, 22.5 x 30.25in. Gorringes, Lewes. Apr 05. £900.

1138

Gnyuki Torimaru, original design for a blue evening dress with draped back and batwing sleeves, for Princess Diana, pencil, pen & water-colour, signed, dated 1986 lower right, 31.5 x 25.5cm, unframed. Designed & made for the late Diana Princess of Wales. Dreweatt Neate, Donnington. Nov 02. £900.

1139

E W Cooke, pair of 18thC oil paintings on canvas, Barges and Ships by Shore with Figures, 11 x 15in, signed, re-lined and damage to one canvas. Denhams, Warnham, Sussex. Feb 05. £900.

1140

George Arthur Fripp, (1813-1896) On Hampstead Heath, signed and dated May 9th 1841, watercolour, 8.25 x 12.25in. Clarke Gammon, Guildford. Dec 04. £900.

1141

Herbert Royle, Harvesting in Merionethshire, signed, 11.5 x 15.75in, gilt frame. Andrew Hartley, Ilkley. Dec 04. £900.

1142

Fabbrini Adalgisa, Mme Vigee de Bruin, oval, signed on the stretcher and dated 1886, 24 x 20in, gilt frame. Andrew Hartley, Ilkley. Feb 01. £900.

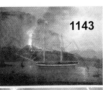

1143

Italian School, 19thC, a pair, Vesuvius erupting by night and by day, one signed indis-tinctly and dated 1822, gouache, 43.5 x 65cm & 40 x 53cm. (2) Sworders, Stansted Mountfitchet. Mar 04. £880.

1144

William Bromley, (19thC) A Boy practising the Flute, signed, oil on canvas, 36.5 x 31cm. Sworders, Stansted Mountfitchet. Feb 05. £880.

1145

English Provincial School, early 19thC, Two mackerel on a platter, oil on panel, in an oak moulded frame, 34 x 43.2cm. Rosebery's, London. Sep 02. £880.

1146

Manner of Sickert, Reclining nude in an interior, oil on panel, 31 x 23.5cm. Rosebery's, London. Mar 05. £880.

1147

Archibald Thorburn, water-colour, one of a pair of head studies of birds of prey, 5.5 x 4in. Louis Taylor, Stoke on Trent. Jun 03. £880.

1148

Yvonne Mottet, (1906-1968) Still life with pot of flowers, oil on canvas, signed lower right, 56 x 45cm. Dreweatt Neate, Donnington. Nov 02. £880.

1149

Carl Budtz Moller, (Danish, 1882-1953) Study of Naked Girls in a Woodland Glade signed lower right 'Budtz Moller 1909', oil on canvas, shaped top 76 x 119cm. Cheffins, Cambridge. Feb 05. £880.

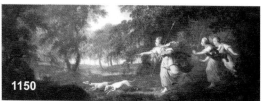

1150

French School, 19thC, oil on tin, Diana the huntress with dogs and companions chasing through a wood, 18.5 x 51.5cm, framed. Bristol Auction Rooms, Bristol. Mar 03. £880.

1151

J A Mclillan Arnott, Portrait of a young woman on a garden path, oil, signed, 43 x 23.75in, gilt frame. Andrew Hartley, Ilkley. Dec 04. £880.

1152

Campbell Melon, a riverscape depicting figures and cows by a farm dwelling, oil on canvas, signed, 12 x 16in. Amersham Auction Rooms, Bucks. Apr 01. £870.

1153

W. Hounsom Byles, (1872-?), New Zealand, oil on board, Depicting an elegant young lady wearing a flowing dress, carrying a parasol, signed, 14 x 10in, framed & glazed. Diamond Mills & Co, Felixstowe. Dec 04. £860.

1154

Alfred Wheeler, oil on board, 9 x 11in. Sworders, Stansted Mountfitchet. Sep 01. £860.

1155

After Jacopo Bassano, Adoration of the Shepherds, on stone, arched top, 70 x 47cm. Sworders, Stansted Mountfitchet. Nov 04. £860.

1156

Noel H. Leaver, watercolour, Continental scene, 14.25 x 10.25in. Louis Taylor, Stoke on Trent. Dec 04. £860.

1157

18thC English School, oil on canvas fragment, portrait of a child, 23.5 x 17.5in. Gorringes, Lewes. Apr 01. £860.

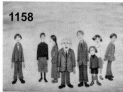

1158

Laurence Stephen Lowry, (1887-1976) Artist's proof coloured print, His Family, 20.5 x 28in, published by The Medici Society, signed in pencil to lower right margin, painted frame. Canterbury Auc. Galleries, Kent. Aug 02. £860.

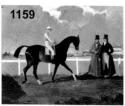

1159

Oil on board by Doris Zinkeisen, 1898-1991, entitled 'Before the Race', 48.2 x 58.9cm. Bristol Auction Rooms. Bristol. Oct 01. £860.

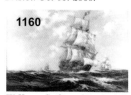

1160

W Knox, Sailing ships in full sail on a choppy ocean, on canvas, signed lower left, 20 x 29.5in. Wintertons Ltd, Lichfield. Mar 01. £850.

1161

Andrew McCallum, Burnham Beeches, named on reverse, framed, 36 x 53in. Tring Market Auctions, Herts. Jan 03. £850.

1162

William Sextie, pair, Portrait of a bay hunter in a stable setting, one signed & dated 1887, framed, 9.5 x 11.5in. Tring Market Auctions, Herts. Apr 05. £850.

1163

Frederick John Widgery, watercolour and gouache, Fernworthy Bridge, Dartmoor, signed, 28 x 46cm. Cleveland Saleroom, Bristol. June 05. £850.

1164

Jose Weiss, (1859-1919) A Wooded Landscape with a fence, signed, oil on canvas, 41 x 61cm. Sworders, Stansted Mountfitchet. Feb 05. £850.

1165

Jules Pascin, Portrait of a woman seated in a chair, bears stamp 'Atelier Pascin', and stamped 'Sucession Pascin le Commissaire Priseur...' verso, black crayon and watercolour, 17.5 x 33.5cm. Rosebery's, London. Sep 04. £850.

1166

Yuri Matushevski, Orange Sunset, 1964, oil on board, 28.5 x 39.5cm, signed, framed. Lots Road Auctions, Chelsea. Jun 04. £850.

1167

Early 19thC English School, oil on canvas, White terrier in a landscape, 10 x 11.75in. Gorringes, Lewes. Oct 04. £850.

1168

Louis Wain, (1860-1939) Taffy portrait of a Lakeland Terrier, 1923, watercolour, signed, 28 x 22cm. Cheffins, Cambridge. Dec 01. £850.

1169

Colin Bent Phillip, (1855-1932) watercolour, Alpine landscape, signed and dated 1905, 24 x 36in. Gorringes, Lewes. Mar 02. £850.

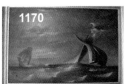

1170

19thC English School, oil on canvas, Shipping off Cuckmere Haven, 24 x 36in. Gorringes, Lewes. Dec 04. £850.

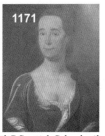

1171

18thC Scottish School, oil on canvas, Portrait of Margaret Menzies, and companion portrait of John Loch of Drylaw. Gorringes, Bexhill On Sea. Sep 04. £850.

1172

Charles Rowbotham (1856-1921) watercolour, Near Amalfi, signed, 8 x 19 ins. Gorringes, Lewes. Mar 04. £850.

1173

18th/19thC Dutch School, Still life, flowers in a vase on a ledge, oil on canvas, 27.5 x 22.5in, unframed, and an etching, and 5 Baxter prints. (7) Clarke Gammon Wellers, Guildford. Feb 05. £850.

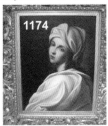

1174

19thC Italian School, oil on canvas, portrait of a young girl. Gorringes, Bexhill On Sea. Sep 04. £850.

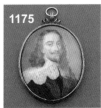

1175

19thC English School, oval miniature on copper, Charles I. Gorringes, Bexhill On Sea. Dec 04. £850.

1176

Charles Walther Simpson, (1885-1971) watercolour, Cattle in a farmyard, signed and dated 1918, 19 x 23.5in. Gorringes, Lewes. Jul 04. £850.

1177

Thomas Rowlandson, (1756-1827) pen, ink and watercolour, The Judgement of Paris, 4.25 x 5.75in. Gorringes, Lewes. Apr 03. £850.

1178

After Albrecht Durer, (1471-1528), Sophionista with cup of poison, oil on canvas, 30 x 25in. Gorringes, Lewes. Apr 02. £850.

Ensure you never hang your watercolours etc in direct or reflected sunlight. Fading seriously affects value.

1179

Frederick John Widgery, watercolour and gouache, Fernworthy Bridge, Dartmoor, signed, 28 x 46cm. Clevedon Saleroom, Bristol. Jun 05. £850.

1180

Marion Roger Hamilton Harvey, (Scottish, 1886-1971) A Cairn Terrier, signed lower left 'Marion Harvey', pastel, 42 x 36cm. Cheffins, Cambridge. Feb 05. £850.

1181

George Shalders, highland scene, oil on canvas, signed, 24 x 24in, moulded gilt frame. Amersham Auction Rooms, Bucks. Mar 04. £850.

1182

19thC French School, pair of reverse paintings on glass heightened in mother of pearl, Views of '?ouvel Opera, Paris', and 'Statue Henri IV sur Pont Neuf, Paris', gilt moulded frames, 14 x 17.5in. (frames overpainted) Canterbury Auction Galleries. Mar 05. £840.

1183

L S Lowry, Landscape with Farm Buildings, reproduction in colours, signed in pencil with guild stamp, limited edition, 17 x 20.5in, gilt frame. Andrew Hartley, Ilkley. Dec 03. £840.

1184

Thomas Smythe, Ipswich School, (1825-1906), watercolour, depicting figures and dogs with a team of cows pulling a Ransomes Sims & Head of Ipswich Plough, and a horse and cart loaded with hay, unsigned, 19.75 x 30in, framed and glazed. Diamond Mills & Co, Felixstowe. Dec 04. £825.

1185

L. S. Lowry, print, Market scene in a northern town, reproduction in colours, signed in pencil, limited edition, 19 x 24.75in, gilt frame. Andrew Hartley, Ilkley. Dec 03. £825.

1186

William Langley, A Scottish landscape with sheep and drover on hillside, mountains in background, on canvas, signed, framed, 19.5 x 29.5in. Tring Market Auctions, Herts. Sep 02. £820.

1187

Charles Johnson Payne, called 'Snaffles' 'The Bonnie Blue Bonnets frae ower the Border', limited edition reproduction, printed in colours and finished by hand, 44.5 x 43cm & another 'The D.R.', 48 x 42cm. (2) Sworders, Stansted Mountfitchet. Nov 04. £820.

1188

St. Ives School c1960, 'Buenevista'; oil on canvas, inscribed with title and dated March '63 on stretcher, 107 x 81.2cm. Rosebery's, London. Sep 04. £820.

1189

Archibal Ziegler, Still life of fruit in a bowl on a patterned table cloth, oil on canvas, signed, 50.5 x 61cm. Rosebery's, London. Mar 05. £820.

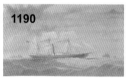

1190

J Hoskins, 19thC, oil on canvas, steam ship, 20 x 36in. Clevedon Salerooms, Bristol. Nov 01. £820.

1191

George Horlor, 19thC, oil on canvas, rural landscape with church, hamlet and figures in foreground, signed, 65 x 106cm. Clevedon Saleroom, Bristol. Jun 05. £820.

1192

Charles Frederic Tunnicliffe, 1901-1979, watercolour sketch, mute swan in flight, 8.75 x 10.75in, signed, inscribed March 21st Bont (?) Pool Mute Swan. Canterbury Auc. Galleries, Kent. Feb 04. £820.

1193

A Goodwin, 1845-1932, 'Freybourg', view of town and valley at sunset, signed and inscribed, 6.75 x 9.75in, framed. Canterbury Auction Galleries. Apr 05. £820.

1194

Owen Bowen, Dutch Rural Scene with sheep in the foreground, signed, 17.25 x 23.25in, gilt frame. Andrew Hartley, Ilkley. Feb 05. £820.

1195

William Luker, August 29th 1877, near Tyndruin, signed and dated, framed, 14 x 26in, tear to canvas. Tring Market Auctions, Herts. Sep 02. £800.

1196

F H Henshaw, Cattle watering in a wooded landscape setting, on canvas, re-lined, signed, framed, 11.5 x 13.5in. Tring Market Auctions, Herts. Sep 02. £800.

1197

Thomas Shotter Boys, (1803-74) watercolour, Castle with shipping, Fine Art Society label, 3.75 x 4.75in. Gorringes, Lewes. Dec 04. £800.

1198

John Porter, oil on canvas, full length portrait of three ladies, signed and dated 1846, 30 x 25in. Gorringes, Lewes. Jun 01. £800.

1199

Laurence Stephen Lowry, 1887-1976, colour print, Street scene, signed in pencil, 21 x 17in. Gorringes, Lewes. Oct 01. £800.

1200

John Skeaping 70, a pastel and charcoal sketch of a mare and foal, signed, framed & glazed, 37x 13in. Tring Market Auctions, Herts. Apr 05. £800.

1201

Mementomori miniature of a Victorian gentleman, oval plain brass frame with a blue enamelled back centred with plaited hair, 6 x 5cm. Thos. Mawer & Son, Lincoln. Mar 04. £800.

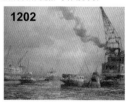

1202

Marinus Johannes de Jongere, Busy harbour scene with shipping, oil on canvas, signed, 49.5 x 75cm, and a coloured lithograph of a harbour scene by the same hand, signed within the plate, 44.5 x 65.5cm. Rosebery's, London. Mar 05. £800.

1203

Eugene Corneau, Figures reading on a Terrace, signed, oil on canvas, 90 x 49cm. Sworders, Stansted Mountfitchet. Mar 04. £800.

1204

Italian School 17/18thC, Portrait study of a bearded man, red chalk on laid, 26.5 x 19.7cm, and with one other profile study of a male head in red chalk by a different hand, 4.2 x 3.5cm, unframed. Rosebery's, London. Dec 04. £800.

Frames and mounts should enhance your picture. Empathy, rather than fashion should dictate your choice.

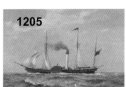

1205

Arthur J W Burgess, Tagus, a paddle steamer with following wind, signed, oil on panel, 42 x 58cm. Henry Adams, Chichester. Sep 02. £800.

1206

An oil of The Barley Harvest, initialled by Ferd E Grone, 41 x 59cm. Stride & Son, Chichester. Jun 02. £800.

1207

Yoshio Aoyama, self portrait of the artist, oil on canvas. Rosebery's, London. Sep 01. £800.

1208

William Heaton Cooper, Highland loch scene, water-colour, signed, 39.7 x 54.5cm. Rosebery's, London. Mar 05. £800.

1209

Harold Gresley, Monsal Dale, Derbyshire, signed, pencil and watercolour heightened with white, 27.5 x 36.5cm. Mellors & Kirk, Nottingham. Apr 03. £800.

1210

Patrick Downie, oil on board, coastal scene, 17.5 x 23.5in. Louis Taylor, Stoke on Trent. Jun 03. £800.

1211

Sir David Muirhead Bone, (1876-1953) A View of Pamplona, signed, charcoal, 28 x 36cm. Sworders, Stansted Mountfitchet. Feb 05. £800.

1212

Yuri Lusenko, 'The Stranger', oil on canvas, signed, 57 x 42cm, framed. Lots Road Auctions, Chelsea. Dec 04. £800.

1213

James McBey, A Grey Day, Venice, signed, dated 1925, brown toned watercolour on paper, (foxing) 25 x 26.5cm, mounted, glazed and framed. Locke & England, Leamington Spa. Jan 03. £800.

1214

Florence Engelbach, Anemones in a blue vase, oil on canvas, signed, 17 x 11.5in. Halls Fine Art Auctions, Shrewsbury. Jun 04. £800.

1215

Snaffles, (Charles J. Payne 1884-1967) 'Jim Whatever Ye de Keep t'owd Tamboureen a rawlin', and 'John Jorrocks Esq., MFH, Tell Me a Man's a Foxhunter and I Loves Him At Once', prints in colour, a pair, each 38 x 40.5cm. Hobbs Parker, Ashford. Nov 04. £800.

1216

Charles E Dixon (1872-1934) Thames scene, near Tower Bridge, with barges and other vessels, water-colour, faintly signed, 19 x 24cm. Hobbs Parker, Ashford. Jan 05. £800.

1217

Paul Maze, Harbour Scene, signed, pastel, 25 x 35cm. Henry Adams, Chichester. Sep 02. £800.

1218

19thC English School, Stour Valley, oil on canvas, 38.5 x 69cm, original deep foliate moulded gilt frame. Locke & England, Leamington Spa. Jan 03. £800.

1219

Edward Alfred Goodall, (1819-1908) watercolour, The Rialto, Venice, signed, 7 x 10.5in. Gorringes, Lewes. Feb 01. £800.

1220

A. A. Caldewn, oil on canvas, Portrait of a Scottish boy, signed and dated 1908, 24 x 20in. Gorringes, Lewes. Dec 03. £800.

1221

Charles Walter Simpson, (1885-1971) watercolour, Ducks resting, signed, dated (19)15, 20 x 24in. Gorringes, Lewes. Apr 01. £800.

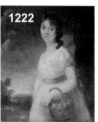

1222

Follower of Henry Raeburn, Portrait of a young girl standing beneath a tree in a landscape setting, holding a basket of apples, oil on canvas, giltwood frame, 29.5 x 24in. Gorringes, Lewes. Apr 01. £800.

1223

Attributed to Andrew Wilson, Sleaford Church, Lincoln-shire, watercolour, unsigned on board, mid 19thC, 8.5 x 6.75in. gilt frame. Andrew Hartley, Ilkley. Apr 04. £800.

1224

Arthur Higgins Rigg, Figures before Cottage at Tems Beck, Giggleswick, 29 x 19.5in, gilt frame. Andrew Hartley, Ilkley. Dec 04. £800.

1225

J R Richardson, Figures before a Croft, signed, 14.5 x 21.25in, gilt frame Andrew Hartley, Ilkley. Feb 05. £800.

1226

William Frederick Hulk, (1852-1906) a pair, oils on canvas, Cattle Watering and Returning Home, signed, 12 x 9in. Gorringes, Lewes. Jan 04. £800.

1227

Frank Wootton, (1911-1998) oil on canvas, Alfriston Church and River Cuckmere, signed, label verso, 23.5 x 29.5in. Gorringes, Bexhill. May 04. £800.

1228

Gnyuki Torimaru, original design for a black and white evening dress, for Princess Diana, to be worn with a black clutch bag, pencil and watercolour, signed, dated 1986 lower right, 31.5 x 25.5cm, unframed. Dreweatt Neate, Donnington. Nov 02. £800.

1229

Ludwig Knaus, oil on canvas, portrait of a young boy. Gorringes, Bexhill On Sea. Sep 04. £800.

1230

Attributed to Lucien Pissaro, (1863-1944) charcoal and watercolour, 'In Kew Garden', monogrammed, 10 x 8in, unframed. Gorringes, Lewes. Mar 04. £800.

> Ensure your watercolours etc are mounted on acid free boards. Have old pictures checked out by a framer.

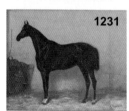

1231

Louis Charles Bombled, (1862-1927) French, pair of oils on wooden panels, Portraits of horses; 'Avenay' and 'Sultan', signed, 6 x 8.5in. Gorringes, Lewes. Mar 04. £800.

1232

Van der Veen, oil on canvas, Moonlit Napoleonic harbour, 14 x 17in, gilt gesso frame. Gorringes, Lewes. Dec 02. £800.

1233

Mason Hunter, (1854-1921) oil on board, 'Tarbert Bay, Loch Fyne', signed, 14 x 16in. Gorringes, Lewes. Apr 03. £800.

1234

Attributed to Martin de Vos (1532-1603) Flemish, oil on oak panel, Portrait of a lady, dated 1584, 10.5 x 9in. Gorringes, Lewes. Mar 03. £800.

1235

Late 18thC English School, watercolour on ivory miniature, Portrait of a lady, wearing a white dress and hair band, 2.75 x 2.25in, gold locket frame. Gorringes, Lewes. Jun 03. £800.

1236

David Woodlock, (1842-1929) Porta della Carta, Entrance to the Ducal Palace, Venice, signed lower right 'D Woodlock', water-colour, 22 x 14cm. Cheffins, Cambridge. Feb 05. £800.

1237

Samuel Atkins, (fl.1787-1808) Delft Haven, signed lower left, 'Atkins', water-colour, 36 x 48cm. Cheffins, Cambridge. Feb 05. £800.

1238

Michael Rothenstein, (1908-1993) Landscape with Figure in Red, signed lower right, 'Rothenstein '60', oil on canvas, 60 x 73cm. Cheffins, Cambridge. Feb 05. £800.

1239

Anthony Devas, (1911-1958), March Sunshine, landscape with trees, oil, canvas 14in square, signed Devas in black, gilt moulded & swept frame. Canterbury Auction Galleries, Kent. Apr 05. £800.

1240

M. MacGonigal, signed oil on canvas, study of a rocky Irish coastal scene with gulls and a distant sail boat, 14.5 x 21in. Biddle & Webb, Birmingham. Dec 03. £800.

1241

Mid 19thC English School, study of a horse in coaching harness, oil on canvas, 14 x 17.5in. Amersham Auction Rooms, Bucks. Apr 01. £800.

1242

W Affleck, 1869-1909, A Flower of the Garden, 14.75 x 10.25in, signed, contemporary gilt frame, glazed, frame damaged. Canterbury Auc. Galleries, Kent. Apr 05. £800.

1243

Charles H Poingdestre, 27.1.63, Cervara, signed and dated, framed. Tring Market Auctions, Herts. Jan 03. £780.

1244

David Woodlock, water-colour, 'a path through the wood', signed, 11.75 x 8in. Louis Taylor, Stoke on Trent. Mar 03. £780.

1245

Josef Kriehuber, (1800-1876) oil on board, Portrait of Arthur Russell (1825-1892), label verso, 9.25 x 6.5in. Gorringes, Bexhill. Sep 03. £780.

1246

R. Dearn, 'Gathering the Hay', oil on canvas, 11.5 x 17.5in, signed. Louis Taylor, Stoke. Mar 05. £780.

1247

Trevor Chamberlain, A Sea of Mud at Maldon, water-colour, 53 x 70cm. Hobbs Parker, Ashford, Kent. Sep 04. £780.

1248

Sheldon Williams, (English, fl.1867-1881) 'The Young Entry', and 'Moving Off', one signed lower left 'Sheldon Williams 1876' and one signed 'Sheldon Williams 1877', watercolours, 29 x 44cm, a pair. Cheffins, Cambridge. Feb 05. £780.

1249

Irish School, (early 19thC) Sheep with a Shepherdess at a Well, oil on canvas, 47 x 60cm. Cheffins, Cambridge. Feb 05. £780.

1250

Edward Wolfe, RA (1897-1982) water and bodycolour over pencil, Coastal vegetation with town across the bay, signed, 48.5 x 64cm. Bristol Auction Rooms, Bristol. Jun 02. £780.

1251

L S Lowry, Man on the Wall, reproduction in colours, limited edition signed in pencil, 16.75 x 20.5in, aluminum frame. Andrew Hartley, Ilkley. Apr 04. £775.

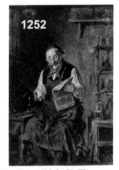

1252

F... Kern (19th C) The Shoemaker, signed, oil on canvas 47 x 31.5cm. Sworders, Stansted Mountfitchet. Feb 05. £760.

1253

Elizabeth Whitehead, Okens Corner, Warwick, water-colour on paper, signed, 31 x 20cm, glazed and gilt frame. Locke & England, Leaming-ton Spa. Sep 03. £760.

1254

Henry Cooper, (19th/20thC British) a pair of river landscapes, canvases 20 x 30in, signed to front and inscribed on stretcher, gilt frames. Canterbury Auction Galleries. Aug 02. £760.

Hammer Price £750

Alexander Khrapachev, 'She has Fallen asleep', oil on canvas, signed, 80 x 60cm, framed. Lots Road Auctions, Chelsea. Dec 04. £750.

1256

Kate Greenaway, original pen and ink sketch, 10 x 15cm, signed K.G. 1898. Tring Market Auctions, Herts. May 02. £750.

1257

Leon Bakst, Manservant holding a candelabra, pencil & gouache, signed, dated '23, 44.3 x 28.2cm. Rosebery's, London. Sep 04. £750.

1258

Sergei Marshenkov, Beauty by the Pond, oil on canvas, 65 x 50cm, signed, framed. Lots Road Auctions, Chelsea. Jun 04. £750.

1259

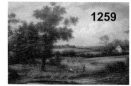

W Yates, British, 19thC, Figures by a pool with woodland and a cottage, oil on canvas, signed, 76 x 127cm. Rosebery's, London. Mar 05. £750.

1260

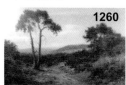

D. Sherrin, dusk rural landscape with 2 figures resting beside a path, on canvas, signed lower left, 48 x 75cm. Wintertons Ltd, Lichfield. Dec 01. £750.

1261

John Syer, Coastal scene with castle, watercolour, signed, dated (18)70, 31 x 49.5cm. Locke & England, Leamington Spa. Feb 03. £750.

1262

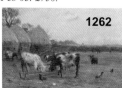

Ernest Higgins Rigg, Cattle and poultry in a landscape, signed, oil on canvas, 33 x 48cm. Henry Adams, Chichester. Jul 02. £750.

1263

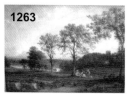

Circle of George William Mote, Girls gathering flowers on a river bank, oil on canvas, 22 x 30.5in. Halls Fine Art Auctions, Shrewsbury. Jun 04. £750.

1264

John Duncan Fergusson, RBA, 1874-1961, pastel 'Lily of the Valley', gallery label to the reverse, 9.5 x 7.5in. Great Western Auctions, Glasgow. Apr 05. £750.

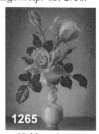

1265

James Noble, oil on canvas, Golden Rose in a Chinese vase. Gorringes, Bexhill On Sea. Dec 04. £750.

1266

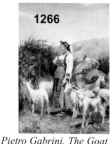

Pietro Gabrini, The Goat Herder, watercolour, signed, inscribed verso, 28.5 x 21.25in, gilt frame. Andrew Hartley, Ilkley. Dec 04. £750.

1267

F. Mabel Hollams, (1877-1963) oil on panel, Horse in a yard, signed and dated '48, 12.5 x 18.5in. Gorringes, Lewes. Jun 05. £750.

1268

L P Smythe, watercolour, Harvest scene. Gorringes, Bexhill On Sea. Sep 04. £750.

1269

Vernon Ward, (1905-1985) oil on canvas, Bruges fish market, signed, 14 x 18in. Gorringes, Lewes. Sep 04. £750.

1270

James Meegan, Liverpool Docks, Evening, signed and titled roundel, 19in dia, gilt frame. Dee Atkinson & Harrison, Driffield. Nov 04. £750.

1271

James Stinton, (1870-1961) watercolour, Pheasants in a woodland clearing, signed, 9.75 x 14.5in. Gorringes, Lewes. Apr 03. £750.

1272

Curtius Duassut, (fl.1889-1903) watercolour, 'Farm near Groombridge, Sussex', signed, 8.5 x 13in. Gorringes, Lewes. Apr 03. £750.

1273

Francis Bott, (1904-1998) German, gouache, 'Composition V', signed, Zwemmer Gallery label, 29 x 41in. Gorringes, Lewes. Jan 05. £750.

Section VII < £750 to £500

Moving to the Hulk junior at **1324** (1851-1922 British) this price is about right. We could get more excited if the work was by Hulk senior (1813-1897 Dutch) whose seascapes have recently fetched up to £25,000.

Previous Sections have followed many themes and the same applies here, an abundance of 'scapes', portraiture, particularly of women and children, more still life than previously, equestrian, dogs, genre, abstracts, pen and inks, nudity and a lot of prints! Yet, as the prices fall to an affordable level, what is changing? Yes, many of the great artists and works of art have been left behind, but many fine artists have not. Presumably then, here we have lesser works, or at least smaller works of art. Perhaps condition plays a part - not always apparent in photographs - nor in auctioneers descriptions!

Picture Prices at UK Auctions is unique. For the first time ever in the history of price guides, the reader is presented with a specialist study of a subject which marries the real market to real images and prices. This will continue to be a useful and an exceptional service, but it cannot provide the tens of thousands of results covering tens of thousands of artists provided by say, Hislop's *Art Sales Index*, which contains text only. The following analysis therefore will study some of the images and artists in this Section and demonstrate how, by consulting Hislop's, more may be gleaned from these pages. Hence this reference book becomes the illustrated auctions guide to the market for several thousand artists, and Hislop's is used to check their form.

Frederick Whitehead (1853-1938) landscapes appear on page 86 at **1275** and **1287**. These are 12 x 18 inches and 10 x 7 inches respectively, but the smaller, painted nine years later is much more desirable! What does Hislop's say? Well, it tells us that Whitehead has achieved up to £2,400 for an oil recently and £700 is about right for a watercolour, but I know which I would rather have and so does the market, which paid as much for the small watercolour as the larger oil!

The reader can study about ten Frederick John Widgery (1861-1942) in this work including the typical example at **1285**. Widgery can be very good, mediocre, and at times, awful! There must be about 60-80 recent results in Hislop's. This small painting seems to be one of his better efforts and probably good value. Now let us check out Harry Sutton Palmer (1854-1933) at **1291**. This watercolour is below his median (middle price) of £850 and two recent watercolours have reached £3,000, but this seems a fair price for an undistinguished painting.

Now examine the atmospheric winter landscape of Rowland Hilder at **1293**. (1905-1993). £700 plus premium seems a lot for such a small picture. However, let us check his form. Hilder's oils have recently gone to

£3,600 and works on paper to £6,500 hammer. His median is £850, so the market was right. Check the quality of this artist's work at **346** where a stunning still life fetched £3,800 hammer. See also **1707** on page 110. Did the market undervalue this fine painting?

Now go to Henry Earp Snr. (1831-1914) at **1302**. Earp's works on paper have a median of £660 so this prospect of Canterbury seems right at £700 hammer. However, Hislop's shows that, exceptionally, a pencil highlighted with watercolours (white) fetched an astonishing £9,000 at Mellors & Kirk, Nottingham in April 2004, size 19 x 29 inches. Frank Moss Bennett (1874-1953), on the other hand, whose *Blacksmith's Cottage* at **1304**, fetched £700 was a prolific and important artist who regularly attains in today's market, five figure sales, the recent best being £15,000 at Christie's in May 2004. We can stay on this page and move to seascapes at **1310**. Arthur Meadows (1843-1907), is another prolific painter with a median of £2,500 and recent sales up to £14,000. Of course, this is a small picture well worth the price!

Moving to the Hulk junior at **1324** (1851-1922 British) this price is about right. We could get more excited if the work was by Hulk senior (1813-1897 Dutch) whose seascapes have recently fetched up to £25,000. See p15. Go to the Trevor Chamberlain oil at **1343**, which I would have rated at least in the high hundreds. However, £660 is bang on the artists median and £820 is as good as he gets. This is the market operating, but it says nothing for the longer term investment potential of such a painting, except if you like it, buy it. This is not to say that this and other books say nothing about the market.

Take Mary Fedden. Her oil median is £5,200 and her watercolour median £2,400, according to *Hislop's 2005 Pocket Price Guide*. In Hislop's *Art Sales Index* there are at least 80 examples of oils between £280 and £20,500, and watercolours between £300 and £6,000. Here are examples from £9,000 to £480, a primary opportunity for the reader to study her style, as we provide pictures, and then to move onto a more detailed study from other sources. Take another example, L S Lowry. In this Section alone there are three examples at **1370**, **1434**, and **1446**, all, of course, prints in this price range, but there are earlier originals. *Art Sales Index* shows scores of recent results of originals but nothing on prints. In this Section is the last of C E Dixon: he doesn't come any cheaper. See also the prolific Wyllie, who in this Section alone has examples at **1305**, **1308**, **1309**, **1329**, **1361**, **1417** and **1486**.

1274

Elizabeth Frink, Eagle, limited edition lithograph, 93/150, signed in pencil with blind stamp, 25.25 x 18.5in, white frame. Andrew Hartley, Ilkley. Feb 05. £740.

1275

Frederick Whitehead, (1853-1938) Summer orchard, with haycart, chickens, farmhouse to left, oil on canvas, signed, dated 1895, leaf moulded gesso frame, 29.5 x 45cm. Locke & England, Leamington Spa. Mar 05. £740.

1276

Claire Eva Burton, Bula Hurdle, Cheltenham, Cruising Altitude leads Floyd and Nomadie Way, signed, 15.5 x 19.5in, gilt frame. Andrew Hartley, Ilkley. Feb 01. £725.

1277

William Hunter, signed oil on canvas, study of a terrier dog, 20 x 16in. Biddle & Webb, Birmingham. Jan 04. £725.

86 *Picture Prices*

1278

James Salt, (19thC British) Venetian Capriccio, oil on canvas, 27 x 19in, signed in red, modern painted frame. Canterbury Auc. Galleries, Kent. Aug 03. £720.

1279

Robert Morley, English garden scene, oil on panel, 22 x 30in, signed in full, modern gilt moulded frame. Canterbury Auc. Galleries, Kent. Dec 03. £720.

1280

Frederick William Newell, (1870-1958), Continental townscape (poss. Cahors), signed, indistinctly dated, on board, 15.5 x 11.5in, painted frame. Dee Atkinson & Harrison, Driffield. Nov 04. £720.

1281

Gnyuki Torimaru, original design for an ensemble with green, purple, white & black printed top, for Princess Diana, pencil, pen & watercolour, signed, dated 1986, 31.5 x 25.5cm, unframed. Dreweatt Neate, Donnington. Nov 02. £720.

1282

Margaret Morris, 1891-1980, conte drawing, Female Head, 7 x 5in. Great Western Auc. Glasgow. Apr 05. £720.

1283

Flemish School, (early 19thC) a pair, 'Female and child outside a country cottage', and 'Child being given a bunch of grapes outside a cottage', oils on panel, 35 x 42cm. (2) Hampton & Littlewood, Exeter. Jul 04. £720.

1284

Wycliffe Eggington, (1875-1951) 'Bishopsteignton', inscribed on reverse, signed, 53 x 73cm, watercolour, unframed. Hampton & Littlewood, Exeter. Jul 04. £720.

1285

Frederick John Widgery, 'The Moors, West Tavy Cleave, Dartmoor', gouache, signed, 29 x 24.2cm. Henry Adams, Chichester. Jul 02. £720.

1286

Watercolour of Windsor Castle by H C Fox. Kivell & Sons, Bude. Dec 02. £720.

1287

Frederick Whitehead (1853-1938) Study of Chesterton Mill, watercolour, signed, dated 1904, gilt frame, 25.5 x 19cm. Locke & England, Leamington Spa. Jan 05. £720.

1288

Decorative pair of songbirds by Michelangelo Meucci, (c1840-1905), dated 1875, Florence, original frames. Lots Road Auctions, Chelsea. Apr 03. £720.

1289

18thC Italian School, campana scene, cattle/shepherdess beside classical ruins, oil on re-lined canvas, unsigned, later gallery frame, 53 x 66cm. (re-touching/damage) Richard Winterton, Burton on Trent, Staffs. Feb 04. £720.

1290

W Verschuur, 1812-1874, watercolour drawing of a grey horse, contemporary cut out mount and frame, 19 x 27cm. Thos Mawer & Son, Lincoln. Feb 03. £720.

1291

Harry Sutton Palmer, A Bit of Amberley, Sussex, signed and dated '84, inscribed on artist's label on back board, watercolour, 34.5 x 24.5cm. Sworders, Stansted Mountfitchet. Mar 04. £720.

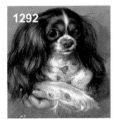

1292

Gourlay Steele, Head of a King Charles Spaniel, watercolour, signed, dated 1851, 7.5 x 7in, gilt frame. Andrew Hartley, Ilkley. Dec 04. £700.

1293

R Hilder, 1905-1993, 'Corfe Castle, Dorset', landscape with cottage and animals to foreground, 9.5 x 13.25in, signed, framed. Canterbury Auction Galleries, Kent. Apr 05. £700.

1294

James Noble, (1919-1989) oil on canvas, Mimosa, signed, 12 x 16in. Gorringes, Lewes. Dec 03. £700.

1295

J Aumonier, 1832-1911 The Chain Pier, Brighton, with fishing boats on beach to foreground, 12.25 x 18.5in, signed, dated 1896. Canterbury Auc. Galleries, Kent. Apr 05. £700.

1296

Alexander Moulton Foweraker, (1873-1942) watercolour, Moonlit street scene, signed, 8.5 x 11in. Gorringes, Lewes. Dec 04. £700.

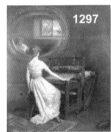

1297

Anne J Pertz, (Exh 1880-1911) The Lady of Shalott, oil on canvas, 80 x 64cm. Cheffins, Cambridge. Feb 04. £700.

1298

Otto Eerelman, (Dutch, 1839-1926) Exmoor Pony, watercolour, signed lower left 'O Eerelman', 68 x 52cm. Cheffins, Cambridge. Feb 05. £700.

Condiiton, rarity, provenance and fashion are the key market operators currently dictating values.

1299

Guy Bardone, (b.1927) View near Nice, signed and dated on the reverse '61, oil on canvas, 35.5 x 23in. Clarke Gammon Wellers, Guildford. Jun 05. £700.

1300

Kilby Webb Elwell, (1841-1916), American School, oil on canvas, sailing vessel hove-to at sunset, two figures on the beach, signed, dated 1878, 8.75 x 17.5in. Dee, Atkinson & Harrison, Driffield. Apr 01. £700.

Hammer Price £700

1301

Lucy Bentley Smith, (exh 1881-1914) portrait of a young lady, signed, watercolour, 16.5 x 12.75in. Gorringes, Lewes. Oct 01. £700.

1302

Henry Earp Snr, (1831-1914) watercolour, extensive prospect of Canterbury with a cart, horses, figures and cattle in meadows before, signed, 14 x 21in. Reverse with contemporary obituary on Earp. Gorringes, Bexhill. May 02. £700.

1303

Maurice Decamps, (1892-1953) French, oil on canvas, Reine marguerites et bleuetes, signed, 18 x 21in. Gorringes, Lewes. Apr 01. £700.

1304

Frank Moss Bennett, (1874-1953) Blacksmith's Cottage, Ashton, Devon, oil on board, signed, 14 x 10in. Gorringes, Lewes. Jun 03. £700.

1305

W L Wyllie, etching, HMS Victory. Gorringes, Bexhill On Sea. Sep 04. £700.

1306

Curtius Duassut, (fl.1889-1903) watercolour, Riverside Cottage, signed, 9.5 x 13.5in. Gorringes, Lewes. Apr 03. £700.

1307

Charles Taylor (Exh. 1841-1883), watercolour, Schooner at sea, 17 x 28in. Gorringes, Lewes. Apr 05. £700.

1308

William Lionel Wyllie, a View of the Thames, St Paul's in the distance, signed in pencil, 16 x 38cm. Henry Adams, Chichester. Sep 02. £700.

1309

William Lionel Wyllie, Sugar Boats off Greenwich, signed in pencil, etching, 12 x 33cm. Henry Adams, Chichester. Sep 02. £700.

1310

Arthur Meadows, Fishing Smacks and other Shipping off coast, pair, oil on canvas, signed, 23.5 x 39cm, one af to canvas. Hobbs Parker, Ashford, Kent. Jul 04. £700.

Hammer Prices £700 - £680

Bernard Dunstan, (1920-), oil on board, 'Pam Forsey', nude study, initialled, 11.5 x 9.5in. Gorringes, Lewes. Apr 05. £700.

One of six early 20thC Chinese School, depicting various fish, watercolour on rice paper, 15 x 25cm, framed. (6) Lots Road, Chelsea. Dec 03. £700.

Artashes Abraamyan, b.1921, 'Holiday', 1972, oil on canvas, signed, 54 x 75cm, framed. Lots Road Auctions, Chelsea. Dec 04. £700.

English 19thC silhouette portrait of a gentleman, verre eglomise, oval moulded frame, 9.3 x 8cm, and two 19thC silhouette portraits, matching frames. Rosebery's, London. Mar 05. £700.

Follower of Bernard Van Orley, The Madonna and Child, brown ink, watercolour and gold, ivory veneered & ripple carved frame, 9 x 6.8cm. Rosebery's, London. Mar 02. £700.

Early 19thC British School, portrait of a gentleman in a landscape, 29.5 x 24.5in. Wintertons Ltd, Lichfield. Feb 02. £700.

A Marcotte de Quivieres, Lady and parasol, oil on panel, signed, dated 1879, 21 x 16cm. Rosebery's, London. Sep 02. £700.

Alistair Proud, young male cheetah, signed, oil on board, 43 x 72.5cm. Rosebery's, London. Sep 03. £700.

Reuben Ward Binks, two Irish wolfhounds, signed, watercolour, 26 x 39cm. Sworders, Stansted Mountfitchet. Dec 03. £700.

Attributed to David Cox, Mountainous river landscape with horses at a ford, oil on canvas, bears signature, 40.5 x 63.5cm. Rosebery's, London. Sep 04. £700.

After Juan Miro, untitled abstract on black, lithograph in colours, signed within the plate, 31.5 x 24.5cm, and twenty other colour lithographs after same or related hand, unframed. Rosebery's, London. Mar 05. £700.

English portrait miniature of an officer, oval, 9.2 x 7.5cm, gilt metal oval mount with an ebonized pendant frame and one other 19thC miniature of an officer and a further printed example. Rosebery's, London. Mar 05. £700.

Prices quoted are hammer and exclude the buyer's premium. Adding 15% will give approx. buying price.

18thC School, Portrait of a gentleman, on panel, 10.25 x 7.25in. Wintertons Ltd, Lichfield. Jul 01. £700.

A Hulk Junior, Children on a country track with farmstead beyond, titled verso 'near Shalford, Surrey' and 'Autumn Morn, Albury, Surrey', on panel, signed lower right, unframed, 20 x 31cm. (2) Wintertons Ltd, Lichfield. Jul 03. £700.

Thomas Rose Miles, Breakers to Leaward, A Filey Brigg in Rough seas, oil, signed and inscribed verso, 23.25 x 41.75in, stained frame. Andrew Hartley, Ilkley. Apr 05. £680.

Kenneth Newton, (1933-1984) Still Life, flower tub containing a geranium, oil, canvas 25 x 29in, signed in full, Victorian gilt moulded frame, frame later over-painted. Canterbury Auction Galleries. Apr 05. £680.

Thomas Lindsay, NWS (1793-1861) Hastings Beach, Sussex, signed lower left 'T Lindsay, Hastings 1839', watercolour, 35 x 60cm. Cheffins, Cambridge. Feb 05. £680.

English School, 19thC, The Green Man, Trumpington, Cambridgeshire, oil on board 37 x 29cm. Cheffins, Cambridge. Feb 05. £680.

William Lionel Wyllie, (1851-1931) etching, View from Greenwich Royal Observatory, signed in pencil, unframed, 6.25 x 14.5in. Gorringes, Lewes. Mar 03. £680.

1330

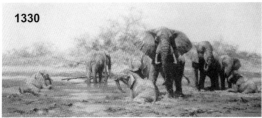

Elephant Heaven, signed in pencil, 661/850, published 1975, 19 x 38.5in, gilt frame. Andrew Hartley, Ilkley. Dec 03. £680.

1331

Hall after Frith, The Railway Station, and Ramsgate Sands, engraving, 62 x 119cm. Dreweatt Neate, Donnington. Nov 02. £680.

1332

A small oval portrait miniature of David Garrick, possibly by William B. Ford, after Gainsborough, reverse inscribed 'Garrick after Gainsborough', with initials and date 'WBF 1889', gilt metal frame, miniature height 1.75in. Fellows, Birmingham. Jul 03. £680.

1333

Alfred Wheeler, two dogs heads, signed, oil on board, 8 x 13in. Sworders, Stansted Mountfitchet. Jul 01. £680.

1334

Attributed to Walter Bayes, (1869-1956) oil on board, The Terrace, 9.25 x 9.25in. Gorringes, Lewes. Jul 03. £680.

1335

Samuel John Lamorna Birch, (1869-1955) 'Clapper Mill, Trewoofe', watercolour over pencil, signed, label 'LBH no. 1043- S. Lamorna Birch, Clapper Mill, Tre-woofe', 36 x 50cm. Hampton & Little-wood, Exeter. Jul 04. £680.

1336

Roland Wheelwright, Haywain, beside a thatched cottage, oil on canvas, 50 x 60cm. Henry Adams, Chichester. Jan 03. £680.

1337

Frank Gresley, (Exh 1881-1920) study of a rural church, watercolour, signed, dated 1925 lower right, framed, 27 x 37cm. Richard Winterton, Burton on Trent, Staffs. Jan 04. £680.

1338

Cesare Bacchi, Portrait of a girl holding a bouquet of flowers, oil on canvas, signed, dated 1907, 100 x 81cm. Rosebery's, London. Jun 04. £680.

Hammer Prices £680 - £650

1339

C E Dixon, 1872-1934, River scene, 8.25in x 14in, signed, dated '96, gilt frame, glazed. Canterbury Auc. Galleries, Kent. Apr 05. £660.

1340

English School, Portrait of a Young Woman, unsigned, 19.75 x 13.75in, stained frame. Andrew Hartley, Ilkley. Dec 04. £660.

1341

Ernesto Serro, oil on canvas, portrait of a girl wearing a white cloak, signed, 28 x 17.5in. Gorringes, Bexhill. Dec 02. £660.

1342

Miniature head and shoulder portrait of a naval officer. Gorringes, Bexhill On Sea. Dec 04. £660.

1343

Trevor Chamberlain, Mill near Hatfield, signed, oil on canvas 39 x 49cm. Sworders, Stansted Mountfitchet. Nov 04. £660.

1344

Jessica Hayllar, (1858-1940) Anemones, signed and dated 1911, oil on board 25 x 18cm. Sworders, Stansted Mountfitchet. Feb 05. £660.

1345

After Thomas Sidney Cooper, pastoral scene with sheep and lambs to the foreground, oil on canvas, 18 x 24in, gilt frame. Amersham Auction Rooms, Bucks. Apr 02. £650.

1346

David Shepherd, Tiger in the Sun, reproduction in colours, limited edition, 375/850, signed in pencil, 21.25 x 38in, gilt frame. Andrew Hartley, Ilkley. Feb 05. £650.

1347

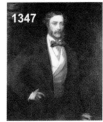

English School, Portrait of a Gentleman, 3/4 length, signed with monogram WD, dated 1859, 48 x 39in, ebonised frame. Andrew Hartley, Ilkley. Apr 05. £650.

1348

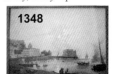

Neapolitan School, gouache, The Bay of Naples, 16 x 24.5in. Gorringes, Lewes. Dec 04. £650.

Hammer Price £650 - £640

Kenneth Lawson, (British, b.1920) Ruined Cottage in the Wood, The Gardens of Heligan inscribed on a label on the reverse, oil on board, 39 x 50cm, Cheffins, Cambridge. Feb 05. £650.

James Neal, Kiplingcoats in snow, signed on board, 11.5 x 15.5in, painted frame. Dee Atkinson & Harrison, Driffield. Nov 04. £650.

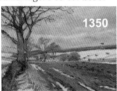

Edward Richardson, (1810-1874) watercolour, Town street scene, ancient tower and figures walking, signed, 8.75 x 12.75in. Gorringes, Bexhill. May 02. £650.

Mary Fedden, (1915-) watercolour, Hill Town, signed and dated 1988, 4.5 x 6.75in. Gorringes, Lewes. Dec 04. £650.

Sir David Wilkie, (1785-1841) watercolour, Old sailors and Market women, 6.5 x 8.25in. Gorringes, Lewes. Dec 04. £650.

18thC English School, oil on canvas, Portrait of Margaret Toke as a child. Gorringes, Bexhill. Sep 04. £650.

Sergei Menyayev, (b.1953), Marina, oil on canvas, signed, 50 x 70cm, framed. Lots Road Auctions, Chelsea. Dec 04. £650.

Henry Sylvester Stannard, (1870-1951) A Country Cottage beside a lane, signed, watercolour, 28 x 38cm. Sworders, Stansted Mountfitchet. Feb 05. £650.

Alfred Went, Hound in Full Cry, signed, oil on canvas, 36 x 54cm. Sworders, Stansted Mountfitchet. Apr 05. £650.

Peter Leslie, a pair, oil on canvas, a wheat field during harvest and a river scene, gilt frames, 29 x 39.5cm. Thos Mawer & Son, Lincoln. Sep 04. £650.

G. D'Esposito, gouache, Steam yacht off the coast, signed and dated 1899, 13 x 18.25in. Gorringes, Lewes. Jul 04. £650.

Dame Laura Knight, (1877-1970) lithograph, A Pantomime, signed in pencil, 13.75 x 9.75in. Gorringes, Lewes. Jul 04. £650.

William Lionel Wyllie, (1851-1931) etching, The City from Waterloo, signed in pencil, 6.5 x 14.75in. Gorringes, Lewes. Mar 04. £650.

Sidney Pike, (fl.1880-1901) a pair, oils on canvas, Coastal landscapes at low tide, signed, dated '01, 6 x 18in. Gorringes, Lewes. Mar 04. £650.

After John Downman, (1750-1824) set of 4 coloured chalk half length portraits, Lady Mary Paice, Lady Elizabeth Paice, Miss Susan Paice and Miss Susan Gordon Ovals, giltwood frames 4.5 x 3.25in. Gorringes, Lewes. Mar 03. £650.

The flower girl, oil on canvas, signed, 27 x 21in. Halls Fine Art Auctions, Shrewsbury. Dec 03. £650.

Vincent Clare, (1855-1925), Still life study of a bird's nest with clutch of eggs & spring flowers, oil on board, signed, gilt gesso frame, 18 x 23cm. Locke & England, Leamington Spa. Mar 05. £650.

Frank Richards, watercolour, Farmyard scene, panel signed, 36 x 28cm, gilt frame. Lambert & Foster, Tenterden. Jun 03. £640.

After John Piper, Halifax, signed in pencil with initials, numbered 47/70, coloured lithograph, 38 x 60cm. Locke & England, Leamington Spa. May 05. £640.

Arthur Reginald Smith, Girl crossing an old stone bridge with a village beyond, watercolour, signed, 18.7 x 37cm. Rosebery's, London. Dec 04. £640.

1369

Joseph Horlor, Mountainous landscape with a figure on a bridge and A Mountainous landscape with a figure by cottages, a pair, one signed, oil on canvas, 56 x 45cm. Sworders, Stansted Mountfitchet. Nov 04. £640.

1370

Laurence Stephen Lowry, RA (1887-1976) A Football Match, limited edition reproduction, signed in pencil, numbered 665/850, 25 x 36cm. Sworders, Stansted Mountfitchet. Feb 05. £640.

The numbering system acts as a reader reference as well as linking to the Analysis of each section.

1371

Early 18thC coloured aquatint, Marine Terrace, Margate, 14 x 21in, walnut/gilt frame. (mount covering margins) Canterbury Auc. Galleries, Kent. Aug 02. £620.

1372

Victorian School, oil on millboard, Portrait of a boy with a spinning top, indistinctly signed and dated 1841, 16 x 12in. Gorringes, Lewes. Jan 05. £620.

1373

Edward Lear, (1812-1888) pencil, a peasant seated by a tree with chapel and hills beyond, inscribed '1847, Rome', inscribed verso 'an invitation to Lady Duff Gordon and her d'ters from the P&P de Broglie'. 16.5 x 11.2cm. Bristol Auction Rooms. May 02. £620.

1374

J Varley, Carnaervon Castle, with figures & boats to foreground. 8.5 x 12.25in, apparently unsigned, modern gilt frame. Canterbury Auction Galleries, Kent. Apr 05. £620.

1375

Mary Gallagher, oil on canvas, 'Stillness at Dusk', signed recto, gallery label and receipt dated 1985 to the reverse, 24 x 24in. Great Western Auctions, Glasgow. Jun 05. £620.

1376

Henry Parsons Riviere, (1811-1888) A View of the Coliseum and the Arch of Constantine from the Palace of the Caesars, Rome, signed lower left 'H P Riviere', watercolour, 31 x 43cm. Cheffins, Cambridge. Feb 05. £620.

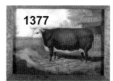

1377

E M Fox. Study of a shorthorn, on board, signed lower right and dated 1869, 10.25 x 14in. Wintertons Ltd, Lichfield. Jul 01. £620.

1378

Emil A Kraus, English, 19thC, Lynmouth Harbour, Devon, signed lower left 'E A Kraus', oil on canvas, 23 x 33cm. Cheffins, Cambridge. Feb 05. £620.

1379

Frederick William Elwell, (1870-1958) Spanish coastal scene, signed, dated 1911, oil on panel, 11.5 x 15.5in, gilt frame. Dee, Atkinson & Harrison, Driffield. Feb 05. £620.

1380

S Clark, 19thC oil painting on canvas, study of 'The Race Horse Blair Athol in Stable', 22 x 26in, signed 'S Clark', some paint loss. Denhams, Warnham, Sussex. Feb 05. £620.

1381

Jack Merriott, (1901-1968) pastel, Afternoon in Venice, signed, Pastel Society label verso, 18.5 x 21in. Gorringes, Lewes. Mar 03. £620.

1382

British School 19thC, The steam & sail yacht 'Venetia' running in stormy seas, gouache, signed and titled, 40.5 x 61cm. Rosebery's, London. Dec 04. £620.

1383

Attributed to Gerald Gardiner. Passenger steamship berthing by night at the pier in Gravesend, oil on board, signed with initials and dated 1956, 41 x 76.8cm. Rosebery's, London. Mar 02. £620.

1384

Betalan de Karlovsky, Lady with a mandolin, oil on canvas, signed and inscribed 'Paris', 33.2 x 41.2cm. Rosebery's, London. Sep 02. £620.

1385

Andrew Macara. 'St Palais Sur Mer,l S.W. France', oil on canvas, signed, inscribed with title on the reverse, 30.5 x 35.3cm. Rosebery's, London. Mar 04. £620.

1386

William Alfred Gibson, figure on a woodland path, oil on board, signed, 30 x 35cm. Rosebery's, London. Mar 05. £620.

Hammer Prices £620 - £600

1387

Keith Vaughan, *The Walled Garden*, 1951, lithograph in colours, signed, dedicated & dated June '66, pencil, 49.5 x 65.5cm, unframed. Rosebery's, London. Sep 04. £620.

1388

G Paice, *A portrait of 'Mac'* a Scottish Terrier, on canvas, signed, framed, 8.5 x 11in. Tring Market Auctions, Herts. Sep 02. £620.

1389

Tom Campbell, oil on panel still life, signed, 18 x 23in. Great Western Auctions, Glasgow. Jun 05. £605.

1390

Lawrence Biddle, a still life study of flowers in a vase, oil on board, signed, dated '44, 16 x 12in, white painted frame. Amersham Auction Rooms, Bucks. Aug 03. £600.

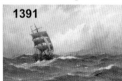

1391

J D Liddell, (English School, 19thC) *A Sailing Ship in a Stormy Sea and A Steam Tug towing a Sailing Ship*, both signed lower right 'J D Liddell', oil on board, 29 x 44cm. (2) Cheffins, Cambridge. Feb 05. £600.

1392

A H Vickers, *Windsor Castle and another*, a pair on panel, one signed, 7.25 x 15.25in, gilt frame. Andrew Hartley, Ilkley. Apr 03. £600.

1393

Mason Hunter, *Fishing Boats at Stonehaven*, oil, unsigned, inscribed verso, 29.5 x 19.5in, gilt frame. Andrew Hartley, Ilkley. Dec 03. £600.

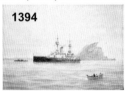

1394

E Tufnell, *HMS Majestic 1899, & HMS King George V*, signed pair, 10.25 x 14.25in, ebonised frames. Andrew Hartley, Ilkley. Feb 05. £600.

1395

William Mellor, *Derwent Water, Cumberland*, signed, inscribed verso, 7.75 x 11.5in, mounted, unframed. Andrew Hartley, Ilkley. Feb 05. £600.

1396

James Mudd, *Richmond Castle, Yorkshire*, oil, signed and dated 1892, 24 x 36in, gilt frame. Andrew Hartley, Ilkley. Apr 05. £600.

1397

Raoul Dufy, 1877-1953, artist's proof coloured print, 'Regatta', yachts, shipping and various flags, 20in x 18in, signed in pencil and no. 83/200, painted frame, glazed. Canterbury Auction Galleries, Kent. Apr 05. £600.

1398

Graham Sutherland, OM (1903-1980) *Predatory Form*, signed lower right in pencil, numbered lower left 1/50, lithograph, 56 x 76cm. Cheffins, Cambridge. Sep 03. £600.

1399

Wilfrid Gabriel de Glehn, RA, RP, NEAC (1870-1951) *Vallée du Var, Provence* signed lower right 'W de Glehn', watercolour, 33 x 52cm. Cheffins, Cambridge. Feb 05. £600.

1400

May Lyon?, 19thC oil painting on canvas, 'Sheep in Wooded Area with Track and Lady at Pond with Jug', signed, dated 1891? 24 x 18in, gilt frame. Denhams, Warnham. Oct 04. £600.

1401

Edward Louis Lawrenson, (b.1868) *Sussex Farm*, signed lower left 'E L Lawrenson', oil on board, 31 x 42cm. Cheffins, Cambridge. Feb 05. £600.

1402

Pierre Mortier, 'Bruslot a la Sonde', coloured engraving, 16.5 x 21.5in, and a similar engraving. Clarke Gammon Wellers, Guildford. Apr 05. £600.

1403

C Whitfield, 20thC, *Animals in a farm yard*, signed on board, 11.75 x 9.5in, stained frame. Dee Atkinson & Harrison, Driffield. Nov 04. £600.

1404

Continental School, oil on canvas, *Still life of an egg, spoon, pottery and fruit on a ledge*, indistinctly signed, 15 x 18in. Gorringes, Lewes. Jul 01. £600.

1405

Victorian School, oil on canvas, *figures on a riverside path*, 20 x 24in. Gorringes, Lewes. Feb 01. £600.

1406

John Caesar Smith, oil on canvas 'Spring in the Hope Valley', signed, Stacy-Marks label verso, 16 x 22in. Gorringes, Lewes. Jan 02. £600.

1407

George William Whitaker, (1841-1916) American, oil on board, Inn interior with figures playing draughts, signed, 12 x 17.5in. Gorringes, Lewes. Mar 01. £600.

1408

Des Gorman, oil on gesso 'Garden Roses', signed recto & signed and entitled verso, 17 x 15in. Great Western Auctions, Glasgow. Apr 05. £600.

1409

William Crosbie, RSA 'Reclining Nude', oil on panel, signed/dated 76 recto, gallery label, 5.625 x 13in. Great Western Auctions, Glasgow. Jun 05. £600.

1410

Norman Wilkinson, Trout Rising, signed, oil on canvas, 44 x 60cm. Henry Adams, Chichester. Jan 03. £600.

1411

Y Gianni, (19thC Neapolitan School) gouache, Coastal view of Naples with figure in foreground, signed, 12.5 x 19.5in. Gorringes, Lewes. Apr 01. £600.

1412

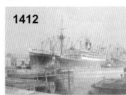

Colin Verity, watercolour, SS Athenic in harbour, signed, 16 x 24.5in. Gorringes, Lewes. Jun 03. £600.

1413

Leslie Worth, (1923-) watercolour, Angmering, signed, 14.25 x 22.5in. Gorringes, Lewes. Dec 04. £600.

The illustrations are in descending price order. The price range is indicated at the top of each page.

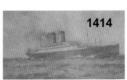

1414

W M Birchall, watercolour, Transylvania. Gorringes, Bexhil. Sep 04. £600.

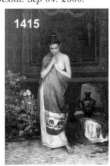

1415

Sergei Marshenkov, Grace, oil on canvas, 61 x 40cm, signed, framed. Lots Road, Chelsea. Jun 04. £600.

Hammer Price £600

1416

Keith Stuart Baynes. Landscape, Cote d'Or, oil on canvas, signed, dated '48, inscribed verso, 35.5 x 46cm. Rosebery's, London. Mar 02. £600.

1417

W L Wyllie, watercolour, Kiel Canal. Gorringes, Bexhill On Sea. Sep 04. £600.

1418

Manner of C T Bale, a pair of oils on panel, Still Life, fruit and songbird, and another still life. Gorringes, Bexhill. Dec 04. £600.

1419

Frank Paton, (1856-1909) watercolour, 'A Promising Litter', signed, 18 x 28.5in. Gorringes, Lewes. Jan 04. £600.

1420

Dame Laura Knight, (1877-1970) aquatint, Actress at a dressing table, signed in pencil, 11.75 x 9.75in. Gorringes, Lewes. Jul 04. £600.

1421

G F Waldo Johnson, (Exh. 1894-1896) oil on canvas, Portrait of a greyhound in a field, signed and dated 1893, 20 x 26in. Gorringes, Lewes. Mar 04. £600.

1422

Alfred Montague, (fl. 1832-1883) oil on canvas, View of Rotterdam, signed, 12 x 16in. Gorringes, Lewes. Mar 04. £600.

1423

Leslie Arthur Wilcox, (1904-1982) oil on canvas, Fishing boat leaving harbour, attributed on mount & dated 1960, 6.5 x 9in. Gorringes, Lewes. Mar 03. £600.

1424

Attributed to Willem Van der Velde, pen and ink, shipping off the shore, 6 x 8.75in. Gorringes, Lewes. Mar 03. £600.

1425

W. Fussli, (19thC), oil on canvas, Portrait of Mrs Eleanor Sickert (mother of Walter), 1870, 31 x 25in. Gorringes, Lewes. Oct 02. £600.

Picture Prices 93

1426

Patrick William Adam, (1854-1929), oil on canvas, 'Capri', signed, dated 1881, 11 x 16in. Gorringes, Lewes. Apr 02. £600.

1427

Tom Mostyn, (1864-1930) oil on canvas, The Lacemaker, 17.5 x 24in. Gorringes, Lewes. Jan 05. £600.

1428

William Russell Flint, Reflection in the Mirror, reproduction in colours, signed in pencil, Fine Art Trade Guild blind stamp, published by Frost & Reed, 1962, 27 x 46cm. Sworders, Stansted Mountfitchet. Mar 03. £600.

1429

Cecil Aldin, (1870-1935) watercolour on ivorine, study of a Sealyham terrier, signed, 5 x 7in. Gorringes, Bexhill. Mar 02. £600.

1430

English School c1900, oil on canvas, English royalty watching Indian dancers, 10 x 14in. Gorringes, Lewes. Jun 03. £600.

1431

H. Earp Senior, (1831-1914) Farm Road, Nr. Reigate, Surrey, inscribed verso, landscape with sheep and shepherd, watercolour, 44 x 66cm. Hobbs Parker, Ashford, Kent. Jul 04. £600.

1432

Francis Bott, (1904-1998) German, gouache, 'La Zone des Miracles', signed, dated 1958, Zwemmer Gallery label, 22 x 33in. Gorringes, Lewes. Mar 05. £600.

1433

Pair of early 20thC framed & glazed gouache scenes of Valetta Harbour, Malta, signed with monograms, each 5 x 2.5in. Kent Auction Galleries, Folkestone. May 05. £600.

1434

Laurence Stephen Lowry, (1887-1976), Children and fishing boats on a beach, signed in pencil, coloured photolithograph, 26 x 50cm. Locke & England, Leamington Spa. Sep 04. £600.

1435

Henry H Parker, (1858-1930) The Thames near Henley, signed, watercolour 36 x 54cm. Sworders, Stansted Mountfitchet. Feb 05. £600.

1436

Robert John Hammond, Farm Buildings, Slade Lane, near Gravelly Hill, oil on canvas, signed, dated 1880, foliate moulded gilt gesso frame, 29 x 44.5cm. Locke & England, Leamington Spa. May 05. £600.

1437

Geoffrey Watson, 'Fokkers & Sopwith Camels nr. Ypres', watercolour, signed, dated 1920, 46 x 58cm. Rosebery's, London. Sep 04. £600.

> Artists or themes can be followed through the colour coded Index which contains over 4500 cross references.

1438

Kate E Booth, At the shore, Scarbro, watercolour, signed and inscribed, 14 x 19.5in. Sworders, Stansted Mountfitchet. Apr 01. £600.

1439

Louis Icart, 'Blue Macaw', etching with colours, signed in pencil, numbered 125, published in 1920 by Estampe Moderne, Paris, oval 47 x 38cm. Sworders, Stansted Mountfitchet. Nov 04. £600.

1440

Garden William Fraser, (1856-1921) John Bunyan's Cottage, Elstow, watercolour, signed W F Garden, dated 1907, framed and glazed, 14 x 18cm. W & H Peacock, Bedford. Jun 03. £600.

1441

Donald A Paton, (Edward Horace Thompson, 1866-1949), 'Loch Maree and Ben Slioch', watercolour, signed, paper label verso. W & H Peacock, Bedford. Jul 03. £600.

1442

William Eadie, Tuning Up, on canvas, signed, dated 1898 lower left, 17 x 11.5in. Wintertons Ltd, Lichfield. Mar 01. £600.

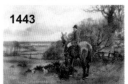

1443

Ivestor Lloyd, watercolour, Huntsman on horseback. Wintertons Ltd, Lichfield. Nov 03. £600.

1444

Henry H Parker, (English, 1858-1930) On the Thames below Great Marlow, signed lower right 'Henry H Parker', watercolour, 37 x 54cm. Cheffins, Cambridge. Feb 05. £580.

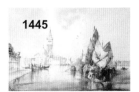

1445

Wilfred Knox, The Church of St Marco, Venice, signed, 11 x 17in, gilt frame. Andrew Hartley, Ilkley. Jun 05. £580.

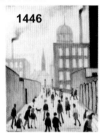

1446

Laurence Stephen Lowry, print, Mrs Swindell's picture in colour, signed in pencil in the margin (the original 1967), 41 x 29cm. Dockree's, Manchester. Jun 01. £580.

1447

Frank Moss Bennett, (1874-1953) oil on board, Cottage at Laycock, Wiltshire, signed and dated 1929, 9.5 x 13.5in. Gorringes, Lewes. Jul 01. £580.

1448

Hugo Kotschenreuter, (1854-1908) oil on canvas, Smokers at a tavern table, signed, 9 x 11.5in. Gorringes, Bexhill. Mar 02. £580.

1449

Pair of designs for a stained glass window, unsigned, ink and watercolour, 59 x 35cm. Lots Road Auctions, Chelsea. Apr 03. £580.

1450

John Byrne, 'The Bay', oil on panel, signed recto and signed & entitled verso, 15 x 15in. Great Western Auctions, Glasgow. Jun 05. £580.

1451

Mikhail Zharov, Sunflowers, oil on canvas, signed, 87 x 65cm, framed. Lots Road, Chelsea. Dec 04. £580.

1452

European School, 19thC, River landscape, fishermen and a mountainside town in the distance, oils on canvas, 40 x 54.2cm. (2) Rosebery's, London. Mar 05. £580.

1453

Archibald Ziegler, Trees by the Spring, oil on canvas, signed, inscribed on labels attached to the reverse, 66.7 x 76.5cm. Rosebery's, London. Mar 05. £580.

1454

Thomas Hilton Garside, A.R.C.A., Canadian, 20thC, The Cutting near Joliette, Que, oil on canvas, signed, 30.5 x 40.5cm. Rosebery's, London. Mar 05. £580.

1455

Aldo Severi, Portrait of a young girl, oil on canvas, signed, dated 1912, framed, 40 x 30in. Sworders, Stansted Mountfitchet. Apr 01. £580.

1456

Attributed to Joseph Thors, Figure and chickens by farm buildings, oil on canvas, 40 x 50cm. Sworders, Stansted Mountfitchet. Nov 04. £580.

1457

19thC scene of four ladies in a library amused by the content of a book, unsigned, framed, 9.5 x 7.5in. Tring Market Auctions, Herts. Jul 04. £580.

1458

Samuel John Lamorna Birch, (1869-1955) The Hillside Aughton Lane, signed, dated 1897, inscribed in pencil on reverse, watercolour, 11.5 x 10in. Clarke Gammon, Guildford. Jun 02. £575.

1459

I. Read, study of a grey hunter, beside a water trough, oil on canvas, signed, 20.5 x 26in, moulded gilt gesso frame. Amersham Auc. Rooms, Bucks. Feb 04. £570.

1460

19thC Italian School, mother and infant attended by a child holding a finch in one hand and a cross, water-colour on card, 11.75 x 15.3cm. Thos. Mawer & Son, Lincoln. Mar 04. £560.

1461

Graham McKean, oil on canvas 'When Night Falls', signed, 7 x 5in. Great Western Auctions, Glasgow. Apr 05. £560.

1462

James Stinton, (1870-1961), Cock & hen pheasant in a landscape, watercolour with body colour, signed, 15 x 24cm. Locke & England, Leamington Spa. Sep 04. £560.

1463

Christopher Richard Wynne Nevinson, ARA, 1889-1946, drypoint Waterloo Bridge from a Savoy window, signed in pencil, 10.75 x 13.75in. Great Western Auctions, Glasgow. Apr 05. £560.

Graham McKean, oil on canvas 'Late Night Shopper', signed, 8 x 6in. Great Western Auctions, Glasgow. Apr 05. £560.

Kenneth Newton, 1933-1984, Still life, pot of everlasting flowers and stoneware wine jar, cloth draped background, canvas 24 x 29in, signed in full, 19th C gilt moulded frame. Canterbury Auction Galleries, Kent. Apr 05. £560.

J. H. Smith, portrait of two children, oil on canvas, signed, dated 1854 verso, 24in dia, moulded gilt frame. Amersham Auction Rooms, Bucks. Mar 04. £550.

John Hassall, (1868-1948) ink and watercolour, French washerwoman, inscribed 'Trepied 1900', 21 x 11.5in. Gorringes, Lewes. Sep 03. £550.

English School, (19thC) Deerhound in a Highland Landscape, oil on board, 21 x 33cm. Cheffins, Cambridge. Sep 03. £550.

Mel Ramos, (American b.1935) and Pietro Psaier (Italian b. 1939), Chiquita, Naked girl in a banana, initialled, acrylic and silk screen on canvas, 65 x 50cm. Cheffins, Cambridge. Feb 04. £550.

Italian School, (19thC) Portrait of a Young Boy with a Cat, oil on board, 22 x 17cm, Florentine gilded frame. Cheffins, Cambridge. Feb 05. £550.

Charles Hayter, (1761-1835) pencil & watercolour, sketch, Portrait of Lady Haywarden, signed, dated 1846, 29 x 21in. Gorringes, Lewes. Apr 01. £550.

Frederick Milner, RWA, RBA, RBC (1863-1939) A Spring Day inscribed on the reverse 'Fred Milner' and with title, oil on panel, 25 x 35cm. Cheffins, Cambridge. Feb 05. £550.

William Frederick Settle, (1821-1897): HMS Britannia, the Royal Yacht Victoria and Albert and a Navel Cutter in the Solent, monogrammed & dated '72, 6.75 x 14.25in, gilt frame. Dee, Atkinson & Harrison, Driffield. Feb 05. £550.

English School, (mid 19thC), Fete Champetre, after Watteau, oil on canvas, 30 x 40cm. Dreweatt Neate, Donnington. Nov 02. £550.

Tom Robertson, (1850-1947) oil on board, Gorse on cliff tops, signed, 7.5 x 9.5in. Gorringes, Lewes. Jul 04. £550.

Dahl, oil on canvas, portrait of two ladies, signed, dated 1871, 30 x 25in. Gorringes, Lewes. Feb 01. £550.

Herbert Dicksee, (1862-1942) etching, The King, 20 x 25.5in. Gorringes, Lewes. Apr 01. £550.

Paul Maze, (1887-1970) pastel on paper, Scene at Henley, signed, 9.5 x 17.25in. Gorringes, Bexhill. Oct 02. £550.

Sarah Louise Kilpack, Unloading the day's catch, oil on board, signed, 23.8 x 31.1cm. Rosebery's, London. Sep 04. £550.

Circle of J E Buckley, Figures by a Romanesque cathedral, watercolour, 66 x 98cm. Rosebery's, London. Mar 05. £550.

S J Bowers (19thC) pair of watercolours, Figures in woodland, signed, one dated 1884, 29 x 19.5in. Gorringes, Lewes. Jul 03. £550.

1482

English School, c1900, oil on canvas, seated female nude, 32.5 x 14.5in. Gorringes, Lewes. Mar 04. £550.

1483

Follower of Stanhope Alexander Forbes, oil on canvas, Children beside a cottage doorway, signature, 16 x 12in. Gorringes, Lewes. Dec 04. £550.

The abbreviations following artist's names can be located in the Appendices.

1484

Robert Thorne Waite, (1842-1935) watercolour, Heather gatherers, signed, 13 x 20in. Gorringes, Lewes. Jul 04. £550.

1485

Patrick Procktor, R.A. 'David Oxtoby', 1967, oil on canvas, 46 x 35.5cm. Rosebery's, London. Dec 04. £550.

1486

William Lionel Wyllie, (1851-1931) drypoint etching, The Thames & St Pauls, signed in pencil, 8 x 15.75in. Gorringes, Lewes. Apr 03. £550.

1487

19thC Italian School, oil on canvas, Portrait of a female saint, 20 x 16in. Gorringes, Bexhill. Mar 02. £550.

1488

Watercolour by George Branscombe of Nanny Moors Bridge in Bude. Kivell & Sons, Bude. Dec 02. £550.

1489

John Edwards, Cottages at Wilford in Winter, a pair, oils, both signed, 35 x 24.5cm. (2) Mellors & Kirk, Nottingham. Jun 03. £550.

1490

Leonard Rosoman, Portrait of Nicholas Bentby, signed, gouache, 40 x 49cm. Henry Adams, Chichester. Jan 03. £550.

1491

Paul Drevet, A lady with a fan, pastel, 13.5 x 9.75in. Sworders, Stansted Mountfitchet. Dec 01. £550.

1492

Emily Stanton. Portrait of an old man reading a book, oil, signed and dated 1893, 19.5 x 15.5in. Sworders, Stansted Mountfitchet. Apr 01. £550.

1493

19thC English School, Frederick Charles Macaulay, portrait of a young man, inscribed and dated 1878, verso, oil on canvas, 36 x 30cm. Sworders, Stansted Mountfitchet. Dec 03. £550.

1494

Charles Johnson Payne, called 'Snaffles' 'Indian Cavalry (B.E.F.)' limited edition reproduction, printed in colours, finished by hand, 44 x 34cm and another 'The Gunner, Good Hunting! Old Sportsman', 44.5 x 34.5cm. (2) Sworders, Stansted Mountfitchet. Nov 04. £550.

1495

Peter Graham, ROI, oil on canvas, Japanese print with flowers, signed and dated (19)98, 59 x 74cm, framed. Bristol Auction Rooms, Bristol. Jan 03. £540.

1496

Josef Herman, 1911-1999, ink and wash drawing, 'In the Doorway', 6.5 x 8.5in. Canterbury Auc. Galleries, Kent. Apr 05. £540.

1497

Charles Walter Radcliffe, (1817-1903) oil on canvas, 12 x 18.5in. Gorringes, Bexhill. Dec 02. £540.

1498

Louis Icart, 'Blindfold', etching with colours, signed in pencil, numbered 68, pub'd in 1922 by Estampe Moderne seal, Paris, 36 x 43cm. Sworders, Stansted Mountfitchet. Nov 04. £540.

1499

Henry Maidment, (19/20thC) 'Returning to the fold', signed with monogram, oil on canvas 36 x 46cm. Sworders, Stansted Mountfitchet. Feb 05. £540.

1500

Mount Ventoux from Roussillon, Provence, signed on board, inscribed and dated '97 verso, 34 x 70in, gilt frame. Andrew Hartley, Ilkley. Jun 01. £520.

1501

Arthur Moulton Foweraker, signed watercolour on paper, 'Courtyard of Posada Malago', 10.5 x 14in. Biddle & Webb, Birmingham. Jan 04. £520. Felixstowe. Dec 04. £520.

1502

Walter Tyndale, The Zatterie Venice, watercolour, signed, framed and glazed, 11.5 x 14in. Tring Market Auctions, Herts. Nov 03. £520.

1503

Impressionist oil painting on canvas, 'In the Shade Cyprus 1948', bears signature Bomberg, reverse with typed written label, 14 x 19in, gilt frame. Denhams, Warnham, Sussex. Feb 05. £520.

1504

Manner of William Sydney Cooper, 'Cattle resting in a summer landscape', and a companion, oils, 24 x 34cm. (2). Hampton & Littlewood, Exeter. Jul 04. £520.

1505

Thomas Smythe, Ipswich School, (1825-1906), watercolour, Depicting farm hands with a steam traction engine and pulley driven baler with attendant figures, unsigned, 17 x 30in, framed & glazed. Diamond Mills & Co, Felixstowe. Dec 04. £520.

> Fresh to the market paintings perform better than those which have been in and out of auction.

1506

Herbert St John Jones, (1870-1939) Welsh Maid, signed and dated lower right 1895, signed to verso 'Painted from life', oil on canvas, framed, 30 x 40cm. Peter Wilson, Nantwich. Feb 02. £520.

1507

James Stinton, watercolour, cock and hen pheasants in an autumnal landscape, signed lower right, 16.5cm square. Wintertons Ltd, Lichfield. Sep 02. £520.

1508

Watercolour of a coastal landscape by W B Thomas, 9 x 12in. John Taylors, Louth. Mar 01. £510.

1509

Charles Rowbotham, At Vico, Bay of Naples, signed, dated 1902(?), 3 x 7.5in, gilt frame. Andrew Hartley, Ilkley. Dec 01. £500.

1510

Henry Cooper, Whitby Harbour, signed, 15.5 x 23.5in, gilt frame. Andrew Hartley, Ilkley. Dec 04. £500.

1511

Louis Icart etching. Brettells Auctions, Newport, Shropshire. Sep 04. £500.

1512

David W. Haddon, oil on board, portrait of a fisherman standing on a quayside, signed, 20 x 13.5in. Clevedon Salerooms, Bristol. Feb 02. £500.

1513

Roy Lichtenstein, American, 1923-1997, a pair, Fire Controls and Wham! reproduction prints, 75 x 89cm. Cheffins, Cambridge. Jul 04. £500.

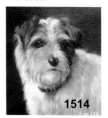

1514

Walter Herbert Wheeler, (1878-1960), Study of a rough haired terrier's head, on board, signed, 24 x 20cm. David Duggleby, Scarborough. Jun 01. £500.

1515

Frederick Tatham, (1805-1878) watercolour, Portrait of three children with a donkey, mountains beyond, signed and dated 1844, 22.5 x 17.5in. Gorringes, Lewes. Sep 04. £500.

1516

F Peluso. oil on canvas, young man dressed in fine 17thC costume, smoking a pipe and carrying a sword at his side, signed, 23 x 13in, framed. Fieldings, Stourbridge. Apr 05. £500.

1517

Augustus Osborne Lamplough, watercolour, desert scene with figures and camels in foreground, signed, 23 x 60cm. Clevedon Saleroom, Bristol. Jun 05. £500.

1518

James Aitken, early 20thC Scottish, watercolour, headland view from a garden, signed, 13.5 x 19.5in. Gorringes, Bexhill. Feb 03. £500.

1519

Thomas Frederick Collier, (fl.1848-1874) watercolour, still life of pansies, signed, 7.5 x 11in. Gorringes, Lewes. Dec 03. £500.

1520

Charles Knight, (1901-1990) watercolour, 'Thunderclouds', signed, RWS label verso, 11 x 14in. Gorringes, Lewes. Apr 03. £500.

1521

John Arthur Hay, (1887-1974) oil on canvas, Portrait of a lady, signed, 30 x 25in. Gorringes, Lewes. Jan 05. £500.

1522

Jean Hugo, (1894-1984) French, ink and gouache, Castle and church from across a lake, signed, 4.5 x 12.5in. Gorringes, Lewes. Sep 04. £500.

1523

W A Rouch, Portrait of 'Workman', winner of the Grand National 1939, signed, oil on board, 24 x 28.5in, and a photograph of Workman. Gorringes, Lewes. Jan 04. £500.

1524

Karoly Patko, Hungarian 20thC, still life of a jug, mug and apple on a plate, (recto), portrait of a man head and shoulders, (verso) oil on board, signed, dated '34(?), 42.5 x 46.7cm Rosebery's, London. Dec 04. £500.

1525

Sir David Young Cameron, watercolour, 'Loch Lomond', signed and entitled, 5 x 9in. Great Western Auctions, Glasgow. Jun 05. £500.

1526

Samuel John Lamorna Birch, (1869-1955), watercolour, coastal landscape, signed, dated 1940 with presentation inscription to his cousin Muriel, 5 x 6.75in. Gorringes, Bexhill. Mar 02. £500.

1527

L Martinez, Still life study in the Dutch manner of flowers and fruit, oil on canvas, signed, 122 x 91.5cm, gilt gesso frame. Locke & England, Leamington Spa. Jul 03. £500.

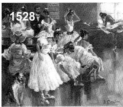

1528

Yuri Denisov, 'Dress Rehearsal', oil on canvas, signed, 55 x 64cm, framed. Lots Road Auctions, Chelsea. Dec 04. £500.

1529

Series of four miniature portraits of a lady, one in Victorian costume, three in allegorical costume representing Faith, Hope and Charity, each 3.75 x 3in. Tring Market Auctions, Herts. Nov 02. £500.

1530

Norman Blamey, R.A., oil on board, Daffodils in a glass vase by a window with a winter landscape, signed, 50 x 40cm. Rosebery's, London. Sep 03. £500.

1531

Sergei Shapovalov, (b.1948), 'Irises', oil on canvas, signed, 71 x 90cm, framed. Lots Road Auctions, Chelsea. Dec 04. £500.

1532

Charles Fernand de Condamy, Basset Hounds, watercolour, signed, 6 x 9.5in. Halls Fine Art, Shrewsbury. Dec 03. £500.

1533

English School, c1860, portrait of a lady, arched gilt mount, within a plush velvet lined morocco leather case, 27.5 x 18.7cm. Rosebery's, London. Mar 05. £500.

1534

Stefanie Von Trauttweiller, Still life, signed, oil on canvas, 55 x 44cm. Sworders, Stansted Mountfitchet. Mar 03. £500.

1535

W Cruickshank, Birds Nest and Blossom, watercolour. W & H Peacock, Bedford. Jul 03. £500.

Section VIII < £500 to £400

Smaller size paintings, lesser artists, or lower quality works reflect lower prices. This is what we should expect. The market is paying the market price! Indeed the market, as one should expect is very wise! Take for example Yeend King and follow this artist through the *Index*....................

For the first time prices fall below £500 and from now on we will be analysing £100 sections. It is worthwhile summarising what has happened so far and what is likely to appear now. Firstly we will be looking at recurring themes and suggesting new. We can look at recurring artists, or artists we have left behind, or new artists. And we can perhaps point up examples of lower prices that reflect either a lesser quality, smaller size or condition.

All of the earlier themes continue in this Section. There are landscapes, seascapes and townscapes galore, but portraiture has become almost excessive at about 25% of the total. Still life accounts for 10% of examples and animalia about 15%. One can also find similar percentages of abstract and modernist painters and 15% at least of prints. Interesting landscapes occur at **1631**, the Norman Lloyd (1897-1985) *Summer River*. This 'impressionist' work has a modern feel that young or old would buy and should represent good value. Lloyd has fetched up to £1,700. Contrast **1631** with **1635**, a traditional English winter landscape by Robert Winchester Fraser, (1846-1906) who has only achieved up to £650. Contrast other landscapes in this Section and seascapes. Use the *Index*. Go to the Henry Redmore (1820-1887) beachscape at **1787**. Dated 1866, this 8 x 10 inch picture reached only £400 in July 2004. Check this artists other works at **98**, (£10,500) **101**, (£10,000) **759**, (£1,600) and 'circle of' at **908** for £1,300. *Art Sales Index* lists only two works at £580 and £900. Apart from size, what other market factors resulted in the £400 price? Was it a good buy for a dealer or good value for a collector?

Now look at townscapes. There are at least 30 in this Section but see, for example **1673** and **1684**. J W Milliken (fl.1887-1930) was a competent British watercolourist and **1673** is good value. Alternatively **1684** is a 'school' painting of Naples, very small, but a popular subject. This raises a new theme. The *Index* is comprehensive. The reader could study only London townscapes. There are almost 40 in this work and even more of Venice, the most painted townscape of all. There are, to take the case in point about 10 Naples townscapes - as many as Paris! In fact the reader could study specific townscapes or even specific countries such as Italy or France, or the French School, or for that matter individual French artists.

So much for new themes relating to towns and countries, but this Section could point you in many more directions. For example check out the Donald Bain (1904-1979) chalk drawing at **1742**, *Cubist Head*. Bain was not a prolific artist and his work appears infrequently. Oils fetch up to £2,000 and works on paper, £800. There are at least two dozen more chalk pictures in this work. Check the *Index*, or similarly follow a *charcoal* theme. There is an example at **1809**. Other examples which come to mind when browsing this Section are *military*, with over 30 examples. See **1706** and **1731**, or *mythology* with a similar number of entries.

Now for artists old and new! We started studying Royle at **65** on page 11 but left him behind at page 77 when a smallish 11 x 16 inch work fetched £900. Hence the *Index* can give the reader an instant price range for this artist. Similarly we left William Mellor behind with a small view of *Derwent Water* at **1395** and a lowest price of £600. Now look at W. L Wyllie. There are at least seven examples alone in this Section. Wyllie paintings started on page 20 for £5,600 and stretch right through to an etching at **3347** for £40! Check out a Louis Wain at **1749** and follow this artist forward or backward. Look up Henry John Stannard at **1730** or **1773**. Is the Stannard on page 146 by the same artist? Stannard pictures go back to £6,000 on page 20 but the examples here are much smaller. Alternatively W M Birchall first appears at **1414** and £600 and can also be found at **1553**, **1562** and **1602**, all paintings of individual ships. Birchall concludes at **2429** and £240. His oil and watercolour medians are both £320 so our results reflect this artist very well. Sir Frank Brangwyn appears on page 102 for the first time but then there are a dozen examples to **3183** on page 97.

Smaller size paintings, lesser artists, or lower quality works reflect lower prices. This is what we should expect. The market in general, is paying the market price! Indeed the market, as one should expect is very wise! Take H J Yeend King. On page 15 is an example at £9,400. On page 17, £7,500, but on page 104, a much smaller picture, of a lady from behind, only £460! A better Yeend King should have fetched more. This is about the lowest this artist has ever gone. The term 'body colour' suggests a watercolour. His watercolour median is £480. His oils on the other hand have recently ranged from £350-£4,800. I suggest that the market has also got this right and that the artist didn't always choose his subjects very well. Remember our maxim. Better to buy the best of a modest artist than the worst of a good artist. The £500 spent here with added premium, was for the artist, not the painting. The buyer ended up with the portrait of a woman from behind rather than in front!

1536

Arthur T Leyde, Portrait of a young girl, monogrammed and dated 1869, 23.25 x 18.5in, gilt frame. Andrew Hartley, Ilkley. Oct 01. £480.

1537

Continental School, 19thC, a pair, oils on glass, a 'rustic courting couple' and 'the birds nest', 17.5 x 14.25in. Dee, Atkinson & Harrison, Driffield. Apr 01. £480.

1538

19thC British School, 'Portrait study of Thomas Fletcher of Handsworth', oil on canvas, wax lined, 29 x 24in. Peter Wilson, Nantwich. Nov 01. £480.

1539

Arthur Wilkinson, watercolour, Old Palace Terrace, Richmond Green, signed/dated (19)29, 8.5 x 13.75in. Gorringes, Lewes. Mar 01. £480.

1540

Alexandre Roubtzoff, (1884-1949) oil on canvas, Aziara - cherry blossom, signed/dated 1916, 6.5 x 10.25in. Gorringes, Lewes. Apr 01. £480.

1541

Oil portrait on panel of a Russian Grand Prince Alexander Nevsky, stamped and engraved silver frame, frame dated 1876, 9 x 7in. Tring Market Auctions, Herts. May 02. £480.

1542

George Marks, Evening Glow, signed, gilt frame, glazed, 12 x 16in. Tring Market Auctions, Herts. May 02. £480.

1543

20thC Continental School, Winter town scene with figure skating on the river, on panel, 28 x 38cm. Wintertons Ltd, Lichfield. Jan 03. £480.

1544

Initialled J. H. Barn, interior with two horses, on canvas, 49.5 x 75cm. Wintertons Ltd, Lichfield. Mar 03. £480.

1545

English School, early 19thC, The Coat of Arms of the City of Newcastle with supporters, motto and mantling, oil on mahogany panel, 15.5 x 19in, unframed. Clarke Gammon, Guildford. Apr 03. £480.

Hammer Price £480

1546

Keeley Halswelle, (1832-1891) Harvest scene, watercolour, 7.25 x 14.5in, signed with initials and date '78, modern gilt frame with non reflective glass. Canterbury Auction Galleries, Kent. Aug 03. £480.

1547

C. W. Oswald, Highland cattle on the banks of a loch, oil on canvas, signed, 20 x 15in. Halls Fine Art, Shrewsbury. Sep 03. £480.

Provenance is an important market factor which can bare positively on results achieved at auction.

1548

S. Bowers, 19thC, rural cottage scene, oil on canvas, panel 68 x 50cm. Lambert & Foster, Tenterden. Aug 03. £480.

1549

Circle of Lawrence, oil on artist board, Portrait of a blue-eyed girl, 9 x 7in. Gorringes, Lewes. Dec 03. £480.

1550

Scottish School, 19thC, Fisher boy and his dog, oil on canvas, 19 x 15in. Halls Fine Art, Shrewsbury. Jun 04. £480.

1551

Roland H Hill, 1899 s.d., watercolour drawing of an English village, 14 x 22cm, mounted and framed. Thos Mawer & Son, Lincoln. Jun 04. £480.

1552

C Potten, pair of pen/inks of Tring. Tring Market Auctions. Oct 04. £480.

1553

Watercolour, signed William Minshall Birchall, date 1920, Highlight and Low light at North Shields 'Towing out' 25cm x 35.5cm. Boldon Auction Galleries, Tyne & Wear. Sep 04. £480.

1554

Follower of Thomas Bush Hardy, 'A Yarmouth fishing smack entering a French port', with signature, watercolour, 24 x 45cm. Sworders, Stansted Mountfitchet. Nov 04. £480.

Hammer Price £480

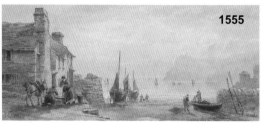

James Elliot, 19thC, A Fishing Village and A Rocky Shore, one of a pair, signed and dated 1869, watercolour 25 x 52cm. (2) Sworders, Stansted Mountfitchet. Feb 05. £480.

1556

Gillian Ayres, Untitled, black felt tipped pen and coloured crayon, signed in pencil, 17.5 x 22.8cm and one other similar drawing by the same hand, signed. (unframed) Rosebery's, London. Sep 04. £480.

1557

Henry Cliffe, 'Winter Day', gouache, signed with initials, dated '54 in pencil, inscribed title on reverse, 28.5 x 39.5cm. (unframed) Rosebery's, London. Sep 04. £480.

1558

George James Rankin, (1864-1937), Study of a partridge in a hedgerow, signed, 11.25 x 15.5in, gilt frame. Dee Atkinson & Harrison, Driffield. Nov 04. £480.

1559

John Blair, watercolour, Spital and Berwick Gorringes, Bexhill On Sea. Sep 04. £480.

102 *Picture Prices*

1560

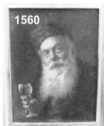

E. Lingen Felder, (19th C) German, Lady with a tea cup and Gentleman with a wine glass, oils on wooden panels, signed, 7 x 5.5in. Gorringes, Lewes. Dec 04. £480.

1561

Mary Fedden (1915-) watercolour, Bird in a landscape, signed, dated 1981, with presentation inscription, 6.25 x 8.5in. Gorringes, Lewes. Dec 04. £480.

1562

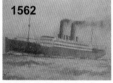

W M Birchall, watercolour, Cameronia. Gorringes, Bexhill. Sep 04. £480.

1563

Sir Frank Brangwyn, (1867-1956), ink and wash, The artist in bed, initialled, 7 x 9in, unframed. Gorringes, Lewes. Sep 04. £480.

1564

J Hamilton Mackenzie, (1875-1926) shepherd & his flock, signed, 10.5 x 12.5in, gilt frame. Dee Atkinson & Harrison, Driffield. Jul 04. £480.

1565

William Lionel Wyllie, (1851-1931) etching, HMS President & Blackfriars Bridge, signed in pencil, 8 x 16in. Gorringes, Lewes. Mar 04. £480.

> Most auction catalogues carry an explantation of the terminology used in descriptions. See Appendices.

1566

Oval portrait of a military gentleman, written verso, 'portrait of Captain R Hays, Light Dragoons 1772', with framers label Thomas Doe, Worcester, painted on ivory, 12 x 10cm. Thos. Mawer & Son, Lincoln. Mar 04. £480.

1567

Pablo Picasso, `Tete de femme', signed and dated 4/12/56, lithograph, no. 128 of 200, 53 x 43cm. Henry Adams, Chichester. Jan 03. £480.

1568

Charles H H Burleigh, (1875-1956) oil on canvas, Mevagissey, signed, 18 x 24in. Gorringes, Lewes. Apr 03. £480.

1569

Frederick James Aldridge, (1850-1933) Shipping on the Norfolk Broads, signed lower right 'F J Aldridge', watercolour, 46 x 71cm. Cheffins, Cambridge. Feb 05. £480.

1570

James Sant, (English, 19thC) Horses with a Drover and a Sheepdog on a Towpath, signed lower right 'James Sant', oil on panel, 26 x 36cm. Cheffins, Cambridge. Feb 05. £480.

1571

Maria Louisa Selwyn, English, 19thC, Portrait of a Syrian Man, oil on card, 12 x 10cm. Cheffins, Cambridge. Feb 05. £480.

1572

H R Hall, Highland Cattle, Loch Scaraig, Isle of Skye, oil on canvas, signed, inscribed on reverse, 24 x 36in. Halls Fine Art, Shrewsbury. Feb 05. £480.

Percy R. Craft, (1856-1937) oil on card, Still life of a dead falcon, signed, 16 x 12in. Gorringes, Lewes. Jan 05. £480.

John Syer, (1815-1885) oil on canvas, Figures resting beside farmhouses, signed and dated (18)58, 19ins x 14in, unframed. Gorringes, Bexhill. Mar 02. £480.

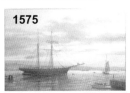

Roderick Lovesey, (1944-) oil on canvas, Shipping in the Thames Estuary, signed, swept gilt frame, 23.25 x 35.25in. Gorringes, Bexhill. Mar 02. £480.

Jacob Bornfriend, Still life, oil on baord, signed, 47 x 54.5cm, unframed. Rosebery's, London. Mar 05. £480.

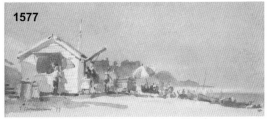

Trevor Chamberlain (1933-) watercolour, Beach scene, signed and dated '77, 4.75 x 9.5in. Gorringes, Lewes. Apr 03. £480.

After Picasso, Studio interior with easel, lithograph in colours, signed, dated 15.11.55 within the plate, 26 x 42cm, and seven other prints after the same hand. Rosebery's, London. Mar 05. £480.

After Teniers, oil on canvas, Smokers in a tavern, bears signature, 14 x 13in. Gorringes, Lewes. Jun 03. £480.

Salvador Dali (1904-1989) Song of Songs Series. Five, pencil signed and each numbered 122/250, etching and aquatint, 40 x 25cm. Sworders, Stansted Mountfitchet. Apr 05. £480.

Attributed to William B. Henley, (late 19thC) 'Near Pentre Foelas' and 'In the Ogwen Valley, a pair, both signed, oil on canvas, 31 x 46cm. (2) Sworders, Stansted Mountfitchet. Apr 05. £480.

David Hockney, an etching, signed, limited edition collotype, 41/2000, 36.5 x 26.75in, aluminium frame. Andrew Hartley, Ilkley. Jun 05. £480.

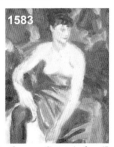

Berthomme Saint-Andre, 'La Jarretiere', oil on canvas, signed, inscribed on stretcher, 41.2 x 33cm. Rosebery's, London. Jun 05. £480.

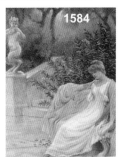

After John William Godward, 'On the Terrace', oil on canvas, 35 x 24.8cm. Rosebery's, London. Jun 05. £480.

Alfred Leyman, (1856-1933) Devon Village with horse & cart and cattle in a landscape, signed lower right 'A Leyman', watercolour, 35 x 52cm. Cheffins, Cambridge. Apr 05. £480.

David Tindle, 'Shingle Street, Suffolk', oil on board, signed with initials, 14.2 x 29.3cm. Rosebery's, London. Jun 05. £480.

Mary Gallagher, oil on canvas 'Still life with iron', signed verso, 27 x 36in. Great Western Auctions, Glasgow. Jun 05. £480.

Graham McKean, oil on canvas 'Bargain Hunter', signed, 8 x 6in. Great Western Auctions, Glasgow. Apr 05. £470.

After Cecil Aldin, A Country Fair, a quartette of colour prints, framed and glazed, 38 x 59cm. Dockree's, Manchester. Jun 01. £460.

Hammer Price £460

1590

J Hughes Clayton, watercolour, Nr Colby, Isle of Man, 10.5 x 17.5in. Gorringes, Lewes. Mar 01. £460.

1591

Tito Lessi, (1858-1917) Italian, watercolour, Elderly man with basket and walking stick, signed, 11.5 x 7in. Gorringes, Lewes. Mar 01. £460.

1592

Mary Holden Bird, watercolour, The Little Beaches, signed, Fine Arts Society label dated 1950, 13.5 x 20in. Gorringes, Lewes. Mar 01. £460.

1593

Cecil Aldin, The Blackmore Vale, coloured print, No. 10/250, signed in pencil, oak frame, 15 x 28.5in. Sworders, Stansted Mountfitchet. Apr 01. £460.

1594

Cavendish Morton, (1911-) watercolour, Estuary & Mills, signed, dated 1971, 14 x 21.5in. Gorringes, Bexhill. Mar 02. £460.

1595

Henry Warren, a girl with a spinning wheel, signed, watercolour, 12 x 9in. Sworders, Stansted Mountfitchet. Jul 01. £460.

1596

Alice L Hulme, (Exh 1882-1891) oil on board, Still life of nasturtiums in a vase, signed and dated '90, 11 x 15in. Gorringes, Lewes. Sep 03. £460.

1597

After Teniers, oil on panel, Dutch school interior scene with figures gambling, 14.5 x 12in. Biddle & Webb, Birmingham. Feb 04. £460.

1598

After Canaletto, oil on canvas, Grand Canal, Venice, 27 x 42in. Gorringes, Lewes. Oct 04. £460.

1599

John Hitchens, (1940-) oil on canvas, Evening Hills, signed and dated 1965, 16 x 34in. Gorringes, Bexhill. Mar 02. £460.

1600

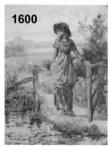

Henry John Yeend King, (1855-1924), body colour, Lady beside a farm gate, signed, 10 x 7in. Gorringes, Lewes. Oct 04. £460.

1601

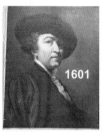

18thC Continental School, oil on canvas, Portrait of a gentleman, 25.5 x 20in. Gorringes, Lewes. Oct 04. £460.

> Ensure you never hang your watercolours etc in direct or reflected sunlight. Fading seriously affects value.

1602

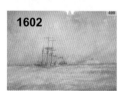

Watercolour, signed William Minshall Birchall, dated 1920, 'Heavy weather off North Shields'. Boldon Auction Galleries, Tyne & Wear. Sep 04. £460.

1603

Ahmed Parvez, Untitled abstract, mixed technique on paper, signed and dated '59, 26.3 x 31.5cm and two other similar works on paper by the same hand, both signed and dated '59, unframed. (3). Rosebery's, London. Sep 04. £460.

1604

European Post Impressionist School, early 20thC, Child seated in a chair, oil on canvas laid down on panel, 24.2 x 20.2cm. Rosebery's, London. Sep 04. £460.

1605

P. Jones, British 19thC, Two terriers in a mountain landscape, oil on canvas, signed and dated 1858, 21 x 26.2cm. Rosebery's, London. Sep 04. £460.

1606

Rowland Suddaby, (1912-1972) unframed, mixed media, Cambridgeshire landscape, signed, 12 x 21in. Gorringes, Bexhill. Mar 02. £460.

1607

Sir David Muirhead Bone, (1876-1953) War Drawings, Edition De Luxe, approx 50 prints signed in pencil. Sworders, Stansted Mountfitchet. Nov 04. £460.

1608

Follower of George Morland, 'After the Storm', bears signature, oil on canvas 25.5 x 38cm. Sworders, Stansted Mountfitchet. Nov 04. £460.

1609

Horace van Ruith, Portrait of a Lady, half length, seated holding an ostrich feather, signed, oil on canvas, 79 x 59cm, unframed. Sworders, Stansted Mountfitchet. Nov 04. £460.

1610

W H Franklin, a pair of oils on board. Gorringes, Bexhill On Sea. Sep 04. £460.

1611

Ben Callow, oil, coastal scene. Gorringes, Bexhill On Sea. Sep 04. £460.

1612

After Lawrence Stephen Lowry, three reproduction colour prints. Gorringes, Bexhill. Dec 04. £460.

1613

Wycliffe Eggington, (1875-1951) A Devonshire country cottage believed to be at Sampford Courtney, oil on canvas, signed, 55 x 76cm, unframed. Hampton & Little-wood, Exeter. Jul 04. £460.

1614

Donald A Paton, (E H Thompson) watercolour, 'Loch Lomond', signed and dated '04, 7 x 10in. Gorringes, Lewes. Jan 04. £460.

1615

Oval portrait of a young Victorian lady wearing a feather bonnet, gilt brass and fabric frame, written verso 'after Sir Thomas Laurence, Duchess of Wellington', 16 x 12cm, frame 33.5 x 17cm. Thos. Mawer & Son, Lincoln. Mar 04. £460.

1616

Elizabethan style portrait of a young boy, oil on copper, 20 x 17cm. Thos. Mawer & Son, Lincoln. Mar 04. £460.

1617

Attributed to Henry John Hildyard, Portrait of a lady, traditionally held to be Mrs. H. J. Hildyard, nee Harriet Meakin, seated half-length in a pink dress, oil on canvas, 74 x 62cm. Rosebery's, London. Jun 05. £460.

1618

Richard W. Hubbard, (1817-1888), oil on canvas, entitled The Novel Reader, a young woman seated at a table reading, titled, dated 1857 verso, 16.5 x 20.5in, gilt frame. Diamond Mills & Co, Felixstowe. Dec 04. £460.

1619

Robert Hofmann, Camels by a Wadi, oil on board, signed indistinctly, 34.5 x 49.7cm, and 2 other studies of North African subjects by the same hand, both signed, one dated 1913, 26.5 x 34cm and 19 x 23.8cm. (3) Rosebery's, London. Mar 05. £460.

1620

19thC Continental School Portraits of a King and Queen, pair, oils on canvas, 10.5 x 8.75in. Gorringes, Lewes. Jun 03. £460.

1621

Follower of Pieter Casteels, Still life with flowers, oil on canvas, 40 x 32cm, unframed. Rosebery's, London. Jun 05. £460.

1622

Anda Paterson, mixed media 'Newspaper Vendor', signed and dated 83, 27 x 36in. Great Western Auctions, Glasgow. Apr 05. £460.

1623

E. Holder, 'Sheep grazing beneath trees', oil, 12.5 x 17.5in. Louis Taylor, Stoke on Trent. Mar 05. £460.

1624

William Lionel Wyllie, (1851-1931) etching, Valley of Glencoe, signed in pencil, 9.5 x 13.75in. Gorringes, Bexhill. Mar 02. £460.

1625

Adam Buck, quarter length portrait of a lady, water-colour and pencil, signed, dated 1828, 5 x 4.5in and a companion similar water-colour and pencil, signed and dated 1828, glazed gilt frames. Amersham Auction Rooms, Bucks. Jun 01. £450.

1626

Leon Danchin (1887-1939) Portrait study of 2 springer spaniels, signed in pencil by artist lower left, lithograph, framed, 14.75 x 18.5in. Peter Wilson, Nantwich. Nov 01. £450.

1627

Thomas Smythe, two figures in conversation in front of an out building, oil on canvas, signed, 20 x 16in. Sworders, Stansted Mountfitchet. Jul 01. £450.

1628

19thC Continental School. Figures in an Italianate landscape, on board, verso bears indistinct inscription incl. date 29 March 1843, 24 x 34cm. Wintertons Ltd, Lichfield. Nov 02. £450.

1629

English School, view of a boy on a rock fishing, oil on canvas, 54 x 43cm. Sworders, Stansted Mountfitchet. Mar 03. £450.

1630

Fred Bennett, 1918, related pair of WW1 pen and wash cartoons, Battle of the Somme 1918, Lt Col A. Keates of the 6 Bn the Buffs, East Kent Regt portrait, 'Some Advance, 1918', 30 x 15cm and All Objectives Taken, also Few Objects!', 20 x 26cm. (2) Richard Winterton, Burton on Trent, Staffs. Feb 04. £450.

1631

Norman Lloyd, (1897-1985) Summer river landscape with figure in a rowing boat, oil on board, 12 x 16in, signed, moulded and swept frame. Canterbury Auc. Galleries, Kent. Dec 03. £450.

1632

Follower of Sidney Cooper, mid 19thC, tondo, farmyard scene, oils on canvas, unsigned, contemporary swept gallery frame, 36cm dia. Richard Winterton, Burton on Trent, Staffs. Apr 04. £450.

1633

Henry Schafer, (1854-1915): St Ouen Rouen, Normandy, signed & titled, 18 x 13.5in, gilt frame. Dee Atkinson & Harrison, Driffield. Mar 04. £450.

1634

After an old master, Madonna and Child, oil on canvas, re-lined, unframed, 83 x 63cm. Hobbs Parker, Ashford. Nov 04. £450.

1635

Robert Winchester Fraser, Children fishing in the Fens, signed and dated '94, pencil and watercolour, 17.5 x 36cm. Mellors & Kirk, Nottingham. Jun 03. £450.

1636

Portrait of Henry Barnard Gent, unsigned. Tring Market Auctions, Herts. Oct 04. £450.

1637

Adam Edwin Proctor, R.B.A., R.I., R.O.I., Tranquil wooded river landscape, oil on canvas board, signed, dated '04, 24.5 x 34.8cm. Rosebery's, London. Sep 04. £450.

1638

Follower of Armfield, Two terriers catching a rat in a barn interior, on canvas, 58 x 72cm. Wintertons Ltd, Lichfield. Jan 03. £450.

1639

James Neal, The canal, Leven, East Yorkshire, signed mixed media on board, 11.25 x 17in, painted frame. Dee Atkinson & Harrison, Driffield. Nov 04. £450.

1640

Harry Hudson Rodmell, (1896-1984) Cartmel Priory, signed, 14 x 19.75in, painted frame. Dee Atkinson & Harrison, Driffield. Nov 04. £450.

1641

E. Gatewood, pair of oils, View of Devil's Tower on River Wensum, Norwich and The Fish Market, Norwich, canvases 8 x 12in, one signed and dated 1887, gilt moulded frames. Canterbury Auc. Galleries, Kent. Apr 05. £450

1642

Gervasia Vartanyan, The Temple, oil on canvas, signed, 50 x 72cm, framed. Lots Road Auctions, Chelsea. Dec 04. £450.

1643

Alexander Utkin, 'Old Toy Master', oil on canvas, signed, 60 x 75cm, framed. Lots Road Auctions, Chelsea. Dec 04. £450.

Reg Gammon, (1894-1997) oil on board, Woman and fishing boat on a beach, signed, 18 x 24in. Gorringes, Lewes. Jul 04. £450.

Portrait miniature of David Garrick, labelled verso 'similar to the museum portrait at Stratford in Avon etc', oval ivory frame with applied gilt brass ribbon bouquets, miniature 13 x 10.5cm. Thos. Mawer & Son, Lincoln. Mar 04. £450.

Frames and mounts should enhance your picture. Empathy, rather than fashion should dictate your choice.

After Charles Cooper Henderson, The London to Brighton Mail Coach, oil on canvas, 56 x 80cm. Henry Adams, Chichester. Jan 03. £450.

Follower of Marie Elizabeth Vigee Lebrun, Portrait of a lady quarter-length, oil on canvas, 60.8 x 47.8cm. Rosebery's, London. Dec 04. £450.

Harry John Johnson, water-colours, 'Beached fishing boats at Hastings', and 'A Fishing Smack in a Storm off Honfleur', 24.6 x 35.8cm and 28 x 45.8cm, one bears seal, inscription and dated 1851, (2). Rosebery's, London. Dec 04. £450.

William B Lamond, Coastal Scene at Dusk, signed, 11.5 x 17in, gilt frame. Andrew Hartley, Ilkley. Feb 05. £450.

Randolf Schwabe, (1885-1948) The Abbey Farm, Cerne Abbas, signed with initials, inscribed, dated 1939, watercolour, 35.5 x 39cm. Sworders, Stansted Mountfitchet. Apr 05. £450.

Gaston Sebire, oil on canvas, Rue au Village, signed, 59.8 x 73cm. Rosebery's, London. Jun 05. £450.

James Luntley, 19thC, pair of pastels, Portraits of a boy and girl, signed, dated 1867, 24 x 18.5in. Gorringes, Lewes. Dec 01. £440.

Hammer Prices £450 - £440

18thC Italian School, oil on canvas laid on board, Italian landscape with figures beside a stone bridge, 7 x 9.5in. Gorringes, Lewes. Mar 01. £440.

David Jagger, (fl.1917-1940 - died 1958) Lamplight Study, self portrait of the artist, signed, 18 x 14in, dark oak wide frame. Canterbury Auc. Galleries, Kent. Aug 02. £440.

Circle of Romney, portrait of a lady in white dress, reverse of the frame engraved 'Ann Turner nee Farley', painted in 1823, 9 x 7cm. Rosebery's, London. Sep 02. £440.

English School, half portrait of a lady, pastel, 70 x 50cm. Sworders, Stansted Mountfitchet. Dec 02. £440.

Deborah Brown, Abstract design, signed, inscribed verso, 1956, oil on board, 25.5 x 83cm. Locke & England, Leamington Spa. Jan 03. £440.

Dame Laura Knight, R.A., R.W.S., R.E., 'Fun fair on the Heath', etching, signed and numbered 11/25 in pencil, 17.2 x 22cm. Rosebery's, London. Sep 04. £440.

George Henry Jenkins, Ansteys Cove, Devon, signed, oil on canvas, 46 x 76cm. (2) Sworders, Stansted Mountfitchet. Nov 04. £440.

Circle of George Armfield, Terriers chasing a cat, oil on canvas, 51 x 61cm. Sworders, Stansted Mountfitchet. Nov 04. £440.

Ryland after Kauffman, pair of coloured engravings, The Triumph of Venus & Cupid punished by the Graces, Tondo, 11.5in, eglomise framed. Gorringes, Lewes. Dec 04. £440.

Hammer Price £440

1662

W L Wyllie, ink wash study of shipping. Gorringes, Bexhill On Sea. Sep 04. £440.

1663

Thomas Sewell Robins, watercolour drawing, Dutch barge and English ketch. Gorringes, Bexhill On Sea. Dec 04. £440.

1664

18thC Italian School, oil on canvas, Landscape with figures resting and cattle drover, 25 x 33in. Gorringes, Lewes. Jan 04. £440.

1665

19thC English School, watercolour on ivory miniature, Portrait of an army officer, Oval, 2 x 1.75in. Gorringes, Lewes. Mar 04. £440.

1666

T Baker, oil on canvas, Landscape with castle ruins and cattle, signed and dated 1849, 13 x 19in. Gorringes, Lewes. Mar 04. £440.

1667

Portrait of a Victorian lady wearing a straw bonnet with roses and carrying a basket of pink roses, signed Ch. Roze, elaborate gilt brass & fabric frame, 27 x 20cm overall. Thos. Mawer & Son, Lincoln. Mar 04. £440.

1668

Edward Horace Thompson, Highland loch scene, watercolour, signed and dated 1909, 24 x 39cm. Rosebery's, London. Dec 04. £440.

> Ensure your watercolours etc are mounted on acid free boards. Have old pictures checked out by a framer.

1669

Leon Underwood, (1901-1975) colour print, 'Harvest Corn', signed, dated 1943, 24/25, 19 x 25in. Gorringes, Lewes. Apr 03. £440.

1670

Italian School, watercolour, Madonna & child, tondo, 7in, Florentine frame. Gorringes, Lewes. Mar 03. £440.

1671

William Lionel Wyllie, (1851-1931) etching, 'Cobles, off Northumberland' signed in pencil, 8.25 x 19.25in. Gorringes, Bexhill. Mar 02. £440.

1672

L Van Staaten N, Dutch Canal Scenes, signed pair, 11.5 x 15 .25in, white frames. Andrew Hartley, Ilkley. Feb 05. £440.

1673

J.W.Milliken, watercolour, 'A Market Day, Tours', signed, 9.5 x 13.75in. Gorringes, Bexhill. Mar 02. £440.

1674

Patrick Caulfield, R.A. Vessel, screen print in blue & black, signed, titled and inscribed 'AP' in pencil, 116 x 87.3cm, unframed. Rosebery's, London. Mar 05. £440.

1675

Attributed to Benjamin Barker of Bath, (1776-1838) Below the Falls, watercolour 26 x 38cm. Cheffins, Cambridge. Apr 05. £440.

1676

19thC Italian School, Portrait of the Virgin, oil on canvas, oval mounted ornate gilt frame, 48 x 41cm overall. Hobbs Parker, Ashford. Apr 05. £440.

1677

J. H. Kien, early 19thC European School, Family group in an orchard, and with a bird cage and spaniel, a pair, pencil and red chalk, one signed, 48 x 34.5cm each. (2) Rosebery's, London. Jun 05. £440.

1678

Henry E Hobson, (English, fl.1857-1866) Portrait of a Lady in a Pink Dress and a Portrait of a Lady in a Pink and Cream Dress, one signed lower left 'Hobson 1866', watercolours, 34 x 27cm, pair. (2) Cheffins, Cambridge. Apr 05. £440.

1679

After Guido Reni, Madonna and Child, oil on panel, in an oval, 22 x 18cm. Hampton & Littlewood, Exeter. Jul 04. £430.

1680

John Varley, (1778-1842) watercolour, Figures on a lane passing houses, signed, dated 1838, 10 x 14.5in. Gorringes, Lewes. Jul 04. £430.

1681

N**B, Set of four, a zebra, squirrel, fox and an antelope, signed with monogram NB, watercolour, sizes from 25 x 21cm to 28 x 26cm. Cheffins, Cambridge. Jun 01. £420.

1682

J Elliot, Welsh coastal scene. Tring Market Auctions, Herts. Jan 02. £420.

1683

Lucas Van Leyden, Adam and Eve, engraving, signed with initials and dated 1410, 16.3 x 12cm, unframed. Rosebery's, London. Mar 02. £420.

1684

19thC Neapolitan School, gouache, Naples with cathedral, numerous figures and Vesuvius beyond, 5.25 x 9in. Gorringes, Lewes. Mar 01. £420.

1685

John Pipe, Little Cressingham, limited edition print, 136/150, signed in the margin. Sworders, Stansted Mountfitchet. Apr 01. £420.

1686

Sir Cedric Morris, Exotic birds, pencil & watercolour, signed and dated 12.21, 49 x 27cm, unframed. Rosebery's, London. Mar 02. £420.

1687

W Arntz, oil on canvas, 18thC, Italian landscape, signed, 34 x 42in. Gorringes, Lewes. Apr 01. £420.

1688

E Kaufmann after H Walkins Wild, The Bramham Hunt, one of a set of six coloured lithographs with inscribed mounts, 18.5 x 23.25in, stained frames. Andrew Hartley, Ilkley. Aug 02. £420.

1689

Unsigned, 18thC portrait of two female saints with a book, on canvas, framed, 11 x 12in. Tring Market Auctions, Herts. Sep 02. £420.

1690

Flemish School, Cobbler and Lady, oil on panel. W & H Peacock, Bedford. Jan 03. £420.

1691

George Fall, Ripon Cathedral, signed, 10 x 14in, stained frame. Andrew Hartley, Ilkley. Aug 04. £420.

1692

Victorian portrait miniature on ivory, Seated Young Girl, 4 x 3.5in. Denhams, Warnham. Aug 03. £420.

1693

J. F. Herring Jnr, oil painting on canvas, Chestnut Horse in Stable, 12 x 15in, relined. Denhams, Warnham. Aug 04. £420.

1694

Sally Hynard, (b.1959) Zebra, signed lower left, S A Hynard, cromacolour, 48 x 30cm. Cheffins, Cambridge. Sep 03. £420.

1695

Early 18thC English School, oil, shoulder length portrait of a young girl, relined canvas, 30 x 25in, gilt moulded and swept frame. Canterbury Auc. Galleries, Kent. Dec 03. £420.

1696

Naive miniature portrait, c1830, lady wearing a blue gown, watercolour, framed, 17 x 12cm. Richard Winterton, Burton on Trent, Staffs. Apr 04. £420.

1697

Continental School, oil on canvas, courting couple by a river, indistinctly signed, decorative gilt frame, af, 61 x 74cm. Thos Mawer & Son, Lincoln. Sep 04. £420.

1698

A. Gardiner, British School early 20thC, High tea by a fireplace in an interior, oil on canvas, signed, 60.7 x 80.2cm. (unframed) Rosebery's, London. Sep 04. £420.

1699

Attributed to Thomas Bredford Meteyard, Alpine valley in winter, oil on panel, inscribed on the reverse, 21.5 x 32.5cm. Rosebery's, London. Sep 04. £420.

1700

Frank Rousse, (FL 1897-1915) Upper Harbour, Whitby, signed, 11 x 16.5in, stained frame. Dee Atkinson & Harrison, Driffield. Nov 04. £420.

1701

Follower of Richard Wilson, A Mountainous landscape with a figure and cattle and a Landscape with a figure and a dog, pair, oil on canvas, 46 x 60cm. Sworders, Stansted Mountfitchet. Nov 04. £420.

1702

William Lionel Wyllie, (1851-1931) etching, South Bay, Scarborough, signed in pencil, 4.75 x 14.75in. Gorringes, Lewes. Mar 04. £420.

1703

Yuri Frolov, (1925-1989), 'Two Fishermen', 1964, oil on board, signed, 40 x 50cm, framed. Lots Road Auctions, Chelsea. Dec 04. £420.

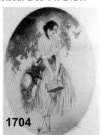

1704

Louis Icart, 'Empty Cage', etching with colours, signed in pencil and numbered 238, published 1922, oval 44 x 32cm to plate mark. Sworders, Stansted Mountfitchet. Nov 04. £420.

1705

Follower of Adriaen Van Ostade, Boors in a Tavern, oil on panel 34 x 24cm. Sworders, Stansted Mountfitchet. Nov 04. £420.

1706

Charles Johnson Payne, called 'Snaffles' 'Bon Voyage (French Artillery Man)' limited edition reproduction, printed in colours, finished by hand 44 x 34cm and another, 'VIMY', signed in pencil, 43.5 x 33.5cm. (2) Sworders, Stansted Mountfitchet. Nov 04. £420.

1707

Rowland Hilder, (1905-1993) sailing boat in an estuary, signed, 10.25 x 18.75in, gilt frame. Dee Atkinson & Harrison, Driffield. Jul 04. £420.

1708

William Richardson, (fl.1842-77) oil on canvas, Street scene, York Minster, 30 x 25in. Gorringes, Lewes. Jul 04. £420.

1709

Tom Robertson, (1850-1947) oil on wooden panel, 'Near Haddon Hall, Derbyshire', signed, 9.5 x 11.5in. Gorringes, Lewes. Jul 04. £420.

1710

Philip Padwick, (1876-1958) pair of oils on board, Hillside town and harbour, signed, 14 x 20in. Gorringes, Lewes. Mar 04. £420.

1711

Charles Johnson Payne, (1884-1967) colour print, 'The Guns!, Thank God!, The Guns!', signed in pencil, 18 x 25in, unframed. Gorringes, Lewes. Mar 03. £420.

1712

William Lionel Wyllie, (1851-1931) etching, 'Westminster', signed in pencil, 7.25 x 9in. Gorringes, Lewes. Mar 03. £420.

1713

Gnyuki Torimaru, original design for a green evening dress with red draped back, for Princess Diana, front and back views, pencil & water-colour, signed, dated 1986 lower right, 31.5 x 25.5cm, unframed. Dreweatt Neate, Donnington. Nov 02. £420.

> Condiiton, rarity, provenance and fashion are the key market operators currently dictating values.

1714

Philip H. Rideout, (fl.1880-1912), pair of oils on board, Hunting scenes, signed, dated 1907, 7 x 14.5in. Gorringes, Lewes. Oct 02. £420.

1715

Circle of J Crome, Senior (English, 19thC) View of two Church Towers from a Bridge, bears signature lower left 'J Crome' on the bridge, oil on board, 26 x 21cm. Cheffins, Cambridge. Feb 05. £420.

1716

Cecilia Goulborn, water-colour, trophy painting of a salmon, killed by L. J. Rich ardson-Gardner, Essiemore Pool1910', signed, 15 x 44in. Gorringes, Lewes. Oct 02. £420.

1717

Early 19thC English School, oil on wooden panel, family at rest before a Georgian country house, 6 x 9in. Gorringes, Lewes. Apr 02. £420.

1718

Charles James McCall, 1907-89, watercolour, landscape, signed & dated 1933, 14.75 x 12.5in. Great Western Auctions, Glasgow. Apr 05. £420.

1719

English School, late 19thC, A Landscape with a Camel Train, Egypt, oil on canvas, 73 x 127cm. Sworders, Stansted Mountfitchet. Feb 05. £420.

1720

Colin Ruffell, (1939-) Steam Sailing Ship with Two Seagulls, signed, inscribed verso 'Mag (Thirteen)', acrylic on canvas board, 61 x 76cm. Sworders, Stansted Mountfitchet. Apr 05. £420.

1721

Henry Earp Senior, oil on board, Cattle in a landscape, signed, 8 x 12in. Gorringes, Bexhill. Mar 02. £420.

1722

Rowland Langmaid, (1897-1956) etching, Tower Bridge, signed in pencil, 8.5 x 12in, unframed. Gorringes, Bexhill. Mar 02. £420.

1723

English School 19thC, Two Judges sampling a drink at a table, oil on canvas, 55.8 x 40.5cm. Rosebery's, London. Jun 05. £420.

1724

Early 19thC English School, watercolour, cart passing a country house, 12 x 16in. Gorringes, Bexhill. Mar 02. £420.

1725

Manner of Murillo, The Madonna and Child in a stable, oil on metal panel, signed 'J Harman Invenit et pinxit A: 1781', 33.1 x 26.3cm, unframed. Rosebery's, London. Mar 05. £420.

Hammer Price £420

1726

After Picasso, Archer & lips amongst the clouds, litho-graph, signed within plate, twice, 40 x 32cm, and 6 more lithographs after the same hand, unframed. Rosebery's, London. Mar 05. £420.

1727

Late 18thC English School, watercolour on ivory minia-ture, Portrait of a young lady with flowing locks, 2.25 x 2in, locket frame. Gorringes, Lewes. Jun 03. £420.

1728

Edward Tristrom (?) wooded river landscape, oil on panel, signed and dated 1901, 36.8 x 23.4cm. Rosebery's, London. Mar 05. £420.

1729

Edward Lear, (1812-1888) 'San Marino', ink and water-colour inscribed, dated May 8. 1867, 2.75 x 4.5in. Gorringes, Lewes. Jun 03. £420.

1730

Henry John Sylvester Stannard, (1870-1951) River Landscape at Sunset, signed, watercolour, 24.5 x 34.5cm. Sworders, Stansted Mountfitchet. Apr 05. £420.

1731

Victorian School, water-colour on ivory, miniature of an army officer, 3 x 2.5in. Gorringes, Lewes. Mar 05. £420.

1732

Richard Peter Richards, (1840-1877) Portrait of a Seated Lady, watercolour and bodycolour, 33 x 25cm. Sworders, Stansted Mountfitchet. Apr 05. £420.

1733

Des Gorman, oil on gesso 'Still life with flowers, signed recto and signed and entitled verso, 29.5 x 25.5in. Great Western Auctions, Glasgow. Jun 05. £420.

Hammer Prices £420 - £400

1734

William Crosbie, RSA, oil on canvas, 'The Frenchman', signed, 30 x 24in. Great Western Auctions, Glasgow. Jun 05. £420.

1735

John Stezaker, 'Eros', post-card collages, (7 pieces) 20 x 24.5cm each. Rosebery's, London. Jun 05. £420.

1736

William George Robb, The Shepherd, oil on panel, signed, inscribed label verso, 43 x 51.4cm. Rosebery's, London. Jun 05. £420.

1737

William Watt Milne, (British, exh.1927-1934) oil on canvas, Trees & Water at Houghton, Cambridgeshire, oil on canvas, 51 x 61cm. Cheffins, Cambridge. Apr 05. £420.

1738

Henry Matthew Brock, RI (1875-1960). The Beekeeper's Rest, watercolour, signed, 32.5 x 49.7cm. Bristol Auction Rooms. May 02. £410.

1739

Grigory Azizyan, (b.1923), 'Village at the Foot of the Mountain', oil on canvas, signed, 75 x 100.5cm, framed. Lots Road Auctions, Chelsea. Dec 04. £410.

1740

William Lionel Wyllie RA, R.I., R.E. (1851-1931) Fishing boats passing Spit-bank Fort on their return to Portsmouth, etching, signed in pencil, 19.5 x 24.5cm. D M Nesbit & Company, Southsea. May 03. £410.

> Prices quoted are hammer and exclude the buyer's premium. Adding 15% will give approx. buying price.

1741

English School (19thC) 'Summer landscape with a young girl seated beside a pond', also a companion, 'A young girl on a country track', oils on panel, both with monogram signature 'csy(?)' and dated '83, 17 x 25cm (2). Hampton & Little-wood, Exeter. Jul 04. £410.

1742

Donald Bain, 1904-79, chalk drawing, 'Cubist Head', signed, 11.75 x 10.75in. Great Western Auctions, Glasgow. Apr 05. £410.

1743

19thC oil painting of a young woman, 24 x 29in. Lambert & Foster, Tenterden. May 02. £410.

1744

Watercolour of a coastal scene depicting moored boat, by W B Thomas, approx 8 x 13in. John Taylors, Louth. Mar 01. £405.

1745

Mary Charlotte Green, (exh 1890-1919) Cambridge with King's College Chapel to the distance from across Coe Fen, signed with monogram, watercolour, 22 x 46cm. Cheffins, Cambridge. Jun 01. £400.

1746

Thomas Danby, (1818-1886) watercolour, fisher boys resting by the banks of a pond, old label attached verso, 'Royal Common near Esltreat, Surrey', signed, 10.5 x 19.75in. Gorringes, Bexhill. Oct 01. £400.

1747

Stanley Orchart. A view of Dedham High Street, oil on canvas, signed, 20 x 24in. Sworders, Stansted Mountfitchet. Apr 01. £400.

1748

An original Donald McGill seaside cartoon, watercolour on board, 24.9 x 17.8cm. Dreweatt Neate, Newbury. Nov 01. £400.

1749

Louis Wain, (1860-1939) pair of pen and ink carica-tures 'Catrobats', signed, 10.25 x 5in. Gorringes, Lewes. Mar 01. £400.

1750

G Capone, Garden steps beneath lemon trees, water-colour, signed, 50 x 32cm. Sworders, Stansted Mountfitchet. Apr 01. £400.

1751

Claude Pratt, signed, dated 1905, watercolour on paper, full portrait of Edwardian gentleman, titled to the mount 'Allen Edwards', 15.5 x 9in. Biddle & Webb, Birmingham. Dec 03. £400.

Arthur Dudley, still life with fruit, one of a pair of water-colours, 10 x 30in. Sworders, Stansted Mountfitchet. Jul 01. £400.

1753

Arthur Brandish Holt, oil on canvas. Locke & England, Leamington Spa. Nov 02. £400.

1754

Henry Earp Snr, (1831-1914) watercolour, cattle watering in a pond before cottages and a church, 21 x 15.5in. Gorringes, Bexhill. May 02. £400.

1755

J F Bland, 'Paxos, Greece', pencil & watercolour heightened with white, signed and inscribed, 14.4 x 22.5cm. Rosebery's, London. Mar 02. £400.

1756

James Kay, Head of Glen Falloch, signed, framed and glazed, 9.5 x 13.5in. Tring Market Auctions, Herts. May 02. £400.

1757

Francis Kelly (1927-) oil on canvas, 'Reflection', signed, 24 x 18in. Gorringes, Lewes. Apr 02. £400.

1758

After Edward Wolfe, R.A., 'Song of Songs', complete set of 12 illustrations printed offset lithography by Adrian Lack at the Senico Press, Charlbury on aluminium lined paper in 4 colours and matt varnish, 24 from the edition of 250, each signed and numbered in pencil on the mount, 35.6 x 26.5cm ea., frontispiece dedicated in pencil, with slipcase, four framed. Rosebery's, London. Dec 04. £400.

1759

English School, 19thC portrait of a lady in a red cloak, oil, 21 x 17in. Sworders, Stansted Mountfitchet. Jul 01. £400.

1760

North Italian School, 17th/18thC, Portrait of a cleric, traditionally held to be St Charles Borromeo, Archbishop of Milan, oil on copper panel, ripple moulded frame, 29.2 x 23.2cm. Rosebery's, London. Sep 02. £400.

1761

Dubardeau, (French 19thC) The Standard Bearer, signed, oil on canvas, 82 x 64cm. Locke & England, Leamington Spa. Jan 03. £400.

1762

F. E. Clave, Le Moulin Rouge, Paris, signed, also signed and inscribed on reverse, oil on canvas, 39 x 46cm. Sworders, Stansted Mountfitchet. Mar 03. £400.

1763

L Riva, The Rosary, watercolour, signed, 46 x 25.5cm. Locke & England, Leamington Spa. Jul 03. £400.

1764

Edward Arden, (Edward Tucker Jnr), watercolour of Staithes, 10.5 x 16.5in. Boulton & Cooper, Malton. Jul 04. £400.

1765

Herbert Dicksee, 'Sleeping puppy', etching, signed in pencil, 10 x 14in. Halls Fine Art, Shrewsbury. Dec 03. £400.

1766

Jacques Abraham Herman Jat, Arab horsemen in a desert landscape, signed with initials A H, oil on panel, 12.5 x 22.5cm. Sworders, Stansted Mountfitchet. Nov 04. £400.

1767

Charles Pickard, ARCA, portrait of Charles Wyville Thomson, FRS, signed, watercolour, 24.5 x 28cm. Sworders, Stansted Mountfitchet. Feb 04. £400.

1768

Theodore Henry Augustus Fielding, aquatint, 'Tortola - one of the Virgin Islands', for Johnson's Views in the West Indies, 1827, 10.5 x 17in. Gorringes, Lewes. Oct 04. £400.

Charles Edward Brittan, (19th/20thC), Sheep grazing near Burrator Reservoir, watercolour, signed, 35 x 26cm. Hampton & Littlewood, Exeter. Apr 04. £400.

Circle of Henrietta Ronner, (1821-1909), Kitten stealing a fish from a vegetable laden kitchen table, oil on panel, bears signature H. Ronner, 25.5 x 20.5cm. Hampton & Littlewood, Exeter. Jul 04. £400.

Figures outside The New Inn, Lynmouth Bridge, oil on canvas, inscribed, 63 x 83cm. Hampton & Littlewood, Exeter. Jul 04. £400.

Pietro Psaier, Italian b.1939, The Beatles, NOW, silkscreen print, 67 x 48cm. Cheffins, Cambridge. Jul 04. £400.

Henry Sylvester Stannard, (1870-1951), watercolour, Hayrick and haycart, signed, 10 x 14in. Gorringes, Lewes. Oct 04. £400.

Charles Chaplin, oil on canvas, nude study of a young woman, 1877, 26 x 19in. Gorringes, Lewes. Oct 04. £400.

Watercolour, signed Thomas Swift Hutton, 'Cocklers sands of Dee' 25 x 35cm. Boldon Auction Galleries, Tyne & Wear. Sep 04. £400.

Circle of Andrea Casali, The Madonna and Child, oil on canvas, 20.5 x 22.8cm. Rosebery's, London. Sep 04. £400.

Dirk Anton Teupken, Dutch School early 19thC, 'The Snow Sarh off Amsterdam', pen, black ink & watercolour, signed and dated 1827, 47 x 66.5cm. Rosebery's, London. Sep 04. £400.

Evelyn Gibbs, Moored vessels in a tranquil Mediterranean harbour, oil on canvas, signed and dated '45, 50 x 61cm. Rosebery's, London. Sep 04. £400.

Clifford Hall, A Woman reclining on a Chaise Longue, signed and dated 1945, oil on canvas 34 x 44cm. Sworders, Stansted Mountfitchet. Nov 04. £400.

Erte, gouache, stage set, street scene with flower seller. Gorringes, Bexhill. Sep 04. £400.

W L Wyllie, etching, The Upper Pool. Gorringes, Bexhill. Sep 04. £400.

Alfred Cohen, Matador standing full-length, (recto), Meat market, (verso), watercolour, gouache and chalk, signed with initials, 70 x 47.5cm with a cityscape in watercolour by the same hand, signed, 48.5 x 63.5cm. (2) Rosebery's, London. Sep 04. £400.

Hannah Barlow, pen and ink drawing 'To The Rescue', of a tethered dog, cat and mouse, initialled and dated April 12th 1870, 10.5 x 7.5in. Gorringes, Lewes. Sep 04. £400.

Circle of John Hoppner, R.A. Portrait of a gentleman, quarter-length turned to the left, oil on canvas, 74.5 x 62cm. Rosebery's, London. Sep 04. £400.

Henri Pfeiffer, Organic form and flower, watercolour and coloured ink, signed with monogram, dated '27 in pencil, 47 x 32.5cm with two other similar studies in watercolour. (3) (unframed) Rosebery's, London. Sep 04. £400.

Elena Khmeleva, 'Modelling for the Young Artist, oil on canvas, signed, 50 x 40cm, framed. Lots Road Auctions, Chelsea. Dec 04. £400.

1787

Henry Redmore, (1820-1887) beached shipping vessels, fishermen in the foreground, signed and dated 1866, 8.5 x 10.5in, gilt frame. Dee Atkinson & Harrison, Driffield. Jul 04. £400.

1788

After Myles Birkett Foster, Cattle and figures by a stream in a Highland landscape, monogrammed, watercolour, 23 x 30cm. Henry Adams, Chichester. Jan 03. £400.

The numbering system acts as a reader reference as well as linking to the Analysis of each section.

1789

F W Booty, (1840-1924) Yorkshire Abbey, original artist's label attached, signed, 13.25 x 9 .5in, stained frame. Dee Atkinson & Harrison, Driffield. Jul 04. £400.

1790

George Frederick Bird, (b.1883) oil on canvas, Portrait of Kitty Bird, wearing a fur cape, 22 x 17in. Gorringes, Lewes. Jan 04. £400.

1791

Valentin Masieri, engraving, Amfiteatro Detto Larena di Verona, 1696, 28 x 35in. Gorringes, Lewes. Jul 04. £400.

1792

William Lionel Wyllie, (1851-1931) etching, Blackwall Reach, signed in pencil, 7 x 12.75in. Gorringes, Lewes. Mar 04. £400.

1793

Italian School, oil on canvas, figures on a sunlit sandy track beside a rocky outcrop, sea in the distance, indistinctly signed, 20 x 25in. Dee Atkinson & Harrison, Driffield. Mar 04. £400.

1794

J B Crome attributed on the frame, Continental moonlit river landscape with figure in a rowing boat in the foreground and ruins on a hill, oil on canvas, 30 x 40cm. Thos. Mawer & Son, Lincoln. Mar 04. £400.

1795

Frank Rousse, (19th/20thC) fishing boats Whitby harbour, signed, 9.25 x 15in, stained frame. Dee Atkinson & Harrison, Driffield. Jul 04. £400.

1796

Follower of Ozias Humphrey, unfinished study of a family group, pencil with touches of red chalk, 11.2 x 14.8cm and Follower of Bartolozzi, Two putti in a glade, pencil and red chalk, 18.2 x 30.5cm. (2) (unframed) Rosebery's, London. Dec 04. £400.

1797

19thC English School, oil on board, Royal Mail steam ship 'Valetta', 16.5 x 22in. Gorringes, Lewes. Mar 03. £400.

1798

Louis Icart, 'Cassanova', etching with drypoint and aquatint printed in colours, signed and numbered 445 in pencil, 51.3 x 33cm. Rosebery's, London. Dec 04. £400.

1799

Caeser Willich, Figures by an arch in a village street, oil on canvas, signed, 46.7 x 33.1cm. Rosebery's, London. Dec 04. £400.

1800

Henry J Kinnaird, (fl.1880-1908) watercolour, Shepherd and flock on a lane, signed, 6 x 8in. Gorringes, Lewes. Apr 03. £400.

1801

William Thomas Nicholas Boyce, (1857-1911) watercolour, Sail and steam ships in a rough sea, signed, dated 1904, 14 x 21in. Gorringes, Lewes. Mar 03. £400.

1802

Gaele Covelli, (1872-1912) Portrait of a Woman, inscribed verso on a label, pastel, 52 x 39cm. Hobbs Parker, Ashford. Jan 05. £400.

1803

Thomas H. Hunn, (Exhibited 1880-1908), watercolour, Old Manor House near Guildford, signed, 13 x 20in. Gorringes, Lewes. Apr 02. £400.

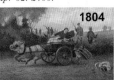

1804

A... Roland Knight, (19thC) Mixed Sports, signed, inscribed with title on reverse, oil on canvas, 36 x 56cm. Sworders, Stansted Mountfitchet. Feb 05. £400.

Hammer Price £400

1805

Italian School, oil on canvas, Cupid and a putto, oval, 14 x 17in. Gorringes, Lewes. Apr 02. £400.

1806

S Maresca, Italian 19/20thC, oil on canvas, Portrait of a boy, head and shoulders, smoking a cigarette, signed, 38.2 x 26cm. Rosebery's, London. Jun 05. £400.

1807

Anne Mew, (Exhibited 1908-19), watercolour, Portrait of Mrs. Elsie Chiele, signed and dated 1910, 16 x 11.5in. Gorringes, Lewes. Apr 02. £400.

1808

Des Gorman, mixed media 'Seated Figure', signed recto and signed & entitled verso, 14.25 x 10in. Great Western Auctions, Glasgow. Jun 05. £400.

1809

Oliver Messel, (1904-1978) charcoal and gouache, 'Pages in Cinderella', signed, 9 x 11in, unframed. Gorringes, Lewes. Jul 03. £400.

1810

H.G. Gibson, 19thC, oil on canvas, entitled The Sentinel, on the Lookout, dog looking out of a wooden kennel, signed and dated 1893, 11.25 x 14.5in, gilt gesso frame. Diamond Mills & Co, Felixstowe. Dec 04. £400.

> The illustrations are in descending price order. The price range is indicated at the top of each page.

1811

English School (19thC) Portrait of a Young Girl with a music box, oil on panel, 27 x 21cm. Cheffins, Cambridge. Feb 05. £400.

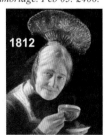

1812

C... Heuser, (19/20thC) Lady in traditional head-dress drinking tea, signed top left, oil on panel, 15.5 x 12cm. Sworders, Stansted Mountfitchet. Feb 05. £400.

1813

Snaffles, 'The Bonnie Blue Bonnets frae ower the Border', panel 30 x 32cm, framed and glazed. Lambert & Foster, Tenterden. Jan 05. £400.

1814

Tom Coates, (born 1941) 'Christiana Krulich' Portrait of an artist in her studio, signed with monogram, oil on canvas board, 24 x 34cm. Sworders, Stansted Mountfitchet. Apr 05. £400.

1815

Edward Holroyd Pearce, RBA (British, 1901-1990) Walberswick Harbour, Suffolk, signed lower left Holroyd Pearce '81, oil on board, 26 x 35cm. Cheffins, Cambridge. Apr 05. £400.

1816

K. Simpson, early 20thC, Viareggio and Venetian scene, signed pair, one titled and dated 1910, 10 x 13.75in, gilt frames. (2) Dee, Atkinson & Harrison, Driffield. Feb 05. £400.

1817

French School 19thC, 'Pastoral Normandie', pair, gouache, 36 x 53cm ea. (2) Rosebery's, London. Jun 05. £400.

1818

Mid-19thC English School, oil on panel, Portrait of a lady, seated beside a water cistern, 24 x 18in. Gorringes, Bexhill. Mar 02. £400.

1819

Follower of Frederick Calvert, Fishing vessels in stormy weather by a pier, oil on canvas, 71 x 91cm. Rosebery's, London. Mar 05. £400.

1820

Attributed to John Downman, (1750-1824) Portrait of a young man, half length, oil on canvas, 11.9in, oval. Clarke Gammon Wellers, Guildford. Jun 05. £400.

1821

17thC Flemish School, oil on copper panel, Travellers in a landscape, initialled W, 7 x 9.5in. Gorringes, Bexhill. Mar 02. £400.

1822

After Guido Reni, (1575-1642) The Madonna with the Sleeping Christ Child, oil on canvas, 48 x 58cm. Cheffins, Cambridge. Apr 05. £400.

Section IX < £400 to £300

More young people are entering the market. They prefer Trevelyan, or for example Beryl Cook, (1926-) the *Groovy Granny*! Beryl's originals now go to £14,000 and a lithograph, *Girls Night Out* at 33 x 29 inches recently fetched a staggering £3,000!

30% more pictures now sell at provincial auctions than in the previous Section. What is the nature of pictures now that is different from previously? Let us work our way through pages 118-119 to see if anything comes to light. The first named painter is G F Price at **1824**, a decent sized landscape. We cannot really measure quality but as far as I can tell this artist has no form. Neither it would seem has J Miller Watts at **1825**, *Study of a Terrier*. **1826** is an attribution to David Farquharson who incidentally has an oil median of £3,400, and a recent top price of £6,600. We are not told the size of this painting but at £380 hammer the market doesn't seem convinced. We can forget **1827** and **1828** is a 'school' picture of small size. At **1829** is what appears to be a competent London townscape, although only a small watercolour. But who is Henry M Livens, painting in 1920? Probably not the nineteenth century Henry Livens who painted still life. **1830** is an Archibald Thorburn print. His last watercolour at **1147**, (very small) fetched £880 and his next picture on page 126 at £340 is also a print, so nothing amiss here. *The Grand Canal* at **1831** is by S Herbert, which could be Sidney Herbert. (1854-1914) At only £380 this is less than half this artist's median but it is also small and the price fits pro-rata with his other works. Next at **1832** is a Herbert Moxon Cook (1844-c1920) watercolour of Windsor Castle which is bang on this artist's median. Next at **1833** is an attribution to Walter Schroder. (fl.1885-1932 British) Everything has been run-of-the-mill but this genre style oil is different. Large and not perhaps a home picture, this is a piece of history and could be a worthwhile investment. I would have bought this painting if I could be sure it hadn't faded, but it looks alright.

After more minor artists we come to the Henry Sylvester Stannard (1870-1951) at **1838**. Yes, a good artist but W&H Peacock, the auctioneers tell us nothing about the size or the condition so one should assume the market got it right. *Three Children at the Seaside* at **1839** is the right painting but has no attribution. The Lilian Stannard *Cottage Garden* at **1842** for only £380 is delightful and well below her recent median of £600. However it is also very small at only 4 x 6.5 inches, so over £400 with premium wasn't particularly cheap. Need we go on? Peter Graham (1836-1921) at **1857** seems to be under performing. His oil median is £700 and he averages over £2,000. Recently one of his works fetched £16,000 but also another fetched only £370, and our example is even smaller. We must expect that this latest figure reflects the poorer performance of many nineteenth century artists in recent times. Presumably, also, this may be run-of-the-mill. It looks it! This is bound to be reflected in sales across the board and the market shift over the last twenty years, which has quickened in the last four, is a factor discussed in detail in the ***Introduction***. Can we therefore possibly identify in this Section further pictures which could have been influenced by this shift in the market towards twentieth century art?

At **1846** and **1853** are two portraits, the second very modernist and popular. Other portraiture on this page no longer has the same appeal for younger buyers. This Section has more than its usual share of modernist and abstract art. You cannot miss such pictures as **1841**, **1848**, **1864** and **1878**. See also **1876** and **1885**. At **1875** is a very small oil by Edward Holroyd Pearce (1901-1990), showing the Ald at Aldeburgh, Suffolk. This 'traditional' work has a modern feel and, for a small painting from an artist with little form, has done well. See also the Charles McCall beach scene painted in 1968 which could now fetch more if it were to return to the market. This is precisely what the market is looking for. Compare the Trudolf Stone hunting scene at **1915**, an original oil at 13 x 26 inches and a nice decorative size, with the Julian Trevelyan (1910-1988) artist's proof print of *Westminster* for the same money. Trevelyan oils have gone to £18,000 and works on paper over £4,000. See the ***Introduction***. More young people are entering the market. They prefer Trevelyan, or for example Beryl Cook, (1926-) the *Groovy Granny*! Beryl's originals now go to £14,000 and a lithograph, *Girls Night Out* at 33 x 29 inches recently fetched £3,000. See Beryl Cook at **1922**. Turning to page 125 we are due a laugh! At **1956** is the actual *Fallen Madonna with the Big Boobies* from the famous stage show *Allo, Allo*. Try to spot other prints, say by Archibald Thornburn, which defy fashion. Note also the good price paid for a modern 'school' nude, quite small at only 13 x 8 inches. See also **2100**. Other interesting pictures which explain our theme is the Henry Moore lithograph at **2059** and **2089**, **2104** and **2109**. Meanwhile I am surprised that an Adrian Gillespie *Beach* did not fair better at **2095**. I cannot trace this artist or a date. Finally, at **2166**, the Walter Beauvais (is he not English?) *Beach Scene* is about right for this artist, but this is an improving market. I like **2180**, the girl on a beach with a teapot, best of all. This portrait is typical twentieth century popular art and, at about 24 x 20 inches just the right size.

Hammer Prices £390 - £380

Two photographic montages depicting Canterbury Cricket Week 1877 and Canterbury Cricket Week, Jubilee Meeting 1891, each 17.5 x 22.5in. (damaged) Canterbury Auction Galleries, Kent. Aug 01. £390.

G. F. Price, oil painting on canvas, Lane at Addington Kent, scene with cattle being driven, 15 x 24in. Denhams, Warnham. Aug 04. £380.

J Miller Watts, Study of a Terrier, oil on wooden panel, signed, 12.5 x 13in. Gorringes, Lewes. Feb 01. £380.

Attributed to David Farquharson, oil sketch on board, study of five sheep. Gorringes, Bexhill On Sea. Dec 04. £380.

Andre Dzierzynkski, 'Binnen', Amstel en Groenburgual, Amsterdam, oil on board, signed and dated 1965, 50 x 40cm. Cheffins, Cambridge. Jun 01. £380.

118 *Picture Prices*

Anglo-Chinese school (19thC) 'Study of Chinese female boat people', and companion, 'A Chinese male with an opium pipe, while a female looks on', oils on canvas, 26 x 32cm, unframed. Hampton & Littlewood, Exeter. Jul 04. £390.

Henry M Livens, watercolour, Oxford Circus, signed, dated (19)20, 11 x 15in. Gorringes, Lewes. Jun 01. £380.

Archibald Thornburn, Black grouse, signed in pencil in the margin, coloured print, 10 x 7in. Sworders, Stansted Mountfitchet. Apr 01. £380.

S. Herbert, The Grand Canal, Venice, Italy, c1890, oil, signed lower left, period gilt gallery frame, 25 x 46cm. Richard Winterton, Burton on Trent, Staffs. Jan 02. £380.

Herbert Moxon Cook, (1844-c1920) watercolour, Windsor Castle, signed and inscribed, 6.5 x 13.5in. Gorringes, Bexhill. Dec 01. £380.

Attributed to Walter Schroder, (Exh 1885-1932) Sewing day, oil on canvas, unsigned, 36 x 28in. Sworders, Stansted Mountfitchet. Apr 01. £380.

A. Holland, pair of extensive wooded riverscapes with mountains in the distance, signed, framed and glazed, 17.5 x 29in. Tring Market Auctions, Herts. May 02. £380.

William Hulk, (1852-1906) Near the Brook, oil on canvas, signed & entitled verso, 12 x 18in, unframed. Gorringes, Lewes. Apr 01. £380.

After Robert Home, J Ramsden Optician to His Majesty, mezzotint by John Jones pub'd 1791, 17 x 13.5in. Sworders, Stansted Mountfitchet. Jul 01. £380.

H. S. Lynton, A Street Scene in Cairo, oil on canvas, signed, dated 1866, glazed gilt gesso frame, 19.5 x 29in. Amersham Auction Rooms, Bucks. Sep 02. £380.

H Sylvester Stannard, Autumnal landscape, watercolour. W & H Peacock, Bedford. Feb 03. £380.

Unsigned, on board, Three children at the seaside, 14 x 19in, framed. Tring Market Auctions, Herts. Jan 03. £380.

Federico Ballesio, 19thC, Italian, watercolour, peasant girl holding a cabbage, signed, 25 x 18.5in. Gorringes, Bexhill. Feb 03. £380.

Wilson Scottie, modern art pencil drawing, 'Heads', 14 x 11in, signed. Denhams, Warnham. May 04. £380.

1842

Lilian Stannard, Cottage Garden, signed, watercolour, 10 x 16.5cm. Sworders, Stansted Mountfitchet. Mar 03. £380.

1843

Conrad H R Corelli, Fishing Smack on Hastings Beach, signed, framed and glazed, 7 x 9.5in. Tring Market Auctions, Herts. Mar 03. £380.

1844

D Bates, Welsh landscape with watering cattle, oil on canvas, signed, dated 1863, 29 x 39cm, gilt frame. Locke & England, Leamington Spa. May 03. £380.

1845

George Deville Rowlandson, Refusing at the Brook, signed, 10.25 x 14.25in, gilt frame. Andrew Hartley, Ilkley. Aug 03. £380.

1846

James Bolivar Manson, (1879-1945) oil on wooden panel, 'Jean Manson, the artist's daughter', Maltzahn Gallery label, 14 x 9.75in. Gorringes, Lewes. Jul 04. £380.

1847

Follower of Henry Moore, Seated female nude, charcoal, 58 x 44cm. Rosebery's, London. Sep 04. £380.

1848

Pierre Noel Martin, Op Art construction, perspex mixed media construction, signed, dated 1977 on the reverse, 50.5 x 50.7cm, with another Op Art construction titled 'The Vigotouse Trumpeting', signed with monogram, dated 1976 on the reverse, 53 x 61cm. (2) Rosebery's, London. Sep 04. £380.

1849

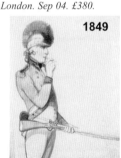

Attributed to Thomas Rowlandson, Study of a soldier standing full-length, pen, black ink, wash and water colour, 20.7 x 12.8cm. Rosebery's, London. Sep 04. £380.

1850

18thC English School, oil on canvas, portrait of Benjamin Follett of Topsham, Devon, 29 x 24in. Gorringes, Lewes. Apr 02. £380.

Hammer Price £380

1851

W L Wyllie, etching, harbour scene. Gorringes, Bexhill. Sep 04. £380.

1852

Ruskin Spear, oil on canvas, Portrait of Rt. Hon. The Lord Netherthorpe. Gorringes, Bexhill. Sep 04. £380.

> Artists or themes can be followed through the colour coded Index which contains over 4500 cross references.

1853

Lidia Khanameryan (b.1930), 'Spotted Dress', 1960, oil on canvas, signed, 65 x 60cm, framed. Lots Road Auctions, Chelsea. Dec 04. £380.

1854

Circle of James Leakey, Portrait of a gentleman, quarter-length, traditionally held to be Mr. Southworth, oil on canvas, oval, inscribed verso, 69.5 x 57.2cm, unframed. Rosebery's, London. Dec 04. £380.

1855

John Blair, watercolour, Edinburgh from Greenend. Gorringes, Bexhill. Sep 04. £380.

1856

Vartika Karapetyan, (b.1927) 'Grapes and Peaches', 1984, oil on canvas, 50 x 65cm, framed. Lots Road Auctions, Chelsea. Dec 04. £380.

1857

Peter Graham, RA (Scottish, 1836-1921) The Scottish Coast, signed lower right 'Peter Graham', oil on canvas, 37 x 60cm. Cheffins, Cambridge. Apr 05. £380.

1858

Tom Robertson, (1850-1947) oil on board, 'Old Cottages, Oudon', signed, 10 x 12in. Gorringes, Lewes. Jul 04. £380.

1859

James Bolivar Manson, (1879-1945) oil on wooden panel, 'Windmill, Storrington', signed, dated 1911, 10 x 14in. Gorringes, Lewes. Jul 04. £380.

Hammer Price £380

1860

George Chapman, (1908-1993) oil on board, 'Welsh Gossip', signed, exhibition label verso, 36 x 25in. Gorringes, Lewes. Sep 04. £380.

1861

Emily Beatrice Bland, oil on board,Flowers in a jug by a window, signed, inscribed on remains of label verso, 60.8 x 51cm, unframed. Rosebery's, London. Dec 04. £380.

1862

Attributed to Maxime Dastugue, Portrait of a lady standing full-length in a blue dress holding a fan, oil on canvas, signed, 60.7 x 38cm, unframed. Rosebery's, London. Dec 04. £380.

1863

Follower of Thomas Sydney Cooper, Sheep descending from a crag, oil on panel, 18.7 x 28.8cm & a British School 19thC, Haymaking by a thatched cottage, oil on canvas, 18 x 25.5cm. Rosebery's, London. Dec 04. £380.

120 *Picture Prices*

1864

Agustin Ubeda, Two figures in a landscape, oil on canvas, signed, 18.2 x 23.5cm. Rosebery's, London. Dec 04. £380.

1865

Charles Knight, (1901-1990) watercolour, 'Rocky Shore and Open Sea', signed, RSW label verso,10.5 x 14.5in. Gorringes, Lewes. Apr 03. £380.

1866

Frederick Golden Short, (1863-1936) View in the New Forest, oil on artist board, signed, 9 x 12in. Gorringes, Lewes. Mar 03. £380.

1867

John Rattenbury Skeaping, (1901-80) watercolour and charcoal, Horse and jockey jumping a fence, signed and dated '59, 16 x 21.5in. Gorringes, Lewes. Mar 03. £380.

1868

Scipione Simoni, (1895-1930), oil on canvas, Fishing boats in the Bay of Naples, signed, 19 x 27in. Gorringes, Lewes. Oct 02. £380.

1869

19thC English School, oil on canvas, portrait of Charlie, a fox terrier for Lord Salisbury, 8 x 10in, unframed. Gorringes, Lewes. Apr 02. £380.

1870

Philip Rickman, Pair of Mallard Ducks, signed, 6.5 x 8.5in, white frame. Andrew Hartley, Ilkley. Feb 05. £380.

1871

Neapolitan School (17thC) The Flagellation, oil on board 25 x 33cm. Cheffins, Cambridge. Feb 05. £380.

1872

Early 19thC English School, watercolour on ivory miniature, Portrait of Sarah Tibbatt, holding a letter and seated beside a piano organ, initialled M.J.H, 4 x 3.25in. Gorringes, Lewes. Jan 05. £380.

1873

Central European School, late 19thC, fruiting branches and flowers in an ornamental urn, oil on canvas, 81.2 x 86cm. Rosebery's, London. Mar 05. £380.

1874

Sir George Clausen, R.A. The Labourer, watercolour, signed, 25.5 x 30cm. Rosebery's, London. Mar 05. £380.

1875

Edward Holroyd Pearce, RBA (British, 1901-1990) The Ald at Aldeburgh, Suffolk, signed lower left 'Holroyd Pearce '80", oil on board, 25 x 35cm. Cheffins, Cambridge. Apr 05. £380.

The abbreviations following artist's names can be located in the Appendices.

1876

Ethel Rawlins, Morning Light, oil on canvas, signed and inscribed on labels attached to reverse, 62.5 x 75cm, and Willi Rondas 'L'Abbaye de Vezelay (Cote d'Or-France)', oil on canvas board, signed, titled, inscribed and dated 17 Juin 1962 on reverse, 50.8 x 60.7cm. Rosebery's, London. Mar 05. £380.

1877

European School 19thC, drovers watering livestock in a wooded river landscape with a ruin in the distance, oil on panel, 39.2 x 50.5cm. Rosebery's, London. Mar 05. £380.

After Ceri Richards, Ethereal figures, lithograph printed in colours, signed/dated within the plate, 51 x 38cm, and a quantity of lithographs after different hands, unframed, a lot. Rosebery's, London. Mar 05. £380.

John Frederick Tayler, (1802-1889) A Girl leading a Pony laden with baskets, signed with initials and dated 1863, watercolour, 27 x 37cm. Sworders, Stansted Mountfitchet. Apr 05. £380

Manner of Teniers, Tavern scenes, oil on tin, a pair, 18.5 x 22.8cm. (2) Rosebery's, London. Mar 05. £380.

19thC oil on canvas of a heavy shire horse stallion entitled King Tom, indistinctly dated, indistinct signature 'James Clarke Snr'.? Kent Auction Galleries, Folkestone. Jun 05. £380.

19thC English School, Shipping in a swell, lighthouse beyond, oil on canvas, 11.5 x 16.5in. Clarke Gammon Wellers, Guildford. Apr 05. £380.

Isaac Charles Ginner, (1878-1952) An Italian Town with a Cathedral, woodcut, signed in pencil and numbered 12/30, hand coloured, 30 x 25cm. Sworders, Stansted Mountfitchet. Apr 05. £380.

William Newzam Prior Nicholson, 'James McNeill Whistler', lithograph printed in colours, 26.7 x 24.8cm, and ten other lithographs of portraits by the same hand, including: H. M. The Queen, W. E. Gladstone, Cecil Rhodes, H.R.H. The Prince of Wales, etc. (11) Rosebery's, London. Jun 05. £380.

Sonia Lawson, R.A. 'Adrift in Choppy Seas', oil on canvas laid down on board, signed, and inscribed on the reverse, 45.8 x 59.8cm. Rosebery's, London. Jun 05. £380.

19thC Continental School, Children retrieving a doll from a stream, signed indistinctly, oil on canvas, 59.5 x 49.5cm. Locke & England, Leamington Spa. Sep 03. £375.

19thC miniature painting on ivory of a nude female reclining accompanied by two cherubs and admiring shepherds, 3.25 x 4in. Tring Market Auctions, Herts. Sep 02. £370.

A F Mutrie, still life, flowers and fruit. Tring Market Auctions, Herts. Oct 04. £370.

Eulalie watercolour, Fairies dancing before pixies, signed and dated 1936, 9 x 15in. Gorringes, Lewes. Mar 04. £370.

Patrick Hickey. West Midlands, oil on canvas, unsigned, back with label for the Dawson Gallery, Dublin, 30 x 40in. (some loss of paint) Sworders, Stansted Mountfitchet. Apr 01. £360.

Eugene Verboeckhoven, oil painting, study of a dog. Hogben Auctioneers, Folkestone. Jun 01. £360.

H. Overton-Jones, Little girl in a flower filled garden, on canvas, signed and dated 1894 lower right, 65 x 49cm. Wintertons Ltd, Lichfield. Dec 01. £360.

Frederick George Reynolds, pair of watercolours, girl beside a stile and seated on a tree stump, monogrammed, 5 x 4.25in. Gorringes, Lewes. Feb 01. £360.

18thC English School, pastel, Study of a cherubs head, 9.5 x 8in. Gorringes, Lewes. Mar 01. £360.

Elizabeth Whitehead, Little Butcher Row, Coventry, watercolour on paper, signed and dated, 28 x 19.5cm, mounted, glazed and gilt frame. Locke & England, Leamington Spa. Sep 03. £360.

Hammer Price £360

1896

E Harling, pencil, Ponies carrying stags, signed, dated 1904, 18 x 24in. Gorringes, Lewes. Apr 01. £360.

1897

Charles McCall, gouache maquette, Beach scene at Carteret, 1968, 12 x 18.5in. Gorringes, Lewes. Apr 01. £360.

1898

After Munnings, signed coloured print 'The Saddling Paddock at the Cheltenham March Meeting, 40 x 63cm. Thos Mawer & Son, Lincoln. Nov 02. £360.

1899

19thC English School, oil on canvas, landscape with a lady on horseback, signed indistinctly. Locke & England, Leamington Spa. Feb 03. £360.

1900

Pietro Psaier, Italian b.1939, The Beatles, Changing Faces, (Coca Cola), silkscreen print, 1877, 64 x 50cm. Cheffins, Cambridge. Jul 04. £360.

1901

F Golden-Short, Figures on a path in the New Forest, oil on canvas, signed and dated. W & H Peacock, Bedford. Jul 03. £360.

1902

George Fagan Bradshaw, Choppy sea and cloudy sky, signed, oil on board, 52 x 72.5cm. Locke & England, Leamington Spa. Sep 03. £360.

1903

English School c1880, Two girls skating on a frozen pond, water and bodycolour, 17.2 x 14.2cm, unframed. Rosebery's, London. Dec 03. £360.

1904

George Vincent, oil on canvas, cattle watering at a woodland pool, 9 x 11in. Biddle & Webb, Birmingham. Feb 04. £360.

1905

Kershaw Schofield, River Meadow with Cattle Grazing, oil, signed on board, 18.5 x 23.5in. Andrew Hartley, Ilkley. Dec 03. £360.

1906

After William Russell Flint, Semi clad young woman on a beach, signed in pencil, coloured reproduction pub'd by W J Stacey, 26 x 40cm. Locke & England, Leamington Spa. Sep 04. £360.

1907

Circle of Boilly, portrait of a gentleman, oil on vellum? 8 x 6.75in. Gorringes, Lewes. Oct 04. £360.

1908

Oil on canvas, 19thC English School, The English Fleet at Sea, 25 x 35in. Gorringes, Lewes. Oct 04. £360.

1909

Patrick Procktor, R.A., R.E., R.W.S. 'Genus Pom Pom Nan Kivell', watercolour, signed, inscribed El Farah, dated 10.68, dedicated to Rex Nan Kivell in pencil, 22.5 x 35.2cm. Rosebery's, London. Sep 04. £360.

1910

Follower of Gainsborough, Sheep sheltering in a wood, a view of a village beyond, oil on panel, 18 x 23cm. Rosebery's, London. Sep 04. £360.

1911

After Louise Abbema, Diana, oil on paper laid down on board, signature and date, 102 x 134cm. Rosebery's, London. Sep 04. £360.

1912

Leonard Baskin, 'Daedelus II', pencil, signed, inscribed & dated as follows: 'Daedelus II, 30.11.59 Leonard Baskin from Michael Ayrton 26.5.61', 35 x 50.8cm, unframed. Rosebery's, London. Sep 04. £360.

1913

Leonard Baskin, Figure and board, etching printed in blue and green, signed within the plate, signed/inscribed 'proof' in pencil, 14.8 x 13.7cm, & eight other prints, some hand-coloured by the same hand, all signed in pencil, unframed. Rosebery's, London. Sep 04. £360.

1914

Edna Clarke Hall, Standing figure of a woman, brown ink and watercolour, signed, 24.8 x 16.5cm and four other watercolours by the same hand, various subjects, two signed. (5) Rosebery's, London. Sep 04. £360.

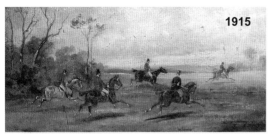

1915

Trudolf Stone, A Hunting Scene, signed, oil on panel, 66 x 32cm. Sworders, Stansted Mountfitchet. Nov 04. £360.

1916

Charles Hodge Mackie, A Forest Clearing, signed, oil on board, 34 x 28cm. Sworders, Stansted Mountfitchet. Nov 04. £360.

> Fresh to the market paintings perform better than those which have been in and out of auction.

1917

Early 20thC watercolour on ivorine miniature, traveller & maid beside a tavern door, in manner of William Shayer, signed Abel, ornate gilt metal frame, 7in wide. Gorringes, Lewes. Dec 04. £360.

1918

Geer Van Velde, Abstracted figure, gouache, signed with initials, 21 x 7cm. Rosebery's, London. Dec 04. £360.

1919

Victorian School, oil on canvas, 'On The Trent....', 12 x 20in. Gorringes, Lewes. Dec 04. £360.

1920

Harry Morley, (1881-1943) oil on canvas, 'Passers By', signed, 30 x 20in. Gorringes, Lewes. Dec 04. £360.

1921

Sir Frank Brangwyn, (1867-1956) etching, 'Santa Maria from the Street, Venice', signed in pencil, 21.75 x 17.25in. Gorringes, Lewes. Jul 04. £360.

1922

Beryl Cook, colour print, Three lady artists, signed in pencil, 16 x 16in. Gorringes, Lewes. Mar 04. £360.

Hammer Price £360

1923

K Greenaway, oval watercolour, young girl. Gorringes, Bexhill On Sea. Sep 04. £360.

1924

Miniature portrait of a young girl, late 19thC, oil on ivory, wearing a blue dress, sitting in a garden, ebonised frame, miniature 10cm. Rosebery's, London. Dec 04. £360.

1925

English School, Portrait of a Traveller Resting in a Country Lane, unsigned on board, early 19thC, 18.75 x 15in, gilt frame. Andrew Hartley, Ilkley. Dec 04. £360.

1926

Allen Jones, R.A. 'Noir East', lithograph in colours, signed, dated '73, inscribed 'Artist's Proof' in pencil, 37.5 x 34.2cm. Rosebery's, London. Dec 04. £360.

1927

Florence Jay, (Exh. 1905-20) watercolour, Head of an Irish setter, signed, 10 x 14in. Gorringes, Lewes. Mar 04. £360.

1928

Modern British School, c1970, 'Summer Cromlech No. 1', black chalk, gouache and wax resist, signed, titled and dated 4/5/69, 37 x 51.7cm. Rosebery's, London. Dec 04. £360.

1929

Thomas William Morley, Returning from the fields, watercolour, signed, 38.2 x 53.5cm and one other watercolour of a shepherdess and her flock sheltering under a tree, by same hand, signed, 35.5 x 50cm. (2) Rosebery's, London. Dec 04. £360.

1930

Julian Trevelyan, (1910-1988) Artists proof print, 'Westminster', signed, 14 x 18.75in. Gorringes, Lewes. Apr 03. £360.

1931

F. Soyer, modern oil on board, still life of fruit on a table, signed, 35 x 45in. Gorringes, Lewes. Apr 02. £360.

Hammer Price £360

1932

John Bates Bedford, (Exh. 1881-1886), watercolour, Horsemans Farm, near Haywards Heath, Sussex, monogrammed and dated 1865, 10 x 13.75in. Gorringes, Lewes. Oct 02. £360.

1933

Percy Hague Jowett (1882-1955), oil on canvas 'Backwater on the Seine', signed and dated 1928, National Society Exhibition label verso, 25 x 30in. Gorringes, Lewes. Apr 02. £360.

1934

Steven Outram, oil on canvas board, 'Heavy Showers Approaching', signed, dated 1990 verso, 26 x 23in. Gorringes, Lewes. Apr 02. £360.

1935

Giarvelli, watercolour, street scene, Cairo, signed, 12.5 x 7in. Gorringes, Lewes. Apr 02. £360.

1936

English School, (18thC) Pan with Music-Making Maidens in an Arcadian Landscape, pen and ink, 46 x 57cm. Cheffins, Cambridge. Feb 05. £360.

1937

Fairlieth (British, 20thC) In the Morning Room, signed lower right 'Fairlieth', oil on canvas 66 x 87cm. Cheffins, Cambridge. Feb 05. £360.

1938

Henry Bright, (1814-1873) pencil, Old Windmill 'Near Leyden, Holland', signed and dated (18)39, 9 x 8.5in. Gorringes, Bexhill. Mar 02. £360.

1939

William Ayerst Ingram, (1855-1913) watercolour, Return of The Herring Fleet, signed, 13.5 x 20.5in. Gorringes, Bexhill. Mar 02. £360.

1940

Ronald Ossory Dunlop, (1894-1973) watercolour, London Bridge, signed, 15 x 22in. Gorringes, Lewes. Jun 03. £360.

1941

G Carelli, 1821-1900, 'Castle of Europe, Bosphorus, Constantinople' Castle to foregound. 5.5 x 13.25in, signed, gilt moulded frame, glazed. Canterbury Auction Galleries, Kent. Apr 05. £360.

1942

J.F.Atkinson, oil on board, Leaving Port, monogrammed and dated 1921, 14.5 x 18.5in. Gorringes, Bexhill. Mar 02. £360.

> Provenance is an important market factor which can bare positively on results achieved at auction.

1943

European School, 19thC, servant girl with a cat and onlookers in an interior, body colour on laid, 18 x 12.3cm, and a small collection of 18-19thC drawings in pencil, pen and ink and wash, a lot, unframed. Rosebery's, London. Mar 05. £360.

1944

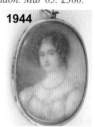

19thC English School watercolour on ivory miniature, Portrait of Harriet, Countess of Guilford, oval, 3 x 2.25in, gilt locket frame. Gorringes, Lewes. Jun 03. £360.

1945

Tommy Lydon, oil on board 'Picasso', signed and entitled verso, 24.5 x 20.5in. Great Western Auctions, Glasgow. Jun 05. £360.

1946

Peter Jones, 'Group Of Eight - Black, White and Green', mixed media relief construction in eight conjoined parts, signed and dated 66, signed & titled on label on reverse, box frame, 110 x 55cm. Rosebery's, London. Jun 05. £360.

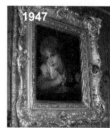

1947

19thC, oil on canvas, head and shoulders portrait of a young child leaning on furniture holding an apple, deep in thought, unsigned, panel 32 x 41cm, ornate gilt frame. Lambert & Foster, Tenterden. May 05. £360.

1948

European Modernist School early 20thC, Still life of a jug of flowers, plate of fruit and a bottle in an interior, oil on canvas, bears remains of paper labels and indistinct stamps, verso, 49 x 59.5cm. (unframed) Rosebery's, London. Jun 05. £360.

1949

William Benjamin Chamberlin (Exh.1880-95) watercolour, 'At Perugia, Italy', signed and dated '84, 14 x 21in. Gorringes, Lewes. Jun 03. £360.

1950

19thC. English School, watercolour, Miniature of Princess Eugenie (?), 5.25 x 4.25in, elaborate silver and paste frame. Gorringes, Lewes. Apr 05. £360.

1951

Owen Bowen, Riverscene, signed on board, 15.5 x 22.5in, painted frame. Andrew Hartley, Ilkley. Oct 03. £350.

1952

Ralph Reuben Stubbs (1820-1879), Cornelian Bay, Scarborough, signed and dated 1874, 9 x 13.5in, gilt frame. Dee, Atkinson & Harrison, Driffield. Feb 05. £350.

1953

Italian School, 18thC, seated male nude, black chalk on grey laid, 42 x 28.2cm, unframed. Rosebery's, London. Jun 03. £350.

1954

Attributed to James Campbell, Hide & Seek, oil on canvas, unsigned, 20 x 16in. Sworders, Stansted Mountfitchet. Jul 01. £350.

1955

English School, 19thC, Portrait of a lady harvester, 18thC style, oil on panel, 23 x 18cm. Sworders, Stansted Mountfitchet. Sep 03. £350.

1956

Oil painting of 'The Fallen Madonna with the Big Boobies', probably used in the stage show of the famous television series 'Allo' 'Allo', 174 x 113cm. Sworders, Stansted Mountfitchet. Nov 04. £350.

1957

Mikhail Zharov, 'Roses and Fruit', oil on canvas, signed, 61 x 49.5cm, framed. Lots Road Auctions, Chelsea. Dec 04. £350.

1958

J Langlois, two terriers. Tring Market Auctions, Herts. Jan 02. £350.

1959

Italian School, 18thC oil on canvas, figures in a woodland setting, 14.75 x 17in. Dee Atkinson & Harrison, Driffield. Mar 04. £350.

1960

18thC Continental School, oil on canvas laid on board, women watering livestock, 22 x 29in. Gorringes, Lewes. Apr 02. £350.

1961

G.R. Rushton, RI, R.B.A., (1868-1948), watercolour, Beccles, Norfolk, Church and buildings with a river in the foreground, signed, 14.5 x 21.5in, unframed. Diamond Mills & Co, Felixstowe. Dec 04. £350.

1962

William Boscombe Gardner, A Surrey Cottage, watercolour, signed, 10 x 8.5in. Halls Fine Art, Shrewsbury. Feb 05. £350.

1963

Attributed to William Callow, R.W.S., Cattle droving along a country lane with a ruin beyond, oil on canvas, 31.2 x 41.3cm. Rosebery's, London. Mar 05. £350.

1964

H. Burgess, Naval vessels in a dockyard, poss. Portsmouth Harbour, pen, black ink and watercolour, signed, dated 1854, 32 x 65cm. Rosebery's, London. Mar 05. £350.

1965

Gnyuki Torimaru, original design for a white evening dress for Princess Diana, front and back, pencil and watercolour, signed, dated 1986 lower right, 31.5 x 25.5cm unframed. Dreweatt Neate, Donnington. Nov 02. £350.

Hammer Prices £350 - £340

1966

Sir William Russell Flint, RA, Reclining Nude, reproduction printed in colours, published in 1963 by Frost and Reed Ltd., signed in pencil, blind stamp to corner 35 x 61cm. Sworders, Stansted Mountfitchet. Nov 04. £350.

1967

Edward Holroyd Pearce, RBA (British, 1901-1990) St Benet's Abbey, Norfolk, oil on board, 20 x 24cm. Cheffins, Cambridge. Apr 05. £350.

1968

Peter Howson, woodcut 'Millwall' signed and dated 91 in pencil, 24 x 18in. Great Western Auctions, Glasgow. Jun 05. £350.

1969

Attributed to Thomas Blinks, 'Coachman in Livery', gouache, stamped signature, 27.5 x 17.7cm. Rosebery's, London. Jun 05. £350.

1970

J L Petit, 1801-1965, Twenty one watercolour sketches, views in France, all unframed. Canterbury Auc. Galleries, Kent. Apr 05. £350.

1971

Engraving of Kings College Chapel, double page size, 18thC. Cheffins, Cambridge. Jun 01. £340.

1972

W. D. Guthrie, (Exh 1881-82) watercolour, still life of wallflowers, signed, 13 x 18.5in. Gorringes, Lewes. Feb 01. £340.

1973

Norman Partridge, Croydon School of Art, Autumn term 1938, two body colour illustrations, signed and dated 1968, largest 16 x 21.5in. Sworders, Stansted Mountfitchet. Apr 01. £340.

1974

William Lionel Wyllie, (1851-1931) etching, docklands view, signed in pencil, 9 x 14.75in. Gorringes, Lewes. Feb 01. £340.

1975

Archibald Thornburn, Greenland Falcons, coloured print, signed in pencil in the margin, 10 x 7in. Sworders, Stansted Mountfitchet. Apr 01. £340.

1976

William Lionel Wyllie, black and white etching, 'Leith' fishing boats leaving the port, signed in pencil, 7 x 15.25in. Gorringes, Lewes. Mar 01. £340.

1977

C H Wadsworth, Racing pigeon, No 733, oil on canvas, signed and dated 1914 (?), 18 x 14in. Sworders, Stansted Mountfitchet. Apr 01. £340.

1978

Three 19thC silhouettes, largest 10 x 8in. Sworders, Stansted Mountfitchet. Jul 01. £340.

1979

Henry Earp Snr, (1831-1914) watercolour, horse, cart and figures on a country track, signed, 9.5 x 19in. Gorringes, Bexhill. May 02. £340.

1980

Hamilton Glass, unframed oil on canvas, Sheep in a landscape, signed, 16 x 24in. Gorringes, Lewes. Apr 01. £340.

1981

English School, oil on canvas, extensive riverscape with cattle and children paddling, 20 x 30in. Gorringes, Lewes. Apr 01. £340.

Most auction catalogues carry an explantation of the terminology used in descriptions. See Appendices.

1982

English School, 19thC, pair of sailing ships off shore, watercolours, one indistinctly initialled, each 6.5 x 14in. (2) Sworders, Stansted Mountfitchet. Jul 01. £340.

1983

W L F Wastell, one of a pair, Crowmarsh, Oxfordshire and The Harbour, Mevagissy, by another hand, watercolours, one signed and dated 1925, each 12 x 17in. Sworders, Stansted Mountfitchet. Jul 01. £340.

1984

19thC British School, half length portrait of a seated woman, oil on panel, 13 x 11.5in, moulded bead edge, gilt frame.
Amersham Auction Rooms, Bucks. May 02. £340.

1985

James Burrell, Sailing Boats in Harbour, watercolour. W & H Peacock, Bedford. Feb 03. £340.

1986

Roland Green. Eagle in flight, watercolour on paper, signed, 53 x 64cm, glazed & framed. Locke & England, Leamington Spa. May 03. £340.

1987

Alfred H. Vickers (fl. 1853-1907) oil on canvas, Estuary with town and castle beyond, signed and dated 1894, 8 x 12in. Gorringes, Lewes. Jul 04. £340.

1988

Joseph William Carey, (1859 -1937) watercolour, The Dun River, Co Antrim, signed and dated 1918, 8.25 x 15.25in. Gorringes, Lewes. Jul 04. £340.

1989

Nadia Benois. (1896-1975) Oil on canvas, still life of flowers in a vase, signed, 22 x 16in. Gorringes, Lewes. Jan 04. £340.

1990

Henry Bernard Chalon, Portrait of a Spaniel, feigned vignette, oil on panel, signed, 19.6 x 22cm. Rosebery's, London. Jun 04. £340.

1991

J De Wette, watercolour and gouache drawing 'Adam and Eve', couple kissing beneath a tree, 30 x 36in. Denhams, Warnham. Sep 04. £340.

1992

C.F.Buckley, watercolour, Syrian figures at rest amongst classical ruins, 7.25 x 10.25in. Gorringes, Lewes. Oct 04. £340.

1993

Circle of Robert Braithwaite Martineau, 'Lady with Fan', oil on canvas, 38.5 x 28.5cm. Rosebery's, London. Sep 04. £340.

1994

Loic Dubigeon, the artist's model, black ink & gouache, signed and dated 15.6.58, 65 x 49.6cm, and 3 other similar works on paper by the same hand all signed & dated '58, unframed. (4) Rosebery's, London. Sep 04. £340.

1995

Attributed to Emily Stannard, Flowers in an urn with a birds nest on a ledge, oil on panel, 50 x 33.8cm. Rosebery's, London. Sep 04. £340.

1996

John Farleigh, 'Library, Oriel', oil on canvas, signed, & inscribed on label attached on the reverse, 18 x 23.5cm. Rosebery's, London. Sep 04. £340.

1997

Carl Werner, watercolour, An Armenian Chapel, inscribed 'Armenische Capelle?', 51 x 35cm. Sworders, Stansted Mountfitchet. Nov 04. £340.

1998

C Ginner, Woodland Cottage, watercolour. W & H Peacock, Bedford. Feb 03. £340.

1999

C Pavek, oil on canvas, Venetian canal side scene, indistinctly signed, 28 x 40in. Gorringes, Lewes. Mar 04. £340.

2000

Rowland Suddaby, (1912-1973) watercolour and ink, Sussex landscape, signed and dated '49, 16 x 22in. Gorringes, Lewes. Mar 04. £340.

2001

Alan Sorrell, (1904-1974) watercolour, Hadrians Wall, looking west towards Chollerford, signed, 9.5 x 15in. Gorringes, Lewes. Mar 04. £340.

2002

Attributed to Alfredo Campajola, Gondalas on a Venetian canal, oil on panel, signed, 36.8 x 45cm. Rosebery's, London. Dec 04. £340.

2003

Frank Fiddler, untitled abstract composition in blue, oil on board, inscribed with date '61 on the reverse, 122 x 92cm. Rosebery's, London. Dec 04. £340.

2004

Hercules Brabazon Brabazon (1821-1906) pencil & wash, 'Seville', initialled, 8.5 x 10in. Gorringes, Lewes. Apr 03. £340.

2005

Harry Becker, (1865-1928) charcoal, 'Head of a Belgian Refugee', signed and dated (19)17, Redfern Gallery label, 10.5 x 7.5in. Gorringes, Bexhill. Mar 02. £340.

2006

Attributed to Samuel Prout, (1783-1852) watercolour, beached fishing boats, monogrammed, 10 x 7in. Gorringes, Lewes. Apr 02. £340.

2007

G.R. Rushton, RI, R.B.A., (1868-1948), watercolour, Kenilworth Castle, Warwickshire, signed, 14.5 x 21.5in, unframed. Diamond Mills & Co, Felixstowe. Dec 04. £340.

2008

F W Hopper (English, 20thC) A Frigate in a Stormy Sea, signed lower left 'F W Hopper '40" watercolour, 37 x 52cm. Cheffins, Cambridge. Feb 05. £340.

2009

James M Robert Greenlees, RSW (1820-1894) Ben More and Holy Loch, signed lower left 'J Greenlees 1884' and inscribed with title on the reverse, oil on board, 22 x 34cm. Cheffins, Cambridge. Feb 05. £340.

2010

E. Bianchini, oil on canvas, fishermen and boats on the shore of a Neapolitan village, signed, 20 x 29in. Gorringes, Lewes. Oct 02. £340.

2011

After F.T. Daws, oil on canvas, portrait of a black terrier, signed, dated (19)27, 11 x 15in. Gorringes, Bexhill. Mar 02. £340.

2012

George Wilkins, 19thC, 'A Bit of Sunshine near Froggatt Edge, Derbyshire', inscribed verso, oil on canvas, 36 x 46cm. Sworders, Stansted Mountfitchet. Feb 05. £340.

2013

After Picasso, Studio interior at 'La Calafornie', lithograph printed in colours, dated within the plate 21.11.55 VII, 46 x 30cm, and seven other similar lithographs after the same hand, unframed. Rosebery's, London. Mar 05. £340.

> Ensure you never hang your watercolours etc in direct or reflected sunlight. Fading seriously affects value.

2014

English School, (19thC) Portrait of a Lady, seated at the Harpsichord, oil on canvas, 47 x 35cm. Cheffins, Cambridge. Feb 05. £340.

2015

19thC English School watercolour on ivory miniature, Portrait of a naval captain, oval, 2 x 1.5in, hair bordered locket frame Gorringes, Lewes. Jun 03. £340.

2016

A... Court, A Horse and Dog in a Stable, signed, initialled 'W R' on bucket, oil on canvas, 18 x 25cm. Sworders, Stansted Mountfitchet. Feb 05. £340.

2017

Di Lanza, watercolour on ivory miniature, Portrait of a lady wearing a black dress with lace ruff, signed and dated 1821, Tondo, 2.25in. Gorringes, Lewes. Jun 03. £340.

2018

Isabella Beetham, silhouette, Portrait of a young lady, in verre eglomise convex mount and moulded frame, 3.5 x 3.25in and another by a different hand. Gorringes, Bexhill. May 03. £340.

2019

Roger Muhl. (born 1929) 'Magagnosc', signed, dated 1967, oil on canvas 16.5 x 23.5cm. Sworders, Stansted Mountfitchet. Apr 05. £340.

2020

Attributed to Joseph Raskin, Market scene, oil on canvas, signed, dated '48, unframed, 51 x 60.8cm. Rosebery's, London. Jun 05. £340.

2021

Early 19thC English School watercolour on ivory miniature, Portrait of an army officer, oval, 2.75 x 2in, enamel back locket frame. Gorringes, Lewes. Jun 03. £340.

2022

Charles Rowbotham, Two children with a dog resting by a path in moorland landscape, watercolour, signed, dated 1908, 29.5 x 59cm. Rosebery's, London. Jun 05. £340.

2023

European School 19thC, Portrait of a Cardinal holding a letter by a table, feigned oval, oil on copper panel, 23.8 x 18.5cm, unframed. Rosebery's, London. Jun 05. £340.

2024

British School late 19thC, A couple by a shop window, gouache, signed with initials C.R, 18.2 x 12.5cm, unframed. Rosebery's, London. Jun 05. £340.

2025

Evelyn Abelson, R.B.A., 'Les Andelys', oil on canvas, signed and dated 1927, inscribed label verso, Rowley Gallery frame. Rosebery's, London. Jun 05. £340.

2026

Attributed to Walter Duncan, (1848-1932) Fallow Deer in Woodland bears indistinct signature 'Duncan' lower right, watercolour, 27 x 28cm. Cheffins, Cambridge. Apr 05. £340.

2027

W Cruikshank, (English, 19thC) Peaches, Grapes and an Apple with a Blackbird's Nest, signed lower right 'W Cruikshank', watercolour, 17 x 29cm. Cheffins, Cambridge. Apr 05. £340.

2028

Edward Holroyd Pearce, RBA (British, 1901-1990) Sizewell, on the Deben, Suffolk, signed lower right with initials 'EHP', oil on board, 26 x 36cm. Cheffins, Cambridge. Apr 05. £340.

2029

Edward Holroyd Pearce, RBA (British, 1901-1990) Suffolk Coast, signed lower left 'Holroyd Pearce '75'', oil on board, 26 x 35cm. Cheffins, Cambridge. Apr 05. £340.

2030

European School 20thC, Female nude seated full-length, oil on canvas, signed indistinctly, 32.8 x 24.2cm, unframed. Rosebery's, London. Jun 05. £340.

2031

Edward Holroyd Pearce, RBA (British, 1901-1990) Walberswick Marches, Suffolk, signed lower left 'Holroyd Pearce '81'', oil on board, 26 x 36cm. Cheffins, Cambridge. Apr 05. £340.

2032

Edward Holroyd Pearce, RBA (British, 1901-1990) Walberswick Marshes, Suffolk, signed lower left 'Holroyd Pearce '80'', oil on board, 25 x 35cm. Cheffins, Cambridge. Apr 05. £340.

2033

Llewellyn Petley-Jones, (Canadian School, 1908-1986) Still life of Roses, signed 'Petley' and dated '71, oil on board, 53 x 44cm. Sworders, Stansted Mountfitchet. Sep 03. £330.

2034

Albert Pollitt, watercolour, landscape scene with drover and sheep by a river, possibly the 'Clwyd Valley', signed and dated 1905. 6.5 x 19in, framed and glazed. Fieldings, West Hagley, Worcs. Jun 05. £330.

2035

J Varley, 1778-1842, panoramic view of Snowdon. 8.5 x 18in, signed (indistinct), framed. Canterbury Auction Galleries, Kent. Apr 05. £330.

2036

Manner of Murillo, The Infant Christ with a vision of the Cross, oil on panel, 30.4 x 22cm. Rosebery's, London. Mar 05. £330.

2037

James Kessell, oil painting on canvas, Winter landscape with chicken runs in centre ground, 54 x 56cm, framed. Locke & England, Leamington Spa. Feb 03. £325.

2038

Early 19thC English School, watercolour, extensive landscape with fortified town in the distance, 10 x 14.25in. Gorringes, Lewes. Mar 01. £320.

2039

English School, 19thC portrait of a lady, oil, 17.5 x 12in. Sworders, Stansted Mountfitchet. Jul 01. £320.

2040

Eight 19thC hand coloured engravings, Russian Army subjects, various sizes, framed. Lots Road Auctions, Chelsea. Aug 01. £320.

2041

19thC English School, Foreshore with ships at sunset, oil on canvas, unsigned, 9 x 14in. Sworders, Stansted Mountfitchet. Apr 01. £320.

2042

Portrait of George III, paper on canvas, unsigned, gilt framed, 18 x 16in. Tring Market Auctions, Herts. May 02. £320.

2043

Adrianus Johannes Groenewegen, (1874-1963) watercolour, Chickens and cattle before a windmill, signed, 7 x 10in. Gorringes, Lewes. Apr 01. £320.

2044

E*** Solomons, 'Magdalen College, Oxford', watercolour, signed and dated 1901, 14 x 10.5in. Dockree's, Manchester. Feb 01. £320.

2045

Suffragist poster designed by T Hassall, printed and published by W Popper, Underwood Street, London, portraying an angry suffragette, 30 x 19in. Tring Market Auctions, Herts. May 02. £320.

2046

William Russell Flint, (British 1880-1969) Studies of female nudes, sepia print, signed in red chalk lower right, 41 x 30cm. Fellows & Sons, Hockley, Birmingham. Oct 02. £320.

2047

Oval portrait miniature on ivory of a lady in late 16thC Renaissance costume, named on reverse Mary Stuart, 3.25 x 2.5in. Tring Market Auctions, Herts. Nov 02. £320.

2048

Tristram Ellis. 'Palermo', signed, inscribed and dated 1909, watercolour, 24 x 53.5cm. Locke & England, Leamington Spa. May 03. £320.

2049

After A J Munnings, coloured print 'Their Majesties returning from Ascot', signed by the artist, framed and glazed, 15 x 26in. Tring Market Auctions, Herts. Mar 03. £320.

2050

After Ketagawa Utamaro, a coloured print of a Japanese lady in the rain with an umbrella, framed and glazed, 14.5 x 9.25in. Tring Market Auctions, Herts. Mar 03. £320.

2051

G Carelli, watercolour, Neopolitan landscape. W & H Peacock, Bedford. Feb 03. £320.

2052

W. Robin Jennings, Fishing the Severn below Bewdley, oil on canvas, signed, 20 x 24in. Halls Fine Art, Shrewsbury. Sep 03. £320.

2053

L Rouch, 18thC, watercolour drawing, portrait of a lady, 11 x 9in. Denhams, Warnham. Nov 03. £320.

2054

A Jack, half length portrait of a mid Victorian woman, on canvas, signed lower left, 21 x 17.5cm. Wintertons Ltd, Lichfield. Jan 04. £320.

Frames and mounts should enhance your picture. Empathy, rather than fashion should dictate your choice.

2055

J. K. Bedley, signed oil on canvas, large portrait study of an elegant lady. Biddle & Webb, Birmingham. Feb 04. £320.

2056

Andreu Mariano, pencil drawing, 'Musician', 17 x 9in. Denhams, Warnham. May 04. £320.

2057

Engraving signed in pencil W. Wyllie 'View of St. Pauls Cathedral from River Thames'. Boldon Auction Galleries, Tyne & Wear. Sep 04. £320.

2058

John White, British School 19/20thC, Sussex Windmill, watercolour, signed, 36 x 53.5cm. Rosebery's, London. Sep 04. £320.

2059

Henry Moore, 'Sculptural Objects', pub'd. by Schools Prints Ltd., 1949, lithograph printed in colours, 49 x 75cm. Rosebery's, London. Sep 04. £320.

2060

William Thomas Nicholas Boyce, (1858-1911) Boats in a stormy sea, signed, dated 1896, 12 x 17.75in, gilt frame. Dee Atkinson & Harrison, Driffield. Nov 04. £320.

2061

French School c1850, Portrait of a gentleman, quarter-length, oil on canvas, 45.5 x 36cm. Rosebery's, London. Sep 04. £320.

2062

British School, late 19thC, Sailing vessels in choppy seas, oil on canvas, signed with monogram and dated indistinctly, 30.5 x 24cm. Rosebery's, London. Sep 04. £320.

2063

John Ward of Hull, (1798-1849) Seascape off the coast with fishing boats, unsigned, 13 x 19in, gilt frame. Dee Atkinson & Harrison, Driffield. Nov 04. £320.

2064

Raphael Nelson, Portrait of a girl, head and shoulders in a pink robe, coloured chalk, signed, 32.3 x 26.3cm and two other portrait studies in black and coloured chalk by the same hand, both signed, one dated 1924. (3) Rosebery's, London. Sep 04. £320.

2065

Circle of George Armfield, Study of a Terrier, oil on canvas, painted circle, 30 x 30cm. Sworders, Stansted Mountfitchet. Nov 04. £320.

2066

Louis Icart 'Playfulness', etching with colours, signed in pencil, numbered 273, pub'd in 1922 by Estampe Moderne, Paris, 43 x 30cm. Sworders, Stansted Mountfitchet. Nov 04. £320.

2067

English School, oil on canvas, Gordon Setters, Sport on the Moors, inscribed verso, 16 x 24in. Gorringes, Lewes. Dec 04. £320.

2068

W L Wyllie, etching, HMS Natal. Gorringes, Bexhill On Sea. Sep 04. £320.

2069

W L Wyllie, etching, estuary scene. Gorringes, Bexhill On Sea. Sep 04. £320.

2070

Edward Grimston, watercolour, A Boys Pets. Gorringes, Bexhill On Sea. Sep 04. £320.

2071

Joseph Ellis, (exh 1856-1881) 'On the Winnien, Dolgelly, with figures fishing & cattle grazing', signed, dated 1879, oil on canvas, also inscribed on reverse, 47 x 73cm. Hampton & Littlewood, Exeter. Jul 04. £320.

2072

Alexander Khrapachev, 'Reminiscences', oil on board, signed, 46.5 x 32cm, framed. Lots Road Auctions, Chelsea. Dec 04. £320.

2073

Andrea Biondetti, water-colour drawing, Piazza San Marco. Gorringes, Bexhill On Sea. Dec 04. £320.

2074

Nan Goldis, Clemens at lunch, a cafe de Sade, Lacoste, France 1999, Whitechapel Art Gallery, Benefit Edition, 477/500, signed, 28 x 35.5cm. Rosebery's, London. Dec 04. £320.

2075

Philip Rickman, (1891-1982) watercolour, 'Throwing up from the Stoop, The Tay Estuary, Fotheringham', Tryon Gallery label verso, 22 x 30.5in. Gorringes, Lewes. Jan 04. £320.

2076

Joel Owen, river landscape with thatched cottage, signed & dated 1926, 19.5 x 29.5in, gilt frame. Dee Atkinson & Harrison, Driffield. Jul 04. £320.

2077

Dudley Harding, (1866-1922) monochrome watercolour, cafe scene, signed, dated 1891, 10 x 14in. Gorringes, Lewes. Apr 02. £320.

2078

Tom Robertson, (1850-1947) oil on wooden panel, 'Palace of the Kaid of Armsmiz - from the river', signed, 10 x 13in. Gorringes, Lewes. Jul 04. £320.

2079

Fred Lawson, Horse and Cart on a Woodland Path, signed and dated 1915, 10 x 13.25in, gilt frame. Andrew Hartley, Ilkley. Dec 04. £320.

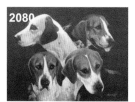

2080

English School, (20thC) study of hounds, on board, signed Marriott (?), 15.5 x 19.5in, gilt frame. Dee Atkinson & Harrison, Driffield. Mar 04. £320.

2081

Rectangular portrait miniature, written verso 'Antique Miniature on Ivory George III', 9 x 7cm, modern Hogarth type frame. Thos. Mawer & Son, Lincoln. Mar 04. £320.

2082

Early 19thC English School, watercolour on ivory, miniature of a gentleman, 3.5 x 2.75in. Gorringes, Lewes. Jul 04. £320.

2083

British School 20thC, 'Woolly Bearded Protea', water and bodycolour on silk, signed with initials 'IM', titled, 15 x 15cm, and 16 other botanical studies by the same hand, all mounted in one common stepped frame. Rosebery's, London. Dec 04. £320.

2084

Frank Brangwyn, R.A. European city street scene, etching, signed in pencil, 14.7 x 14.5cm and one other similar etching of a busy street scene by the same hand, also signed in pencil, 16 x 14cm. (2) Rosebery's, London. Dec 04. £320.

2085

Attributed to Claude Flight, Chapel with fields beyond, pencil and watercolour, 34.5 x 50.5cm and a watercolour of a woodland scene by the same hand, bears signature, 34.5 x 48cm. (2) Rosebery's, London. Dec 04. £320.

2086

19thC School, portrait of a bearded gentleman, head and shoulders, possibly a Jewish cleric, unsigned, 14.75 x 12.5in, gilt frame. Dee Atkinson & Harrison, Driffield. Jul 04. £320.

2087

Duncan Grant, (1885-1978) watercolour, Still life of ornaments, signed and dated '74, 18 x 12in. Gorringes, Lewes. Apr 03. £320.

2088

English School, watercolour, Blakney Creek, indistinctly signed and dated '36, 8 x 11.5in. Gorringes, Lewes. Apr 03. £320.

2089

Leon Underwood, (1901-1975) colour print, 'Quetzalcoatl', signed, dated '39, 14 x 18in. Gorringes, Lewes. Apr 03. £320.

2090

English School, c1840, View below Ludford Bridge, signed, watercolour, heightened in white, 27 x 44cm. Sworders, Stansted Mountfitchet. Feb 05. £320.

2091

Oil on board, attributed to Thomas Hart, exhibited 1880-82, L1 scene of Lizard, Helston, Cornwall, oak frame. Lambert & Foster, Tenterden. Jan 05. £320.

2092

Eugenio Oliva y Rodrigo (1854-1925) Spanish, oil on canvas, Portrait of an elderly lady, signed, unframed, 24 x 18in. Gorringes, Lewes. Apr 03. £320.

English School, c1910, oil on board, Portrait of a Pomeranian, 9 x 9in. Gorringes, Lewes. Mar 03. £320.

L.M.R. oil on canvas, portrait of an infant holding a whistle, initialled, 18.5in. Gorringes, Lewes. Apr 02. £320.

Adrian Gillespie Beach, oil on canvas, 'Odysseus Befriended by Nausicaa', signed, 28 x 36in. Gorringes, Lewes. Apr 02. £320.

19thC English School, pair of unframed oils on canvas, cattle in landscapes, 16 x 26in. Gorringes, Lewes. Apr 02. £320.

G.R. Rushton, RI, R.B.A., (1868-1948), Castle Coombe, Wiltshire, signed, watercolour, 14.5 x 21.75in, unframed. Diamond Mills & Co, Felixstowe. Dec 04. £320.

Attributed to George Armfield, (1808-1893) Two Norfolk Terriers chasing a Cat, oil on canvas, 49 x 60cm. Cheffins, Cambridge. Feb 05. £320.

English School (19thC) Portrait of a Lady, with an ermine shawl on a chair beside her, oil on canvas, 51 x 37cm. Cheffins, Cambridge. Feb 05. £320.

Ensure your watercolours etc are mounted on acid free boards. Have old pictures checked out by a framer.

Studio of Achille Emile Othon Friesz, (French, 1879-1949) Portrait of Miss Alice Kohn, (1902-1990) oil on canvas, 37 x 43cm. Cheffins, Cambridge. Feb 05. £320.

Snaffles 'The Guvner - Good Hunting old Sportsman', panel 20 x 29cm, framed and glazed. Lambert & Foster, Tenterden. Jan 05. £320.

Joseph Appleyard, (1908-1960) Country road with gypsy caravan and horses, signed, 6 x 8.5in, gilt frame. Dee, Atkinson & Harrison, Driffield. Feb 05. £320.

17thC English School, oil on zinc, miniature of a gentleman with lace collar, oval, 2.75 x 2.25in. Gorringes, Bexhill. Mar 02. £320.

Francois Thango, untitled, abstract composition, oil on board, signed, 59 x 74cm. Rosebery's, London. Mar 05. £320.

Attributed to John Linnell, (1792-1882) watercolour, The Thames and St Pauls, 8 x 10.75in. Gorringes, Bexhill. Mar 02. £320.

Peter Sedgley, Contour, acrylic on board, inscribed on the reverse, 122 x 122cm. Rosebery's, London. Mar 05. £320.

Dame Laura Knight, (1877-1970) pen and ink, sketch of a clown, signed, 8 x 6in. Gorringes, Bexhill. Mar 02. £320.

Follower of Ary Scheffer, French 19thC, portrait of a lady, oil on canvas, oval mount, 76 x 55cm. Rosebery's, London. Mar 05. £320.

Francois Thango, untitled scene with figures seated on rugs, oil on board, signed, 60 x 74.5cm. Rosebery's, London. Mar 05. £320.

English 19thC, portrait miniature of a lady, half length seated in a pink dress, 6.8 x 5.7cm, and two other portrait miniatures, one of a gentleman, one of Mrs Cox attributed to Mr Paisley, maple veneered frames. Rosebery's, London. Mar 05. £320.

Hammer Price £320

2111

Pair gilt wood framed altar paintings, Italian early 20thC, each painted with the figure of an angel in the manner of Fra Angelica, lancet form, Gothic architectural frames, 78cm high. Rosebery's, London. Mar 05. £320.

2112

Budwin Conn, Portrait of Yuki, standing in a green and blue lined robe, inscribed Torimaru Gnyuki in Japanese characters, oil on board, 77 x 56cm, contemporary mirrored frame, c.1974. Dreweatt Neate, Donnington. Nov 02. £320.

2113

After Gilbert Stuart, watercolour on ivory miniature, Portrait of George Washington, initialled R.S. and dated '05, oval, 2.75 x 2.25in, gold locket frame. Gorringes, Lewes. Jun 03. £320.

2114

Late 19thC English School, four watercolours, Studies of fisherfolk, boats at sea and children by a cottage, 3.5 x 5.5in. Gorringes, Lewes. Jun 03. £320.

2115

South African School, oil on canvas, Mountainous landscape, 35 x 46in. Gorringes, Lewes. Mar 05. £320.

2116

J L Petit, 1801-1865, selection of watercolour sketches, views of the Pyrenees. (16) Canterbury Auc. Galleries, Kent. Apr 05. £320.

> Condiiton, rarity, provenance and fashion are the key market operators currently dictating values.

2117

Thomas Rowlandson, (1756-1827) Dr Syntax, etchings & aquatint, set of 8, published 1812 by R Ackermann, each 11 x 19cm, framed as one. Sworders, Stansted Mountfitchet. Apr 05. £320.

2118

Maria Gianni, (late 19thC) 'A Coastal Scene near Naples', signed, gouache, and 'A Monk sitting on a Terrace', signed by another member of the Gianni family, gouache, each 19 x 25cm. Sworders, Stansted Mountfitchet. Apr 05. £320.

2119

William Manners, (fl.1885-1910) Cattle by a Wood and Cattle in a Moonlit landscape, pair, signed and dated 1904, oil on board 15 x 20cm. Sworders, Stansted Mountfitchet. Apr 05. £320.

2120

Cuthbert Bradley, (1861-1943) 'In the Belvoir Country, Jan 3 1913...', signed and dated 1913, watercolour heightened with white, 23 x 35cm. Sworders, Stansted Mountfitchet. Apr 05. £320.

2121

Alexander Macpherson, RSW watercolour, 'A Brittany Beach', signed, 11 x 14.75in. Great Western Auctions, Glasgow. Jun 05. £320.

2122

Stefan Knapp, untitled abstract composition, ink and spray gun on paper laid down on board, signed and dated 53, 90 x 122cm, unframed. Rosebery's, London. Jun 05. £320.

2123

Arthur Varney, 'York Minster, Evening' and 'Lynmouth Harbour, Evening', watercolours, pair, both signed 33.7 x 72.3cm ea. Rosebery's, London. Jun 05. £320.

2124

Emmanuel Listnau, German 18thC, Portrait of Frederick the Great on horseback, pen & brown ink, wash & watercolour with gold on vellum(?), signed, dated 1760, inscribed extensively on reverse, 51.2 x 35.4cm, unframed. Rosebery's, London. Jun 05. £320.

2125

English School 19thC, Mother and children sheltering from a storm, watercolour, 26.2 x 21.5cm, and a watercolour study of a girl seated by a fence, different hand, 14.2 x 9.8cm, unframed. Rosebery's, London. Jun 05. £320.

2126

Conroy Maddox, untitled surreal woodland scene, oil on panel, signed and dated '36, 14 x 20.2cm. Rosebery's, London. Jun 05. £320.

2127

European School, 19thC, Allegorical scene with a female nude and musician in a landscape, oil on canvas, 53.5 x 43cm, unframed. Rosebery's, London. Jun 05. £320.

2128

Sir John Watson Gordon, RA, PRSA (1788-1864) Study of a Bernese Mountain Dog, watercolour, 19 x 26cm. Cheffins, Cambridge. Apr 05. £320.

2129

William Herbert Allen, RBA, ARCA (English, b.1863) Villagers on a Packhorse Bridge, with a horseman riding by, signed lower left 'W H Allen '72", watercolour, 27 x 38cm. Cheffins, Cambridge. Apr 05. £320.

2130

Robert Malcolm Lloyd, (English, fl.1879-1899) The Quay, Gorleston, Norfolk, signed lower right 'R Malcom Lloyd 1919', watercolour, 12 x 17cm. Cheffins, Cambridge. Apr 05. £320.

2131

Australian School (19thC) Lake Connewarre, near Geelong, Australia, oil on canvas, indistinctly signed lower left, 21 x 34cm. Cheffins, Cambridge. Apr 05. £320.

2132

Edward Holroyd Pearce, RBA (British, 1901-1990) Aldeburgh, Suffolk, signed lower left 'Holroyd Pearce '81", oil on board, 25 x 35cm. Cheffins, Cambridge. Apr 05. £320.

2133

Manner of Jacopo Bassano, (c1510-1592) A Peasant Woman with a goat and cow in a landscape, red chalk, 20 x 26cm. Present drawing is an 18thC copy after a figure group in one of Bassano's paintings. Cheffins, Cambridge. Apr 05. £320.

2134

Charles Morris, oil on wooden panel, Landscape with watermill and figure on a lane, signed and dated 1860, 6.5 x 8.5in. Gorringes, Lewes. Mar 01. £310.

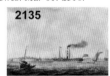

2135

Thomas Sutherland, (fl early/mid 19thC) after W.I. Huggins, coloured aquatint, Margate with the Venus Steam Packet entering the Harbour, 14 x 20in, pub'd April 5th 1823 by R. Lambe, 96 Gracechurch Street, walnut frame. (small repair) Canterbury Auc. Galleries, Kent. Aug 02. £310.

2136

M. Gianni, (late 19thC) Mediterranean coastal town with a figure on a path, and a companion, Figures on a Mediterranean coastal footpath, gouache, signed, 29 x 15cm. Hampton & Littlewood, Exeter. Apr 04. £310.

2137

Frederick John Widgery, (1861-1942), Summer Coastal Scene, gouache, signed, 23 x 32cm. Hampton & Littlewood, Exeter. Jul 04. £310.

2138

Miniature watercolour portrait, unsigned. Tring Market Auctions, Herts. Oct 04. £310.

2139

19thC study of 4 cows, watering beneath willow trees, unsigned, oil on board, framed, 9 x 11in. Tring Mkt Auctions, Herts. Apr 05. £310.

2140

Harry Fidler, Portrait of a field worker in a landscape, oil on panel, 27.7 x 18.8cm. Rosebery's, London. Jun 05. £310.

2141

William Lionel Wyllie, (1851-1931) etching, convoy under fire, signed in pencil, 6.75 x 16.5in. Gorringes, Lewes. Feb 01. £300.

2142

Edmund Morison Wimperis, (1835-1900) oil on canvas, open landscape, with cattle, ducks & farmhouse beyond, monogrammed and dated (18)80, 12 x 20in. Gorringes, Lewes. Feb 01. £300.

2143

J. Stanley, oil on board, mountain landscape, signed and dated 1873, 10 x 7.5in. Gorringes, Lewes. Jun 01. £300.

2144

Manner of Christopher Wood, image from Luna Park Ballet, oil on panel, 103cm high. Cheffins, Cambridge. Jun 01. £300.

2145

Six Japanese woodblock prints, two depicting geisha, the others various birds amongst foliage with calligraphic script. Ambrose, Loughton. Feb 02. £300.

Hammer Price £300

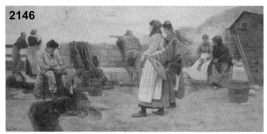

2146

After Walter Langley, Fishermen and Wives on Quayside, oil on board. W & H Peacock, Bedford. Feb 03. £300.

2147

Miss Austin Carter, (fl. 1862-1873) The Sampler, watercolour, 17 x 12.75in, signed with monogram, contemporary gilt frame, glazed. Canterbury Auc. Galleries, Kent. Apr 04. £300.

2148

Victorian School, oil on board, Penshurst Park, June 16, 1886, figure seated beneath trees, monogrammed J.W., 14 x 12in. Gorringes, Lewes. Mar 01. £300.

2149

After Henry Scott Tuke, modern oil on canvas, Nude boys picking fruit in an orchard, monogrammed, 23 x 19in. Gorringes, Lewes. Mar 01. £300.

2150

Eve Cebal, young girl holding a posy of flowers, signed, oil on canvas, 45 x 37cm. Sworders, Stansted Mountfitchet. Feb 03. £300.

2151

Archibald Thornburn. Goldfinch, coloured print, signed in pencil in the margin, 10 x 7in. Sworders, Stansted Mountfitchet. Apr 01. £300.

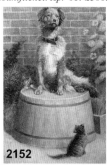

2152

Edwin C Gardner, study of a mongrel with 2 playful kittens, watercolour, signed & dated '92, 16.5 x 10.5in, glazed gilt frame. Amersham Auction Rooms, Bucks. Feb 04. £300.

2153

Archibald Thornburn, Wigeon & Teal, coloured print, signed in pencil in the margin, 7 x 10in. Sworders, Stansted Mountfitchet. Apr 01. £300.

2154

James Gorman, (British, 20thC) Embrace, pencil and wash, 13 x 14in, framed, and two similar by the same artist. Lots Road Auctions, Chelsea. Aug 01. £300.

2155

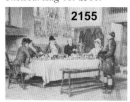

Walter Dendy Sadler, Hunting Breakfast, and A Fishermans Breakfast, 2 engravings, signed in pencil by W. Dendy Sadler & the engraver, each 14 x 20in. Sworders, Stansted Mountfitchet. Apr 01. £300.

2156

18thC English School, gouache, Travellers passing ruins in a landscape, 11 x 16in. Gorringes, Lewes. Mar 01. £300.

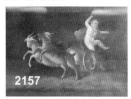

2157

19thC Italian School, pair of allegorical scenes, oil on card, unsigned, 8 x 13in. Sworders, Stansted Mountfitchet. Apr 01. £300.

2158

J T Banks, An 'S.E. & C.R.' green steam locomotive no. 516, with driver, stoker and manager, signed and dated 1909, oil on canvas, 60 x 92cm. Sworders, Stansted Mountfitchet. Jul 03. £300.

2159

John Abernathy Lynas Gray, Gathering firewood by a coastal cottage, watercolour, signed and dated 1917, 29.2 x 44cm. Rosebery's, London. Dec 03. £300.

2160

R Simkin 77, two infantry officers, signed and dated, framed and glazed, 7 x 5.5in. Tring Market Auctions, Herts. Mar 02. £300.

2161

Silhouette of a young lady in watercolour, 19thC, églomisé frame, 30 x 21cm. Lots Road, Chelsea. Sep 02. £300.

2162

Thomas Churchyard, (1798-1865) watercolour, The Deben from Martlesham, 3.75 x 4.75in. Gorringes, Lewes. Feb 01. £300.

2163

Willis Pryce, oil on board, Guy's Cliffe from the lake, signed, 29 x 36.5cm. Locke & England, Leamington Spa. Feb 03. £300.

2164

Walter J. Donne, (1867-?) watercolour and body colour on grey paper, Evening in the Dolomites, signed and dated 1882, 10 x 20in. Gorringes, Lewes. Mar 03. £300.

2165

Sidney Eastlake, 20thC, Peaceful day by the sea, signed, oil on canvas, 19.5 x 23.5in. Clarke Gammon, Guildford. Apr 03. £300.

2166

Walter Beauvais, French, 20thC, Beach Scene, oil on board, signed, 40 x 50cm, framed. Lots Road Auctions, Chelsea. Aug 03. £300.

2167

Unsigned watercolour, oval portrait of a lady, gilt framed and glazed, 7.5 x 8.5in. Tring Market Auctions, Herts. Nov 03. £300.

2168

W Cruickshank. Dead Bullfinch by a Nest, watercolour. W & H Peacock, Bedford. Jul 03. £300.

2169

T Whittle Senior, Still life studies of fruit, a pair, one signed and dated 1866, one unsigned, oil paint on board, 20.5 x 30cm, unframed. Locke & England, Leamington Spa. Jul 03. £300.

Prices quoted are hammer and exclude the buyer's premium. Adding 15% will give approx. buying price.

2170

Rowland William Fox, 'Figures on a riverbank with cottage beyond', oil on panel, signed & dated 1896, 12 x 17.5in. Halls Fine Art, Shrewsbury. Feb 04. £300.

2171

William Ellis, In the Lledr Valley, watercolour, signed, framed and glazed, 14 x 21in. Tring Market Auctions, Herts. Nov 03. £300.

2172

Jungle Gentleman, signed in pencil, 258/2000, published 1990, 20.25 x 32in, stained frame. Andrew Hartley, Ilkley. Dec 03. £300.

Hammer Price £300

2173

Clive Madgwick, 'Hill Farm, Mid Wales, Spring', oil on canvas, 20 x 30in, signed, gilt moulded frame. Canterbury Auc. Galleries, Kent. Feb 04. £300.

2174

Oval portrait of a Victorian lady, unsigned. Tring Market Auctions, Herts. Oct 04. £300.

2175

John Marchbank, Figures seated before a Cottage, signed, 9.5 x 12.25in, ebonized frame. Andrew Hartley, Ilkley. Oct 03. £300.

2176

D. Esposito, (Maltese) gouache, 'H.M.S Sapphire', signed, 10 x 15.5in. Gorringes, Lewes. Oct 04. £300.

2177

Watercolour, signed Beatrice Parsons, Garden landscape, 23 x 15cm. Boldon Auction Galleries, Tyne & Wear. Sep 04. £300.

2178

Guy Cambier, Horse and rider in a wintry town village street, oil on canvas, signed, 60.2 x 73cm. Rosebery's, London. Sep 04. £300.

2179

Alfred Cohen, Still life of a basket of flowers, oil on board, signed, 31.5 x 39.5cm and a portrait study of a jester in gouache, signed with initial, stamped with Atelier mark, dedicated on the reverse, 28.2 x 20cm. (2) Rosebery's, London. Sep 04. £300.

2180

Attributed to Harold Hume Piffard, Portrait of a girl with a tea pot and cup by the seaside, oil on canvas, signed, 61 x 51cm, unframed. Rosebery's, London. Dec 04. £300.

2181

English School, c1900 Girl sitting beneath a Tree and by a river, watercolour 45 x 34cm. Sworders, Stansted Mountfitchet. Nov 04. £300.

Hammer Price £300

2182

William Manners, (fl. 1885-c1910) Bolton Abbey, West Yorkshire, signed, 5.75 x 9.25in, gilt frame. Dee Atkinson & Harrison, Driffield. Nov 04. £300.

2183

English School, c1800, Portrait of a Cleric, half length, oil on canvas, 76 x 63cm. Sworders, Stansted Mountfitchet. Nov 04. £300.

> The numbering system acts as a reader reference as well as linking to the Analysis of each section.

2184

After Sir Joshua Reynolds, Portrait of a Lady, mezzotint, signed in pencil, pub'd 1897 by Leggatt Brothers, ornate late 19thC carved giltwood frame, image 45 x 35cm. Sworders, Stansted Mountfitchet. Nov 04. £300.

2185

Henry Edward Hiles, Anglesey, signed, oil on canvas, 32 x 40cm. Sworders, Stansted Mountfitchet. Nov 04. £300.

2186

A. Moginie Bryant, A bay hunter in a stable, oil on canvas, signed, 39 x 49cm. Hobbs Parker, Ashford. Nov 04. £300.

2187

Elliot H Marten, (Scottish, fl.1886) Shoreham, Sussex, watercolour, 24 x 41cm. Cheffins, Cambridge. Apr 05. £300.

2188

Gervasia Vartanyan (b.1927), 'Climbing Exercises', 1966, oil on canvas, signed, 48 x 68cm, framed. Lots Road, Chelsea. Dec 04. £300.

2189

E St John Earp, (late 19thC) Continental mountain landscape with goat herder in the distance, signed, 23 x 26.5in, gilt frame. Dee Atkinson & Harrison, Driffield. Jul 04. £300.

2190

English School, mid-19thC, A Country House with a lake in the foreground, watercolour and body colour, 18 x 27cm, Victorian maple frame Sworders, Stansted Mountfitchet. Feb 05. £300.

2191

Julian Trevelyan, (1910-1988) Artists proof print, 'Lava Quarries', signed, Redfern Gallery label verso, 17 x 22in. Gorringes, Lewes. Apr 03. £300.

2192

R W Milliken, study of a hare, signed pencil drawing, 11 x 14in, gilt frame. Dee Atkinson & Harrison, Driffield. Jul 04. £300.

2193

Walter J Donne, (1867-?) watercolour, Montreuil sur Mer, signed, 8 x 10.75in. Gorringes, Lewes. Mar 04. £300.

2194

Margaret Fisher Prout, Cattle in a Meadow, signed and dated 1910, 12.75 x 15.75in, gilt frame. Andrew Hartley, Ilkley. Feb 05. £300.

2195

Ernest Albert, watercolour, 'Running before the wind', signed, 11 x 14.5in. Gorringes, Lewes. Mar 04. £300.

2196

Hal Waugh, 'The Swag Man', pencil and watercolour, signed and dated '14, 21 x 28cm. Rosebery's, London. Dec 04. £300.

2197

Attributed to Barbara Redpath, 'Still life with Red Table', oil on board, inscribed label verso, 96.5 x 127cm. Rosebery's, London. Dec 04. £300.

2198

Bernard Meadows, 6 studies of organic sculptural forms; aquatints printed in black & orange, in common mount and frame, 14.7 x 10.4cm sheet size ea. Rosebery's, London. Dec 04. £300.

2199

Manner of Giuseppe Costantini, Blind Man's Buff, oil on panel, signature, 27.3 x 39.3cm. Rosebery's, London. Dec 04. £300.

2200

John Doyle, (1928-) oil on canvas, 'Les Baux, Provence' signed and dated 1966, 12 x 16in. Gorringes, Lewes. Mar 03. £300.

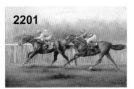

2201

Max Brandrett, (20thC), oil on canvas, 'Dancing Brave winning the 2000 Guineas' signed, 20 x 30in. Gorringes, Lewes. Oct 02. £300.

2202

English School, 19thC oil on canvas, Portrait of a lady in a black dress, unsigned, 82 x 65cm. Clevedon Saleroom, Bristol. Jun 05. £300.

2203

Vernon Ward 46, oil on canvas, signed twice in the left hand corner, Still Life of Flowers in a Bowl, gilt frame, 23 x 16in. Kent Auction Galleries, Folkestone. Apr 05. £300.

2204

J. Edgar, oil on canvas, riverscape with cottage and bridge, signed, 16 x 24in. Gorringes, Bexhill. Mar 02. £300.

2205

After Paolo Veronesi, (1528-1588) oil on canvas, Mary Magdalene, 18 x 15in. Gorringes, Lewes. Apr 02. £300.

2206

William Walcot, Whitehall, London, etching, artist proof, signed in pencil, plate size 3.75 x 6in, ebonised frame. Andrew Hartley, Ilkley. Feb 05. £300.

2207

William Drummond Bone, RSW ARSA, oil on board 'In the park', 24 x 30in. Great Western Auctions, Glasgow. Jun 05. £300.

2208

Frank B Jowett, River Meadows with Cattle Grazing, signed and dated 1917, 25.5 x 38.5in, stained frame. Andrew Hartley, Ilkley. Feb 05. £300.

2209

Vernon Ward, 'Afternoon Tea', oil on board, signed, and inscribed with title and dated 1942 on the reverse, 28 x 22.3cm. Rosebery's, London. Jun 05. £300

2210

English School (19thC) Yachts preparing for a Race, watercolour, 14 x 21cm. Cheffins, Cambridge. Feb 05. £300.

2211

J F Branagan, (English, 19thC) Ready to Sail, off the Dutch Coast, signed lower left 'J F Branagan', watercolour, 25 x 36cm. Cheffins, Cambridge. Feb 05. £300.

2212

English School, late 19thC, A Cottage Garden with Beehives, oil on canvas, 45 x 60cm. Sworders, Stansted Mountfitchet. Feb 05. £300.

2213

Will Perry, British, early 20thC, The Warriors, watercolour, signed, 57.5 x 87cm. Rosebery's, London. Mar 05. £300.

2214

Edward Holroyd Pearce, RBA (British, 1901-1990) The Broads, Hickling, Norfolk, 1945, signed lower left 'Holroyd Pearce', oil on board, 24 x 34cm. Cheffins, Cambridge. Apr 05. £300.

2215

Robert MacKenzie, Detente, 1960, oil on canvas, inscribed on labels attached to reverse, 33 x 50.6cm. Rosebery's, London. Mar 05. £300.

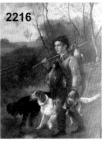

2216

William Walker Morris, The Day's Bag, oil on canvas, 31 x 25in. Halls Fine Art, Shrewsbury. Feb 05. £300.

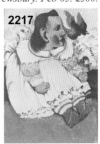

2217

John Byrne, etching in colours, 'Girl with Monkey', signed Patrick and entitled and numbered 6/12 in pencil, 13.75 x 9.75in. Great Western Auctions, Glasgow. Apr 05. £300.

2218

Edward Holroyd Pearce, RBA (British, 1901-1990) Girls on a Beach, Low Tide, Suffolk Coast, oil on board, 25 x 31cm. Cheffins, Cambridge. Apr 05. £300.

2219

David M. Martin, oil on board, still life, signed, 11.5 x 8.75in. Great Western Auctions, Glasgow. Jun 05. £300.

Section X < £300 to £200

Much of the portraiture is unfashionable, particularly the late eighteenth/ nineteenth century. How good the 'After Gainsborough' portrait is at **2539** is difficult to say. It is pastel and unframed. Another £100-£200 needs spent. I like it. It has appeal and would help decorate a period house nicely!

The sample analysis in each Section is always dependent on the market analyses covered thoroughly in the *Introduction*, and on the themes and narratives that have been developed in previous Section analyses. Here again the number of contributions from provincial auctions exceeds the previous Section.

It is going to be difficult to find anything inspirational. There is competent work for the price range and good decorative 'art on a budget'! Take, for example, the *London Street Scene* at **2233** by a minor artist. This type of townscape seems to have been fetching about this kind of price for as many years as I can remember. However, there will be jewels, and we shall find them, even if the stones are small, or of paste. Those who want a Stannard can still buy at **2245**, those wishing to brighten up their drawing room might buy the 'Follower of Matthew William Peters' at **2241** *Ballroom Scene* and, there is nothing amiss with the restful *Yorkshire Cobbles* at **2247**. Those who cannot afford Louis Wains prints, (and that includes many of us) shouldn't mind getting two cat cartoons (after Louis Wain) for only £280.

There are competent 'scapes on page 143 and portraits. You can have a good *Yorkshire Terrier* for the same price, and an oil at that. Or the modernist 'Circle of A Kuhn' woman with a cockerel is a good decorative picture for the kitchen as is the more traditional still life next to it. See **2260** and **2265**. Don't be surprised by the plethora of abstract art. Even so it is very decorative and you could fit it into an appropriate colour scheme, or hang anywhere providing it doesn't lean too far towards Dali, the surreal, or even Moore, *Sunflowers* is attractive at **2401** or perhaps the decorative and very large *abstract bird forms* at **2565**. I am surprised at the low price although I do not know this artist. Competent paintings by minor artists or schools continue, but there are still recognisably good artists, witness the John Henry Mole (1814-1886) at **2294**, which at 7 x 12 inches fetched only £270, and that at its local auction. This isn't his best view. I admire the post-war abstract at **2296**. It could fit into a decor created around these colours.

Cats reappear again at **2311**. This small watercolour is amusing, and cat pictures never go amiss. See also **2420**, an 'after Louis Wain' at **2430**, also **2525** and **2542**. See a bright Mediterranean harbour picture at **2314** and the nice riverscape *The Waters of Leith* by R Marshall. Surely, this picture is worth more? There are at least three Russell Flint prints. I have a friend who owns a small original chalk, worth now about £700, but he

insists it is worth much more. This is normal! 'After Lowry' appears at **2336** for £260. This is also normal. At **2341** is a nice sized seascape by 'Callow' indistinctly signed at £260. Clearly the buyers had no confidence in the attribution being the famous William Callow and the caption, missing the christian names suggest it is open to interpretation. For a summary of auction terminology, see *Appendix I*. See also **2353** the charming 'Circle of Emma Belloc' portrait, worth buying and researching. Emma Belloc (exh. 1895-1911) was a portrait painter who exhibited at least 17 times during this period.

Nothing catches the eye on page 150. At **2400** on page 151 is another good portrait in oil of a peasant girl in the manner of Sir David Wilkie, (1785-1841). This means in the artist's style but of a later date. See also another good portrait at **2425**. I don't know the artist but this 1911 study is typically Edwardian and very good value at £240. Also at **2445** is a good decorative townscape of Venice. None of the reference works put a date to David Thomas but he has reached £1,600 for a large work, so this seems about right. The East Yorkshire market doesn't seem to want to pay too much either for the Bridlington scene at **2467**, or the *Channel Fleet off Scarborough* by C Edson. Though the artist is obscure, this must be an important documentary painting. Naval historians, where were you? And where were the cat lovers who passed up the mother and kitten group at **2490**? And the William Frederick Hulk was undersold at **2503**, being well under this artist's £460 median.

On p158, is a further Frederick John Widgery. (**2519**) This famous artist is offering little and £220 reflects the market value. Much of the portraiture is unfashionable, particularly the late eighteenth/nineteenth century. How good the 'After Gainsborough' portrait is at **2539** is difficult to say. It is pastel and unframed. Another £100-£200 needs spent. I like it. It has appeal and would help decorate a period house nicely! At **2571** is a John Piper print at £200. John Piper is a major artist whose oils have recently fetched up to £65,000 and works on paper up to £17,000. I know of only one print which sold for £2,500. I like the Beatrice Johnson *Still Life with Apples and Bottles* at **2589**. See also a further Julian Trevelyan lithograph at **2600**. At **2611** is a David Law watercolour. This is competent and sold below his median of £420. *Pass of Achray, Stirlingshire*, would probably, at the very least have doubled its price, if sold in Scotland rather than the south east. And why did **2642**, a Manchester townscape, fetch only £200, unless it lacks quality?

Van, oval still life, a vase of flowers, signed, framed, 21 x 17in. Tring Market Auctions, Herts. Mar 02. £290.

M Snape, Haymaking in the Lake District. Tring Market Auctions, Herts. Oct 04. £290.

W Fitz 07, self portrait. Tring Market Auctions, Herts. Oct 04. £290.

Nathaniel Everett Green. 'Near Dorking', watercolour, signed, 15 x 11.5in, framed and glazed. Maxwells, Wilmslow. Sep 04. £290.

Roland Green, (1896-1972) A Brown Owl, a Chaffinch and Blue Tits, signed, watercolour and bodycolour, 36 x 29cm. Sworders, Stansted Mountfitchet. Feb 05. £290.

Antal Berkes, Hungarian 19/20thC, Busy city street scene, oil on canvas, signed, 40.7 x 50.5cm. Rosebery's, London. Jun 05. £290.

Late 19thC study of a tethered, stable horse, oil on canvas, signed indistinctly, 12 x 16in. Amersham Auction Rooms, Bucks. Apr 01. £280.

19thC, Piazza Navona and Church of Saint Agneese, Rome, panel 12 x 16in, gilt frame and glazed. Lambert & Foster, Tenterden. Apr 01. £280.

Ernest Higgins Rigg, (Exh 1897-1923) oil on board, bluebell wood, signed, 16 x 12.5in. Gorringes, Lewes. Mar 02. £280.

Albrecht von Occolowitz, oil on canvas, deer in a meadow, signed, dated 1901, label verso, 23 x 17.5in. Gorringes, Lewes. Feb 01. £280.

Ray Campbell, Portrait of a lurcher, oil on canvas, signed, 24 x 36in. Sworders, Stansted Mountfitchet. Apr 01. £280.

20thC English School, Dead partridge and hen pheasant, oil on canvas, unsigned, 20 x 24in. Sworders, Stansted Mountfitchet. Apr 01. £280.

The illustrations are in descending price order. The price range is indicated at the top of each page.

George Fall, Water Tower York, signed and inscribed, 8.25 x 10.75in, gilt frame. Andrew Hartley, Ilkley. Jun 02. £280.

George Hann 1946, London Street Scene, on board, signed and dated, framed, 20.5 x 25.5in. Tring Market Auctions, Herts. Sep 02. £280.

Portrait of a reclining nude, unsigned. Tring Market Auctions, Herts. Oct 04. £280.

S C Harris, Boy in a stream, oil on board, signed, 30 x 20in. Sworders, Stansted Mountfitchet. Apr 01. £280.

Raphael Nelson, Still life of tulips in a jug on a table, 61.5 x 51cm and with a still life of a violin and a landscape study, oils on canvas, all signed. (3) Rosebery's, London. Sep 04. £280.

Follower of William John Wainwright, still life of fruit & flowers, oil on board, 15.5 x 12in. Sworders, Stansted Mountfitchet. Jul 01. £280.

Follower of W H Pearson. Thames Barges, one of a pair, signed, inscribed, 33 x 25cm. Sworders, Stansted Mountfitchet. Dec 02. £280.

Hammer Price £280

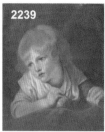

2239

Portrait of a child with an apple, unsigned, unframed, 18 x 15in. Tring Market Auctions, Herts. Mar 03. £280.

2240

Circle of Peter Van Lint, (1609-1690) 'The Enthronement of a Bishop', oil, relined canvas, 69 x 55in, ebonised moulded frame. Canterbury Auc. Galleries, Kent. Aug 03. £280.

2241

Follower of Matthew William Peters, Ballroom scene, pencil, water and bodycolour heightened with gum arabic, 16.8 x 24.5cm, unframed. Rosebery's, London. Sep 03. £280.

2242

Llewellyn Petley-Jones, Canadian School 1908-1986, still life of roses in a vase, signed, dated '71, oil on board, 53 x 44cm. Sworders, Stansted Mountfitchet. Dec 03. £280.

2243

S. Sampson, Middle Eastern figures at leisure, oil on panel, 20.5 x 14cm. Hobbs Parker, Ashford, Kent. Jul 04. £280.

2244

One of five 18thC Italian engravings of ancient ruins, each 12 x 17in. Sworders, Stansted Mountfitchet. Jul 01. £280.

2245

Henry Sylvester Stannard, (1870-1951), watercolour, The River Dart, signed, 10 x 14in. Gorringes, Lewes. Oct 04. £280.

2246

Circle of George Chambers, (fl 1848-1868) 'Shipping becalmed off the coast', oil on canvas, 44 x 60cm. Hampton & Littlewood, Exeter. Jul 04. £280.

2247

Gyrth Russell, (1892-1970) Canadian watercolour, 'Yorkshire Cobbles', signed, 12.5 x 16in. Gorringes, Lewes. Jan 04. £280.

2248

Enid Chauvin, Metal workers beneath an archway, oil on canvas, signed, 50.4 x 70.5cm, unframed. Rosebery's, London. Sep 04. £280.

2249

W L Wyllie, etching, battle cruisers. Gorringes, Bexhill On Sea. Sep 04. £280.

2250

George Henry Boughtonk, pair of watercolours, coastal & estuary scenes. Gorringes, Bexhill. Sep 04. £280.

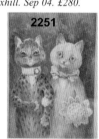

2251

After Louis Wain, pair of coloured prints, Twins and A Happy Pair, 16.75 x 11.5in. Dee, Atkinson & Harrison, Driffield. Aug 04. £280.

2252

Alice Fussell, (Exh. 1880-1902) watercolour, 'Cliffs at Beachey Head', signed and dated 1883, 24 x 15.5in. Gorringes, Lewes. Jul 04. £280.

2253

J Fraser, oil on wooden panel, Junk at sea, signed, inscribed verso & dated 1893, 6.5 x 8.25in. Gorringes, Lewes. Mar 04. £280.

2254

G Ellarby, 20thC, Ashness Bridge, Derwent Water and a pair of oils on board, signed, 18 x 24in, gilt framed. Dee Atkinson & Harrison, Driffield. Mar 04. £280.

Artists or themes can be followed through the colour coded Index which contains over 4500 cross references.

2255

Victorian miniature portrait of a gentleman wearing a white stock and black coat, unsigned, brass frame glazed both sides, appears to be painted on card, 10 x 7.5cm Thos. Mawer & Son, Lincoln. Mar 04. £280.

2256

Edwardian portrait miniature, hand painted on ivorine, signed, dated 'EMPK, 1909', gold pendant locket, seed pearl border, overall length 51mm. Fellows & Sons, Birmingham. May 03. £280.

2257

T C Moore, Shipping off the coast in choppy seas, signed, oil on canvas, 38 x 50cm. Henry Adams, Chichester. Jan 03. £280.

2258

European School c1900, Figures promenading in a park with a dome in the distance, oil on board, 11.7 x 21cm. Rosebery's, London. Dec 04. £280.

2259

L. Hope, Portrait of a boy, quarter-length in a landscape, black & coloured chalk, oval, signed and dated 1916, 49.5 x 39cm and with a portrait miniature of a lady seated three-quarter length by a balustrade, and one other portrait miniature, (3) Rosebery's, London. Dec 04. £280.

2260

Circle of Andrzej Kuhn, Woman with a cockerel in a landscape with cottages, oil on canvas, 80 x 61.5cm. Rosebery's, London. Dec 04. £280.

2261

Charles Knight, (1901-1990) watercolour, River Dart, signed, 9 x 14.5in. Gorringes, Lewes. Apr 03. £280.

2262

Charles Knight, (1901-1990) watercolour, 'Near Poynings, Sussex', signed, dated '35, 9.5 x 13.75in. Gorringes, Lewes. Apr 03. £280.

2263

Follower of Maurice Wilks, oil on canvas, Irish landscape, 16 x 20 in, unframed. Gorringes, Lewes. Mar 03. £280.

2264

Phil May, (1864-1903), pen and ink, 'A Bit of Newlyn', signed and inscribed 'To Haynes King ... 1893', 8 x 7in, and with a Mortimer Menpes etching of a girl, 5.75 x 3.5in. Gorringes, Lewes. Oct 02. £280.

2265

J. Watson Nichol, oil on canvas, still life of flagons & apples on a table, signed and dated 1873, 13.5 x 20in. Gorringes, Lewes. Apr 02. £280.

2266

Adrian Daintry, (1902-1988), oil on board, Vesuvius, signed and dated 1945, 1947 Fine Art Society label verso, 9 x 16.5in. Gorringes, Lewes. Apr 02. £280.

2267

G.R. Rushton, RI, R.B.A., (1868-1948), watercolour, Coastal Scene, South of France, signed, 12.5 x 18.75in, framed and glazed. Diamond Mills & Co, Felixstowe. Dec 04. £280.

2268

English School, (19thC) Yorkshire Terrier, signed with initials lower right 'RCS', oil on canvas, 34 x 24cm. Cheffins, Cambridge. Feb 05. £280.

2269

Neapolitan 20thC, H. M. T. Wilton with a Volcano in the distance, gouache, 37 x 50cm. Sworders, Stansted Mountfitchet. Feb 05. £280.

2270

J. Acton Butt, (Exh.1883-91) oil on canvas, Weir with fields beyond, signed, dated 1881, 10 x 18in. Gorringes, Bexhill. Mar 02. £280.

2271

G... Klein, (20thC) Four Shooting Cartoons, signed, watercolour, 27 x 36cm. (4) Sworders, Stansted Mountfitchet. Feb 05. £280.

2272

G Dean, (English, 19thC) Study of a Dutch Woman, signed lower right 'G Dean', oil on canvas, 34 x 24cm. Cheffins, Cambridge. Feb 05. £280.

2273

Eizan, Figure in the snow, oban, and another similar print. Dreweatt Neate, Donnington. Nov 02. £280.

2274

Bernard Finegan Gribble, (1873-1962) oil on board, fishing boats off the Cornish coast, signed, 12 x 15.5in. Gorringes, Bexhill. Mar 02. £280.

2275

D. Fulton, oil on canvas, bulldog in a garden 'Jerry', signed, 12 x 18in. Gorringes, Bexhill. Mar 02. £280.

Hammer Prices £280 - £270

2276

Raymond Coxon, Mythological scene with Centaurs by a pool, oil on canvas, 76 x 91.3cm, and one other similar study, oil on canvas, by same hand, 73.2 x 91.2cm. Rosebery's, London. Mar 05. £280.

2277

Colonial School, 19thC, possibly American, figures with a canoe on a lake with mountains in the distance, oil on board, signed indistinctly, 45.1 x 59.8cm. Rosebery's, London. Mar 05. £280.

2278

Joan Miro, (1893-1983) Untitled, lithograph printed in colours, signed in pencil and numbered 56 x 76cm. Sworders, Stansted Mountfitchet. Apr 05. £280.

2279

Robert Fowler, The North Wales coast, oil on canvas, signed, 39.5 x 54.5cm. Rosebery's, London. Mar 05. £280.

2280

Arthur William Redgate, The Trent Vale, oil on canvas, signed, 61 x 92cm. Rosebery's, London. Mar 05. £280.

2281

Clive Garniner, (1891-1960) 'Europa and the Bull', oil, board 10 x 12.75in, apparently inscribed to reverse, c1950, modern gilt moulded and cloth covered frame. Canterbury Auc. Galleries, Kent. Apr 05. £280.

2282

Salvador Dali, (1904-1989) Bullfighter, pencil signed and numbered 36/300, coloured lithograph and The Tribes of Israel frontispiece, pencil signed and numbered 3/20, 49 x 36cm. Sworders, Stansted Mountfitchet. Apr 05. £280.

2283

Manner of Jean-Baptise Monnoyer, Chrysanthemums, daisies, foxgloves, hydrangea & tulips in a glass vase on a ledge, oil on canvas, Rosebery's, London. Jun 05. £280.

2284

English school 19thC, Lady opening shutters on a balcony, oil on canvas, 53 x 43cm. Rosebery's, London. Jun 05. £280.

2285

Manner of Francisco Bores, Untitled abstract composition, oil on canvas, signature, inscribed 'Galerie Lois Carre, 10 av. de Messine' on label attached to stretcher, 47 x 56cm. Rosebery's, London. Jun 05. £280.

2286

19thC Heraldic Picture, painted in oils and gold on canvas, depicting a shield with 3 wreaths surmounted by a helmet & armour holding a further wreath aloft, inscribed 'Celestem Spero Coronam', 32.3 x 29.8cm. Rosebery's, London. Jun 05. £280.

2287

British School, Figure on a hillside with a village and an extensive landscape beyond, oil on paper laid down on panel, 29 x 44.5cm. Rosebery's, London. Jun 05. £280.

2288

Clifford Hall, 'St. Mark's, Venice', oil on canvas board, signed and dated 1948, and inscribed on label attached to the reverse, 31 x 40.8cm. Rosebery's, London. Jun 05. £280.

2289

William Fulton Brown, RSW (1873-1905) Cattle in Pasture, signed lower right 'W Fulton Brown', watercolour, 29 x 39cm. Cheffins, Cambridge. Apr 05. £280.

2290

Italian School, (18th/19thC) The Madonna, oil on canvas, 50 x 39cm. Cheffins, Cambridge. Apr 05. £280.

2291

Edward Holroyd Pearce, RBA (British, 1901-1990) Watermill Farm, Wenhaston, Suffolk, signed lower left 'Holroyd Pearce', oil on board, 25 x 36cm. Cheffins, Cambridge. Apr 05. £280.

2292

Dame Laura Knight, Figure Scene, pencil sketch and watercolour, signed, 15.25 x 13.25in, ebonised frame. Andrew Hartley, Ilkley. Oct 01. £275.

2293

English School c1840, View of York Minster with Figures, hand-coloured lithograph, 70 x 102cm. Sworders, Stansted Mountfitchet. Apr 05. £270.

2294

John Henry Mole, (1814-1886) Children fishing on the beach, South Bay, Scarborough, signed, 7 x 12.25in, gilt frame. Dee Atkinson & Harrison, Driffield. Nov 04. £270.

2301

H Langeet (? 20thC Dutch School) Canal scene with man in a rowing boat, oil, canvas 16 x 24in, indistinctly signed in red, modern gilt swept frame. Canterbury Auction Galleries, Kent. Aug 03. £270.

2305

Oliver Senior, A.R.C.A., 'The Thames, Battersea Reach, Evening', pastel, signed, inscribed on label on reverse, 23 x 34.2cm. Rosebery's, London. Sep 04. £270.

2295

Leon Danchin, (1887-1939) 'Springer spaniel chasing a rabbit', signed in pencil lower right, coloured litho-graph, published by Leon Danchin, 6 Rue Edmond About Paris, 1938, framed, 10 x 17.25in. Peter Wilson, Nantwich. Nov 01. £270.

The abbreviations following artist's names can be located in the Appendices.

2298

English School, c1800, water-colour on ivory miniature, Portrait of a gentleman, backed with a portrait of a lady, ovals, 1.5 x 1.25in. Gorringes, Lewes. Jun 03. £270.

2302

Victorian Portrait School, Portrait of Henry Lee (1765-1838) wearing a black jacket and white cravat, half length, oil painting, 24 x 18cm, and a portrait of Harry Lee (1793-1880) wearing a black jacket and white cravat, 23 x 18cm. (2) Hampton & Little-wood, Exeter. Jul 04. £270.

2306

19thC Primitive School, oil painting, head of a liver and white hound, board 9 x 13.5in, rosewood frame. Canterbury Auc. Galleries, Kent. Mar 05. £270.

2296

British Post War Abstract School c1960, Untitled abstract composition, oil on canvas, signature and date on the reverse, 49.7 x 39.5cm. Rosebery's, London. Jun 05. £270.

2299

Manner of Richard Rothwell, (1800-1868) Portrait of a gentleman, wearing a fur collared jacket, white shirt and black cravat, oil on canvas, 74 x 60cm. Hampton & Littlewood, Exeter. Jul 04. £270.

2303

Anda Paterson, gouache over ink 'Outsiders', signed and dated 82, 23 x 17.5in. Great Western Auctions, Glasgow. Apr 05. £270.

2307

Watercolour of a Quay Side with Fishing Boats & Village to the rear, signed Robert W Allan RWA, entitled Sicily. Kent Auction Galleries, Folkestone. Apr 05. £270.

2308

W Hendriks, Cattle grazing in a wooded landscape beside a stream, signed, framed, 15.5 x 19.5in. Tring Market Auctions, Herts. Jan 03. £270.

2297

British School, 19thC, oil on canvas, Watching the cradle, indistinctly signed, 89.3 x 69cm, framed. Bristol Auction Rooms. Dec 03. £270.

2300

19thC English School, Two children, playing with a lizard, oval, oil on panel, 16 x 12cm. Henry Adams, Chichester. Jan 03. £270.

2304

Percy Car***, oil on canvas, late 19thC, waterfall scene, indistinctly signed, 35.5 x 27.5in. Dee, Atkinson & Harrison, Driffield. Apr 01. £270.

2309

British Post War Abstract School c1960, Untitled abstract composition, oil and mixed media on board, sign-ature and date on reverse, 103 x 109cm. Rosebery's, London. Jun 05. £270.

Hammer Prices £270 - £260

2310

British Post War Abstract School, c1960, Untitled abstract composition, mixed media and oil on board, bears signature and date, 49.9 x 61.5cm. Rosebery's, London. Jun 05. £270.

2311

Tony Sutton. A kitten and caterpillar watercolour, signed, 6.25 x 9.25in Sworders, Stansted Mountfitchet. Mar 01. £260.

2312

Archibald Thornburn, Bullfinches, coloured print, signed in pencil in the margin, 10 x 7in. Sworders, Stansted Mountfitchet. Apr 01. £260.

2313

Norman Stone, oil on canvas, 'Garrya Elliptica & Freesias', signed, 20 x 18in. Gorringes, Lewes. Mar 01. £260.

2314

D'Oyly John, oil on canvas, Mediterranean harbour, 17.5 x 25.5in. Gorringes, Lewes. Apr 01. £260.

146 *Picture Prices*

2315

Young woman, oil, signature Henry F........ 20 x 27in, gilt frame. Lambert & Foster, Tenterden. May 02. £260.

2316

After James Armstrong, The Celebrated Greyhounds....., coloured lithograph, pub'd 1870, 18 x 25in. Sworders, Stansted Mountfitchet. Jul 01. £260.

2317

Josephine Miller, A.R.S.A., 'Mixed Flowers', oil on board, signed, inscribed on label attached to the verso, 31.5 x 26.4cm. Rosebery's, London. Sep 04. £260.

2318

J C Uren, 'At Land's End', watercolour, signed. W & H Peacock, Bedford. Jul 03. £260.

2319

J. J. Fonecca, watercolour, grey horse in a stable, signed and dated 1876, 11.5 x 15in. Gorringes, Lewes. Oct 02. £260.

2320

One of a pair of coloured French landscape prints, signed Henry Fondois?, 47 x 54cm. Thos Mawer & Son, Lincoln. Nov 02. £260.

2321

T Baker, Riverscape of Hampton Lucy village with cattle, watercolour on paper, signed, 25.5 x 39.5cm, mounted, glazed and framed. Locke & England, Leamington Spa. Jul 03. £260.

2322

English School, 19thC, Family of African lions after the kill, pen and brown ink & watercolour, 34.2 x 51.2cm, unframed. Rosebery's, London. Sep 03. £260.

2323

Gebrand F. Van Schagen, (1880-1968) Dutch, oil on canvas, Country Landscape, signed, 20 x 28in. Gorringes, Lewes. Oct 04. £260.

2324

Early 19thC English School, oil, half length portrait of a young woman, relined canvas, 30 x 25in, gilt moulded frame. Canterbury Auction Galleries, Kent. Dec 03. £260.

2325

Henry Stannard, Winter Landscape, watercolour, signed. W & H Peacock, Bedford. Jul 03. £260.

> Fresh to the market paintings perform better than those which have been in and out of auction.

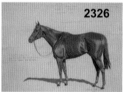

2326

Michael Jeffery, Artist's working sketch portrait of the racehorse 'Pivotal' at Heath House, Newmarket, signed and dated 1997 and extensively annotated, oil on paper 44 x 59cm. Sworders, Stansted Mountfitchet. Nov 04. £260.

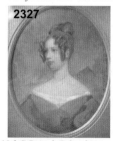

2327

19thC British School. Portrait miniature of a lady, gilt metal mount and gilt gesso frame, image 10 x 8cm. Rosebery's, London. Mar 04. £260.

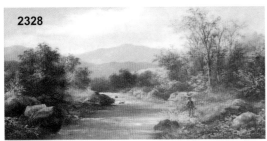

2328

R Marshall, oil on canvas, The Waters of Leith, signed, 12 x 24in. Gorringes, Lewes. Mar 01. £260.

2329

Giuseppe Gambino, 'Pretini Rossi', oil on canvas, signed and dated 1964, and signed, titled & dated on the reverse, 43.5 x 63.5cm. Rosebery's, London. Sep 04. £260.

2330

William Kermode, Bombed dwelling, gouache, signed & dated '48, 46.2 x 62.2cm, unframed. Rosebery's, London. Sep 04. £260.

2331

Frank Runacres, 'Richmond Bridge', oil on canvas board, signed, inscribed, titled and dated 1971 on letter attached to the reverse, 66 x 74.7cm. Rosebery's, London. Sep 04. £260.

2332

E. Hughes, oil on board, Mother and child in a street, signed, 6 x 5in. Gorringes, Lewes. Jan 04. £260.

2333

Henry Silkstone Hopwood, Arab Street Scene, unsigned, on board, 8 x 1.25in, gilt frame. Andrew Hartley, Ilkley. Dec 04. £260.

2334

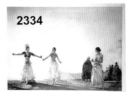

Sir William Russell Flint, Castanets, reproduction in colours, signed in pencil, blindstamp for The Fine Art Guild, 16.25 x 22.25in, white painted frame. Andrew Hartley, Ilkley. Apr 04. £260

2335

James P Power, Cornish Homestead, signed, oil on canvas 41 x 51cm. Sworders, Stansted Mountfitchet. Nov 04. £260.

2336

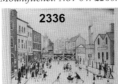

After Laurence Stephen Lowry, (1887-1976) 'Level crossing - Burton on Trent', coloured print, signed by the artist in pencil, with fine art trade guild blindstamp, 43cm x 58cm. Hampton & Little-wood, Exeter. Jul 04. £260.

2337

C.R. Doyly-John, (1906-1993) 'San Sebastian', oil on canvas, signed, 18 x 26in. Gorringes, Lewes. Jul 04. £260.

2338

Elizabeth Keith, (1887-) American coloured woodcut, 'Morning Mists, Korea', signed in pencil, 9.5 x 14.5in. Gorringes, Lewes. Mar 04. £260.

2339

Allin Braund, 'Coalmen', pen and ink and watercolour, signed, titled and dated '50, 45.5 x 34cm and Mathias(?) Henward, Abstract study, gouache, signed & dated '56, inscribed verso, 39.2 x 46.3cm, unframed. Rosebery's, London. Sep 04. £260.

2340

Circular portrait of figures in a garden bearing a plaque G Moorland, 20thC, gilt frame, 29cm dia. Thos. Mawer & Son, Lincoln. Mar 04. £260.

2341

Callow, Shipping in harbour, oil on canvas, indistinctly signed, 10 x 18in. Gorringes, Lewes. Dec 04. £260.

2342

Elizabeth Keith (1887-) American coloured woodcut, 'The Wong a Scholar & His Disciples', signed in pencil, 13.75 x 9.5in. Gorringes, Lewes. Mar 04. £260.

2343

Bournard, oil on board, Carnations in a basket, signed, 12 x 18in. Gorringes, Lewes. Apr 03. £260.

2344

Circle of Richard Ansdell, (1815-1885) oil on board, Well, W. Gibraltar, 18.5 x 12.25in. Gorringes, Lewes. Jul 03. £260.

2345

English School, (18th/19thC) Landscape with a Drover and Cattle on a Track, oil on panel, 11 x 17cm Cheffins, Cambridge. Feb 05. £260.

2346

Allen Jones, 'Ah', lithograph in colour, signed, dated '73 in pencil, 21.5 x 15cm, and with a menu after a design by same hand, signed, titled The Noir-East, dedicated and dated '71, plexiglass frame, 22.5 x 25.5cm. Rosebery's, London. Dec 04. £260.

2347

Hercules Brabazon Brabazon, Italianate vista, watercolour heightened. Rosebery's, London. Dec 04. £260.

2348

Beatrice Langdon, Victoria & Albert Museum, oil on canvas laid down on panel, signed, 29.5 x 40.7cm & one other oil study on panel of a London mews by the same hand, signed, 26.2 x 35.5cm, unframed. Rosebery's, London. Dec 04. £260.

2349

After Teniers, oil on canvas, tavern interior, 8 x 6.5in. Gorringes, Lewes. Apr 02. £260.

2350

Dimitri Perdikidis, Greek school 20thC, untitled abstract composition, April 1960; oil on panel, signed, 122 x 34.3cm. Rosebery's, London. Dec 04. £260.

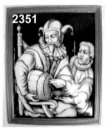

2351

Limoges enamel on copper panel, of a jester pouring a drink from a barrel, monogram signature to bottom corner, later gilt metal frame. 14.5 x 12cm. Rosebery's, London. Dec 04. £260.

2352

J L Petit, 1801-1865, selection of watercolour sketches (15), all unframed. Canterbury Auc. Galleries, Kent. Apr 05. £260.

2353

Circle of Emma Belloc, Portrait of a lady half length holding a pot of lilies, oil on canvas, 76 x 63.5cm. Rosebery's, London. Mar 05. £260.

2354

David Loggan, (d.1693) Christ Church, Oxford, engraving, 1673, 41 x 82cm; and a View of Oxford, and 9 engravings from the Oxford Almanack by George Vertue, incl. one framed approx 39 x 47cm. (10) Sworders, Stansted Mountfitchet. Feb 05. £260.

2355

Robert Gallon, (1845-1925), oil on board, 'At East Garton', inscribed verso and dated 11 August 1924, and with label of certification dated 1846, 18 x 29.5cm. Gorringes, Bexhill. Mar 05. £260

> Provenance is an important market factor which can bare positively on results achieved at auction.

2356

19thC Dutch School, oil on canvas, tavern interior with card players, 21 x 17in. Gorringes, Bexhill. Mar 02. £260.

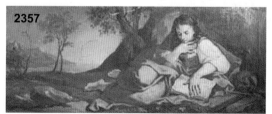

2357

Follower of Sassoferrato 'The Penitent Magdalen', oil on canvas, 37 x 91cm. Hampton & Littlewood, Exeter. Jul 04. £260.

2358

European School 19thC, Two putti with a garland of fruit and flowers, oil on tin, 20.7 x 32cm. Rosebery's, London. Mar 05. £260.

2359

After Ossip Zadkine, Two figures, lithograph in colours, signed within the plate, 45.7 x 34cm, and a quantity of lithographs after different hands, unframed, a lot. Rosebery's, London. Mar 05. £260.

2360

A. Roland Knight (19thC) oil on canvas, 'In The Larder' signed, 16 x 23.5in. Gorringes, Bexhill. Mar 02. £260.

2361

Thomas H. Munn, (Exh. 1880-1908) watercolour, Flowers and lake in a garden, signed, 9 x 14.5in. Gorringes, Lewes. July 03. £260.

Paul Marny, (1829-1914) South Bay Scarborough, monogrammed, 9.5 x 18.5in, gilt frame. Dee Atkinson & Harrison, Driffield. Nov 04. £260.

After Warhol, 'Shirley 2000', coloured photographic print of Shirley Bassey c2000, initialled to bottom right J.F., 57 x 47cm. Rosebery's, London. Jun 05. £260.

Edoardo Forlenza, (late 19thC) Gypsy Girls, a pair, signed, oil on board, 29 x 17cm. Sworders, Stansted Mountfitchet. Apr 05. £260.

William Langley, (fl. 1880-1920), pair, oils, Sunlit River Landscape & River Landscape with Cattle Watering, canvases 16 x 24in, signed in full, gilt moulded frames. Canterbury Auc. Galleries, Kent. Apr 05. £260.

Framed porcelain painted plaque depicting a portrait of a girl, by the Schwarzwalderin Studio, Germany, 46cm dia. Great Western Auctions, Glasgow. May 05. £260.

Andrew Hislop, oil on canvas 'Loch Long', signed recto, entitled on the stretcher, 16 x 24in. Great Western Auctions, Glasgow. Jun 05. £260.

Rowland Suddaby, 'Boats, Dinghy and Fishermen', pen & black ink and watercolour, signed, 32.8 x 54.5cm. Rosebery's, London. Jun 05. £260.

William Callow, R.W.S., Dunster Castle, (Somerset), watercolour, titled and dated Aug 24th. 47, 25.5 x 35.5cm. Rosebery's, London. Jun 05. £260.

Portrait of Shirley Bassey, pencil and poster paint on paper, signed and dated '76'. 70 x 102cm. Rosebery's, London. Jun 05. £260.

Archibald Ziegler, 'The Lesson', oil on panel, signed, 44.3 x 59.7cm. Rosebery's, London. Jun 05. £260.

Joseph Walter West, (1860-1933) watercolour, Norsemen drinking at a banquet, signed and dated 1881, 7.5 x 11in. Dee, Atkinson & Harrison, Driffield. Aug 01. £250.

Pair of early 19thC hand-coloured stipple engravings of the Grand Duchesses Catherine and Marie, sisters to Emperor Alexander I. (1777-1825) Lots Road, Chelsea. Aug 01. £250.

Portrait of a lady in 17thC costume, unsigned, unframed, 27 x 19in. Tring Market Auctions, Herts. Mar 02. £250.

Anna Katrina Zinkeisen, Still life of fruit on a green comport, oil on canvas, signed, 61 x 50.7cm. Rosebery's, London. Sep 04. £250.

George Harvey, oil on board, Sketch for a Picnic in Central Park, 10.5 x 8in. Gorringes, Lewes. Mar 01. £250.

Christian Haug, Norwegian School, 19/20thC, Winter woodland scene with a deer, oil on canvas, signed, 78.4 x 65cm. Rosebery's, London. Sep 04. £250.

English school, Study of a lifeboat going to the rescue of a ship in distress, unsigned on panel, 7.25 x 5.75in, gilt frame. Dee Atkinson & Harrison, Driffield. Nov 04. £250.

Hammer Price £250

2379

J. G. Wells, (fl late 18th/early 19thC) after T. Smith, coloured aquatint, A View of Margate, with the Bathing Place, 11.75 x 17.75in, pub'd August 1st 1786 by R. Pollard, No. 7 Braynes Row, Spar Fields, walnut frame. Canterbury Auc. Galleries, Kent. Aug 02. £250.

2380

Attributed to George Goodwin Kilburne, R.I., R.B.A., The New Violin, watercolour, signature & date, 32.5 x 24.5cm. Rosebery's, London. Sep 04. £250.

2381

Circle of Charles Angrand, Cottages amongst wooded farmland, coloured crayon & pastel, stamped signature, labels for Richmond Gallery, London to reverse, 33.7 x 45.2cm, unframed. Rosebery's, London. Dec 04. £250.

2382

A D Bell, watercolour, Symonds Yat. Gorringes, Bexhill. Sep 04. £250.

2383

Lexden Lewis Pocock, seeding thistles in a meadow, wooded misty landscape beyond, watercolour, signed in mono, framed and glazed, 12 x 19in. Tring Market Auctions, Herts. Nov 03. £250.

2384

William Clarkson Stanfield, (1793-1867) watercolour, Venetian lagoon with figures, fishing boats, signed and inscribed R.A., 8.5 x 12.5in. Gorringes, Bexhill. May 02. £250.

Most auction catalogues carry an explantation of the terminology used in descriptions. See Appendices.

2385

J E Duggins, Fishing boats in harbour, oil painting on canvas, signed, 44.5 x 35.5cm, gilt frame. Locke & England, Leamington Spa. May 03. £250.

2386

After F. Barenger, 'The Earl of Derby's stag hounds', coloured engraving by R. Woodman, pub'd 1823, 19 x 23in. Sworders, Stansted Mountfitchet. Apr 01. £250.

2387

Pair of 19thC watercolours, unsigned. Tring Market Auctions, Herts. Oct 04. £250.

2388

Theodore Hines, 19thC, oil on canvas, landscape believed to be Loch Katrine, decorative gilt frame, 50 x 75cm. Thos Mawer & Son, Lincoln. Sep 04. £250.

2389

Harry Bright, 1885, Bullfinch feeding young, signed and dated, oval framed & glazed, 9.5 x 7in. Tring Market Auctions, Herts. Jul 04. £250.

2390

Victor Koshevoi, (b.1924), 'By the Sea', 1964, oil on board, signed, 34.5 x 48cm, framed. Lots Road Auctions, Chelsea. Dec 04. £250.

2391

Oval miniature of a young man, blue coat with a black stock, embossed gilt metal frame, 5.5 x 4.5cm. Thos. Mawer & Son, Lincoln. Mar 04. £250.

2392

After George Morland, oil on canvas, Figures feeding pigs, bears signature, 20 x 24in. Gorringes, Lewes. Mar 04. £250.

2393

Andre Wilder, 'Moulin sur le vers a Brostanac(?)', oil on canvas, signed, and signed and titled on stretcher, 60 x 73cm. Rosebery's, London. Dec 04. £250.

2394

French School, Allegorical scene, oil on metal panel, 25 x 19cm. Henry Adams, Chichester. Jan 03. £250.

2395

After Rembrandt, Self Portrait, oil on canvas, 30.7 x 25.5cm, original painting c1640 is held by the National Gallery, London. Rosebery's, London. Dec 04. £250.

2396

*French School c1920, River landscape with woodland and cottages, oil on panel, signed Emile ****, 32 x 45cm. Rosebery's, London. Dec 04. £250.*

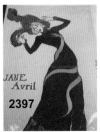

2397

After Henri de Toulouse-Lautrec, Dancehall scene, originally pub'd by H Silva, Paris, 1899, reproduction print in colours, 63 x 41cm, and ten other colour lithographs including examples after Bonnard and Utrillo, unframed. (14) Rosebery's, London. Mar 05. £250.

2398

Oil on canvas, River Scene, by Spencer Coleman, 15 x 19in approx. John Taylors, Louth. Apr 05. £250.

2399

J L Petit, 1801-1865, selection of watercolour sketches, views in France & the continent, all unframed. (19) Canterbury Auction Galleries, Kent. Apr 05. £250.

2400

In the manner of Davie Wilkie, (1785-1841) shoulder length portrait of a peasant girl, oil, mahogany panel 9 x 7in, deep moulded gilt frame. Canterbury Auc. Galleries, Kent. Apr 05. £250.

2401

Donald Bain, chalk over gouache 'Sunflowers', signed with initials, 12 x 11in. Great Western Auctions, Glasgow. Apr 05. £250.

2402

Leslie Charles Worth, Boscastle, Lone dog in shallow water before misty cliffs, gouache, signed, gilt glazed frame, 26 x 36.5cm. Locke & England, Leamington Spa. May 05. £250.

2403

Manner of Clarence Montford Gihon, Figure in a parkland setting, oil on canvas laid over board, bears signature, 53.4 x 43.5cm. Rosebery's, London. Jun 05. £250.

2404

John Byrne, pen drawings 'Corner Boy', signed, 5.5 x 2.5in. Great Western Auctions, Glasgow. Apr 05. £250.

2405

Attributed to Camille Huckenbollner, River landscape with figures on a wooden bridge and cottages, oil on canvas, 69.5 x 84.7cm. Rosebery's, London. Jun 05. £250.

2406

Richard Wayne, scene depicting travellers around a camp fire, watercolour, signed, 18 x 36in. Amersham Auction Rooms, Bucks. Apr 01. £240.

2407

Victorian black and white 'autograph proof' print of a met of the Beaufort Hunt, with facsimile signatures, 'Beaufort' and 'Worcester', 25 x 44in. Sworders, Stansted Mountfitchet. Apr 01. £240.

2408

After C H Olncelin, (?) Two racehorses exercising on a beach, coloured print, 11.5 x 18in. Sworders, Stansted Mountfitchet. Apr 01. £240.

2409

Nils H Christianson. Highland Scenes, a pair of oils on canvas, signed, 18.5 x 8.5in. Sworders, Stansted Mountfitchet. Apr 01. £240.

2410

After Henry Moore, Abstract coloured print dated '49, 19 x 30in. Sworders, Stansted Mountfitchet. Jul 01. £240.

2411

English School, oil on canvas, 18thC figures in an Italian city, 18 x 14in. Gorringes, Lewes. Apr 01. £240.

2412

19thC Italian School, oil on canvas, Monk in a wine cellar, 9.5 x 7.5in. Gorringes, Lewes. Apr 01. £240.

2413

After Sir William Russell Flint, Castanets print, signed in pencil in the margin, 16 x 22in. Sworders, Stansted Mountfitchet. Jul 01. £240.

2414

E B Kincaid, oil on canvas, mountainous landscape with lake, signed lower right hand margin, 30 x 38cm, framed. Thos Mawer & Son, Lincoln. Feb 03. £240.

N C Livingstone, 'Sand Dunes Gullane' and 'Ben Lawers', signed, framed and glazed, each 11 x 14.5in. Tring Market Auctions, Herts. Jan 03. £240.

18thC Continental School, Portrait of a lady reading, oil on canvas. W & H Peacock, Bedford. Feb 03. £240.

Three pen, ink and watercolour drawings, St Margaret's Street, Canterbury, Mercery Lane, Canterbury, 9.5 x 12.5in and Canterbury Cathedral, 7.25 x 9in, all signed, framed and glazed. Canterbury Auct. Galleries, Kent. Aug 03. £240.

Ursula Wood, Portrait of Baby Eric at two years old, oil on canvas, signed titled and dated 1924, 51 x 30.3cm, unframed. Rosebery's, London. Jun 04. £240.

William Russell Flint, (British 1880-1969) Studies of female nudes by a woodland stream, red chalk print, signed in red chalk lower right, 41 x 26.5cm. Fellows & Sons, Hockley, Birmingham. Oct 02. £240.

Late Victorian School, study of a seated cat and 2 kittens, unsigned, oil on canvas, framed, 26 x 37cm. Richard Winterton, Burton on Trent, Staffs. Apr 04. £240.

'Nettie', coloured engraving of a trotting horse. Hobbs Parker, Ashford, Kent. Jul 04. £240.

Frank Brangwyn, (1867-1956), etching, Barnard Castle, signed, 10.5 x 14.5in. Gorringes, Lewes. Oct 04. £240.

Newman Hall Brown, Old Forge, Cockington, and Dittisham on the Dart, pair of watercolours, both signed, 10 x 14in, gilt framed. Maxwells, Wilmslow. Sep 04. £240.

After L. Icart, Cockatoo, inscribed verso, coloured etching, oval, copyright 1928, signed in mount, 23.5 x 30cm. Hobbs Parker, Ashford. Nov 04. £240.

P. van Eysingen, Portrait of a lady seated quarter-length in a broad brimmed hat with a pink ribbon, oil on canvas, signed and dated 1911, 59.5 x 50.5cm. Rosebery's, London. Sep 04. £240.

Paul Jacoulet, 'Longevite, Coree-Moppo', pub'd. 28th November 1948, colour woodblock print, signed in pencil, seals of the carver, Kentaro Maeda and printer, Fusakichi Ogawa, 39.5 x 30cm, unframed. Rosebery's, London. Sep 04. £240.

Mosse Stoopendaal, Swedish School 20thC, Song bird perched on a branch, gouache, signed, dated 1925, 28 x 45.8cm. Rosebery's, London. Sep 04. £240.

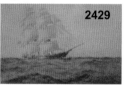

S Harrow, 19thC, Durham Cathedral, signed, 19.5 x 14.5in, gilt frame. Dee Atkinson & Harrison, Driffield. Nov 04. £240.

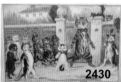

William Minshall Birchall, watercolour drawing, Way back in the Fifties. Gorringes, Bexhill On Sea. Sep 04. £240.

After Louis Wain, coloured print, The Good Puss, 18 x 27.5in. Dee, Atkinson & Harrison, Driffield. Aug 04. £240.

Henri Follenfan, Farmyard Scene, signed, oil on canvas, 54 x 43cm. Sworders, Stansted Mountfitchet. Nov 04. £240.

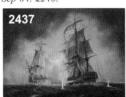

2432

Carl Werner, 'Chapel where the three crosses were found', inscribed verso, watercolour, 34.5 x 49.5cm. Sworders, Stansted Mountfitchet. Nov 04. £240.

2433

Edouard Aniereders, Still life of books, a globe, a chalice and a vase of flowers by a window, signed, oil on panel, 49 x 61cm. Sworders, Stansted Mountfitchet. Nov 04. £240.

Ensure you never hang your watercolours etc in direct or reflected sunlight. Fading seriously affects value.

2434

Aline Ellis, Waiting at the Door, signed, pencil, brush, black ink & coloured washes, 25.5 x 32cm. Sworders, Stansted Mountfitchet. Nov 04. £240.

2435

Victorian School, oil on canvas, portrait of a bearded man. Gorringes, Bexhill On Sea. Sep 04. £240.

2436

A D Bell, watercolour, The Wye from the Wyndcliffe. Gorringes, Bexhill On Sea. Sep 04. £240.

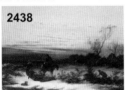

2437

Michael Whitehand, (20thC) marine battle scene, signed, dated 1980, 29.5 x 39.5in, gilt frame. Dee Atkinson & Harrison, Driffield. Jul 04. £240.

2438

E C Williams, oil on canvas, Gathering Winter Fuel. Gorringes, Bexhill On Sea. Sep 04. £240.

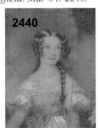

2439

English School, (19thC) pen and ink drawing, cockerel, indistinctly signed, 21 x 16in, rosewood frame. Dee Atkinson & Harrison, Driffield. Mar 04. £240.

2440

A Zinkeisen, red chalk over pencil, young woman playing a piano. Gorringes, Bexhill On Sea. Sep 04. £240.

Hammer Price £240

2441

William Lionel Wyllie, b/w etching, Thames scene with figures labouring under an arch. Gorringes, Bexhill On Sea. Dec 04. £240.

2442

K L F Glen, (20thC) Clan Cumming steamer, King George Dock, Hull, signed, 13.75 x 17.25in, gilt frame. Dee Atkinson & Harrison, Driffield. Jul 04. £240.

2443

Yuki (Gnyuki Torimaru), Chester Square, oil on canvas, signed and dated 1962, 50 x 60cm. Dreweatt Neate, Donnington. Nov 02. £240.

2444

Attributed to Albert Goodwin, (1845-1932) Coach before Mont St. Michel, watercolour, 7 x 10.5in. Gorringes, Lewes. Jul 04. £240.

2445

David Thomas, Sunset over Venice, signed, inscribed verso, oil on a canvas board, 21 x 38cm. Sworders, Stansted Mountfitchet. Nov 04. £240

2446

Henry Mitton Wilson, (1873-1923) An Orchard in Springtime, oil on board, 22 x 29cm. Cheffins, Cambridge. Feb 05. £240.

2447

Henry Childe Pocock, (1854-1934) oil on board, 'A View from the Flagstaff, Hampstead Heath', signed, dated 1927, 7.5 x 11.5in. Gorringes, Lewes. Jul 04. £240.

2448

Lance Thackeray, (d.1916) watercolour, Figures beside a canal, signed, 14 x 21in. Gorringes, Lewes. Mar 04. £240.

2449

Sidney Yates Johnson, (fl. 1901-1910) oil on canvas, '...New Forest, Hampshire', monogrammed, 12 x 18in. Gorringes, Lewes. Mar 04. £240.

Hammer Price £240

2450

William Henry Earp, pair of watercolours, Loch scenes, signed, 9 x 21in. Gorringes, Lewes. Oct 02. £240.

2451

George Ayling, (1887-1960), watercolour 'Fair Evening' signed, 15 x 22in. Gorringes, Lewes. Oct 02. £240.

2452

Elizabeth King, still life study, Vase of Daisies, 13 x 11in, reverse with Royal Institute Galleries, 195 Picadilly, Second Summer Exhibition 1937. Denhams, Warnham, Sussex. Feb 05. £240.

2453

Attributed to Henry Lamb, Head study of a man, pencil, 30.2 x 22.7cm. Rosebery's, London. Dec 04. £240.

2454

William Henry Hunt, (1790-1864) Watercolour and a drawing, Still life of a plum & a peach, signed, 4 x 6.25in, & a sketch of beached fishing boats, 3.5 x 4.5in. Gorringes, Lewes. Mar 03. £240.

2455

British School, 20thC caricature of Eric Gill, pen and black ink and wash, signed with initials 'RV' and dated 1936, 35.5 x 25.4cm, and a similar caricature of Frank Dobson, similarly signed and dated, unframed. Rosebery's, London. Mar 05. £240.

2456

Leon Underwood, (1901-1975) colour print, 'Charro meets Charro', signed and dated '39 25/25, 19 x 15.5in. Gorringes, Lewes. Apr 03. £240.

2457

George Weissbort, (20thC), oil on board, Portrait of an Italian chorister, signed and dated 1954, 24 x 19in. Gorringes, Lewes. Oct 02. £240.

2458

James Longueville, Midday in Viols le Fort, Langedoc, black/coloured chalk, signed, and signed and inscribed with title on the reverse, 26.5 x 37cm. Rosebery's, London. Mar 05. £240.

2459

Attributed to Harold Speed, (1872-1957) oil on canvas, Children in a meadow, 22 x 16in. Gorringes, Lewes. Mar 03. £240.

Frames and mounts should enhance your picture. Empathy, rather than fashion should dictate your choice.

2460

Anthony Devas, oil, portrait of a gentleman. Gorringes, Bexhill. Sep 04. £240.

2461

After Ernest Rigg, modern oil on board, young lady with bridal veil, bears signature & date, 33 x 28in. Gorringes, Lewes. Apr 02. £240.

2462

Samuel Atkins, (fl.1787-1808) A Three-Master in an Open Sea, watercolour, 13 x 9cm. Cheffins, Cambridge. Feb 05. £240.

2463

Victorian School, two cut paper silhouettes, full length profiles of children, largest 5.5 x 4in. Gorringes, Lewes. Jan 05. £240.

2464

Italian School. (19thC) Woman of Pompeii, oil on canvas, 51 x 40cm. Cheffins, Cambridge. Feb 05. £240.

2465

Rowland Langmaid, 1897-1956, drypoint 'Off Ryde' (showing Shamrock, Britannia and Candida) signed in pencil, 6.25 x 12in. Great Western Auctions, Glasgow. Jun 05. £240.

2466

Charles Beatson, (English, 19thC) The Despatch, signed lower right 'Charles Beatson', oil on canvas, 60 x 50cm. Cheffins, Cambridge. Feb 05. £240.

2467

Les Pearson (20thC) Harbour reflections, Bridlington, signed and dated 1966, oil on board, 19.75 x 29.5in, gilt frame. Dee, Atkinson & Harrison, Driffield. Feb 05. £240.

2468

Harold Yates, 'Surreal composition', watercolour, signed and dated '42, 17 x 12.2cm. Rosebery's, London. Jun 05. £240.

2469

Thomas Sewell Robins, Troops departing from a European castle in a river landscape, pencil, pen and brown ink and watercolour, signed with initials & dated, 77.23 x 33.6cm, unframed. Rosebery's, London. Jun 05. £240.

2470

Frank L. Emanuel, Figure on a jetty with a sailing barge & lighthouse, pencil, signed and inscribed 'Treport', 18 x 16.5cm, and a pencil drawing of the Head of Christ and 2 etchings by the same hand, unframed. (4) Rosebery's, London. Jun 05. £240.

2471

Raymond Coxon, untitled abstract composition, oil on canvas, signed, 101 x 126.5cm, unframed. Rosebery's, London. Jun 05. £240.

2472

Watercolour by Orlando Norie of the 9th (Norfolk) Regiment, 7 x 5.5in, oval mount with plain gilt edged frame, 11.5 x 9.5in. Wallis and Wallis, Lewes. May 02. £230.

2473

B. Webb, study of highland stags, oil on canvas, signed and dated (18)64 lower left, gallery frame, 30 x 50cm. (restorations) Richard Winterton, Burton on Trent, Staffs. Jan 04. £230.

2474

Capelin, French School 19thC, Young couple picking apples, red chalk, 30.3 x 19cm, and nine other studies of figures in pencil and black chalk and crayon by the same hand, unframed. (10) (unframed) Rosebery's, London. Sep 04. £230.

Hammer Prices £240 - £230

2475

C Edson, early 20thC, The Channel Fleet off Scarborough, September 1908, signed and dated, 6.25 x 13in, gilt frame. Dee Atkinson & Harrison, Driffield. Nov 04. £230.

2476

Albert Wainwright, Boy with fruit, gouache, signed with monogram, 29.5 x 23.5cm. Rosebery's, London. Sep 04. £230.

2477

French School, early 20thC, View of Juan les Pins, oil on board, 16.5 x 22.7cm, with an alpine landscape study in oils on board by a different hand, 18.5 x 28.6cm. Rosebery's, London. Sep 04. £230.

2478

Circle of Alfred Edward Chalon, R.A., Portrait of a gentleman standing holding a letter, and Portrait of a lady standing, watercolours, a pair, both arched mounts, 42 x 29cm ea. (2) Rosebery's, London. Dec 04. £230.

2479

Keith Baynes, Interior scene with a dressing table mirror, oil on canvas, signed and dated 1924, 33.2 x 41.3cm. Rosebery's, London. Sep 04. £230.

2480

A D Belt, watercolour, The Seven Sisters, Monmouth. Gorringes, Bexhill. Sep 04. £230.

2481

Elizabeth Keith, (1887-) American coloured woodcut, 'Embroidering Korea', signed in pencil, 11.75 x 8.75in. Gorringes, Lewes. Mar 04. £230.

2482

Circle of Egbert Van Heemskerk, Peasant woman holding a bottle and a glass, oil on canvas, 25 x 16cm. Sworders, Stansted Mountfitchet. Nov 04. £230.

Sir William Russell Flint, Corisande, limited edition coloured reproduction, 402 of 850, blind stamp for Michael Stewart Fine Art, published 1980, 11 x 19in, gilt frame. Andrew Hartley, Ilkley. Apr 05. £230.

Elizabeth Keith, (1887-) American coloured woodcut, 'Embroidering Korea', signed in pencil, 11.75 x 8.75in. Gorringes, Lewes. Mar 04. £230.

William Tatton Winter, 'Above Wroxham', watercolour, signed, 17. 5 x 25cm and one other watercolour of a river landscape by the same hand, signed, 20 x 25cm. Rosebery's, London. Dec 04. £230.

Charles W. Oswald, Cattle watering in a highland loch, pair, oils on canvas, signed, 40.5 x 30.5cm ea. Rosebery's, London. Dec 04. £230.

Wilfrid Ball, watercolour, Downland windmill, signed and dated 90, 6 x 9.5in. Gorringes, Lewes. Mar 04. £230.

Jack Rigg, (b.1927), Maldon Essex, on board, signed, dated 1989 verso, 9.25 x 13.25in, gilt frame. Dee Atkinson & Harrison, Driffield. Mar 04. £230.

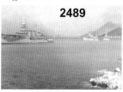

J. Seitz, British battle cruisers in a harbour near Dubrovnik, gouache, signed, inscribed and dated 1931, 14.8 x 29cm, unframed. Rosebery's, London. Dec 04. £230.

Longhaired cat and three kittens, oil on panel, 17.5 x 23.5cm. Hobbs Parker, Ashford. Nov 04. £225.

1930s oil on canvas of a Garden, signed Francis Day, removed from Sibton Park, ornate frame, 54 x 62in. Kent Auction Galleries, Folkestone. Jun 05. £225.

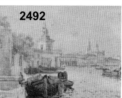

Watercolour study of The Arsenal, Venice by Charles James Fox (British c1860-c1937) dated 1901. Richard Winterton, Burton on Trent, Staffs. Jan 01. £220.

After Walter Dendy Sadler. 'A little practice', published 1915 by L H Lefevre, London, signed in pencil by the artist and John Dobie, 11.8in, remarque proof. Dockree's, Manchester. Feb 01. £220.

Spy, set of 8 coloured prints, caricatures of cricketers, 12.75 x 7.5in. Gorringes, Lewes. Jun 01. £220.

Archibald Thornburn, Wood-pigeons, coloured print, signed in pencil in margin, 7 x 10in. Sworders, Stansted Mountfitchet. Apr 01. £220.

Edwin Dalby, (Exh 1887) York Minster, titled, mono-grammed and dated 1889, 7 x 9.5in. David Duggleby, Scarborough. Dec 01. £220.

Lees, watercolour, pen and ink, Nude bathers in a landscape, signed and dated (19)09, 8 x 12in. Gorringes, Lewes. Mar 01. £220.

John Steeple 1875, moorland scene with cattle grazing and mountains in the distance, signed & dated, framed and glazed, 9.5 x 13.5in, foxing. Tring Market Auctions, Herts. May 02. £220.

English School, portrait of a medieval maiden, water-colour, 14.5 x 10.5in. Sworders, Stansted Mountfitchet. Jul 01. £220.

2500

Reginald Hadley, River scene with boats at a quay, watercolour, signed, 19 x 29.5in, framed & glazed. Maxwells, Wilmslow. Sep 02. £220.

2501

Churchill (W. S.), Vanity Fair cartoon, from 1904, by Spy. Hamptons, Godalming. Oct 02. £220.

2502

Charles Le Brun, (1619-1690), one of a pair of drawings, 13.5 x 11.5cm, Studies of the hand. Locke & England, Leamington Spa. Jan 03. £220.

2503

William Frederick Hulk, (c1880-1900) Norfolk Broad scene, oil on panel, signed, 25.5 x 40.5cm, ornate gilt frame. Locke & England, Leamington Spa. Jul 03. £220.

2504

Graeme McLaren, (1851-1917), Sunset loch scene with figure in a rowing boat, oil on canvas, signed, 30.5 x 61cm, ornate gilt frame. Locke & England, Leamington Spa. Jul 03. £220.

2505

Henry Lamb, 1883-1960, pastel drawing, portrait of a gentleman, 11 x 8.5in, signed and dated '43, modern gilt frame and glazed. Canterbury Auc. Galleries, Kent. Feb 04. £220.

2506

Delvaux Ferninand Maire, oil painting on board, Monastery cloister with monks, 15 x 22in. Denhams, Warnham. May 04. £220.

Ensure your watercolours etc are mounted on acid free boards. Have old pictures checked out by a framer.

2507

Dorcie Sykes, (1908-) oil on canvas, Cornish Street Scene with Fishseller, signed, 14 x 14in. Gorringes, Lewes. Jul 04. £220.

2508

Sir Frances Ros, 'Soleil Obscure', mixed technique on paper, signed, dated '65 and titled, 75 x 53.7cm. Rosebery's, London. Sep 04. £220.

Hammer Price £220

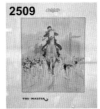

2509

After Cecil Aldin, 'The Master'. Boldon Auction Galleries, Tyne & Wear. Sep 04. £220.

2510

Watercolour, signed John Chamber, 'Sailing vessels at sea', 31 x 47cm. Boldon Auction Galleries, Tyne & Wear. Sep 04. £220.

2511

Jan le Witt, 'The Flower Barrow', gouache, signed, Zwemmer Gallery label verso, 28.4 x 39.4cm. Rosebery's, London. Sep 04. £220.

2512

Continental School, (late 19thC), Martiques, Boats in the Harbour, unsigned on board, 14.25 x 19.25in, gilt frame. Dee Atkinson & Harrison, Driffield. Nov 04. £220.

2513

English School, London Street Scene, dated April 14th 1910, inscribed in pencil verso, watercolour, 24 x 30.5cm. Sworders, Stansted Mountfitchet. Nov 04. £220.

1514

W L Wyllie, etching, The Highway of Nations. Gorringes, Bexhill On Sea. Sep 04. £220.

2515

Blatherwick, watercolour, still life of dog roses. Gorringes, Bexhill On Sea. Sep 04. £220.

2516

C. Meissner, Portrait of a Dutch lady, seated quarter-length, oil on canvas, 68 x 56.7cm. Rosebery's, London. Sep 04. £220.

2517

I L Roberts, (19thC), Cattle with drover in a woodland clearing, signed, 23 x 17.25in, gilt frame. Dee Atkinson & Harrison, Driffield. Nov 04. £220.

2518

Arthur Foord Hughes watercolour, Chailey, 1927, signed, 8.5 x 12.5in. Gorringes, Lewes. Mar 04. £220.

Picture Prices **157**

Hammer Price £220

2519

Frederick John Widgery, (1861-1942) 'Dunkery Beacon', bodycolour, signed, unglazed, 27 x 46cm. Hampton & Littlewood, Exeter. Jul 04. £220.

2520

After Carlo Dolci, 'The Penitent Magdalen', oil on panel, oval, 21 x 16.5cm. Hampton & Littlewood, Exeter. Jul 04. £220.

2521

Late 18thC English School pair of pastels, Portraits of a mother and daughter, 14 x 11in. Gorringes, Lewes. Jul 04. £220.

2522

Oval coloured print of Ferdinand George Waldmuller, (self portrait) 13.5 x 10cm. Thos. Mawer & Son, Lincoln. Mar 04. £220.

2523

Herbert Dicksee, (1862-1942), etching, gypsy girl and dog beside a cauldron, signed in pencil, 18.5 x 23in. Gorringes, Lewes. Apr 02. £220.

2524

French School, early 20thC, Floral still life, signed 'Geo', inscribed 'Vichy' and dated 1914, 54.9 x 37.6cm. Rosebery's, London. Dec 04. £220.

2525

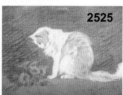

Gabrielle Rainer Ystvanffy, Seated cat with bouquet of flowers, coloured crayon and gouache, signed, 10.5 x 16cm and Martin Stachl, Portrait of a Dachshund, watercolour, signed, dated 1956, & signed titled and dated on mount, 14.2 x 11.8cm. Rosebery's, London. Dec 04. £220.

2526

William Kay Blacklock, Hayricks with a village beyond, watercolour, signed, 25 x 35.5cm. Rosebery's, London. Dec 04. £220.

2527

18thC English School, four unframed watercolour on ivory miniatures, portraits of ladies, one initialled I H, 1779, largest 2.5 x 2in. Gorringes, Lewes. Apr 03. £220.

2528

Averil Burleigh, (1883-1949) watercolour, Place Gregoire, Paris, 12.5 x 10in. Gorringes, Lewes. Apr 03. £220.

2529

Hugh E Ridge, oil on canvas, 'The Pendeen Light', signed, Society of Marine Artists exhibition label verso, 20 x 30in. Gorringes, Lewes. Mar 03. £220.

2530

Henri Riviere, (1864-1951) French, lithograph, Breton View, signed, Colnaghi label verso, 9 x 13.75in. Gorringes, Lewes. Oct 02. £220.

2531

Geoffrey Sparrow, coloured artists proof, Surrey Union Hounds, 1/25, signed in pencil and dated 1954, 10 x 12.5in. Gorringes, Lewes. Oct 02. £220.

2532

19thC English School, oil on canvas, 17thC hunting party preparing to depart, 20 x 24in, gilt gesso frame. Gorringes, Lewes. Oct 02. £220.

2533

English School, watercolour, Estuary with mountains beyond, monogrammed, 6.25 x 9.5in. Gorringes, Lewes. Apr 02. £220.

2534

G.R. Rushton, RI, R.B.A., (1868-1948), watercolour, The Gateway, South of France, signed, 14.25 x 20.75in, unframed. Diamond Mills & Co, Felixstowe. Dec 04. £220.

2535

G.R. Rushton, RI, R.B.A., (1868-1948), watercolour, Autumn, signed, 14.5 x 21.75in, unframed. Diamond Mills & Co, Felixstowe. Dec 04. £220.

2536

19thC English School, oil on canvas, portrait of a girl, 17 x 14.25in, unframed. Gorringes, Lewes. Apr 02. £220.

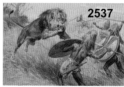

2537

J... F... Campbell, (early 20thC) 'The Nandi were ready when at last he sprang', signed, watercolour, heightened with white, 19 x 29cm. Sworders, Stansted Mountfitchet. Feb 05. £220.

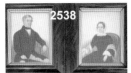

2538

Victorian School, pair of watercolour miniatures, half length portraits of a seated lady and gentleman, 5.25 x 3.75in. Gorringes, Bexhill. Mar 02. £220.

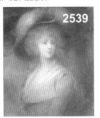

2539

After Gainsborough, pastel portrait of an 18thC lady, 30 x 25in, unframed. Gorringes, Bexhill. Mar 02. £220.

2540

Curtius Duassut, British 19thC, Horse and cart with cottages on a country lane, watercolour, signed, 24 x 36cm. Rosebery's, London. Mar 05. £220.

2541

Tibor Szontagh, Hungarian 19th/20thC, Peasant girl sitting by a stream & cottages, oil on canvas, signed, 79.8 x 99.6cm. Rosebery's, London. Mar 05. £220.

2542

Gabriella Rainer Ystvanffy, white kitten with a butterfly, black chalk and gouache, signed, 22.4 x 29cm. Rosebery's, London. Jun 05. £220.

2543

Carl Haag, (German, 1820-1915) The Ruin of a Mausoleum in the Campagna Romana, signed lower right 'Carl Haag 1856', watercolour, 25 x 35cm. Cheffins, Cambridge. Apr 05. £220.

2544

Eleanor Stephen, (English, 19thC) The Tea Party, signed lower right 'E R Stephen', watercolour, 14 x 23cm. Cheffins, Cambridge. Apr 05. £220.

Condiiton, rarity, provenance and fashion are the key market operators currently dictating values.

2545

Oval portrait miniature of a young lady on ivorine, reverse glazed to reveal a lock of hair & yellow metal initials, rose gold coloured metal frame inscribed on reverse 'died 14 Nov. 1811, Aged 28', miniature height 3in, red leather case. Fellows, Birmingham. Jul 03. £220.

2546

Alexander Graham Munro, RSW, pastel over ink 'Fez-Batha Palais', signed and entitled, 17 x 13in. Great Western Auctions, Glasgow. Apr 05. £220.

Hammer Price £220

2547

Pitrozelli Studies of Two Gypsies, head and shoulder, signed, oil on canvas, 26 x 21cm each. Sworders, Stansted Mountfitchet. Apr 05. £220.

2548

W Pinder, (English, 19thc) A Harbour by Night, signed lower left 'W Pinder '99', oil on board, 26 x 43cm. Cheffins, Cambridge. Apr 05. £220.Galleries, Kent.

2549

Edoardo Forlenza, (late 19thC) Gypsy Girl, signed, oil on canvas, 40 x 25cm. Sworders, Stansted Mountfitchet. Apr 05. £220.

2550

Douglas Thomson, oil on canvas 'Operator', signed recto & signed & entitled verso, 30 x 24in. Great Western Auctions, Glasgow. Apr 05. £220.

2551

19thC Continental School, Portrait of a lady, watercolour on ivory miniature, 3 x 2.5in. Gorringes, Lewes. Jun 03. £220.

2552

R Hilder, 1905-1993, Open landscape with trees to foreground, 7 x 11in, signed, framed. Canterbury Auction Galleries, Kent. Apr 05. £220.

2553

Attributed to Margaret Gillies, portrait miniature of a Mother & Daughter, traditionally held to be Miranda & Florence Hill, gilt gesso inner, red plush mounted ebonised box frame. Rosebery's, London. Jun 05. £220.

2554

English School 19thC, Study of a donkey, watercolour, dated 1849, 16.1 x 11.6cm, and a small quantity of 19thC watercolours of landscape subjects, unframed. Rosebery's, London. Jun 05. £220.

Hammer Prices £220 - £200

2555

Circle of William Daniel, Two figures in a landscape, pencil and watercolour, bears initials, 21.5 x 13.4cm, unframed. Rosebery's, London. Jun 05. £220.

2556

Josef Foshko, Russian/American School 20thC, 'A Road to Peekskill', oil on canvas, signed, 61 x 50.8cm. Rosebery's, London. Sep 04. £210.

2557

Newlyn School, watercolour, Street scene, St Ives, 9 x 7in. Gorringes, Lewes. Oct 02. £210.

2558

19thC Continental School, oil on canvas, Portrait of a young lady, 16 x 12.5in. Gorringes, Bexhill. Mar 02. £210.

2559

After Sir William Russell Flint, interior print, signed in pencil in the margin, 23 x 18in. Sworders, Stansted Mountfitchet. Jul 01. £210.

2560

Millet, Gleaners in a cornfield, signed, framed, 9.5 x 12in. (We assume this is a print!) Tring Market Auctions, Herts. Jan 03. £210.

2561

F Lindsay 1837, Northchurch, signed and dated, framed and glazed, 9 x 14in. Tring Market Auctions, Herts. Jan 03. £210.

2562

Attributed to Robert Walker MacBeth, Sailing barges, oil on canvas laid down, 5.2 x 12.5cm. Rosebery's, London. Sep 04. £210.

2563

Arthur Wilde Parsons, (1854-1931), watercolour, fishing vessel, Hove-to, signed, dated 1911, 7 x 9in. Dee, Atkinson & Harrison, Driffield. Apr 01. £210.

2564

James Basire, (1730-1802), Sepia engraving, The Castle at Kingsgate in the Isle of Thanet, 11 x 18.25in, framed & glazed. (border damaged) Canterbury Auc. Galleries, Kent. Aug 02. £210.

2565

Raymond Coxon, untitled abstract bird forms, oil on canvas, signed, 150 x 99.5cm. Rosebery's, London. Dec 04. £210.

2566

Wilfred Williams Ball, North African desert scene with a figure and distant village, water and bodycolour, signed and dated '93, 14.8 x 23.8cm. Rosebery's, London. Dec 04. £210.

2567

Claude Hayes, (1852-1922) 'Changing Pasture, Norfolk Broads', signed, watercolour, 24 x 35cm. Sworders, Stansted Mountfitchet. Feb 05. £210.

2568

Hely Augustus M. Smith, 'Departing Day', oil on panel, signed, and inscribed on label verso, 15 x 23cm. Rosebery's, London. Jun 05. £210.

2569

David Hewitt, Mountain landscape, oil on canvas board, signed & dated 1933, 29.2 x 44.5cm. Rosebery's, London. Jun 05. £210.

2570

English School, Portrait of a Lady seated on a Red Chair, unsigned on ivory, early 19thC, 3.5 x 2.75in, gilt metal and black papier mache frame. Andrew Hartley, Ilkley. Jun 05. £210.

2571

John Piper, coloured print, signed, 30 x 22in. Clevedon Salerooms, Bristol. Sep 01. £200.

2572

English Victorian 19thC School, Rocky fortification in the middle of the sea with boats to horizon, signature, 30 x 50cm, oil painting. Dockree's, Manchester. Jun 01. £200.

2573

Unsigned 18thC portrait. Tring Market Auctions, Herts. Jan 02. £200.

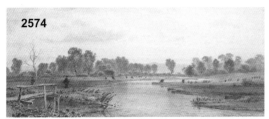

2574

Charles Marshall, (1806-1890) watercolour, River landscape with figures and cattle, signed, 5.5 x 13.25in. Gorringes, Lewes. Mar 02. £200.

2575

Frederick John Widgery, (1861-1942) watercolour, Angler beside a heathland stream, signed, 7 x 13in. Gorringes, Lewes. Mar 01. £200.

2576

G.F.N. watercolour, House and garden, initialled, 15 x 22.5in. Gorringes, Lewes. Mar 01. £200.

2577

M Mirralulla, Flowers in a mosque, watercolour, signed, 16.5 x 12.5in. Sworders, Stansted Mountfitchet. Apr 01. £200.

2578

English School, early 19thC, portrait of an austere mother, oil on canvas, 29 x 24in. Sworders, Stansted Mountfitchet. Apr 01. £200.

2579

After E Montaut 1904, pair of coloured lithographs of motoring scenes titled 'L'Embardee' and 'L'Epave', images 29 x 77cm. Thos Mawer & Son, Lincoln. Apr 02. £200.

2580

Charles Knight, (19th/20thC) watercolour, Eridge Park, Sussex, signed, 11.5 x 21.5in. Gorringes, Lewes. Jul 02. £200.

2581

Sam Bough, a bridge over a river at evening time, signed, framed and glazed, 7 x 10in. Tring Market Auctions, Herts. May 02. £200.

2582

Arthur Lemon, (1850-1912) Cottage with flowers, signed and dated 05(?), watercolour, 34 x 24cm. Sworders, Stansted Mountfitchet. Jul 03. £200.

2583

C Williams, country landscape with shepherd and sheep, signed, oil, 16 x 24in. Sworders, Stansted Mountfitchet. Jul 01. £200.

2584

J W Kettlewell, Bird's nest and blossom, signed and dated 1872, oil on board, 10 x 14in, unframed. Clarke Gammon, Guildford. Apr 03. £200.

Prices quoted are hammer and exclude the buyer's premium. Adding 15% will give approx. buying price.

2585

Giogren Ericksen, portrait of two young children, oil, relined canvas, 25 x 21in, signed, modern gilt moulded and swept frame. Canterbury Auc. Galleries, Kent. Apr 04. £200.

2586

Impressionist oil painting on canvas, Wooded Glade with Mountain, reverse with Arts Council label and Thistle Foundation label, 19 x 24in. Denhams, Warnham. Jul 04. £200.

2587

Irene Lagut, Two girls with a circus horse, oil on canvas, signed, 80.8 x 99.7cm, unframed. Rosebery's, London. Sep 04. £200.

2588

English School, 19thC, Beached fishing vessel, other shipping beyond, oil on canvas, 7.5 x 15in. Clarke Gammon, Guildford. Oct 04. £200.

2589

Beatrice Johnson, 'Still life with Apples and Bottles', oil on panel, signed, 37.2 x 30.3cm. Rosebery's, London. Sep 04. £200.

2590

18th/19thC coloured print, 'Shepherdess', carved gilt wood frame, 30in. Denhams, Warnham. Mar 04. £200.

2591

S Towers, watercolour, figures on a country path. Gorringes, Bexhill On Sea. Sep 04. £200.

2592

Michel Henry, 'Oeillets', oil on canvas, signed, 46.4 x 33.4cm. Rosebery's, London. Sep 04. £200.

2593

Victor Vasarely, Harlequin with ball, screenprint in colours, signed and numbered 122/275 in pencil, 84 x 54cm. Rosebery's, London. Sep 04. £200.

2594

Onslow Whiting, Portrait of a girl in a blue dress, signed with monogram and dated 1924, oil on canvas, oval 82 x 65cm. Sworders, Stansted Mountfitchet. Nov 04. £200.

2595

After Sir Alfred Munnings, (1878-1959) two black and white lithographs, presented by George Blackwell Esq., signed by the artist, one of a horse 'Serjeant', and another of two horses, 21.5 x 26cm and 21.5 x 28.5cm. Hobbs Parker, Ashford. Nov 04. £200.

2596

Edward Donald Walker, Naval frigates, Dual in the Mist, signed, label verso, 19.25 x 29.25in, gilt frame. Dee Atkinson & Harrison, Driffield. Nov 04. £200.

2597

English School, Georgian settee, a Georgian Stool, A Gainsborough Armchair and a Piano, watercolours. (4) Sworders, Stansted Mountfitchet. Nov 04. £200.

2598

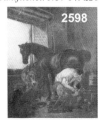

After Sir Edwin Landseer, Shoeing, oil on canvas, 61.5 x 51cm. Sworders, Stansted Mountfitchet. Nov 04. £200.

2599

Guglielmo Welters, Riviera coastal view, oil on canvas, signed, 49 x 69cm. Rosebery's, London. Sep 04. £200.

2600

Julian Trevelyan, RA The Gate of Honour, Gonville & Caius College Cambridge, lithograph, signed in pencil and numbered 44/70, 48.5 x 38cm. Sworders, Stansted Mountfitchet. Nov 04. £200.

2601

Helmut Reuter, oil on canvas, Crab Fishers. Gorringes, Bexhill. Dec 04. £200.

2602

English School (19thC) 'Study of two spaniels and dead game', oil on board, 23 x 33cm. Hampton & Littlewood, Exeter. Jul 04. £200.

2603

Circle of Henry Barlow Carter, (1803-1867) 'The ship wreck', oil on canvas, 19 x 24cm. Hampton & Littlewood, Exeter. Jul 04. £200.

2604

Frank Moss Bennett, (1874-1973) oil on canvas board, 'Winterbourne - Studland, Dorset', Aldridge Bros. label verso, 13.5 x 9.5in. Gorringes, Lewes. Jan 04. £200.

2605

J H Boel, (fl.1890-1910) oil on canvas, Fisherman and boys overlooking a Cornish harbour, signed and dated 1915, 12 x 16in. Gorringes, Lewes. Jan 04. £200.

2606

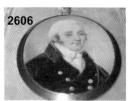

Oval miniature head and shoulder portrait of a gentleman. Gorringes, Bexhill. Dec 04. £200.

2607

George Belcher, R.A. (1875-1947) original pencil and watercolour cartoon sketch of an artist and gent in bowler hat, four handwritten lines of text mounted below as the caption, signed lower right, and the print of same sketch as it appeared in The Tatler magazine dated November 23rd 1910, both framed. (2) Batemans, Stamford. Dec 04. £200.

2608

Sir Robin Darwin, (1910-1974) ink and wash, 'The Fiacre', signed and dated '39, Agnews label no.10032, 8 x 11in. Gorringes, Lewes. Jul 04. £200.

2609

Circle of Salvador Dali, Caped figure with mythological backdrop, aquatint printed in indigo and orange, signatur, numbered 185/250 in pencil, 35.3 x 26.7cm, unframed. Rosebery's, London. Dec 04. £200.

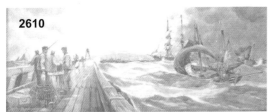

2610

William Hyams, (born 1878), watercolour, Shipping alongside a jetty, signed and dated 1912, 15 x 37in. Gorringes, Lewes. Apr 02. £200.

2611

David Law, watercolour, Pass of Achray, Sterlingshire, signed, 14 x 20.5in. Gorringes, Lewes. Mar 04. £200.

2612

Stuart Armfield, 'Sunflowers', tempera on panel, signed, inscribed on label attached to the reverse, 62.2 x 50.8cm. Rosebery's, London. Dec 04. £200.

2613

Raymond Coxon, Farmstead in a sunlit valley, oil on canvas, signed, 71.5 x 91.5cm, unframed. Rosebery's, London. Dec 04. £200.

2614

Hans Jaenisch, 'Mittelalt. Ruine an der Ostseekuste', gouache, signed & dated '43, 72.3 x 97.5cm. Rosebery's, London. Dec 04. £200.

2615

Adrian Gillespie Beach, oil on canvas, Family resting on a riverbank, signed, 36 x 48in. Gorringes, Lewes. Apr 02. £200.

2616

R. Douglas, 19thC, oil on canvas, Old Seaman seated on the dock recounting stories to a young boy, boats in the background, signed, 11.5 x 15.5in, gilt gesso frame. Diamond Mills & Co, Felixstowe. Dec 04. £200.

2617

H.J.Ford, pen and ink, 'I Once Saw ...' illustration of pixies, signed, dated 1900, 6 x 8in, unframed. Gorringes, Lewes. Apr 02. £200.

2618

Leslie Kent, (1890-1980) oil on canvas, Brownsea Island, Poole Harbour, signed, 16 x 20in. Gorringes, Lewes. Apr 02. £200.

Hammer Price £200

2619

G.R. Rushton, RI, R.B.A., (1868-1948), watercolour, The Open Barn, showing an interior with grey horse and cart, signed, 12.25 x 19in, unframed. Diamond Mills, Felixstowe. Dec 04. £200.

2620

George Finch Mason, (1850-1915) 'I say, Blanche, I wonder if the new Groom can ride?' and 'And There being no Time like the Present, Away they Go', both signed lower left 'Finch Mason', watercolours, each 22 x 27cm, pair. Cheffins, Cambridge. Feb 05. £200.

> The numbering system acts as a reader reference as well as linking to the Analysis of each section.

2621

Henry Mitton Wilson, (1873-1923) Horses in a Village Scene, oil on board, 19 x 24cm. Cheffins, Cambridge. Feb 05. £200.

2622

Will Dyson, (1883-1938), pen and ink, 'Suspect', signed, 14 x 16in. Gorringes, Lewes. Apr 02. £200.

2623

Arthur Cecil Fare, (1876-1958) The Manor House, Frampton on Severn, study of a gentleman carrying two pails, watercolour, 37 x 26cm. Locke & England, Leamington Spa. Jan 05. £200.

2624

19thC Dutch school, Biblical scene with Moses venerating the Golden Cow, oak panel, 10 x 13in, unsigned. Canterbury Auc. Galleries, Kent. Apr 05. £200.

2625

19thC English School, watercolour, family portrait of 'Mary Johann, Aunt Pussy and Campbell Baumgardt', 18 x 14in. Gorringes, Lewes. Apr 02. £200.

2626

John Colin Angus, (1907-Australian School), oil on canvas laid on board, 'Stone Gatherers', signed 12 x 16in, gilt frame. Dee, Atkinson & Harrison, Driffield. Feb 05. £200.

Hammer Price £200

2627

Elizabeth Le Bas, watercolour on ivory miniature, Portrait of a seated lady, signed and dated Guernsey 1832, 4.25 x 3.5in. Gorringes, Bexhill. Mar 02. £200.

2628

Glasgow School, early 20thC, oil on canvas 'The Repentance of Peter', unsigned, 48 x 60in. Great Western Auctions, Glasgow. Apr 05. £200.

2629

19thC silhouette group of a military officer holding a whip and standing beside a greyhound and a terrier, gilt highlights, 25 x 19cm. Clevedon Saleroom, Bristol. Jun 05. £200.

2630

18thC Italian School, 'Study of Storm/End of the World with lightning, figures driving cattle & figures sheltering', oil on canvas, indistinctly signed, 15 x 21in, gilt frame. Denhams, Warnham, Sussex. Mar 05. £200.

2631

Framed oil painting of 'Sheep'. Sandwich Auction Rooms, Kent. Jun 05. £200.

2632

James Kay, Dutch coastal scene, watercolour, 9.5 x 14.5in. Great Western Auctions, Glasgow. Jun 05. £200.

2633

Attributed to Thomas Rowlandson, St George's Hospital with Hyde Park Corner Turnpike, pen and black ink with touches of watercolour wash, signed and inscribed, 17.3 x 23cm, unframed. Rosebery's, London. Mar 05. £200.

2634

In the manner of Richard Cosway, (1742-1821) two miniature shoulder length portraits of a young man, 2.875 x 2.25in and a woman, 3 x 2.5in, gilt reeded and ribbon pattern frames and glazed. Canterbury Auction Galleries, Kent. Apr 05. £200.

2635

Harry Fidler, Cattle in a pasture at Telfont Magna, oil on panel, inscribed verso, 17.7 x 26.5cm. Rosebery's, London. Jun 05. £200.

2636

Iain MacNab, floral piece, oil on board, signed, 91.3 x 70.9cm. Rosebery's, London. Mar 05. £200.

2637

Early 19thC Chinese glass painting depicting the Toilet of Venus, 43 x 28cm, (cracked) verso Ex lot 510, Gresley Collection, c1915. Dreweatt Neate, Donnington. Nov 02. £200.

> The illustrations are in descending price order. The price range is indicated at the top of each page.

2638

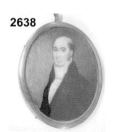

English School, watercolour on ivory, miniature of a gentleman, dated 1808, oval, 3 x 2.5 in. Gorringes, Lewes. Jun 03. £200.

2639

J Orrock, 1829-1913, panoramic view of Lincoln Cathedral with harvest scene to foreground, 8.5 x 13in, signed in pencil. Canterbury Auction Galleries, Kent. Apr 05. £200.

2640

John Fraser, oil on canvas, coastal landscape, signed and dated 1906, 12 x 20in. Gorringes, Bexhill. Mar 02. £200.

2641

John Noble Barlow, (1861-1917) oil on canvas, Beach scene at sunset, signed, 8 x 12in. Gorringes, Lewes. Jun 03. £200.

2642

Mary McNicoll Wroe. watercolour, 'A Manchester Street in the Rain', initialled, titled verso to label, 15.75 x 10in, framed. Fieldings, Stourbridge. Apr 05. £200.

2643

Pair of 19thC Indian portrait miniatures, on ivory of a royal couple holding flowers, 6.5cm. Sworders, Stansted Mountfitchet. Apr 05. £200.

2644

Late 18thC English School, miniature shoulder length portrait of a young man, oval 12.75 x 2in, rolled gold oval frame with plaited hair to reverse. Canterbury Auction Galleries, Kent. Apr 05. £200.

Section XI < £200 to £100

This beautiful, pensive, portrait of a lady, seemingly looking out of the window, with nothing to occupy her, is reflected in the starkness of her surroundings, broken only by a dish of apples and a jug, deliberately, it would appear, presented at the extreme right and away from her focus.

This is the biggest Section of all with more than 500 examples between £100 and £200. Here is popularity reflecting affordability. Here there will be bargains as well as bad buys, that will bring pleasure to their owners and also, no doubt, disappointment.

At **2645**, our first landscape is competent and a good size, but the artist obscure. Similarly, the watercolour of Bruges at **2648**, dating to the mid-twentieth century is colourful and would be a decorative success in a modern setting. Note 'After Thomas Gainsborough' at **2661** and the Scottish lochscape at **2659**. Either of these last two seem a safe buy at this price. On page **2665** is an unusual, probably commissioned picture from Kings Lynn which would be of local interest. Still life is scarce in this Section, but the John Hall Thorpe at **2666** would fit into a modern setting as would the 1969 Leo Schatz of *The Family*. See also the fine G R Rushton at **2673**, selling, I think, at half its value. The Sussex scene at **2678**, sold at the right price. Our first portraits occurred earlier, **2654** being a portrait of a seventeenth century lady who would, of course, display well in a home of that date. I like the tiny early twentieth century portrait at **2681** of a woman, in a rolled gold frame. Collectors display groups of miniatures, particularly around a fireplace. They add a nice touch. Those interested in prices could check out all Sections as they were too numerous to index. Beware of prints masquerading as originals.

Note the 'Manner of John Callow' (1822-1878) seascape at 2713 and check the comments made on Callow in the previous Section. On the subject of seascapes, study the Walter Eastwood (1867-1943) *Harbour Scene* at **2726**. A similar sized painting of his of *Peel Harbour, Isle of Man*, sold recently for £1,100, and this was only an attribution. Why has this good painting fetched so little? Now look at the Frank Runacres *Farm Machinery* at **2717**. Runacres (1904-1974) doesn't fetch a lot but this is a good picture. Imagine it decorating a barn or an industrial conversion, domestic or offices. This painting is worth much more to the right buyer. So does the John Joseph Hughes of *Durham Cathedral* at **2721**. Hughes (?-1909) has a median of £600 and a £450-£800 range. This was bound to have fetched more in the north-east unless it was very small. We don't know the size.

Now the Helen Bradley (1900-1979) at **2724**. Helen was a significant twentieth century artist and nowadays her oils have reached up to £47,000 hammer with *Goodbye to L S Lowry*, an 11 x 14 inch oil. Works on paper go to £9,000 but I have no information on prints. The market for good signed prints is rising at the moment and this should be a good buy. Religious subjects are not popular but at **2734** *Christ and the Disciples in a Wheat Field* looks to have been excellent value for money.

At **2748** and **2749** are townscapes, both competent and capable of adding to any setting. Imagine the atmospheric Ronald Morton, (20th century British) Cornish harbour scene, in a Cornish cottage. Incidentally, on page 172, notice the Norman Wilkinson signed etching (print) at **2759**. This famous artist has already been discussed. See also competent 'scapes on page 173, with a nice sized Rushton at **2784**.

The William Langley (1852-1922) is interesting. His median is £320, and he has reached £1,700. This *Beach Scene* is large at 20 x 30 inches and surprisingly raised only £170 hammer in April 2005. Perhaps not of the usual quality, this painting could still be effective in a seaside home. More surprising is the £160 paid for the c1930 modern British school, *Crowded Beach Scene* at **2819**, although to be fair to the auction, it wasn't large. See also seascapes at **2858**, **2866**, **2871**, **3011**, **3020** and **3078**. Even at only £120, the last two paintings are full of interest, the first unfortunately with a suspicious signature and the second by a minor artist. Check out the F Rousse harbour scene at **2956**. If by Frank Rousse, his median is £550 rising to £1,500. The 'F' on its own suggests uncertainty by the auction.

Returning to the portrait theme, the 'after Rembrandt' at **2801** could fulfil a purpose in an old home but the watercolour at **2814** is more fashionable and desirable. Why this 10 x 10 inch painting fetched only £160 is a mystery! It appears delightful and worth researching. It was probably painted by a woman, but who? The similarly sized portrait by Paul Jackson? at **2837** appears to date from the 1920s and there may be more to this painting than meets the eye. This beautiful, pensive, portrait of a lady, seemingly looking out of the window, with nothing to occupy her, is reflected in the starkness of her surroundings, broken only by a dish of apples and a jug, deliberately, it would appear, presented at the extreme right and away from her focus. Perhaps this painting has slipped through without the appreciation it deserves. Other portraits of women can be seen at **2854**, **2856**, **2865**, **2917**, **2946**, **2986** and the provocative **3028** by Bernard Fleetwood-Walker (1893-1969). *Art Sales Index* shows only two of this artist's paintings, a 23 x 19 inch *Study of a Mother and Child* which fetched £625 and *Repose* a 37 x 40 inch study which fetched £2,600.

Hammer Price £190

2645
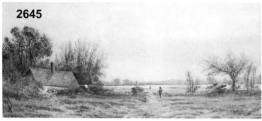
Miss S A Salt, watercolour, Travellers in an open landscape, signed, 9 x 18.75in. Gorringes, Lewes. Mar 01. £190.

2646

Cecil Aldin, print 1902 of a Bulldog in a novelty kennel, shaped framd.
Hyperion Auctions, St Ives, Huntingdon. Jan 01. £190.

2647

Sydney P Kendrick, oil on canvas, Portrait of a lady, signed and dated 1932, 30 x 22in. Gorringes, Lewes. Mar 01. £190.

2648

Charles Knight, watercolour, Bruges, signed and dated (19)47, 22 x 25in. Gorringes, Lewes. Mar 02. £190.

2649

After Toyokuni II and III, collection of four prints, 14 x 9.75in. Sworders, Stansted Mountfitchet. Apr 01. £190.

2650

A Jacomain, Dutch fisherman pulling in their catch, oil on board, signed, 13.5 x 18.5in. Sworders, Stansted Mountfitchet. Apr 01. £190.

2651

Mono AO? 1890, Figures strolling & children playing in a city park, on canvas, signed in mono, dated, framed, 10 x 15in.
Tring Market Auctions, Herts. Sep 02. £190.

2652

Philip Rickman, (1891-1982) watercolour, Woodcock in winter, signed, 9.5 x 11in. Gorringes, Lewes. Mar 03. £190.

2653

H Marty, (French, 20thC) Blue Sea, signed lower right, oil on canvas, 32 x 44cm. Cheffins, Cambridge. Sep 03. £190.

2654

19thC English School, pastel, portrait of a 17thC young lady wearing pearls, 16 x 13in. Gorringes, Lewes. Mar 01. £190.

2655

Davies, (American Primitive School) oil on board, The Lovely Lion, a young child seated on a lion in playroom, signed, 16 x 20in. Gorringes, Bexhill. Feb 04. £190.

Artists or themes can be followed through the colour coded Index which contains over 4500 cross references.

2656

Portrait of a Young Lady, unsigned, miniature oval on ivory, brass strut frame enamelled with birds and flowers. Andrew Hartley, Ilkley. Dec 03. £190.

2657

19thC coloured print on glass. Tring Market Auctions, Herts. Oct 04. £190.

2658

Augustus William Enness, 'Cottages at Whitby, Yorks.', oil on canvas, signed and dated 1912, and inscribed on label attached to the reverse, 33.7 x 23.5cm. Rosebery's, London. Sep 04. £190.

2659

H. Bates, unframed oil on canvas, Loch Fine near Isle of Bute, signed and dated 1898, 20 x 30in. Gorringes, Lewes. Jul 04. £190.

2660

Martin Fuller, Double portrait in profile, gouache, 33.5 x 44.7cm. Rosebery's, London. Sep 04. £190.

2661

After Thomas Gainsborough, 'The Watering-Place', oil on canvas, bears letter attached to the reverse, 20.6 x 25.4cm. Rosebery's, London. Sep 04. £190.

2662

Sir Frank Brangwyn, (1867-1956) lithograph, Breaking up the Caledonia, signed in pencil, 10 x 13.5in. Gorringes, Lewes. Jul 04. £190.

2663

German School, 19thC, Young boy by a haystack and a Farmer's boy holding a turnip, pair, oil on metal, 20.5 x 17cm. (2) Sworders, Stansted Mountfitchet. Nov 04. £190.

2664

English School, early 19thC, Portrait of a gentleman, bust length, holding a pair of spectacles, oil on canvas, 59 x 50cm. Sworders, Stansted Mountfitchet. Nov 04. £190.

2665

William Frederick Austin, 'N. Lowe, Corn Merchant, 1-2 St James Street, Kings Lynn', signed, dated 1874, 15.25 x 16in, stained frame. Dee Atkinson & Harrison, Driffield. Jul 04. £190.

2666

John Hall Thorpe, (b.1874), colour print, still life of flowers and fruit, signed in pencil, 16 x 10in. Gorringes, Lewes. Apr 02. £190.

2667

Eileen Agar, Standing male nude, pencil, signed and dated 1922, 38.5 x 24.8cm Rosebery's, London. Sep 04. £190.

2668

George Earp, watercolour, Lake scene with fishing boat and windmill, signed, 12.5 x 16in. Gorringes, Lewes. Mar 04. £190.

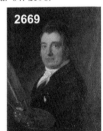

2669

Nathan...., oil on wooden panel, Self portrait, 6.5 x 5in. Gorringes, Lewes. Mar 04. £190.

2670

Leo Schatz, 'The Family', gouache, signed & dated '69, signed titled and dated 1969 on the reverse, 46.4 x 61cm. Rosebery's, London. Dec 04. £190.

2671

William Henry Earp, watercolour, Loch scene, signed, 14 x 21in. Gorringes, Lewes. Apr 03. £190.

2672

Irish School(?), 19thC, Figures by a tranquil shore with hills beyond, watercolour, signed with initials 'EH', dated June 15 1866, 33 x 51.5cm. Rosebery's, London. Dec 04. £190.

2673

G.R. Rushton, RI, R.B.A., (1868-1948), The Dales, York-shire, turbulent river running through rocks, watercolour, signed, 10.75 x 14.75in, framed, glazed. Diamond Mills & Co, Felixstowe. Dec 04. £190.

2674

Indian School, 19thC, Two studies of a Sadhu, standing full-length, bodycolour, 17 x 13.5cm, ea, unframed. (2) Rosebery's, London. Dec 04. £190.

2675

Nigel A Kent, Australian, 20thC, 'Curved Spain (out), No 8, Series 1', brush and black ink, signed, titled and dated '70, 77 x 56cm, and a quantity of brush paintings in black ink and drawings in mixed media by same hand, many signed, unframed, a lot. Rosebery's, London. Mar 05. £190.

2676

John Leech, (1817-1864) Gone Away, chromolitho-graph printed in colours, published by Thomas Agnew & Sons, London 1865, 59.5 x 83.5cm. Sworders, Stansted Mountfitchet. Feb 05. £190.

2677

John Fulleylove, RI (1845-1908) Stamford Old Brewery, Lincolnshire, Temperance March taking Place outside, signed lower left 'J Fulley-love '69", watercolour, 16 x 26cm. Cheffins, Cambridge. Feb 05. £190.

2678

Edgar Thomas Holding, (1870-1952) watercolour, 'Near Haywards Heath, Sussex', signed, 10.5 x 15.25in. Gorringes, Bexhill. Mar 02. £190.

2679

G. Sormani, watercolour, Italian, fishing boats on a calm sea, signed, 9 x 17in. Gorringes, Bexhill. Mar 02. £190.

2680

Fred Taylor, oil on canvas, 'A Country Lane, Warwick-shire, 1879', signed, 10 x 14in. Gorringes, Bexhill. Mar 02. £190.

2681

Early 20thC English School, miniature portrait of a young woman, 2.5 x 1.75in, rolled gold frame, glazed. Canterbury Auc. Galleries, Kent. Apr 05. £190.

2682

Evelyn Wilkinson, (1893-1968) still life, Summer flowers in a vase, signed, oil on board, 12 x 13.75in. Clarke Gammon Wellers, Guildford. Jun 05. £190.

2683

Spanish School 19thC, portrait of a gentleman in a black coat, oil on canvas, 64.5 x 54cm, carved giltwood frame. Rosebery's, London. Mar 05. £190.

2684

Thomas Bowman Garvie, Wounded officer & attendant in a desert campaign, oil on canvas, signed, dated 1900, 137 x 219cm. Rosebery's, London. Mar 05. £190.

2685

Pair of early 19thC coloured mezzotints depicting Hope and Charity, 27 x 20.5cm overall. Dreweatt Neate, Donnington. Nov 02. £190.

2686

Unsigned, oil on board, three figures with packhorses and sheep in an 18thC Italian landscape, unframed, 9 x 13in. Tring Market Auctions, Herts. Apr 05. £190.

2687

Emile Bouzin, 'Fontaine-bleau', oil on canvas, signed, and inscribed on stretcher, 38 x 46cm. Rosebery's, London. Jun 05. £190.

2688

Frank Beanland, 'Architecture (or Henri's Goldfish)', oil on board, signed, titled and dated October 1997 on reverse, 81.5 x 71.8cm, unframed. Rosebery's, London. Jun 05. £190.

2689

Gabriella Rainer Ystvanffy, Study of a brown and white puppy, black chalk and gouache on buff paper, signed, 19.5 x 25.5cm. Rosebery's, London. Jun 05. £190.

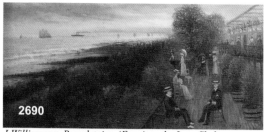

2690

J Williamson, Broadstairs, 'Evening, the Leas Shelter, Folkestone, Kent.' canvas, 10 x 20 in, signed to rear, gilt moulded frame. Canterbury Auction Galleries, Kent. Apr 05. £190.

2691

Raymond Teague Cowern, R.A., R.W.S., R.E., Italian landscape, etching, signed & dated 1937 in pencil, 15.5 x 19.7cm, and 2 other similar etchings by the same hand, both signed and dated 1939 in pencil. (3) Rosebery's, London. Jun 05. £190.

The abbreviations following artist's names can be located in the Appendices.

2692

Hugo Dachinger, Two female nudes with a cat, pen and black ink and watercolour, signed and dated 1941, 19.3 x 24.5cm. Rosebery's, London. Jun 05. £190.

2693

Four black and white portrait miniatures. Tring Market Auctions, Herts. Jan 02. £180.

2694

J L Gear, watercolour, Exotic birds on branches, signed and dated 1889, oval, 12 x 15.5in. Gorringes, Lewes. Dec 01. £180.

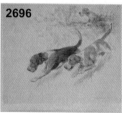

2695

Frederick T Sibley, Moel Siabod, North Wales, signed, 29 x 44cm, oil painting. Dockree's, Manchester. Jun 01. £180.

2696

George Vernon Stokes, (1873-1954) coloured etching, Hounds in pursuit, signed in pencil, 10 x 12in. Gorringes, Lewes. Mar 01. £180.

2697

G. B., watercolour, 'Every Day Life on the Railroad', initials, 5.75 x 9.5in. Gorringes, Lewes. Mar 01. £180.

2698

18th/19thC coloured print 'Noble Woman', carved decorative gilt frame, 19in. Denhams, Warnham. Mar 04. £180.

2699

19thC English School, oil on canvas, half length portrait of a gentleman, 29 x 23in. Gorringes, Lewes. Mar 01. £180.

2700

Norman Partridge, The collectors shop, three body colour illustrations, unsigned, largest 16 x 20in. Sworders, Stansted Mountfitchet. Apr 01. £180.

2701

Harman Sumray, oil on canvas, Stretching Figure V (Lazarus) signed and dated (19)63, 40 x 20in. Gorringes, Lewes. Apr 01. £180.

2702

James Basire, (1730-1802), sepia engraving, Oh! The Noble Captain Digby, Oh! At Kingsgate in Isle of Thanet, 11.25 x 15.25in, framed and glazed, small hole & repair. Canterbury Auc. Galleries, Kent. Aug 02. £180.

2703

19thC English School, a half timbered house in a wooded landscape, a pencil sketch, unsigned, 12 x 15.5in. Sworders, Stansted Mountfitchet. Jul 01. £180.

2704

Coloured 19thC coaching print 'Waking Up', after C. C. Henderson, 20 x 27.5in. Sworders, Stansted Mountfitchet. Jul 01. £180.

2705

After Cecil Aldin, a coloured print 'Who Said Policemen?' framed and glazed, 14.5 x 14in. Tring Market Auctions, Herts. Mar 03. £180.

2706

Unframed oil on canvas, Still Life Fruit, signature G. W. Harris, 1904, 46 x 26cm. Lambert & Foster, Tenterden. Apr 04. £180.

2707

Ernest S Lumsden, 2 etchings, 'The Enthusiast', 6 x 12in, and 'Hail! The Sun', 10.5 x 14in, both signed. Gorringes, Lewes. Mar 01. £180.

2708

'American Girl', a coloured engraving of a trotting horse. Hobbs Parker, Ashford, Kent. Jul 04. £180.

2709

19thC miniature watercolour, unsigned. Tring Market Auctions, Herts. Oct 04. £180.

2710

Late 19thC, oil on canvas, half length portrait of a gentleman, panel 39 x 49cm, unsigned, decorative gilt frame. Lambert & Foster, Tenterden. Nov 04. £180.

2711

Edmes, 'Composition', oil on canvas, signed, inscribed and dated 1960 on label verso, 54 x 65cm. Rosebery's, London. Sep 04. £180.

2712

H. Juncker, Tennis players in a Parisian garden, water-colours, a triptych, one signed and dated 1906, 47.4 x 30.1cm and 47.4 x 14.8cm, unframed. (3) Rosebery's, London. Sep 04. £180.

2713

Manner of John Callow, (1822-1878) 'Shipping in a stiff breeze, off a pier', oil on panel, 20 x 29cm. Hampton & Littlewood, Exeter. Jul 04. £180.

2714

Continental School, (19thC) pair of alpine lake scenes with monuments and figures, unsigned, 13.5 x 20in, gilt frame. Dee Atkinson & Harrison, Driffield. Jul 04. £180.

2715

Attributed to Robert Ponsonby Staple, Portrait of Lord Kitchener, head & shoulders turned to the right, taken from life at the Savage Club, pencil & watercolour height-ened with white, signed with monogram, inscribed and dated Nov. 26. 1898, 17.2 x 12cm. Rosebery's, London. Sep 04. £180.

Hammer Price £180

S... Jones, Steamship, paddle steamer and a man of war in a busy harbour, signed and dated '98, oil on canvas 72 x 107cm. Sworders, Stansted Mountfitchet. Nov 04. £180.

2717

Frank Runacres. Farm machinery in a barn. signed, oil on board, 45 x 55cm. Sworders, Stansted Mountfitchet. Nov 04. £180.

2718

Harald Pryn, (1891-1968) Danish oil on canvas, Fox with prey in the snow, signed, 13 x 16.5in. Gorringes, Lewes. Dec 04. £180.

2719

19thC portrait of Lord Roberts, oil on board, unsigned oval, 5.75 x 4.25in, leather folding case. Dee Atkinson & Harrison, Driffield. Jul 04. £180.

2720

Attributed to Cuthbert Shattock, oil on board, hound with dead rat. Gorringes, Bexhill. Sep 04. £180.

170 *Picture Prices*

2721

J J Hughes, oil on canvas, Durham Cathedral from the river. Gorringes, Bexhill. Sep 04. £180.

2722

W L Wyllie, black ink and wash, study of a ship. Gorringes, Bexhill On Sea. Sep 04. £180.

2723

George Oyston, watercolour drawing, A wherry on the Norfolk Broads. Gorringes, Bexhill. Dec 04. £180.

2724

After Helen Bradley, (1900-1979) 'Hollinwood Market', coloured print, signed in pencil by the artist, with Fine Art Trade Guild blind-stamp, 50 x 71cm. Hampton & Littlewood, Exeter. Jul 04. £180.

2725

Robert Leslie Honey, Moored boats by cottages and castle above, black/coloured chalk, signed & dated '45, 35 x 39.8cm, and Henry Samuel Merritt, View of Zennor, West Cornwall, watercolour, signed with initials, 32.8 x 27.3cm. (2) Rosebery's, London. Sep 04. £180.

2726

Walter Eastwood, (1867-1943) fishing boats in a harbour, signed, 10 x 13.75in, gilt frame. Dee Atkinson & Harrison, Driffield. Jul 04. £180.

2727

Thomas Sidney, (19thC) watercolour, 'Ely', signed, 7 x 9.5in. Gorringes, Lewes. Jan 04. £180.

> Fresh to the market paintings perform better than those which have been in and out of auction.

2728

2729

Leonard Lewis, (1826-1913) Continental river scene with cathedral signed, 13.5 x 9.5in, framed. Dee Atkinson & Harrison, Driffield. Jul 04. £180.

Sir Frank Brangwyn, (1867-1956) unframed etching, 'Street, St Cerque No.2', F.A.S 198, signed in pencil, 11.75 x 7.75in. Gorringes, Lewes. Jul 04. £180.

2730

Derek Mynott, Rockpools, Malta, initialled, oil on canvas, 19 x 39cm. Henry Adams, Chichester. Jan 03. £180.

2731

Maurice Cockrill, R.A. 'Escarpment', oil on canvas, signed, titled and dated 1986 on the reverse, 33 x 35cm. Rosebery's, London. Dec 04. £180.

2732

Attributed to Philip Wilson Steer, Shropshire View, watercolour, 20 x 34cm. Rosebery's, London. Dec 04. £180.

2733

C. Bertman, 2 circus figures, gouache, signed, 31.5 x 23.5cm and one other gouache study of 2 whimsical figures by same hand, signed, 31 x 23cm. (2) Rosebery's, London. Dec 04. £180.

2734

Kaspar Schleibner, Christ and the Disciples in a wheat field, oil on canvas, signed and dated 1925, 70.2 x 100.5cm. Rosebery's, London. Dec 04. £180.

2735

Frederick James Aldridge, (1850-1933) A Quiet Estuary signed lower right 'F J Aldridge', watercolour, 8 x 17cm. Cheffins, Cambridge. Feb 05. £180.

2736

David Muirhead Bone, Parador el los de Mayo, black crayon, 8. 5 x 12.5cm. Rosebery's, London. Dec 04. £180.

2737

A. Avetrani, watercolour, Cardinal and young lady taking tea, signed, 25 x 19in. Gorringes, Lewes. Mar 03. £180.

2738

Walter Tyndale, (1855-1943), watercolour, Cathedral interior, signed, 8.5 x 11in. Gorringes, Lewes. Oct 02. £180.

2739

English School, oil on canvas, still life of fruit, jar & kitchen vessels, 15 x 19in. Gorringes, Lewes. Apr 02. £180.

2740

E. Davies, watercolour, Ducks & cattle in a meadow, signed, 14 x 10in. Gorringes, Lewes. Oct 02. £180.

2741

Isaac Taylor, (1730-1807), after D Harris, The original entrance to the Cloisters at Magdalene College, and four further engravings, after C. Wild, J. Dixon and T. O'Niell, approx 32 x 47cm. (5) Sworders, Stansted Mountfitchet. Feb 05. £180.

2742

Thomas Sidney, Crackington Haven, Bude and Bosham, Sussex, a pair, watercolours, 19 x 44cm, signed. Locke & England, Leamington Spa. Jan 05. £180.

2743

F. Parr, watercolour, 'Mousehole', signed, 7 x 11in. Gorringes, Bexhill. Mar 02. £180.

Hammer Price £180

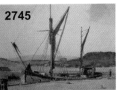

2744

Derek Balmer, 'Beach Pebbles and Pier', 1967, oil on board, signed, titled and dated verso, 61 x 51cm. Rosebery's, London. Mar 05. £180.

2745

Edgar Thomas Holding, Fishing vessel in a canal, pen and black ink and watercolour, signed, 28 x 40.5cm, unframed. Rosebery's, London. Mar 05. £180.

2746

James Proudfoot, R.O.I, portrait of the dentist W. Forbes Whaley, Esq, oil on canvas, signed and dated '60, bears remains of Royal Society of Portrait Painters attached to the reverse, 121.5 x 91.5cm. Rosebery's, London. Mar 05. £180.

2747

Edward Duncan, RWS (1803-1882) Near Ventnor, Isle of Wight, signed lower right 'E Duncan', with studio stamp, pencil heightened with white on grey paper 16 x 25cm. Cheffins, Cambridge. Apr 05. £180.

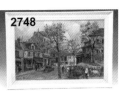

2748

Charles Blondin, Montmartre Paris 1930s, signed, framed, 10 x 16in. Tring Market Auctions, Herts. Apr 05. £180.

2749

Ray Evans, Mill at Sonning Eye, figures seated under umbrellas before buildings at waters edge, adjacent to the mill under repair, signed and dated 1984, watercolour, gilt glazed frame, 29 x 44.5cm. Locke & England, Leamington Spa. May 05. £180.

2750

Raymond Coxon, untitled abstract composition, oil on canvas, signed, bears label for the City of Bradford Art Gallery, Cartwright Memorial Hall, loan number 1946, 122.7 x 103.7cm, unframed. Rosebery's, London. Jun 05. £180.

2751

Georges Rouault, 'Forever Scourged...', from Miserere, pub'd. 1948 by Ambroise Vollard from an edition of 450, aquatint, signed, dated 1929 within the plate, 48 x 36.5cm. Rosebery's, London. Jun 05. £180.

2752

Ronald Morton, Cornish harbour scene, oil on canvas, signed and dated '65, 59.5 x 74.7cm. Rosebery's, London. Jun 05. £180.

2753

Ernest F. Jackson, Portrait of a lady head and shoulders turned to the left, oil on panel, 40.4 x 29.8cm, and a portrait study in pencil by the same hand, 22.3 x 20.7cm. (2) Rosebery's, London. Jun 05. £180.

2754

J Swinton Diston, (Australian, 19th/20thC) A Mining Camp in the Outback, signed lower right 'J Swinton Diston', watercolour, 19 x 16cm. Cheffins, Cambridge. Apr 05. £180.

2755

Mono EAH, Basket of Pansies, signed in mono, framed, 7.5 x 14.5in. Tring Market Auctions, Herts. Jul 04. £175.

2756

G H Newton, River landscape with figures on a bridge, oil on relined canvas. W & H Peacock, Bedford. Feb 03. £170.

2757

Harold Wyllie, (1880-1973) etching, Shipping off the coast, signed in pencil, 6.5 x 12in. Gorringes, Lewes. Oct 04. £170.

2758

E Torck, an English market scene, watercolour, signed, 16 x 12in. Sworders, Stansted Mountfitchet. Jul 01. £170.

2759

Norman Wilkinson, (1878-1971), etching, Fishing boats on a calm sea, signed in pencil, 9 x 12in. Gorringes, Lewes. Oct 04. £170.

2760

H Vincent, View of the River Thames with Westminster Bridge and The Houses of Parliament, signed, framed and glazed, 17 x 13in. Tring Market Auctions, Herts. Sep 02. £170.

2761

John Varley Jnr, Boats on a river, watercolour, signed, 9.5 x 13.5in and a 19thC English School, Fenland scene, watercolour, unsigned, 8 x 15.5in. Sworders, Stansted Mountfitchet. Apr 01. £170.

2762

Mary Krishna, 'Mask', oil on canvas, signed, and inscribed on label attached to verso, 58.7 x 39cm. Rosebery's, London. Sep 04. £170.

2763

Follower of Pierre Paul Prudhon, Male nude full-length standing, black and white chalk on blue paper, 44.3 x 28.8cm, unframed. Rosebery's, London. Dec 04. £170.

2764

Edwin Bale, Portrait of a young girl, pencil and watercolour, signed, 18.7 x 15cm. Rosebery's, London. Dec 03. £170.

2765

John Colin Forbes, Cattle crossing a stone bridge with a village beyond, oil on canvas laid down, signed, 23.5 x 33.8cm. Rosebery's, London. Sep 04. £170.

2766

G. Williams, English late 20thC School, Jumping the fence, oil on panel, signed, 49.5 x 75cm. Rosebery's, London. Sep 04. £170.

2767

James Neal, City Hall, Hull, signed on board, 4.25 x 5.25in, painted & gilt frame. Dee Atkinson & Harrison, Driffield. Nov 04. £170.

2768

Attributed to H Boycott Brown, Braughing Village, Hertfordshire, oil on board, 29 x 39cm. Sworders, Stansted Mountfitchet. Nov 04. £170.

2769

J W Gozzard, 19/20thC, pair of watercolours, 'Springtime in the Fields' & 'Spring Blossoms', monogrammed, 9.75 x 14in, framed. *Dee Atkinson & Harrison, Driffield. Jul 04. £170.*

2770

J Morris, watercolour, Sheep in woodland, signed, dated '91, 12.5 x 18.75in. Gorringes, Lewes. Mar 04. £170.

2771

George Hall-Neale, Rocky coastal landscape, oil on board, signed, 21.7 x 29.3cm. Rosebery's, London. Dec 04. £170.

2772

Circle of Charles Arthur Wheeler, Portrait of a child, seated half-length, oil on canvas, 61 x 46cm. Rosebery's, London. Dec 04. £170.

2773

Frank Lewis Emanuel, Corfe Castle viewed from a distance, oil on board, signed, 24.7 x 32.5cm, unframed. Rosebery's, London. Dec 04. £170.

2774

British School 19thC, Figure by a woodland stream, watercolour, inscribed 'Bettws' and dated May 26 1848, 44 x 60cm. Rosebery's, London. Dec 04. £170.

2775

Pierre Wemaere, 'La Tete en Feu', 1958, oil on board, signed, 22.5 x 27.8cm. Rosebery's, London. Dec 04. £170.

> Provenance is an important market factor which can bare positively on results achieved at auction.

2776

May Furniss, (Exh. 1898-1940), oil on canvas, 1930s portrait of a lady and terrier, signed, oval, 23 x 19in. Gorringes, Lewes. Apr 02. £170.

2777

Leonard Frank Skeats, (English, 1874-1943) The Nymph Calypso, signed lower left 'Leonard Skeats', watercolour, 32 x 24cm. Cheffins, Cambridge. Feb 05. £170.

2778

A.E. Scott, watercolour on ivory, miniature of a young lady, signed, 3.25 x 2.75in. Gorringes, Lewes. Jan 05. £170.

2779

Jean Lareuse, Portrait of a woman seated in a chair, oil on canvas, signed, 55 x 37.7cm. Rosebery's, London. Jun 05. £170.

2780

W White (English, 19th/20thC) Election Day, 14 December 1918, after the Great War, with Lloyd George driving a Donkey Cart, signed lower left 'W White', oil on board, 25 x 35cm. Cheffins, Cambridge. Feb 05. £170.

2781

G.R. Rushton, R.I., R.B.A., (1868-1948), Depicting Walsingham, watercolour, signed, 10.75 x 14.5in, framed and glazed. Diamond Mills & Co, Felixstowe. Dec 04. £170.

2782

19thC English School, Steam & sailing vessels, at anchor, possibly Thames, near Greenwich, watercolour, 28.5 x 37.5cm. Hobbs Parker, Ashford. Jan 05. £170.

2783

Henry Mitton Wilson, (1873-1923) Fishpool Street, St Albans, Hertfordshire, signed lower right 'H M Wilson', oil on board, 25 x 35cm. Cheffins, Cambridge. Feb 05. £170.

2784

G.R. Rushton, RI, R.B.A., (1868-1948), watercolour entitled Pin Mill, with houses and trees in the foreground, signed, 9.75 x 14.5in, framed, glazed. Diamond Mills & Co, Felixstowe. Dec 04. £170.

2785

Clement Morris, oil on canvas, Densely wooded view with stream, 15 x 24in, gilt frame. Gorringes, Bexhill. Mar 02. £170.

2786

Alexander Graham Munro RSW, 1903-85, pastel 'Tasga', signed, entitled & dated 1927, 10 x 18.5in. Great Western Auctions, Glasgow. Apr 05. £170.

2787

Anglo Chinese School, rice paper painting, 19thC, boating on a river with cottages, figures and a stone bridge. Rosebery's, London. Mar 05. £170.

2788

19thC English, Primitive School, oil painting, interior of a barn with two calves, board 11.5 x 14.75in, gilt moulded frame. Canterbury Auc. Galleries, Kent. Mar 05. £170.

2789

William Langley, (fl 1880-1920), Beach scene, oil, canvas 20 x 30in, signed in full, gilt moulded frame. Canterbury Auc. Galleries, Kent. Apr 05. £170.

2790

Claude Hayes, (1852-1922) Sheep before Haystacks, signed, watercolour, 16.5 x 25cm. Sworders, Stansted Mountfitchet. Apr 05. £170.

2791

J. Syer, English 19thC, Figures with a view of a city, cathedral and coast beyond, oil on board, signed, 35.5 x 49.2cm. Rosebery's, London. Jun 05. £170.

2792

Maurice Cockrill, R.A., First Study for 'Ash Series', oil, gesso & wood ash on board, signed, titled, inscribed and dated 1996 on reverse, 19.7 x 38cm. Rosebery's, London. Jun 05. £170.

2793

Grace Matthews, A.R.C.A., 'Nude with Cat' (recto), Portrait of a man at a table, (verso), oil on board, signed, 63 x 74.2cm, and a study of a river scene in oils on board by the same hand, signed, 63 x 74.2cm. (2) Rosebery's, London. Jun 05. £170.

2794

European School 19thC, St. Sebastian, oil on canvas, 64.5 x 44.3cm, unframed. Rosebery's, London. Jun 05. £170.

2795

English Provincial School, c1840, Portrait of a gentleman, quarter-length in a black coat, oil on canvas, 55.5 x 51.3cm, rosewood veneered frame. Rosebery's, London. Jun 05. £170.

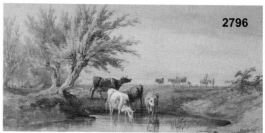

2796

Henry Earp Snr, (1831-1914) watercolour, cattle watering at a pond, figures beyond, 6.75 x 13in. Gorringes, Bexhill. May 02. £160.

2797

Jean Douglas McIntyre. Busy riverscape, signed, framed, 12 x 18in. Tring Market Auctions, Herts. Nov 02. £160.

2798

Cecil Aldin, Old English Inns - The George, Dorchester, Oxon, coloured print, signed in the margin, 13.5 x 15.5in. Sworders, Stansted Mountfitchet. Apr 01. £160.

2799

T Hagiwara, M S Fernhill, body colour on linen, signed, inscribed Yokohama Japan, and dated 1940, 14 x 19in. Sworders, Stansted Mountfitchet. Apr 01. £160.

2800

J Beale. Nuneham Courtenay and Hardwick House, a pair, oils, signed and inscribed, each 14 x 17.5in. Sworders, Stansted Mountfitchet. Apr 01. £160.

2801

After Rembrandt, oil on canvas, Hendrickje Stoffels, 26 x 20in. Gorringes, Lewes. Apr 01. £160.

Most auction catalogues carry an explantation of the terminology used in descriptions. See Appendices.

2802

Edwardian School, watercolour, Girl wearing a red cap and fur trimmed coat in a landscape, monogrammed, 11.25 x 7.75in. Gorringes, Lewes. Mar 01. £160.

2803

Wilfred Wood, The Old Town, Ronda, Spain, signed, dated bottom left '56, watercolour, mounted and framed, 40 x 33.5cm. Sworders, Stansted Mountfitchet. Mar 03. £160.

2804

K Gresley, timbered cottage with figures and cattle, 26 x 37cm. Thos Mawer & Son, Lincoln. Feb 03. £160.

2805

Fedir Klymenko, Russian School, oil on canvas, Moonlit seascape with bay cliffs and calm sea, 23 x 30in. Denhams, Warnham. May 04. £160.

2806

Finnish School, early 20thC, The Old Fisherman, oil on canvas, signed, 25.2 x 21.3cm, unframed. Rosebery's, London. Jun 04. £160.

2807

Pair of framed crystoleums after A L Vernon, of female figures in gardens, 9.75 x 7.5in. Gorringes, Lewes

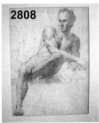

2808

Follower of Domenico Maria Canuti, sepia chalk, male nude study, 14 x 10.5in. Gorringes, Lewes. Oct 04. £160.

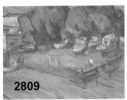

2809

Josef Foschko, Russian/American School 20thC, Beached vessels and figures in a tranquil harbour, oil on canvas, signed, 43 x 51cm. Rosebery's, London. Sep 04. £160.

2810

Sir Hugh Casson, pencil and wash drawing, Cottage, Canon Ashby. Gorringes, Bexhill. Sep 04. £160.

2811

Josef Foshko, Russian/American School, 20thC, Circus Scene, oil on canvas, signed, 35.2 x 46.2cm. Rosebery's, London. Sep 04. £160.

2812

Mary D Ewell, (1874-1952), Alpine landscape (possibly Zermatt) with mountains in the distance, signed, dated 1934, on board, 10 x 13.5in, painted frame. Dee Atkinson & Harrison, Driffield. Nov 04. £160.

1813

William Langley, A lake landscape, oil on canvas, 51 x 76cm. Sworders, Stansted Mountfitchet. Nov 04. £160.

Hammer Price £160

2814

English School, c1890, Lesson in flower arrangement, pencil and watercolour, heightened with white, 26 x 26cm. Sworders, Stansted Mountfitchet. Nov 04. £160.

2815

Brian Hagger, 'Snowy Cheltenham', oil on canvas, signed, 45.7 x 35.6cm. Rosebery's, London. Dec 04. £160.

2816

John Tricket, (20thC) study of a Zebra, signed on paper, 22 x 18.5in, gilt frame. Dee Atkinson & Harrison, Driffield. Jul 04. £160.

2817

Manner of Charles Rosenberg, silhouette painted on glass, Gentleman standing beside tree trunks, 6.5 x 5.5in. Gorringes, Lewes. Jul 04. £160.

2818

Attributed to Philip Connard, (1875-1958) watercolour, Boats off Greenwich, 9 x 11.75in. Gorringes, Lewes. Mar 04. £160.

2819

Modern British School, c1930, Crowded beach scene with a pier beyond, pencil and watercolour, 34.5 x 50cm. Rosebery's, London. Dec 04. £160.

2820

Francis Griffen, unframed pen, ink and wash, 'A View from the Terraces' (Brighton Seafront), signed and dated 1936, 14 x 19.5in. Gorringes, Lewes. Apr 02. £160.

2821

G.R. Rushton, RI, R.B.A., (1868-1948), On the Deben, Nr Martlesham, watercolour, signed, 10.25 x 14.75in, unframed. Diamond Mills & Co, Felixstowe. Dec 04. £160.

2822

English School, (19thC) Sailing Ships in Harbour, poss. East Yorkshire, indistinctly signed and dated '95 lower left, pastel, 36 x 53cm. Cheffins, Cambridge. Feb 05. £160.

2823

Harold Hitchcock, 'Figure in a Glen', watercolour, signed with monogram, dated 1965, 53.7 x 33.6cm. Rosebery's, London. Dec 04. £160.

2824

Pair of 19thC oval miniatures on ivory, head and shoulders of a young girl and another similar, 2.75 x 2.25in, unsigned, oval foliate brass frames. (2). Diamond Mills & Co, Felixstowe. Dec 04. £160.

2825

Raymond C Watson, (British, b.1935) Study of a Bullfinch, signed lower left 'Raymond C Watson', watercolour, 28 x 22cm. Cheffins, Cambridge. Feb 05. £160.

2826

Continental School, watercolour on ivory miniature of an 18thC lady, 3 x 2.5in, oval, ormolu frame. Gorringes, Bexhill. Mar 02. £160.

2827

Isobe, Still life with vegetables, oil on canvas, signed lower right, 16 x 23cm. Dreweatt Neate, Donnington. Nov 02. £160.

2828

Spilsburg after Kauffman, reverse print on glass, Thalia, 14 x 10in. Gorringes, Bexhill. Mar 02. £160.

2829

William Miller Frazer, mountain landscape, oil on board, signed and dated 1919, 34.8 x 44.4cm. Rosebery's, London. Mar 05. £160.

2830

Percy Leslie Lara, Landscape with caravan, oil on board, signed with monogram, 24 x 29.6cm. Rosebery's, London. Dec 04. £160.

2831

William Carl Nakken, Feeding the Cart Horses, watercolour, signed, 32.2 x 48.5cm. Rosebery's, London. Jun 05. £160.

2832

Eduardo Torassa, oil on canvas, 'El Carocol De Las Hadas', mythical scene with figures, a Lima and a Lizard', 19 x 15in. Denhams, Warnham, Sussex. Feb 05. £160.

2833

British School, c1900, The Coldsteam Guards in rank marching to battle, pencil and watercolour with touches of white, 36.8 x 72.8cm, unframed. Rosebery's, London. Mar 05. £160.

2834

English School c1900, watercolour on ivory miniature, Portrait of a lady, after Reynolds, 3.25 x 2.5in, gold locket frame. Gorringes, Lewes. Jun 03. £160.

2835

Horace Brodzky, 'Sketch for a painting', pen and green ink, signed with initials, dated Dec 1931 & inscribed, 26 x 22cm. Rosebery's, London. Jun 05. £160.

2836

Miss M. M. Pettafor (?), miniature shoulder length portrait of Mrs St John Kneller wearing a red shawl, oval 3 x 2.25in, rolled gold frame, domed glass, bears identification label to rear of frame. Canterbury Auction Galleries, Kent. Apr 05. £160.

2837

Paul Jackson, 'Interior, Lambeth', oil on board, signed titled and inscribed on the reverse, 30.2 x 30.2cm. Rosebery's, London. Dec 04. £160.

> Ensure you never hang your watercolours etc in direct or reflected sunlight. Fading seriously affects value.

2838

Late 18thC English School, miniature half length portrait of a young woman wearing a white dress, 2.5 x 2in, rolled gold frame and glazed. Canterbury Auc. Galleries, Kent. Apr 05. £160.

2839

Ithel Colquhoun, 'Tower Interior, Corsica', black chalk and gouache, signed and dated 36, 30 x 41cm. Rosebery's, London. Jun 05. £160.

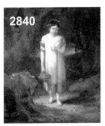

2840

European School 19thC, Portrait of a girl standing full-length in woodland, oil on panel, signed and dated indistinctly, 19.2 x 14.3cm. Rosebery's, London. Jun 05. £160.

2841

C. A. Bartels, German early 20thC, Figure beneath an abbey courtyard arch, oil on canvas, signed, 40 x 50.5cm. Rosebery's, London. Jun 05. £160.

2842

Gertrude Priestman, English, 19thC, Ducks by a Mill Pond, Suffolk, signed lower left 'G Priestman', water-colour, 27 x 37cm. Cheffins, Cambridge. Apr 05. £160.

2843

E H - 1879. The River Thames at Clivedon, signed, dated, framed and glazed, 13 x 20in. Tring Market Auctions, Herts. Nov 02. £150.

2844

After Alfred Munnings, A Huntsman, coloured print, (faded) signed in pencil in the margin, pub'd by Frost & Reed 1929, 15 x 21.5in. Sworders, Stansted Mountfitchet. Apr 01. £150.

2845

Franco Matania, (1922-) oil on board, Nude seated on a bed, signed, 11.5 x 9in. Gorringes, Lewes. Jul 03. £150.

2846

George Strube, Cartoon entitled 'Play The Game You Cad - Play The Game', signed, framed and glazed, 20 x 14in. Tring Market Auctions, Herts. Mar 03. £150.

2847

H T Bordet (?), English School, c1900, seated pen-sive female nude, charcoal, signed, inscribed and dated Feb 13 1897, 58.7 x 41.2cm and another by same hand, 54 x 36.7cm. Rosebery's, London. Jun 03. £150.

2848

After Ruskin Spear, A scene in a public house, signed by the artist, framed and glazed, 13 x 17.5in. Tring Market Auctions, Herts. Mar 03. £150.

Hammer Prices £160 - £150

2849

Michael D'Aguilar, A View of St Paul's at Twilight, oil on canvas, signed, dated '88 and inscribed verso, 17 x 23in, gilt frame with fabric slip. Amersham Auction Rooms, Bucks. Jun 03. £150.

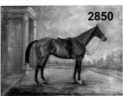

2850

Peggy Mennie, Study of a bay hunter wearing tack outside a country house, oil on canvas, signed lower left, 38 x 50cm. Wintertons Ltd, Lichfield. Sep 03. £150.

2851

European School c1900, Flamenco dancers in a farmyard, oil on canvas, signed R. M*****, 35.8 x 66cm. Rosebery's, London. Sep 04. £150.

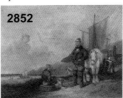

2852

After Shayer, oil on board, Fisherfolk on the shore, initialled, 9 x 12in. Gorringes, Lewes. Mar 04. £150.

2853

H Earp, watercolour, river scene. Gorringes, Bexhill. Sep 04. £150.

2854

Follower of N Hone, oil on panel, portrait of a young woman. Gorringes, Bexhill. Sep 04. £150.

2855

Sir Frank Brangwyn, b/w etching, Italian river scene with town and bridge. Gorringes, Bexhill On Sea. Dec 04. £150.

2856

Mario, Count Grixoni, (Italian, Exh 1914-1940) Portrait of a lady, signed lower right, oil on canvas, 74 x 62cm. Cheffins, Cambridge. Feb 04. £150.

2857

Pair, oil on canvas, signed H Bulmer, 'Violinist & Gentle-man Shaving', dated 1901. Boldon Auction Galleries, Tyne & Wear. Sep 04. £150.

Hammer Price £150

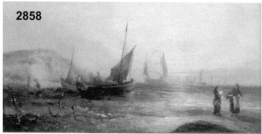

2858

Swifts, oil on canvas, coastal landscape with figures & fishing boats, signed, 7 x 12.5in. Gorringes, Lewes. Apr 02. £150.

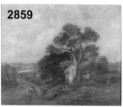

2859

Vickers, oil on oak panel, Surrey Hills, 9.5 x 16in and a Norwich style oil landscape, 13 x 16in. Gorringes, Lewes. Mar 04. £150.

2860

Alfred William Rich, (1856-1921) watercolour, Cathedral city, signed, 11 x 15in. Gorringes, Lewes. Mar 04. £150.

2861

John Fullwood, Coastal landscape, sheep grazing in the foreground, oil on panel, 59.5 x 71cm. Henry Adams, Chichester. Jan 03. £150.

2862

J Eamon, Blustery day, with figures on a harbour wall, watercolour over pencil heightened with white, 33 x 51cm. Henry Adams, Chichester. Jan 03. £150.

2863

Richard Benedetti, 'Human Folly', oil on canvas laid down, signed & titled verso, 32.7 x 57.2cm and one other oil titled 'The Gods that Failed', by the same hand. (2) Rosebery's, London. Dec 04. £150.

2864

Sean Nichol, Irish 20thC, 'Muckish Mountain from Carriage**', oil on canvas laid down on board, signed, inscribed on label verso, 29 x 39.5cm. Rosebery's, London. Dec 04. £150.

> Frames and mounts should enhance your picture. Empathy, rather than fashion should dictate your choice.

2865

Circle of Augustus John, Portrait of a lady seated 3/4 length in a brown dress, oil on canvas, 91.2 x 71cm, unframed. Rosebery's, London. Dec 04. £150.

2866

William Hyams, (born 1878), oil on board, galleons at sea, signed, 21 x 34in. Gorringes, Lewes. Apr 02. £150.

2867

English School, (20thC) The Island of Capri, oil on board, 24 x 33cm. Cheffins, Cambridge. Feb 05. £150.

2868

Victorian silhouette, written verso 'Shelley', from the Desmond Cope collection, (illustrated in the History of Silhouettes), black and gilt metal frame, 10 x 8cm. Thos. Mawer & Son, Lincoln. Mar 04. £150.

2869

Brian Robb, (1913-1979) oil on canvas, Figures by a harbour, signed, 16 x 20in. Gorringes, Lewes. Apr 03. £150.

2870

Miniature of a 16thC gentleman, written verso 'Joh. Keppler 1571-1630 J.ab Heyden Pinxt', 7cm dia. Thos. Mawer & Son, Lincoln. Mar 04. £150.

2871

Hugh E Ridge, Oil on canvas, Steamer and yacht at sea, signed, 18 x 26in. Gorringes, Lewes. Mar 03. £150.

2872

Toyokuni III, mid 19thC Japanese woodblock print, death by lantern light, oban, framed. Cheffins, Cambridge. Feb 05. £150.

2873

Fred Lawson, (1888-1968) Farmyard with Chickens, signed and dated '08, watercolour, 24 x 32cm. Sworders, Stansted Mountfitchet. Feb 05. £150.

2874

French School, oil on canvas board, View on the Seine, indistinctly signed, 15 x 18in. Gorringes, Lewes. Jan 05. £150.

2875

Mirtland, oil on canvas, 'Continental Scene - Barge at Dock', 18 x 24in, unframed. Denhams, Warnham, Sussex. Mar 05. £150.

2876

Early 19thC English School, pencil sketch heightened in watercolour, Portrait of Mr Joseph Wood, 1801-1890, 7 x 6in, contemporary gilt moulded frame and glazed. Canterbury Auc. Galleries, Kent. Apr 05. £150.

2877

19thC Continental School, watercolour on ivory miniature, portrait of a young lady, oval, 2.75 x 2.25in. Gorringes, Bexhill. Mar 02. £150.

2878

20thC School, c1950, Vase of flowers, oil on canvas, 75.8 x 50.5cm. Rosebery's, London. Mar 05. £150.

2879

Grant Kennedy, Rhesus Monkeys, acrylic on canvas, signed, titled and dated 1995 on the reverse, 150.3 x 130cm. Rosebery's, London. Mar 05. £150.

2880

Cecil Aldin, coloured print, depicting figures with motor vehicles, motorcycles and bicycles, 'Brampton Chains'. Fellows, Brimingham. Oct 03. £150.

2881

Patrick Procktor, 'Bow wow', lithograph in colours, signed and dedicated 'For Rex' in pencil, 59 x 56.5cm and one other lithograph by the same hand, and others, unframed, a lot. Rosebery's, London. Mar 05. £150.

2882

E... J... Carter, Bird Studies, pair, inscribed on label verso, watercolour and bodycolour, oval, each 18 x 13cm. Sworders, Stansted Mountfitchet. Apr 05. £150.

2883

Follower of Tom Mostyn, Figures in a moonlit glade, oil on board, inscribed on the reverse, 13.4 x 19cm. Rosebery's, London. Mar 05. £150.

2884

Claude Hayes, (1852-1922) Gypsy Caravans, signed, watercolour, 14 x 23.5cm. Sworders, Stansted Mountfitchet. Apr 05. £150.

2885

Frank McFadden, pastel 'Exotic Dancer', signed, 24 x 18in. Great Western Auctions, Glasgow. Jun 05. £150.

2886

Tom Browne, 'The Straight Tip, sponging friend of the family...', black chalk and wash, signed, inscribed with title on mount and again on reverse, 35 x 25cm, unframed. Rosebery's, London. Jun 05. £150.

2887

19thC Provincial School, Mother and daughter, oil on canvas, 39 x 20cm, unframed. Dockree's, Manchester. Jun 01. £140.

2888

Raymond Coxon, untitled abstract composition, oil on canvas, signed, 73.5 x 91.5cm, unframed. Rosebery's, London. Jun 05. £150.

2889

Milenko Bosanac, 20thC, 'Interieur', oil on canvas, signed titled and dated 1964 on the reverse, 96.5 x 136cm. Rosebery's, London. Jun 05. £150.

2890

E. Wood, figure on a roadway adjoining a thatched homestead in a 19thC rural landscape, watercolour, signed, framed & glazed, 7.5 x 11.5in. Tring Market Auctions, Herts. Nov 03. £140.

2891

Arundel Society, watercolour, Angels in a garden, tondo, 6in. Gorringes, Lewes. Feb 01. £140.

2892

Bertha Constance Smythe, oil on canvas, Spaniel in a landscape, signed and dated 1886, 12 x 14in. Gorringes, Lewes. Mar 01. £140.

2893

Pair of 18th/19thC coloured prints, 'The broken pitcher' and 'The milkmaid', 16in, oval. Denhams, Warnham. Nov 03. £140.

Hammer Price £140

2894

William Lionel Wyllie R.A.R.I.RE., (1851-1931) On the Schelst, black and white etching, signed in pencil on mount and inscribed verso, 12.5 x 30cm. Marilyn Swain, Grantham. Dec 03. £140.

2895

19thC oil painting on canvas, 'Highland Cattle Watering', indistinctly signed, 20 x 30in. Denhams, Warnham. Mar 04. £140.

2896

Tamami Shima, Limited Edn, print 3/50, stylised birds, signed in pencil, dated 1959, 21.5 x 14.75in. Gorringes, Lewes. Mar 01. £140.

2897

Wynford Dewhurst, A North African scene, pastel, signed, 13 x 19in. Sworders, Stansted Mountfitchet. Apr 01. £140.

2898

19thC English School, oil on panel, Huntsmen and hounds in a stable, 34 x 45cm. Locke & England, Leamington Spa. Feb 03. £140.

2899

Oswald Partridge Milne, (1881-1968) Autumn Morning, watercolour sketch, 10 x 14.25in, framed, glazed and a selection of other watercolour sketches. Canterbury Auction Galleries, Kent. Feb 04. £140.

2900

Nemo - Monsieur Lanadere, pen and ink drawing highlighted in crayon, signed, framed and glazed, 10 x 8in. Tring Market Auctions, Herts. Sep 02. £140.

2901

Basil Nightingale, watercolour & body colour, signed and dated 1904. Locke & England, Leamington Spa. Nov 02. £140.

2902

Robinson W Heath, 'Stilton-ising Cheese in the Stockyards at Cheddar', ink cartoon, signed, dedicated to A. Ross, 1931, 15 x 11cm. Richard Winterton, Burton on Trent, Staffs. May 03. £140.

2903

Peter Magro, Russian School, oil on canvas, Bay with thatched cottage, church and figures, 19 x 23in. Denhams, Warnham. May 04. £140.

2904

John Nartker, American School c1960, Three birds in a landscape, mixed media on board, signed, and bears attached label on the reverse with biographical information on the artist, 60.7 x 61cm. Rosebery's, London. Sep 04. £140.

> Ensure your watercolours etc are mounted on acid free boards. Have old pictures checked out by a framer.

2905

Stanley Miller, c1960s, one of two views 'The Maltings at Snape', and a Continental scene, oils on board, each signed, each 16 x 24in. Sworders, Stansted Mountfitchet. Jul 01. £140.

2906

Hugh Weiss, 'The Angry Man', oil on board, signed and dated '63, inscribed on label verso, 75 x 62.3cm. Rosebery's, London. Sep 04. £140.

2907

G.R. Rushton, RI, R.B.A., (1868-1948), watercolour, Arles, South of France, bull-ring with spectators, signed, 10.25 x 14.75in, unframed. Diamond Mills & Co, Felixstowe. Dec 04. £140.

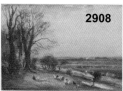

2908

W Manners, (19/20thC) a landscape, hens in foreground, signed, 5 x 7in, stained frame. Dee Atkinson & Harrison, Driffield. Jul 04. £140.

2909

Captain Walter William May, RI (1831-1896) Sea-going Barges on the Norfolk Broads, signed lower left 'W W May', watercolour, 17 x 25cm. Cheffins, Cambridge. Feb 05. £140.

2910

20thC oil painting on canvas '19thC Fox Hunt with Hounds', 24 x 35in, decorative gilt frame. Denhams, Warnham, West Sussex. Jan 05. £140.

2911

Attributed to Maurice Blond, Flowers in a jug, oil on board, signed, 34.5 x 26.8cm, unframed. Rosebery's, London. Sep 04. £140.

2912

Sir Frank Brangwyn, (1867-1956) unframed etching on zinc, 'Porte St. Jacques, Parthenay', F.A.S. 285, signed in pencil, 11 x 10in. Gorringes, Lewes. Jul 04. £140.

2913

Charles Frederick Tunnicliffe, (1901-1979) unframed wood-cut, Owl on a tree stump, signed in pencil, 10 x 7in. Gorringes, Lewes. Jul 04. £140.

2914

Late 19thC oval miniature on ivory, head and shoulders portrait of a blue eyed young lady, unsigned, cast brass & pierced easel frame, 8.75in high. Dee Atkinson & Harrison, Driffield. Jul 04. £140.

2915

Leonard Baskin, Portrait of Wilhelm Lehmbruck, mono-type with overpainting, signed, titled, dedicated and dated 1982 in pencil, 23.4 x 18.8cm. Rosebery's, London. Dec 04. £140.

2916

French School, early 20thC, Market scene, oil on canvas, 30.5 x 35.5cm. Rosebery's, London. Dec 04. £140.

2917

William H. Barribal, Portrait of a lady in a green bonnet, gouache, signed, 50.2 x 37.2cm. Rosebery's, London. Dec 04. £140.

2918

Follower of Stuart Davis, un-titled abstract composition, oil on canvas, 86.3 x 117cm, unframed. Rosebery's, London. Dec 04. £140.

2919

English School, watercolour, Deer in woodland, a castle beyond, 10 x 13.5in and a Spanish landscape, 9.5 x 13.5in. (2) Gorringes, Lewes. Mar 04. £140.

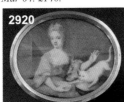

2920

Continental School, water-colour on ivory, Miniature of a lady with a white cat, oval, 2.25 x 3in. Gorringes, Lewes. Jan 05. £140.

Hammer Price £140

2921

Molly W Parkin, untitled abstract in blue and violet, oil on canvas, signed with initials and dated '64, 125 x 116cm. Rosebery's, London. Mar 05. £140.

2922

Circle of Edward Dayes, (late 18thC) A fishing boat with figures amongst rocks, pencil and watercolour, 20 x 29cm. Sworders, Stansted Mountfitchet. Feb 05. £140.

2923

19thC English School, Study of a maid and boy drawing water from a well through an archway, watercolour, 37 x 26cm. Locke & England, Leamington Spa. Jan 05. £140.

2924

James Holland, 1799-1870, wash drawing, 'The Facade of Greenwich Hospital', 9 x 11.25in, inscribed 'Green-wich Hospital', gilt moulded frame and glazed. Canterbury Auc. Galleries, Kent. Apr 05. £140.

2925

Walter Robert Stewart Acton, (1879-1960) watercolour, Downland landscape, signed, 9 x 15.5in. Gorringes, Lewes. Apr 03. £140.

2926

Ronald Ossory Dunlop, (1894-1973), oil on board, woodland path, signed, 15.5 x 19in. Gorringes, Lewes. Apr 02. £140.

2927

In the manner of N Rice, oil on canvas, Caught in the Act, three cottagers being appre-hended with dead chickens, re-lined, signed, unframed, 18 x 23in. Tring Market Auctions, Herts. Apr 05. £140.

2928

Two 19thC Indian portrait miniatures, of princesses, in traditional dress, 5cm oval. Sworders, Stansted Mountfitchet. Apr 05. £140.

2929

Lysbeth Liverton, 'Welsh Hills' and 'The Beach at Ile de Raguenes', oil on board, both signed, 18.5 x 26cm ea. (2). Rosebery's, London. Jun 05. £140.

2930

C Kluchler (?), miniature half length portrait of a young woman, hair in ringlets, on ivory, 3.25 x 3in, indistinctly signed and dated 1841 in Roma to reverse, leather case. Canterbury Auction Galleries, Kent. Apr 05. £140.

2931

French School, 'Le Marteleur', etching, indistinctly signed in pencil, 89 x 52cm. Sworders, Stansted Mountfitchet. Apr 05. £140.

2932

Follower of Thomas Rowlandson, Lady putting on her stockings, signature, pen, ink and watercolour, 22 x 18cm. Sworders, Stansted Mountfitchet. Apr 05. £140.

2933

European School c1970, Figure in a bedside table wearing a hat, pencil, signed and dated '70, 18.2 x 19.2cm. Rosebery's, London. Jun 05. £140.

2934

British Impressionist School, c1920, Two figures resting beneath trees by a pool with a swan, oil on canvas, signed with monogram 'M.P'(?), 25.5 x 35.8cm, unframed. Rosebery's, London. Jun 05. £140.

2935

Henry D'Anty, L'Eglise, oil on canvas, signed, 45.5 x 55.7cm, unframed. Rosebery's, London. Jun 05. £140.

2936

French School, 1900, Caricature of a gentleman, standing full-length in a top hat and overcoat, pen, ink and wash, signed with initials S.E.M., inscribed 'Auteuil' and dated Novembre 1900, 46.7 x 30cm. Rosebery's, London. Jun 05. £140.

2937

Nigel Lambourne, Female nude, pen and black ink on green paper, signed and dated '70, 37.7 x 60.3cm, unframed. Rosebery's, London. Jun 05. £140.

2938

Dutch School, (18th-19thC) A Boor in a Tavern, oil on panel, 15 x 19cm. Cheffins, Cambridge. Apr 05. £140.

2939

Robert Murray, (Exh 1915-16) oil on board, Portrait of a girl, signed, dated (19)19, 15.5 x 11.75in. Gorringes, Lewes. Jul 01. £130.

2940

George Cockram, watercolour, coastal scene with sand dunes, signed, 10.5 x 14.5in. Gorringes, Lewes. Mar 02. £130.

2941

Col. H.R.B. Donne, (Exh 1906-39) watercolour, Amalfi coastline from the cliff tops, signed, 14 x 9.5in. Gorringes, Lewes. Mar 01. £130.

2942

Lionel Edwards, coloured hunting print signed in pencil, 14 x 20.5in. Sworders, Stansted Mountfitchet. Apr 01. £130.

2943

19thC English School, half length portrait of a Victorian lady, oval, watercolour, unsigned, original gesso frame, 10 x 8.5in. Sworders, Stansted Mountfitchet. Apr 01. £130.

2944

Norman Partridge, Bonfire Night, bodycolour, illustration, signed and dated, 16 x 20in. Sworders, Stansted Mountfitchet. Apr 01. £130.

2945

Pair of 19thC Baxter prints, Lord Nelson and Duke of Wellington, gilt framed and glazed, each 4 x 3in. Tring Market Auctions, Herts. Mar 02. £130.

2946

Early 19thC English School, watercolour on ivory miniature of a young lady, 3 x 2.75in. Gorringes, Lewes. Apr 01. £130.

2947

W B Walker, reverse print on glass, Britannias Triumph on the Restoration of Peace, 1801, 10 x 14in. Gorringes, Lewes. Apr 01. £130.

Portrait miniature of a young lady entitled on reverse 'A Thoroughbred', watercolour by Charles W Waller, dated 1809, 5.25 x 3.5in. Tring Market Auctions, Herts. Nov 02. £130.

Regency oval painted silhouette of a gentleman and another silhouette of a young woman. Gorringes, Bexhill On Sea. Sep 04. £130.

English School, silhouette portrait of a young boy, painted on card, unsigned, 19thC, 2.5 x 2in, maple frame. Andrew Hartley, Ilkley. Dec 02. £130.

C E Lovell, Portrait of a gentleman, signed and dated 1890, oil on canvas, 34.5 x 44.5cm. Locke & England, Leamington Spa. Feb 03. £130.

Mono E M, Venetian canal scene, signed in mono, unframed. Tring Market Auctions, Herts. Mar 03. £130.

Francina Dolenec, 'Vases', reverse painting on glass, signed and dated '63, 47.2 x 57cm. Rosebery's, London. Sep 04. £130.

Dutch School, 20thC Still life of a teapot, cup, jug & pears on a table, oil on canvas, signed 'Leo Vander****', 59.8 x 69.8cm, unframed. Rosebery's, London. Sep 04. £130.

Condiiton, rarity, provenance and fashion are the key market operators currently dictating values.

Guy Cambier, Harbour scene, oil on board, signed, 24.8 x 27.2cm. Rosebery's, London. Sep 04. £130.

F Rousse, harbour scene with boats, signed, 13.5 x 17.5in, gilt frame. Dee Atkinson & Harrison, Driffield. Jul 04. £130.

H. Percy Heard, Rocky Coastal Scene, watercolour. Hobbs Parker, Ashford. Nov 04. £130.

Early 19thC silhouette, The Reverend Joseph Coltman, MA depicted in profile to the right with a push bike, cut out on paper, unsigned, 10.25 x 10.25in, ebonised frame. Dee Atkinson & Harrison, Driffield. Nov 04. £130.

Harry Henward, Modern British School, 'Concurrence', pencil and gouache, signed and inscribed, 38.2 x 28cm and five other costume designs for theatre in gouache by same hand, all signed and titled, unframed. (6) Rosebery's, London. Sep 04. £130.

J Cuthbert Salmon, (1844-1917) Coastal scene, signed, 6.75 x 9.25in, gilt frame. Dee Atkinson & Harrison, Driffield. Nov 04. £130.

19thC Italian School, pastel drawing, Portrait of an Italian peasant boy. Gorringes, Bexhill On Sea. Dec 04. £130.

Cecil Aldin, Breakfast at the Three Pigeons, coloured print. Gorringes, Bexhill On Sea. Dec 04. £130.

Edward Haines, (fl.1820s-c.1896) cut paper silhouette, Gentleman and two ladies, signed and dated 1843, 10.5 x 8in. Gorringes, Lewes. Jul 04. £130.

19thC English School, oil on wooden panel, Chickens in a barn, 7 x 9.25in. Gorringes, Lewes. Jul 04. £130.

Watercolour of Greenwich. Gorringes, Bexhill On Sea. Sep 04. £130.

Karl Hagadoorn, oil on board, landscape viewed through trees, 18 x 15in. Gorringes, Lewes. Apr 03. £130.

Hammer Price £130

2967

Henry Earp Snr, (1831-1914) watercolour, pen and ink, 'Reigate, Surrey', cart on a wooded lane, 8 x 11.5in. Gorringes, Lewes. Jul 04. £130.

2968

European Orientalist School, Standing North African man in a fez, pen, brown ink, watercolour & gouache, 14 x 9cm and four other similar figure studies, mounted, unframed. (5) Rosebery's, London. Dec 04. £130.

2969

Rowland Langmaid, (1896-1956), etching, 'An Old Two-Decker', signed in pencil, 10 x 7in. Gorringes, Lewes. Oct 02. £130.

2970

Circle of George Richmond, RA (1809-1896) Portrait of a Lady, c1850, oil on canvas, 56 x 39cm. Cheffins, Cambridge. Feb 05. £130.

2971

French School, 19thC, Male nude, seated full length, black chalk on laid, 57.5 x 41.5cm. Rosebery's, London. Mar 05. £130.

2972

J B Booth, caricature of Sir Henry Beerbohm Tree, poss. as Malvolio in Twelfth Night, pencil, black crayon, black ink heightened with white, signed and dated '01, dedicated and dated 1901 by the subject, 43 x 27.5cm. Rosebery's, London. Mar 05. £130.

2973

Leonard R. Squirrell, R.W.S., R.E., Suffolk School, (1893-1979), etching, entitled Curtis Mill, Wrentham, signed, 6.25 x 9.5in, framed and glazed. Diamond Mills & Co, Felixstowe. Dec 04. £130.

2974

Claude Hayes, R.I., R.O.I., Figures on a bridge in a fenland landscape, watercolour, signed, 20.7 x 29.8cm. Rosebery's, London. Mar 05. £130.

2975

Willie Landels, (born 1928) Abstract, oil on board, signed and dated 1995 verso, 61 x 76cm. Dreweatt Neate, Donnington. Nov 02. £130.

2976

M. Foulkes-Jones, British 20thC, 'Circus', gouache, inscribed on remains of label attached to reverse, 35 x 50cm. Rosebery's, London. Dec 04. £130.

> Prices quoted are hammer and exclude the buyer's premium. Adding 15% will give approx. buying price.

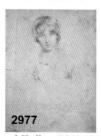

Samuel Shelley, (1750-1808) Portrait of Master Ferguson, inscribed on reverse, pencil, 18 x 13cm and French School (18thC) Portrait of a Lady with a Child, red chalk, 21 x 27cm. (2) Cheffins, Cambridge. Apr 05. £130.

2977

2978

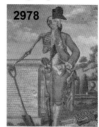

Carington Bowles, pub'd. 25 March 1784, no. 69 in St. Paul's Church Yard, London, 'Death and Life contrasted, or an Essay on Man', hand-coloured engraving, 35 x 25cm, unframed. Rosebery's, London. Jun 05. £130.

2979

Max Ludby, (1858-1943) 'Sheep on a Moorland Path', signed and dated 1894, watercolour, 24 x 36cm. Sworders, Stansted Mountfitchet. Apr 05. £130.

2980

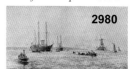

Rowland Langmaid, drypoint 'Off Cowes' (showing Royal Yacht Victoria & Albert and HM Guardship Warspite', signed in pencil, 6.25 x 12in. Great Western Auctions, Glasgow. Jun 05. £130.

2981

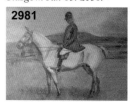

Attributed to Peter Biegel, Portrait of a huntsman on 'Cherry', oil on board, 42.8 x 52.5cm. Rosebery's, London. Jun 05. £130.

2982

Ernest Archibald Taylor, 1874-1951, pastel 'Arran', 5.5 x 8in. Great Western Auctions, Glasgow. Apr 05. £130.

2983

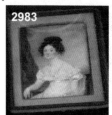

Early 19thC, leather cased portrait miniature of a lady, she sits by a red curtain, a mountain in the distance, 8 x 6cm. Cheffins, Cambridge. Apr 05. £130.

Pair, oil on canvas, signed Erskine Nicol, Portrait of an old man and woman, 26 x 20cm. Boldon Auction Galleries, Tyne & Wear. Sep 04. £125.

Woman on a country path, signed. Tring Market Auctions, Tring. Oct 04. £120.

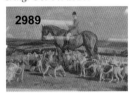

After Henri Matisse, 'Nice Travail et Joie', (m.40), 1947, lithograph printed in colours, signed, dated '47 within the plate, 75 x 56.5cm, unframed. Rosebery's, London. Sep 04. £120.

After Alfred Munnings, Master of Foxhounds, coloured print, 19 x 24in. Sworders, Stansted Mountfitchet. Apr 01. £120. Lincoln. Sep 04. £120.

C Brook Farrar, Three brown and colour wash sketches, French steam engines, signed, 6.5 x 9in, framed as one. Gorringes, Lewes. Apr 03. £120.

Cecil E Cutler, English, 19thC, Portrait of C. W. B. Fernie Esq, MFH, Master of the Fernie Hunt 1888-1919, signed lower right 'Cecil Cutler', watercolour, 26 x 18cm. Cheffins, Cambridge. Feb 05. £125.

Cecil Charles Windsor Aldin, 'Bell Inn, Waltham St. Lawrence', etching with drypoint, signed, numbered 56/75 in pencil, 24.7 x 35cm. Rosebery's, London. Sep 04. £120.

Justin Ouvrie, 'Monsieur Le Docteur Rawlings', signed, inscribed and dated 1871, watercolour and bodycolour 8.5 x 14.5cm. Sworders, Stansted Mountfitchet. Nov 04. £120.

Henry Earp Senior, (1831-1914) watercolour, Girl in a Garden, signed, 10 x 6.5in. Gorringes, Lewes. Jul 04. £120.

Ramond Lapayese, Spanish School, 20thC, Nude clutching wood, monotype, signed and dated '58, 64.8 x 50cm, unframed. Rosebery's, London. Sep 04. £120.

Victorian School, watercolour, Portrait of a child, 5.5 x 4.5in. Gorringes, Lewes. Mar 04. £120.

Nobukazu, General Nozu on his horse in battle, colour woodblock print, signed, 34.2 x 23cm, with three other Japanese colour woodblock prints from the Sino-Japanese War, unframed. (4), Rosebery's, London. Sep 04. £120.

Oil on board, Cattle in a landscape, 30 x 40cm. Boldon Auction Galleries, Tyne & Wear. Sep 04. £120.

Early 19thC British School, portrait miniature, gouache of a young gentleman in a black frock coat, mounted in an ebonised frame, 8.5cm high. Thos Mawer & Son, Lincoln. Sep 04. £120.

Manuel Moros, Still life of jugs and bowl of fruit on a cloth, oil on board, signed, label verso 'Galerie Cardo, 61 Avenue Kleber, Passy 08-45', 32.5 x 57.5cm. Rosebery's, London. Sep 04. £120.

R Groom after I Shaw, (Early 19thC), East view of Hull, hand coloured lithograph published by John Nicholson Stationer & Co., 48 Lowgate, Hull, 12 x 16in, gilt frame. Dee Atkinson & Harrison, Driffield. Nov 04. £120.

A. Kesler after John Singleton Copley RA, 'The death of Major Pierson and the defeat of the French in the market place of Saint Heliers in the Island of Jersey Jan 6th 1781', published in Nuremberg 1800, size 55 x 70cm. Hampton & Littlewood, Exeter. Jul 04. £120.

Hammer Price £120

3001

G W Collins, The beach at Scarborough, signed, 6.25 x 10in, gilt frame. Dee Atkinson & Harrison, Driffield. Nov 04. £120.

3002

Arthur Wilkinson, (19/20thC) farmhouse scene, cattle watering, signed, 10.5 x 15in, framed. Dee Atkinson & Harrison, Driffield. Jul 04. £120.

3003

English School, oil on canvas, Frigate at sea, signed, dated 1883, 7 x 10in. Gorringes, Lewes. Jan 04. £120.

3004

Martin Hardie, three b/w etchings, Essex Boatyard, St Malo and Calvary, Concarneau and a Francis Dodd etching. Gorringes, Bexhill On Sea. Dec 04. £120.

3005

English School, (early 19thC) portrait of a young gentleman, head and shoulders, unsigned on artists board, 10 x 8.25in, gilt frame. Dee Atkinson & Harrison, Driffield. Jul 04. £120.

186 *Picture Prices*

3006

19thC English School, watercolour on ivory miniature, Portrait of a young lady in a white dress, oval, 3 x 2.25in. Gorringes, Lewes. Jul 04. £120.

3007

Manner of Frank Dean, Arabian street scene, on panel, unsigned, 8 x 11in, gilt frame. Dee Atkinson & Harrison, Driffield. Mar 04. £120.

3008

Circle of Herman Schafer, Elegant lady reclining on a chaise, watercolour, 14.3 x 23.4cm & European School, early 20thC, Standing male nude, black brown and white chalk on grey paper, signed with initials 'JH', 22 x 17.3cm, unframed. (2) Rosebery's, London. Dec 04. £120.

3009

English School, c1900, female nude study, quarter length turned to the right, oil on canvas, 50.8 x 40.5cm. Rosebery's, London. Mar 05. £120.

3010

Madeline Enright, untitled abstract composition, oil on canvas, signed and dated '67, 96.5 x 81cm. Rosebery's, London. Mar 05. £120.

3011

English School, (20thC) Menton, France, watercolour, 36 x 26cm. Cheffins, Cambridge. Feb 05. £120.

3012

Mexican School? c1940, Figures in a surreal landscape with cherubs, synthetic polymer on board, signed with initials 'KM', 30.5 x 45cm & another Crucifixion study by the same hand, 47.8 x 30.2cm, signed with initials, unframed. (2) Rosebery's, London. Mar 05. £120.

3013

Pencil drawing of a first world war pilot, bears an inscription 'Baron von Richtofen'. (The Red Baron) Charterhouse Auctioneers, Sherborne. Jun 05. £120.

3014

Pierre Jacobs, 'River Landscape', oil on canvas, signed, 40.5 x 51cm. Rosebery's, London. Dec 04. £120.

3015

F.H.B., oil on canvas, coastal landscape, initialled, 10 x 12in. Gorringes, Lewes. Apr 02. £120.

3016

Cavendish Morton, (1911-?), Study of buildings and trees through archways, watercolour, signed and dated 1973, silvered glazed frame, 19 x 48cm. Locke & England, Leamington Spa. Mar 05. £120.

3017

G. Ballard, watercolour, 'A Yorkshire Village', signed, 9 x 13in. Gorringes, Lewes. Apr 02. £120.

3018

Pair of late 19thC wax profiles depicting a middle aged man and young woman, each oval 6 x 4.25in, both cracked, oak frames and glazed. Canterbury Auction Galleries, Kent. Apr 05. £120.

3019

Anthony Morris, 1989, Arctic Tern, signed, dated, framed and glazed, 12.25 x 13.5in. Tring Market Auctions, Herts. Jul 04. £110.

3020

British School c1900, Misty harbour scene, watercolour on textured ground, on canvas laid down on board, signed 'Forsyth'(?), 39.5 x 50cm. Rosebery's, London. Jun 05. £120.

3021

Late 18thC, leather cased portrait miniature of a lady representing Laetitia resting her hands on an anchor, 6.5cm high. Cheffins, Cambridge. Apr 05. £120.

3022

Sir Peter Scott, White fronted geese at dawn, print, 1939, 52 x 40cm. Dockree's, Manchester. Jun 01. £110.

3023

G. D. Rowlandson, pair of hunting prints, each signed in pencil in the margin, 16 x 24.5in. Sworders, Stansted Mountfitchet. Apr 01. £110.

3024

Robert Havell & Charles Ade, coloured aquatint, View of the Thames East India-man, stranded near East Bourne, 1822, 7.5 x 11.5in. Gorringes, Lewes. Mar 01. £110.

3025

W H Mayo, Still life of flowers, oil on board, signed, 79 x 56cm, ornate gilt frame. Locke & England, Leamington Spa. Jul 03. £110.

The numbering system acts as a reader reference as well as linking to the Analysis of each section.

2026

Early 20thC English School, still life, oil on canvas, 16 x 20in, unsigned, gilt moulded frame. Canterbury Auction Galleries, Kent. Feb 04. £110.

3027

Thomas Mower Martin, 1839-1934, Fast flowing river in Canadian Rockies, 20.25 x 13.25in, signed and dated '87, composition frame and glazed. (faded) Canterbury Auc. Galleries, Kent. Feb 04. £110.

3028

Bernard Fleetwood-Walker, Portrait of Dorothy, watercolour, signed, 26.2 x 21.6cm, bears RWS label verso. Rosebery's, London. Sep 04. £110.

3029

Arild Rosenkrantz, 'At Eventide there Shall be Light', coloured chalk, signed in pencil, inscribed on reverse, Rowley Gallery frame, 31.5 x 47cm. Rosebery's, London. Sep 04. £110.

3030

Leonor Fini, Trois visages, lithograph in colours, signed in pencil, 72 x 52.5cm and one other lithograph by the same hand, signed in pencil, 54 x 43cm. (2) Rosebery's, London. Sep 04. £110.

3031

Circle of Pavel Tchelitchew, Mercury, pencil and oil on board, bears signature date and inscription, 40.5 x 32.5cm. Rosebery's, London. Sep 04. £110.

3032

James Garden Laing, watercolour, Old Inn, Worcestershire. Gorringes, Bexhill On Sea. Sep 04. £110.

3033

Early 20thC English School, oil on board, study of a donkey's head, oval, 20 x 16in. Gorringes, Lewes. Apr 02. £110.

3034

After Juan Miro, three motifs in blue, lithograph printed in colours, 38 x 69.5cm, and a quantity of other lithographs after different hands incl: N Dumitresco, L Marrcoussis, unframed. (4) Rosebery's, London. Mar 05. £110.

3035

Gafgorio Villaris del Cacho, watercolour, Abstract, signed, 19 x 15.5in. Gorringes, Lewes. Mar 04. £110.

Hammer Price £110

3036

Sir Frank Brangwyn, (1867-1956) unframed etching, 'Turkish Well', F.A.S 255, cut from Santa Sophia (71) 1919, signed in pencil, 6 x 8.25in. Gorringes, Lewes. Jul 04. £110.

3037

British Provincial School, 19thC, Girl with a horse by a stable, pencil, black chalk & watercolour, 26.4 x 23cm, and a quantity of picture frames, a lot. Rosebery's, London. Mar 05. £110.

3038

Ch. Marol, Figure by a wooded shore, oil on board, signed, 12 x 18.8cm, unframed. Rosebery's, London. Dec 04. £110.

3039

Circle of Salvador Dali, untitled composition, lithograph in colours, signature and numbered 249/250 in pencil, 75 x 54.3cm, and a colour lithograph in the circle of the same hand, and one other by John Carter, unframed. (3) Rosebery's, London. Mar 05. £110.

3040

European Secessionist School, c1910, Exotic palace viewed through a glade, gouache, arched top, 18 x 25.2cm, unframed. Rosebery's, London. Dec 04. £110.

3041

Frank Wootton, colour reproduction limited edition print, Harvest Time and another similar print by John Hamilton. Gorringes, Bexhill On Sea. Dec 04. £110.

3042

Ern Brooks, 'Men of Tolpuddle', linocut, signed, titled, dated '51, numbered 4/50 in pencil, 24 x 27cm. Rosebery's, London. Dec 04. £110.

3043

Victorian School, watercolour, Portrait of a lady seated with a lap dog, oval, 16 x 14in. Gorringes, Lewes. Mar 03. £110.

3044

Walter H Donne, Dead sea settlement, oil on panel, signed, 23 x 33.8cm. Rosebery's, London. Mar 05. £110.

3045

D. Long, 20thC, Brief conversation, Jersey cow with milkmaid, signed, 15.5 x 19.5in, gilt frame. Dee, Atkinson & Harrison, Driffield. Feb 05. £110.

3046

Job Nixon, (1891-1938) Busy jetty scene with steam ships, signed, 11 x 18in, gilt frame. Dee, Atkinson & Harrison, Driffield. Feb 05. £110.

3047

Dutch School, oil on canvas, fishing boats at sea, indistinctly signed, 7 x 9in. Gorringes, Bexhill. Mar 02. £110.

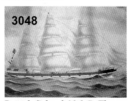

3048

British School 19thC, Three Mast Barque 'Margaret Galbraith' running in open seas, watercolour, 53 x 75.3cm, unframed. Rosebery's, London. Mar 05. £110.

3049

Pastel Portrait of a Child, signed H B Norris, young girl with long blonde hair wearing a bonnet, 10 x 12in, framed & glazed, gilt frame. Kent Auction Galleries, Folkestone. Apr 05. £110.

3050

Chinese School, gouache, seated noble, 9.5 x 7in. Gorringes, Lewes. Apr 03. £110.

3051

European School 18thC, Interior of a Butcher's with a flayed pig, pencil, pen and ink watercolour and gouache on laid, 22 x 26.2cm, unframed. Rosebery's, London. Jun 05. £110.

3052

Large print of a tiger (prob. Indian) upon canvas, within gilt bamboo style frame, 173 x 115cm. Rosebery's, London. Jun 05. £110.

3053

Framed oil painting, 'Cows in Byre'. Sandwich Auction Rooms, Kent. Jun 05. £110.

3054

R Gledstone, (19thC/20thC) study of a horse and foal, oil on canvas, unsigned, 17.75 x 23.5in. Dee, Atkinson & Harrison, Driffield. Apr 01. £100.

3055

After Cecil Aldin, coloured lithograph, 'The Perth Aberdeen mail coach', 29 x 65cm. Thos Mawer & Son, Lincoln. Nov 02. £100.

3056

Walter Duncan, (fl 1880-1910) watercolour, Feeding chickens in a farmyard, initialled, 8.5 x 13in. Gorringes, Lewes. Mar 01. £100.

> The illustrations are in descending price order. The price range is indicated at the top of each page.

3057

19thC English School, a pair of wooded landscapes, oils on panel, unsigned, each 9 x 11.5in. Sworders, Stansted Mountfitchet. Jul 01. £100.

3058

F Alken Kopf, 19thC Continental landscape, 20 x 26cm. Thos Mawer & Son, Lincoln. Feb 03. £100.

3059

Coloured print under glass of a girl holding a book, 15.5 x 12in. Sworders, Stansted Mountfitchet. Jul 01. £100.

3060

J. Rivet (?), watercolour, portrait of a wire-haired terrier, 12.75 x 15.5in, indistinctly signed, later oak frame. Canterbury Auction Galleries, Kent. Dec 03. £100.

3061

19thC English School, View of Leamington post office with milk maid in foreground, inscribed and dated verso, 1815, oil on board, 13.5 x 18cm. Locke & England, Leamington Spa. Sep 04. £100.

3062

C Rogerson, Arctic Ranger and D B Finn, (Boston Deep Sea Fishing Co) pair, on board, signed, dated 1972, 14.5 x 24in, painted frame. Dee Atkinson & Harrison, Driffield. Nov 04. £100.

3063

After Georges Braque, 'The Bird', published by Schools Prints Ltd., 1946-47, from an edition of approximately 3000, lithograph in colours, 49 x 75cm. Rosebery's, London. Dec 04. £100.

3064

Fraser, Connor Bruce, Early 20thC, oil on canvas, head and shoulder portrait of a Victorian soldier, 53 x 44cm. Thos Mawer & Son, Lincoln. Sep 04. £100.

3065

Valerios Caloutsis, Greek School 20thC, untitled abstract composition, monotype and watercolour, signed, 59 x 76cm and with one other similar probably by the same hand, unframed. (2) Rosebery's, London. Sep 04. £100.

3066

Bernard Quentin, untitled abstract in red and black, gouache, signed, 33.3 x 51.2cm and with one other similar by the same hand, unframed. (2) Rosebery's, London. Sep 04. £100.

3067

Oil on canvas, portrait of a Victorian gentleman seated, 104 x 84cm. Thos Mawer & Son, Lincoln. Feb 03. £100.

3068

G. Morgan, English School, early 20thC, 'Southwold from Walberswick', watercolour, signed, and inscribed on label on the reverse, 17 x 24.5cm. Rosebery's, London. Sep 04. £100.

3069

Modern British Surrealist School, 20thC, 'Self Portrait Beach', black chalk watercolour & gouache, inscribed verso: 'S/P Bell, Recognition Procedure, 20 min', 19 x 24.7cm with three charcoal studies by the same hand, unframed. (4) Rosebery's, London. Sep 04. £100.

3070

Pair of Chinese reverse mirror glass paintings, c1920, of figures on terraces and immortals in the sky, mirror degrading, contemporary frames, 64 x 45cm. Sworders, Stansted Mountfitchet. Nov 04. £100.

3071

Oval miniature of a young lady in a plated frame, written verso 'Miss Chambers', 3.5 x 3cm. Thos. Mawer & Son, Lincoln. Mar 04. £100.

3072

3077

3081

Attributed to Charles Tunnicliffe, charcoal, Washing Day. Gorringes, Bexhill. Sep 04. £100.

3073

H. Scott, (18th-19thC) A country mansion, with deer grazing in a park, watercolour, signed, dated 1799, 25 x 35cm. Hampton & Littlewood, Exeter. Jul 04. £100.

3074

19thC Italian School, oil on board, nude maiden carrying fruit, 14 x 9.5in. Gorringes, Lewes. Apr 02. £100.

3075

Follower of William Huggins, (1820-1884) 'Lion & lioness resting', oil on canvas, 58 x 88cm. Hampton & Littlewood, Exeter. Jul 04. £100.

3076

Cavendish Morton, 1958 s.d. titled on the frame verso 'The Age of Elegance', neoclassical building, 30 x 41cm. Thos. Mawer & Son, Lincoln. Mar 04. £100.

E. Morgan, Art Nouveau inspired figure of a woman in an exotic interior, gouache watercolour & gold, signed, dated 1913(?), label attached to reverse for Salon Ste. des Artistes Francaise, 1914, tondo, 15cm. Rosebery's, London. Dec 04. £100.

3078

Arnold Wyllie, gouache and ink, Tug and Liner, signed, 7.5 x 9.5in. Gorringes, Lewes. Apr 02. £100.

3079

Gilbert Wilkinson, 'Derby Day', pencil and gouache on paper laid on board, signed with initials, dated '56 and titled, and signed and titled verso, 40 x 32.2cm. Rosebery's, London. Dec 04. £100.

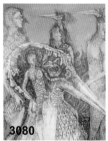

3080

Ken Morton, 'Of Men and Birds', pen and black ink and gouache, en grisaille, signed and dated '76, 19 x 12.5cm. Rosebery's, London. Dec 04. £100.

George Shaw, (1843-1915) 'A clapper bridge, Dartmoor', oil on canvas, signed and dated '96, size 24 x 75cm. Hampton & Littlewood, Exeter. Jul 04. £100.

3082

Italian School c1900, Fishermen off a coastal ruin, watercolour, 33.7 x 50.4cm, unframed. Rosebery's, London. Dec 04. £100.

3083

Limited Edn. coloured print after David Shepherd, Cool Tiger, signed in margin, 8 x 12in. Denhams, Warnham, Sussex. Mar 05. £100.

3084

Harry Horace Sayce, Reclining female nude, oil on canvas, 50.7 x 80cm and two other nude studies in oils on canvas by the same hand, unframed. (3) Rosebery's, London. Dec 04. £100.

3085

Hokuei, a mid 19thC Japanese woodblock print, actor in a female role below blossoms, oban. Cheffins, Cambridge. Feb 05. £100.

3086

Large gilt framed oil on canvas of a Collie Dog. Smiths of Newent, Glos. Jun 05. £100.

3087

William Lionel Wyllie, The Embankment at Cleopatra's Needle, Parliament beyond, etching, signed in pencil, 19.5 x 14.7cm. Rosebery's, London. Mar 05. £100.

3088

Raymond Coxon, still life on a terrace, oil on canvas, inscribed on the reverse and bears remains of paper label on stretcher, 54 x 64.5cm, unframed. Rosebery's, London. Mar 05. £100.

3089

19thC English School, watercolour on ivory miniature, Portrait of a lady, 3 x 2.5in, gilt locket frame. Gorringes, Lewes. Jun 03. £100.

3090

DLB 1867, Evening in Greece, classical landscape with figures in a wooded clearing amongst monuments and ruins, titled on reverse, unframed, 9.5 x 12in. Tring Market Auctions, Herts. Apr 05. £100.

3091

J Middleton, 1895, oil on board, Northern lakeside scene with 2 beached fishing boats, steamer in the distance, figures on a pier and others boating, signed & dated, framed, 16 x 25in. Tring Market Auctions, Herts. Apr 05. £100.

3092

William Miers, (1793-1863) painted silhouette profile heightened in gilt of a young woman, oval 3.25 x 2.75in, black papier mache frame, trade label to rear of frame 'Miers, Profile Painter and Jeweller, 111 Strand, London, c1830'. Canterbury Auction Galleries, Kent. Apr 05. £100.

3093

Manner of David Teniers, the Younger, A Tavern Interior with Figures, oil on canvas, 32 x 26cm. Sworders, Stansted Mountfitchet. Apr 05. £100.

3094

Framed watercolour, 'Seascape'. Sandwich Auction Rooms, Kent. Jun 05. £100.

3095

Follower of Thomas Rowlandson, Actresses Dressing Room at Drury Lane, signature, pen, ink and watercolour, 21 x 16cm. Sworders, Stansted Mountfitchet. Apr 05. £100.

Artists or themes can be followed through the colour coded Index which contains over 4500 cross references.

3096

William Arthur Taylor, 'St. Ives', inscribed on label attached to reverse of frame, oil on canvas, 56 x 76.7cm. Rosebery's, London. Jun 05. £100.

3097

Samuel Lucas, (1805-1870) An Owl at Twilight, watercolour, 17 x 9cm. Cheffins, Cambridge. Apr 05. £100.

Hammer Price £100

3098

Manner of Alan Lowndes, Crowds by the sea side, oil on canvas, 40.2 x 50.6cm, unframed. Rosebery's, London. Jun 05. £100.

3099

Clifford Fishwick, untitled composition, pen and black ink and watercolour, signed, 16.7 x 25.5cm. Rosebery's, London. Jun 05. £100.

3100

June Miles, 'St. Just', oil on canvas board, 29.5 x 34.3cm. Rosebery's, London. Jun 05. £100.

3101

Follower of Paul Henry, Highland coastal landscape with cottages, oil on canvas, 35.5 x 40.5cm, unframed. Rosebery's, London. Jun 05. £100.

3102

19thC English School, oil on canvas, Portrait of a gentleman, 30 x 25in. Gorringes, Lewes. Jun 03. £100.

3103

Frank E Russell, (English, 19thC) Wormingford and Boxted, Hawkedon and Grimes Graves - Suffolk and Norfolk Scenes, some signed with initials 'FER' and dated 1926, watercolours, various sizes. (10) Cheffins, Cambridge. Apr 05. £100.

3104

Maurice Cockrill, R.A., Grapes, gouache, signed with initials and dated 86 in pencil, 13.2 x 9.5cm. Rosebery's, London. Jun 05. £100.

3105

Manner of Georges Emil Charpentier, Mediterranean coastal scene, oil on canvas, signature, 44.5 x 32.3cm. Rosebery's, London. Jun 05. £100.

3106

Robert Hill, R.O.I., Townscape, oil on board, signed, 118 x 178cm. Rosebery's, London. Jun 05. £100.

Section XII < £100

The problem with buying small pretty pictures by minor artists is that it is always much better to save your money and later buy the best you can afford. This applies to whatever you collect.

The number of pictures selling at UK provincial auctions has tailed off. Here are just 284 examples with a dearth of good, original work, plenty of prints and a number of multiple lots. See for example **3122**, **3125**, **3213**, **3245** and so on. Let us start at the beginning with the Lara Ivanovic oil portrait at **3108**, *Sarah by the Window*. It is large, unframed and cost the buyer £95 plus premium for an unknown artist. Its future is hardly promising, but you never know. Fred Lawson (1888-1968) at **3111** is another matter. *Richmond Castle* is a good little painting and will almost certainly, slowly increase in value, over the years, but not much and hardly an investment. At **3115** is a decent still life, with probably the same long term prospects. However, what about Alan Lowndes *Nude Studies* at **3116**. Remember, we met a 'Manner of' at **3098** in the previous Section and there is a later litho-graph at **3186** for £80. His oils go to £7,500, but works on paper are thin. I have only found one example at £500, an earlier crayon sketch of about this size. Perhaps this nude study was a good investment.

I would have thought Max Parsons worth more at **3132**, but again no size. At **3143** is an old master drawing 'Follower of Poussin'. (1594-1665) This is a rising market so speculatively is a sound purchase. Note the Egyptian landscapes at **3144** and **3149**, good value pictures, and a nice still life at **3152**. Those interested in abstracts can still find decorative paintings. See **3155**. On page 197, is a further 'After William Callow' at **3185**. The attribution to Thomas Hearn (1744-1817), hasn't gone down well at **3187** and only £80!

There is a nice size Mediterranean harbour scene at **3199** well worth the money. On page 199, is a good pencil and watercolour at **3211**. Olwyn Bowey RA (1936-) is a competent draughtsman. His only recorded work on paper fetched £800 in 2004. A good buy?

The despairing search for quality continues. There is very little on page 200 except the abstract composition at **3240**. We have already seen examples at **3175**, **3198**, etc, with **3360** *Honey* bringing up the rear at only £25. The George Shaw (1843-1915) landscape at **3237** is pleasant but I doubt a prudent buy at £70. The problem with buying small pretty pictures by minor artists is that it is much better to save the money and buy the best you can afford. This applies to whatever you collect. On page 201 are a few worthwhile paintings. At **3247** is a good modern British School, c1960 portrait of a young woman, worth far more surely than the £70 paid. Also worthwhile is the twentieth century French school,

Shanghai harbour scene and perhaps the R (Rowland?) Suddaby watercolour of a flooded meadow at **3261**. If Rowland Suddaby, his watercolour median is £550 going up to £1,350 but the case isn't proved. Let us check back to pictures **1606**, **2000** and **2368**. Both **2368** and **3261** are similar although, neither stylistically are like our first examples. The Richard E Clarke at **3259** of *Girls picking flowers in a woodland* seems promising. The subject is right but somehow the idea doesn't.

There are good townscapes at **3266** and **3267**. The Hull watercolour is about right for the price. The David Smith (1920-1998) is better. He has a median of £340 and his oils have reached £1,700. This is small at 9 x 13 inches but it is a snip at this price and may turn out to be one of our few bargains. On page 203 there is little of interest, except the Impressionistic Continental work at **3283** and the British Post-Impressionist beach scene at **3286**. I like the John Syer watercolour at **3287**. Again, we don't know the size so we can expect it to be quite small. Also, which John Syer is this? Could it be John Syer (1815-1885) or John C Syer (1846-1913). Presumably the auction are saying the former, whose watercolour median is £450. If so this could be another bargain. See also on page 203, the 'Circle of Donald Bain' harbour scene, quite large at 22 x 26 inches and unframed at only £50. On page 204 is a decent watercolour farmyard scene at **3302**. William Rainey (1852-1936), is recorded only once in the *2005 Art Sales Index* at £620 for a 9 x 15 inch Cornish harbour study. Is this the same Rainey? There are also decent landscapes/townscapes at **3305**, **3309**, **3311** and **3314**. Only the Wilfred Ball (1852-1917) at **3314**, has form with a watercolour median of £500. This is about his average size so why only £50, except there are far too many small, pretty pictures around and this is not a very commercial picture. An artists' median isn't always a guide to prices. Our maxim comes into play. Buy the picture, not the artist.

There are still some decent 'scapes left though artists with form are difficult to find. Examine the two water-colours by an unknown F E Jamieson at **3359** and **3365**. Why were they not sold as a pair? Better to buy the portrait miniatures at **3356** or **3370** if they interest you. Far better though not to buy in this price range at all, unless specialising. In which case you would know that Franco Matania at **3371** is probably twentieth century, and a reclining nude at 12 x 19 inches, with seven others by the same hand, sold at Bonhams in 2003 for £360. Fortunino Matania would have been another matter.

3107

Elizabeth Southerden Thompson, (Lady Butler) Cavalry horses taking water, possibly India or South East Asia, unframed, initialled & dated 1872, 23 x 40cm, watercolour, faded, in need of repair. Dockree's, Manchester. Jun 01. £95.

3108

Lara Ivanovic, oil on canvas, 'Sarah by the Window', 34 x 44in. Gorringes, Lewes. Jul 03. £95.

3109

Vernon Russell, girl feeding pigeons. Tring Market Auctions, Herts. Oct 04. £95.

3110

19thC English School, oval miniature on ivory, and another. Gorringes, Bexhill On Sea. Sep 04. £95.

3111

Fred Lawson, (1888-1968) Richmond Castle, signed, 7.5 x 11.75in, gilt frame. Dee Atkinson & Harrison, Driffield. Jul 04. £95.

3112

Sir Frank Brangwyn, (1867-1956) unframed etching, 'Venetian Bridge', signed in pencil, 8 x 6in. Gorringes, Lewes. Jul 04. £95.

3113

Continental School, colour print, French cavalry, 28 x 39in. Gorringes, Lewes. Mar 04. £95.

3114

George Oyston, (c1860-?) watercolour, Sussex cornfield, signed, 3.25 x 5.25in. Gorringes, Bexhill. Mar 02. £95.

3115

Continental School, oil on board, Still life of flowers in a vase, 9.5 x 7.25in. Gorringes, Bexhill. Mar 02. £95.

3116

Alan Lowndes, Nude studies, pen and ink, black and red chalk, signed in pencil, 33.8 x 43.2cm. Rosebery's, London. Mar 05. £95.

3117

Gnyuki Torimaru, original design for a green evening dress with lily sleeves, pencil, pen and watercolour, signed and dated Spring 1973 lower right, 42 x 30cm. Dreweatt Neate, Donnington. Nov 02. £95.

3118

W. H. Vernon, set of 4 watercolours, lakeland scenes with fishing boats to the fore and mountains in the distance, signed, 9.25 x 21.25in. S/D. Fieldings, West Hagley, Worcs. Jun 05. £95.

> The abbreviations following artist's names can be located in the Appendices.

3119

J*** Fanton, Old Eccles in 1800, oil on canvas, 24 x 39cm. Dockree's, Manchester. Jun 01. £90.

3120

Oswald Partridge Milne, 1881-1968, selection of watercolour sketches, mostly of topographical views, mostly unsigned/unframed. Canterbury Auc. Galleries, Kent. Feb 04. £90.

3121

English School, 3/4 length portrait of a lady, believed to be Mrs Smithson née Cowburn, friend of George IV, unsigned, 11.5 x 9.5in. Dee, Atkinson & Harrison, Driffield. Apr 01. £90.

3122

After Thomas Sydney Cooper, four lithographs of cattle and sheep printed by A Ducote, 70 St Martins Lane, 10.5 x 15.25in. Sworders, Stansted Mountfitchet. Apr 01. £90.

3123

D Kieker, watercolour on ivory miniature of Joshua Keene of Boston, Mass., c1860, 3.75 x 2.5in. Gorringes, Lewes. Apr 01. £90.

3124

Frederick Hines (19th-20thC) River scene with silver birch and swans, watercolour and body colour, signed, 37 x 27cm. Hampton & Littlewood, Exeter. Apr 04. £90.

3125

I. Sawyer, Dutch Canal with a Windmill, signed and dated 1910, pencil & watercolour, 32 x 22cm and 2 other landscapes, one signed W.A.M., dated 1888 and a View of the Venetian Lagoon, indistinctly signed. (4) Sworders, Stansted Mountfitchet. Jul 04. £90.

3126

British School, early 20thC, 'Off the Lizard', (Cornwall) oil on canvas, inscribed with title on the stretcher, 30.3 x 40.5cm. Rosebery's, London. Sep 04. £90.

3127

French School c1930s, 'Les Gants', inscribed with title & dated 1937 on label attached to reverse, oil on canvas, 46 x 55cm, unframed. Rosebery's, London. Sep 04. £90.

3128

Jacob Kramer, Portrait of Jacob Epstein, lithograph, signed, 57.5 x 45.2cm. Rosebery's, London. Sep 04. £90.

3129

20thC School, c1950, Crowded city square, gouache, 37 x 42.5cm. Rosebery's, London. Sep 04. £90.

3130

William Strang, R.A., R.E., 'The Trinket Seller', etching, signed, and inscribed 'David Strang imp.' in pencil, 18.7 x 24cm. Rosebery's, London. Sep 04. £90.

3131

F Rider, watercolour, Pegwell Bay. Gorringes, Bexhill On Sea. Sep 04. £90.

3132

Max Parsons, oil on board, three masted sailing ships. Gorringes, Bexhill On Sea. Sep 04. £90.

3133

Serge Charchoune, untitled abstract composition, lithograph in colours, signed and numbered 'F 75/75' in pencil, 50.5 x 41.5cm, unframed. Rosebery's, London. Dec 04. £90.

3134

English School, 19thC, Man with a shotgun and 2 hounds in a landscape, unsigned, 13.25 x 18in, gilt frame. Dee Atkinson & Harrison, Driffield. Nov 04. £90.

3135

H A Frith, silhouette of Edward Buckle. Gorringes, Bexhill On Sea. Dec 04. £90.

3136

Eimar Filose, View of a coastal village and harbour, oil on canvas, signed, dated 1963, 76.2 x 101cm, unframed. Rosebery's, London. Dec 04. £90.

3137

Yolanda Chetwynd, 'Acteon changed into a deer by Artemis', oil on canvas board, 40.5 x 50.8cm. Rosebery's, London. Dec 04. £90.

3138

Y.J.J., (19thC) oil on wooden panel, 'Geneva', initialled and dated '55, 12 x 17.5in. Gorringes, Lewes. Jul 04. £90.

3139

After Sir D Y Cameron, black & white etching, Perth Bridge, and another etching. Gorringes, Bexhill On Sea. Sep 04. £90.

3140

After Raymond Peynet, 'Une gentillesse par-ci, une caresse par-la, On a jamais fini...', lithograph printed in blue and black, signed and inscribed 'EA' in pencil, 55 x 40.7cm. Rosebery's, London. Dec 04. £90.

3141

F Rider, watercolour over pencil, Morning, Exeter. Gorringes, Bexhill On Sea. Sep 04. £90.

3142

Norwich School, oil on board, watermill in a landscape, 5.5 x 9.5in. Gorringes, Lewes. Apr 02. £90.

3143

Follower of Poussin, Female nude on a dolphin, pen and brown ink on laid, inscribed, 16 x 13cm, unframed. Rosebery's, London. Jun 05. £90.

3144

Major Sir John Ardagh, (English, 19thC) The Pyramids, Giza, Egypt signed lower left 'J Ardagh', watercolour, 15 x 33cm. Cheffins, Cambridge. Feb 05. £90.

3145

Hiroshige, 19thC Japanese woodblock print, lady carried on a litter, 22 x 16.5cm. Cheffins, Cambridge. Feb 05. £90.

> Fresh to the market paintings perform better than those which have been in and out of auction.

3146

John Colin Angus, (1907 - Australian School), oil on canvas, laid on board, 'Bush Gully', signed, 8 x 10in, gilt frame. Dee, Atkinson & Harrison, Driffield. Feb 05. £90.

3147

Clive Gardner, (1891-1960) 'Leda and the Swan', oil, board 8 x 6.75in, unsigned, deep white painted frame. Canterbury Auc. Galleries, Kent. Apr 05. £90.

3148

Late 19th/early 20thC Continental School, half length portrait of a Tyrolean musician playing a violin, oil, 24 x 20in, unsigned, modern gilt moulded frame. Canterbury Auction Galleries, Kent. Apr 05. £90.

3149

Alexander Williams West, (1852-1922) Cairo, signed and inscribed 'Cairo 1898', watercolour, 21 x 31cm. Sworders, Stansted Mountfitchet. Apr 05. £90.

3150

British School c1940, Exotic costume design, woman standing full-length in red white and yellow, black crayon and gouache, 56 x 37.8, and two other similar costume designs by the same hand, part unframed. Rosebery's, London. Jun 05. £90.

Hammer Prices £90 - £85

3151

English School, unframed watercolour on ivory miniature, Portrait of a girl with ribbon-tied dress, monogrammed, oval, 2.75 x 2.25in. Gorringes, Lewes. Jul 04. £85.

3152

Belgian or Dutch School, early 20thC, Still life of flowers in a vase, teapot, candlestick and samovar, oil on canvas, inscriptions on reverse, 71 x 59.4cm. Rosebery's, London. Dec 04. £85.

3153

English School c1900, watercolour on ivory miniature, Lady with a ribbon-tied hat, oval, 3 x 2.25in. Gorringes, Lewes. Oct 04. £85.

3154

Kathleen W. Anderson, 'Boats under canvas at Durban Bay', oil on canvas, signed and dated '46, bears inscribed label attached, 30.5 x 45.6cm. Rosebery's, London. Sep 04. £85.

3155

John Milnes-Smith, untitled abstract composition, oil on paper, signed with initials & dated '56, 26.5 x 36.5cm, unframed. Rosebery's, London. Sep 04. £85.

3156

British School, early 20thC, Unloading the day's catch (recto), West Country cottages, (verso), oil on panel, 32.8 x 41.2cm, unframed. Rosebery's, London. Sep 04. £85.

3157

Sir Frank Brangwyn, (1867-1956) unframed etching, 'Trees. Longpre No.1', F.A.S. 259, signed in pencil, 9.5 x 6.75in and an unsigned head study, 2 x 1.75in. Gorringes, Lewes. Jul 04. £85.

3158

Portrait miniature of Queen Elizabeth I, in regal attire & jewelled headdress, signed Bertier(?) centre right, ivory frame with ebony and mother of pearl inlay, paper label to reverse inscribed 'Queen Elizabeth' and poss. 'J. England', (s.d) miniature height 3.25in. Fellows, Birmingham. Jul 03. £85.

3159

Mrs Sarah Harrington, (fl.1774-87) Hollow cut silhouette with black silk backing, unknown lady, c1770-80, 3.25 x 2.75in, oval, embossed brass frame. Gorringes, Lewes. Mar 03. £85.

3160

Northern European School, c1900, Cottages by a river, oil on canvas, 50 x 68cm, unframed. Rosebery's, London. Mar 05. £85.

3161

Roppel, watercolour, head and shoulders portrait, 'Middlesex Regt. Captain', 16 x 12in, signed and dated '47. Denhams, Warnham, Sussex. Feb 05. £85.

3162

V Todorovic, Yugoslavian 20thC, 'Kompozicija II', oil and mixed media on canvas, signed, titled & dated 24.III. 1961 on reverse, 149.8 x 134.8cm. Rosebery's, London. Mar 05. £85.

3163

James Gavin, Orange, Black and White, oil on board, inscribed verso, 23 x 18.2cm. Rosebery's, London. Mar 05. £85.

3164

Late 19thC oval Bartolozzi print 'The Morning', 17in high overall. Sworders, Stansted Mountfitchet. Jul 01. £80.

3165

H Nurkin? 1908, oil on card, portrait of Mr G Payne's racing pigeon, cup winner 1st Darlington, 3rd Newcastle 1907, 29 x 40cm. T. Mawer & Son, Lincoln. Nov 02. £80.

3166

M de Groot, Fishermen in a boat on a lake, signed, framed, 15 x 27in. Tring Market Auctions, Herts. Jan 03. £80.

3167

19thC watercolour drawing in the form of a draughts board, 40in square, framed. Thos Mawer & Son, Lincoln. Feb 03. £80.

3168

Unsigned, pair of oils on canvas, street scene and a young traveller with a dog, framed, 9.5 x 7in. Tring Market Auctions, Herts. Mar 03. £80.

3169

Francis Derwent Wood, R.A. Reclining female nude, black chalk, signed with initials & dated 1912, inscribed label attached to reverse, 29.3 x 45.5cm. Rosebery's, London. Sep 04. £80.

3170

Alexander Wilson, Flowers in a Baroque gilt vase on a ledge, oil on board, signed, 39.5 x 49.5cm. Rosebery's, London. Sep 04. £80.

3171

Claude Venard, Still life of a figurine fruit and a comport, lithograph in colours, signed & inscribed 'Rives-Epreuve d'Artiste', 50.3 x 57cm. Rosebery's, London. Sep 04. £80.

3172

F. Perez, Camels by a moonlit shore, oil on canvas, signed, label 'Delgemalde v. Prof. Karl Heffner verso, 34 x 84cm. Rosebery's, London. Sep 04. £80.

3173

19thC Continental School, Figures on horseback and other figures by a building, oil on canvas, 60 x 45cm. Locke & England, Leamington Spa. May 03. £80.

3174

Raphael Nelson, Old tree on a hillside, watercolour, signed, 51.7 x 36cm and 3 other watercolours of landscape and botanical subjects by same hand, all signed. (4) Rosebery's, London. Sep 04. £80.

> Provenance is an important market factor which can bare positively on results achieved at auction.

3175

Henri D'Anty, Woodland scene, oil on canvas, signed, 33 x 40.8cm, unframed. Rosebery's, London. Sep 04. £80.

3176

F. Holmqvist, Villagers bearbating in a winter wooded landscape, oil on board, signed and dated 1896, 41 x 57.3cm. Rosebery's, London. Sep 04. £80.

3177

P Marny, 19thC, Sail boat beside a bridge, signed, 4.5 x 7.75in, gilt frame. Dee Atkinson & Harrison, Driffield. Nov 04. £80.

3178

Sir Frank Brangwyn, 1867-1956, St Peters of the Exchange, Genoa, black & white etching, signed and titled in pencil, 7 x 8in, ebonised frame. Dee Atkinson & Harrison, Driffield. Nov 04. £80.

3179

After Thomas Espin, 18thC print, North West view of the town of Louth, 35 x 53cm. Thos. Mawer & Son, Lincoln. Mar 04. £80.

3180

Tom Dudley, (1857-1935) Bolton Abbey, solitary fisherman on the River Wharfe, signed, 6 x 9.5in, framed. Dee Atkinson & Harrison, Driffield. Jul 04. £80.

3181

Follower of J. M. W. Turner, Stone bridge and ruin in a wooded river landscape, watercolour, 22.4 x 31.5cm. Rosebery's, London. Dec 04. £80.

3182

Victorian School watercolour, miniature half length portrait of a young man, 4 x 2.5in. Gorringes, Lewes. Jul 04. £80.

3183

Sir Frank Brangwyn, (1867-1956) unframed etching, 'Bridge over the Tarn', F.A.S 180, signed in pencil, 5 x 6.5in. Gorringes, Lewes. Jul 04. £80.

3184

Claude Hayes, (1852-1922) A River Landscape, signed, watercolour, 17 x 26cm. Sworders, Stansted Mountfitchet. Feb 05. £80.

3185

After William Callow, (1812-1908), watercolour 'A Corner of Old Frankfort', signed, dated 1856, 10.75 x 14.5in. Gorringes, Lewes. Apr 02. £80.

3186

Alan Lowndes, 'The Old Doss House', 1972, lithograph in colours, signed and numbered 42/100 in pencil, 57 x 46cm. Rosebery's, London. Dec 04. £80.

3187

Attributed to Thomas Hearn, on the mount, pastoral scene with figure & mule crossing a wooden bridge, castle amid trees in the distance, verso extract from Country Life, watercolour drawings, 25.5 x 35cm. Thos. Mawer & Son, Lincoln. Mar 04. £80.

3188

Thomas Bayrle, 'Orson Wells', screenprint in colours, signed, titled, dated '71 and numbered VIII/X in pencil, 75.3 x 60cm. Rosebery's, London. Dec 04. £80.

3189

Gabrielle Rainer Ystvanffy, Portrait of a cat, oval, black and coloured crayon, signed, 12.5 x 8.5cm. Rosebery's, London. Dec 04. £80.

3190

Yoshiiku, mid 19thC Japanese woodblock print, daimyo and lady by a waterfall, oban. Cheffins, Cambridge. Feb 05. £80.

3191

19thC English School, oil on canvas, Portrait of Mrs Patrick Robertson Reid. Gorringes, Bexhill On Sea. Sep 04. £80.

3192

F. Ramus, watercolour, View of a Cathedral town, signed and dated 1905, 16.5 x 9.5in. Gorringes, Lewes. Oct 02. £80.

3193

Frederick A. Farrell, View of a promenade in the South of France, etching with drypoint, signed in pencil, Fine Art Trade Guild blind stamp, 21.3 x 37.5cm and 3 other similar etchings, all signed in pencil. (4) Rosebery's, London. Dec 04. £80.

3194

William Vandyke Patten, (fl. 1844-1871) Portrait of a Gentleman, half length, signed and dated August 1845, watercolour, 34.5 x 24cm. Sworders, Stansted Mountfitchet. Apr 05. £80.

3195

20thC ivory framed miniature depicting Marie de Medici, frame 13.5 x 11.5cm. Cheffins, Cambridge. Feb 05. £80.

3196

19thC English School miniature on ivory, oval, head and shoulders portrait of an elderly lady in a lace bonnet, gilt frame. Dee, Atkinson & Harrison, Driffield. Feb 05. £80.

3197

Follower of Prout, 'A Tomb in Mantua', pen & black ink and watercolour heightened with white on buff paper, 30.6 x 22.2cm. Rosebery's, London. Jun 05. £80.

3198

Willie Landels, (born 1928) Abstract in yellow, orange and blue, oil on board, signed and dated 1995 verso, 61 x 76cm. Dreweatt Neate, Donnington. Nov 02. £80.

3199

Negory(?), European School, 20thC, Mediterranean harbour scene, oil on canvas, signed, dated, 48.5 x 58.3cm. Rosebery's, London. Dec 04. £80.

3200

Juel Madsen, (Danish, 19thC) A Study of a Spaniel Puppy, signed lower right 'Juel Madsen', pencil, 21 x 26cm. Cheffins, Cambridge. Apr 05. £80.

3201

Watercolour, 'Fishing Smacks', framed. Sandwich Auction Rooms, Kent. Jun 05. £80.

3202

R. Kopischke, The Sun in Eclipse, oil on board, signed, dated 29 Oct 1979 on reverse, 16.2 x 24.8cm. Rosebery's, London. Jun 05. £80.

3203

Richard Dighton, (1796-1880) Portrait of a Gentleman holding a top hat, signed, pencil & watercolour, 28 x 21cm. Sworders, Stansted Mountfitchet. Apr 05. £80.

3204

Attributed to Mikael Volodine, Russian 20thC, Bathers in a winter landscape, oil on canvas board, 25.5 x 18.2cm, unframed. Rosebery's, London. Jun 05. £80.

3205

Albrecht Durer, The Annunciation, engraving on laid, trimmed to plate mark, 29.2 x 21cm. Rosebery's, London. Jun 05. £80.

3206

C. H. Mathews, British 19thC, 'Maddox, the Wire Dancer', pen, brown ink and watercolour, signed, titled on mount, inscribed verso 'The work of either the father-in-law or husband of Madame Vestey - Sadler's Wells, c1800?', 15 x 22cm. Rosebery's, London. Jun 05. £80.

3207

Guy Standing, Fleet Street, watercolour, signed, dated '96, 26.5 x 19cm. Rosebery's, London. Jun 05. £80.

3208

19thC Continental School, oil on board, Nude and putti in a garden, oval, 3.5 x 2.75in. Gorringes, Lewes. Mar 04. £80.

Most auction catalogues carry an explantation of the terminology used in descriptions. See Appendices.

3209

Philip Naviasky, Portrait of a man, seated half-length in a flat cap, watercolour, signed and dated 1928, 38.8 x 27.8cm. Rosebery's, London. Jun 05. £80.

3210

Late 18thC silhouette of a gentleman detailed in gilt, papier maché frame, and a coloured stipple engraving of a late 17thC lady, deshabillée, ormolu oval frame, 12.5cm high. (2) Cheffins, Cambridge. Apr 05. £80.

3211

Olwyn Bowey, R.A., 'Rowner Mill Stables', pencil and watercolour, inscribed on label on reverse, signed, 33 x 48.5cm. Rosebery's, London. Jun 05. £80.

3212

Henry Bright, (1814-1873) pencil, The Old Well at Trowse, Nr Norwich, signed, 9.25 x 12.25in. Gorringes, Lewes. Mar 01. £75.

3213

English School, Four pencil and wash illustrations of furniture, interior and a stone jardiniere, various sizes, largest 10.5 x 11.5in. Sworders, Stansted Mountfitchet. Apr 01. £75.

3214

English School, (late 19thC) River landscape with figures near a watermill, oil on board, 19 x 25cm. Hampton & Littlewood, Exeter. Jul 04. £75.

3215

Modern British School, View of a city street from roof tops, pen, brown ink and watercolour, 35.5 x 50.7cm, unframed. Rosebery's, London. Sep 04. £75.

3216

Walter Dendy Sadler, Couple about to emigrate, engraving, signed in pencil, by Dendy Sadler and James Dobie, 18 x 14in. Sworders, Stansted Mountfitchet. Apr 01. £75.

3217

Elizabeth Drake, (1866-1954) watercolour, Courtyard and garden, signed and dated 1903, 14.5 x 9.75in. Gorringes, Lewes. Mar 01. £75.

3218

After George Baxter, Duke of Wellington, Lord Nelson, Napoleon and Prince Albert 10 x 7cm. Henry Adams, Chichester. Jan 03. £75.

3219

20thC School, c1960, Couple embracing, oil on canvas, 60.5 x 50.7cm and one other similar group figure composition, oil on canvas, by same hand, unframed. (2) Rosebery's, London. Dec 04. £75.

3220

Leonard R. Squirrell, R.W.S., R.E., Suffolk School, (1893-1979), etching, Bridgnorth by the Severn, signed, 6.5 x 9.75in, framed and glazed. Diamond Mills & Co, Felixstowe. Dec 04. £75.

3221

Norman Wilkinson, (1878-1971) unframed etching, The Coal Tramp, signed in pencil, 7 x 11in. Gorringes, Bexhill. Mar 02. £75.

3222

John Collier, Bus Stop, oil on board, signed and dated '66, 90.5 x 122cm. Rosebery's, London. Mar 05. £75.

3223

Solomon Van Abbe, Reading the News, drypoint, signed and inscribed in pencil, numbered 26/50, 28.5 x 27cm. Sworders, Stansted Mountfitchet. Nov 04. £70

3224

Neapolitan School, On the Neapolitan coast, oil on canvas, unsigned, 13.5 x 17in. Sworders, Stansted Mountfitchet. Apr 01. £70.

3225

J Geldard-Walton, Scarborough Castle, watercolour, 9 x 24in. Sworders, Stansted Mountfitchet. Jul 01. £70.

3226

Leonard Ward, Whittingdon Castle, Denbighshire, c1920, watercolour on paper, signed, 24.5 x 36cm, gilt mounted. Locke & England, Leamington Spa. May 03. £70.

3227

Follower of Landseer, Retriever with a snipe, black chalk heightened with white on grey paper, signed with initials 'RC', 21.3 x 15.5cm. Rosebery's, London. Sep 04. £70.

3228

Ulrico Schettini, 'Speciment', oil and collage on canvas, signed, titled and dated 1964 on reverse, 75.7 x 101.5cm. Rosebery's, London. Sep 04. £70.

3229

Alan Brown, late 20thC, Sammy's Point River Hull, pen & watercolour drawing, signed and dated June '60, 7.5 x 14in, stained frame. Dee Atkinson & Harrison, Driffield. Nov 04. £70.

Picture Prices **199**

3230

Richard Benedetti, 'The Guardian', oil on canvas, signed and inscribed on the reverse, 60.7 x 45.6cm. Rosebery's, London. Sep 04. £70.

3231

E C Booth, (19thC) Kirkstall Abbey, Yorkshire, titled, signed and dated 1889, 20.5 x 13in, gilt frame. Dee, Atkinson & Harrison, Driffield. Feb 05. £70.

3232

Early 19thC, English School, watercolour on ivory miniature, portrait of a young man, oval, 2.75 x 2.25in. Gorringes, Lewes. Jul 04. £70.

3233

Maurice Cockrill, R.A. 'Fire Study', oil on board, signed, titled, dated 1995 & dedicated on reverse, 20 x 8.5cm. Rosebery's, London. Dec 04. £70.

3234

Edward King Redmore, (1860-1941) coastal scene with rough sea, signed, 8.25 x 12.25in, gilt frame. Dee, Atkinson & Harrison, Driffield. Feb 05. £70.

3235

J. MacConville, Coastal scene at dusk, possibly Achill Island, Northern Ireland, water & bodycolour, signed, 36 x 54.5cm. Rosebery's, London. Dec 04. £70.

3236

Guy Gasama, Harbour scene, Anglet, Basses-Pyrenees, oil on canvas, signed and inscribed on the reverse, 27.8 x 41.2cm. Rosebery's, London. Dec 04. £70.

3237

George Shaw, (1843-1915) 'Moorland scene near Fernworthy, with a figure near a bridge', oil on board, signed, 23 x 59cm. Hampton & Littlewood, Exeter. Jul 04. £70.

3238

Peter Sedgley, Blue circle, screenprint, signed, dated 1965 and numbered 22/30 in pencil, 50 x 50.4cm. Rosebery's, London. Jun 05. £70.

3239

Richard Benedetti, American 20thC, The Mirror, oil on canvas, signed with monogram, inscribed on reverse, label 'The Society of the Four Arts, Palm Beach, Florida, Loan No 69-107-22' attached to stretcher, 60 x 50cm. Rosebery's, London. Mar 05. £70.

3240

Andre Lanskoy, untitled abstract composition, c1965, lithograph in colours, signed & inscribed 'E.A.' in pencil, 53.2 x 68.2cm, unframed. Rosebery's, London. Dec 04. £70.

3241

David Scott, 'Camusdarach, the Sand Dune, Scotland', oil on canvas, signed, titled and dated '79, inscribed 'c/o The MacLean Gallery, 35 St. George Street, London, W1' on the stretcher, 75.8 x 101.5cm. Rosebery's, London. Dec 04. £70.

3242

Victor Askew, A woodland track, oil on canvas, signed, 71 x 56cm. Rosebery's, London. Dec 04. £70.

3243

19thC English School, pair of miniature watercolours, portraits of Grandfather & Grandmother Pitt, 1839, 4.5in dia, ebonised frames, glazed. Canterbury Auction Galleries, Kent. Mar 05. £70.

3244

Robert Lutyens, 'La Garde-Freinet, Evening', oil on board, signed, dated indistinctly, 35 x 45.8cm, unframed. Rosebery's, London. Jun 05. £70.

Ensure you never hang your watercolours etc in direct or reflected sunlight. Fading seriously affects value.

3245

Hans Schwartz, 'Woman Reclining', watercolour, 52.5 x 72.5cm, and a coloured chalk drawing of a coastal scene by a different hand, 48 x 68cm. (2) Rosebery's, London. Jun 05. £70.

3246

John Coplans, untitled abstract composition, lithograph, 30 x 42cm. Rosebery's, London. Jun 05. £70.

3247

Modern British School, c1960, Portrait of a lady, head and shoulders, turned to the left, oil on board, 36 x 46cm, unframed. Rosebery's, London. Jun 05. £70.

3248

Sheila Flinn, Reclining cat beneath the moon, oil on canvas board, signed, 19 x 24.5cm, and another similar picture of a cat by the same hand, signed, pair. Rosebery's, London. Jun 05. £70.

3249

French School 20thC, Harbour scene, Shanghai, pen, black ink and watercolour, signed, inscribed and dated 20 Avril 1936, 26.5 x 44cm. Rosebery's, London. Jun 05. £70.

3250

Follower of Sickert, Crowded interior of a theatre, black chalk, black ink and wash, heightened with white, 18.5 x 28.7cm, unframed. Rosebery's, London. Jun 05. £70.

3251

Unsigned, early 18thC red brick mansion in a parkland setting, framed and glazed, 9.5 x 13in. Tring Market Auctions, Herts. Nov 02. £65.

3252

Fores Pub'l., colour print, A Match at Hambledon 1777, 11.5 x 18.25in. Gorringes, Lewes. Apr 03. £65.

3253

Robin Darwin, Urban canal basin with moored vessels, pen, brown ink and watercolour, signed & dated 1940, 24.2 x 33.2cm. Rosebery's, London. Jun 05. £65.

3254

Euston Road School, c1960, Pastoral village landscape, oil on board, 60.4 x 90.7cm. Rosebery's, London. Dec 04. £65.

3255

Pair of framed and glazed watercolours of landscape scenes. Sandwich Auction Rooms, Kent. Jun 05. £65.

3256

Miniature portrait of a gentleman, English c1820, portrayed in profile, water colour on paper, pressed brass frame. Rosebery's, London. Mar 05. £65.

3257

Donald Grant, 'Giving Chase', print, signed in pencil, pub'd by Venture Prints Ltd., 26 x 31in. Sworders, Stansted Mountfitchet. Apr 01. £60.

3258

Michael G. Hadlow, untitled abstract composition, black ink and gouache, signed and dated '57, inscribed on the reverse, 25.2 x 35.5cm and six other abstract studies in gouache by the same hand, each signed & dated '63/'67, unframed. (7) Rosebery's, London. Sep 04. £60.

3259

Richard E Clarke, Girls picking flowers in woodland with a stream, watercolour, signed, 33 x 22.5cm. Rosebery's, London. Mar 04. £60.

3260

Radana Salmonova, Czech School 20thC, Abstracted head study, mixed technique on board, signed and dated '66, 54 x 36cm and three other mixed technique works on board by the same hand, all signed. (4) Rosebery's, London. Sep 04. £60.

3261

R Suddaby, watercolour drawing, flooded meadow, 24 x 51cm, mounted and framed. Thos Mawer & Son, Lincoln. Apr 04. £60.

3262

Thomas Bredford Meteyard, Provencal landscape, watercolour, signed, 12 x 17cm. Rosebery's, London. Sep 04. £60.

3263

Raymond, Spanish milkmaids conversing in a market place, gouache on paper, signed, 60 x 73.4cm, unframed. Rosebery's, London. Sep 04. £60.

3264

Barry E Carter, (20thC), Road to Aike, initialled, 10 x 15.5in, painted frame. Dee Atkinson & Harrison, Driffield. Nov 04. £60.

3265

19thC English School, Portrait of a gentleman, watercolour, 30.2 x 22cm. Rosebery's, London. Mar 04. £60.

3266

Jill Williams, 20thC, Old Market Hull, signed, pen and watercolour drawing, 14 x 19.5in, painted frame. Dee Atkinson & Harrison, Driffield. Nov 04. £60.

3267

David Smith, late 20thC, Surge barrier in construction, signed, 9.25 x 13.25in, painted frame. Dee Atkinson & Harrison, Driffield. Nov 04. £60.

3268

English School (early 20thC), study of a seated European female dressed as a geisha girl in oriental interior, unsigned, 15 x 11in, gilt frame. Dee Atkinson & Harrison, Driffield. Jul 04. £60.

3269

Hubert Andrew Freeth, (1912-1986) etching, 'Le Penseur', signed in pencil and dated '52, inscribed 'For Michael Davys with every good wish and many thanks, from Andrew, 1964', 12 x 9in. Gorringes, Lewes. Mar 04. £60.

3270

Two coloured prints 'Votes for Women' and 'The March of the Women', 18 x 14cm & 19 x 13cm. Henry Adams, Chichester. Jan 03. £60.

3271

After Piranesi, A view of the Piazza Navona, Rome, black and white print, 43 x 66cm, and one other. Henry Adams, Chichester. Jan 03. £60.

3272

Charles Way Senior, Coastal landscape with figures in foreground, signed, watercolour, 30 x 47cm. Henry Adams, Chichester. Jan 03. £60.

3273

Circle of William Frederick Yeames, R.A, Allegorical scene with shepherd and his flock & onlookers in a landscape, pen & black ink heightened with white, buff paper, bears initials & signature, 29 x 35.3cm, unframed. Rosebery's, London. Dec 04. £60.

3274

Ian Cameron, 'Versailles Bikes', charcoal, graphite, pastel and collage on paper, 19.5 x 27.5cm. Rosebery's, London. Dec 04. £60.

3275

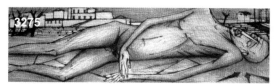

Bernard Buffet, The Deposition, drypoint, 12.5 x 49.4cm. Rosebery's, London. Dec 04. £60.

3276

Valerio Picchiariello, 'Amici', watercolour, signed, 24.2 x 17.5cm and three other similar watercolours of figures subjects by the same hand, all signed. (4) Rosebery's, London. Dec 04. £60.

3277

Attributed to Percy Jacomb-Hood, R.B.A., R.E., Sketch of a fisherman, pencil, 17.5 x 12.5cm and two other pencil and crayon sketches by the same hand. (3) Rosebery's, London. Dec 04. £60.

Frames and mounts should enhance your picture. Empathy, rather than fashion should dictate your choice.

3278

Gregory Masurovsky, 'Running Man', etching, signed, titled, numbered 154/250, dated 1966 in pencil, 24 x 19.7cm, and a mixed quantity of prints by different hands, all late 20thC schools, unframed. (a lot) Rosebery's, London. Jun 05. £60.

3279

20thC ivory framed miniature depicting Mrs Siddons after Gainsborough, frame 14 x 11.5cm. Cheffins, Cambridge. Feb 05. £60.

3280

Follower of Salvator Rosa, figures by a bridge in a stormy mountain landscape, oil on board, 15 x 20cm. Rosebery's, London. Mar 05. £60.

3281

19thC English School, oil on panel, Portrait of a lady, 3.5 x 3in. Gorringes, Bexhill. Mar 02. £60.

3282

Chambers, Portrait of George II, engraving, signed, 15.5 x 10cm, mounted with a clipped signature of King George. Dreweatt Neate, Donnington. Nov 02. £60.

3283

Continental School, oil on board, impressionistic tree-lined river scene with buildings, indistinctly signed, 14 x 17.5in, framed. Fieldings, West Hagley, Worcs. Jun 05. £60.

3284

After Daniel Hernandez, Femme couche, aquatint photogravures printed in colours, 32.5 x 41cm ea. (2) Rosebery's, London. Jun 05. £60.

3285

Acrylic on board, landscape, signed Morrison, 7 x 8.5in. Great Western Auctions, Glasgow. Jun 05. £60.

3286

British Post Impressionist School, 20thC, unfinished study of figures on a beach with a headland, (recto), Shipping in a port with a mountain beyond at sunset, (verso), oil on panel, 27.5 x 36.8cm, unframed. Rosebery's, London. Jun 05. £60.

3287

John Syer, watercolour drawing, Barges & windmills on the Norfolk Broads. Gorringes, Bexhill. Dec 04. £55.

3288

Pair of Indian portrait miniature watercolours, carved ebony frames. Ambrose, Loughton. Feb 02. £55.

3289

Japanese lady in a kimono holding a box, unframed, 13.75 x 9.74in. Tring Market Auctions, Herts. Mar 03. £55.

3290

Miss E. Mordaunt, (Exh. 1927) etching, 'Pollyanna', signed in pencil, 7.25 x 7.25in. Gorringes, Lewes. Jul 04. £55.

3291

Continental School, watercolour on ivory, Virgin and Child, 5 x 3.75in. Gorringes, Lewes. Mar 04. £55.

3292

Oil on canvas, signed Bernard Benedict Hemy, date 1901 'The Headland at Hartlepool', 38 x 51cm. Boldon Auction Galleries, Tyne & Wear. Sep 04. £55.

Hammer Prices £60 - £50

3293

Adriana Zueller, pastel and watercolour, Portrait of 'Ginger', a mastiff, signed and dated '73, 18 x 14in. Gorringes, Lewes. Mar 04. £55.

3294

S. Peters, Modern British School, Reclining female nude, pencil and watercolour wash, inscribed verso, 26 x 40cm. Rosebery's, London. Dec 04. £55.

3295

Gavin Miller, 83 Chester Square, watercolour, signed lower right, dated 17.6.90, 34 x 24.5cm. Dreweatt Neate, Donnington. Nov 02. £55.

3296

19thC English School, oil on canvas, gentleman with silk top hat and frock coat, lady with bonnet and shawl, 90 x 66cm, contemporary gilt slip and frame. Thos Mawer & Son, Lincoln. Feb 03. £50.

3297

Colour print by Mary Tipton, 'The Grand National 1923', signed in pencil, 28 x 55.5cm. Locke & England, Leamington Spa. Apr 03. £50.

3298

Clifford Eric Martin Hall, Standing female nude, pencil, signed and dated 1945 in ink, 38.8 x 28cm, unframed. Rosebery's, London. Sep 04. £50.

3299

Circle of Donald Bain, Moored freighters in a harbour, oil on canvas, 56.8 x 67.3cm, unframed. Rosebery's, London. Sep 04. £50.

3300

Samuel Cousins R.A., The Strawberry Girl, after Reynolds, pub'd. May 1st 1873 by Thos. Agnew & Sons, mezzotint, inscribed in pencil, 47.5 x 36cm, and 3 other prints by same hand, a chromolithograph of a winter woodland scene with figures after Hofer. (5) Rosebery's, London. Mar 05. £50.

Hammer Price £50

3301

Victor Joseph Roux-Champion, Village landscape, pencil & watercolour, signed, 12.5 x 17.5cm and a landscape study in watercolour by the same hand, signed, 23.8 x 31cm. (2) Rosebery's, London. Sep 04. £50.

3302

William Rainey, watercolour, farmyard scene. Gorringes, Bexhill On Sea. Sep 04. £50.

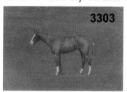
3303

W. Douglas, (20thC) 'Study of a chestnut hunter', oil on panel, signed, 16.5 x 25cm. Hampton & Littlewood, Exeter. Jul 04. £50.

3304

J Wanklyn, oil on canvas, Santolina of Felbridge, pony and trap, signed, 18 x 24in. Gorringes, Lewes. Jan 04. £50.

3305

After Charles Rowbotham, (1856-1921), watercolour, Near Amalfi, Italy, signed, 9 x 11.25in. Gorringes, Lewes. Apr 02. £50.

3306

After W Burgess, early 19thC print, Lincoln Cathedral, marked in margin 'proof', 40 x 57cm. Thos. Mawer & Son, Lincoln. Mar 04. £50.

3307

Continental School, (19thC) interior scene with sleeping mother & child, unsigned on tin, 7.5 x 6.25in, gilt frame. Dee Atkinson & Harrison, Driffield. Jul 04. £50.

> Ensure your watercolours etc are mounted on acid free boards. Have old pictures checked out by a framer.

3308

Victorian School, painted silhouette, profile of a gentleman, 4 x 3in, maple frame. Gorringes, Lewes. Jul 04. £50.

3309

J Allen Shuffkey, Oxford College, watercolour drawing, 34.5 x 25.5cm. Thos. Mawer & Son, Lincoln. Mar 04. £50.

3310

Frank Fidler, Harbour scene, gouache and watercolour, signed, 24.8 x 30.5cm. Rosebery's, London. Dec 04. £50.

3311

E. W. Wray, 'Countryside, Brittany', watercolour, inscribed on the reverse, 35 x 24.5cm. Rosebery's, London. Dec 04. £50.

3312

Kuniyoshi, mid 19thC, Japanese woodblock print, a sheet from a Fujiwara monagatori triptych, oban and a Kiyonaga reproduction print. (2) Cheffins, Cambridge. Feb 05. £50.

3313

Gustave Dore, Policemen with Suffragettes, signed, pen on ink, 13 x 8cm. Henry Adams, Chichester. Jan 03. £50.

3314

Wilfred Ball, (1853-1917) River townscape, signed, 6.5 x 9.5in, gilt frame. Dee, Atkinson & Harrison, Driffield. Feb 05. £50.

3315

Dorothy Turton, oval silhouette style miniature, a 'Gainsborough Lady' in ebonized frame with brass oak-leaf and acorn mount. Dee, Atkinson & Harrison, Driffield. Feb 05. £50.

3316

Carl Marr, 'Rothenburg' and 'Sienna', pencil, both signed and inscribed, 27.7 x 20.3cm & 19.5 x 30.5cm. Rosebery's, London. Mar 05. £50.

3317

Northern Irish School, c1960, 'Olive Dawn', oil on paper laid down on canvas, signed and inscribed on label attached to the reverse, 11.5 x 21.5cm, and seven watercolours and one drawing by different hands. Rosebery's, London. Mar 05. £50.

3318

Modern British School, c1950, Portrait of a gentleman, seated half-length in a brown jacket and green tie, oil on canvas, 65.7 x 55.5cm. Rosebery's, London. Jun 05. £50.

3319

B. Costin Nian, Village on the Niger, oil on canvas, signed, 23.5 x 31cm. Rosebery's, London. Jun 05. £50.

3320

Italian School c1970, 'Pelleas- Amedeo Amodio Teatre alla Scala Marzio 1970', Amedeo Amodio as Pelleas in 'Pelleas and Melisande', music by Sibelius, mixed technique on paper, 69.3 x 31cm. Rosebery's, London. Jun 05. £50.

3321

British School 20thC, Portrait of a man in profile, poss. Lord Boothby, pencil & coloured crayon, inscribed 'London', dated 19, signed indistinctly, 16 x 16.5cm, unframed. Rosebery's, London. Jun 05. £50.

3322

Louise Solomen, coloured print of a stylish female seated upon a bed, signed in pencil bottom right, 85 x 74cm. Rosebery's, London. Jun 05. £50.

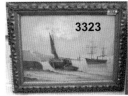

3323

Framed oil painting (signed) of 'Harbour Scene'. Sandwich Auction Rooms, Kent. Jun 05. £50.

3324

Framed watercolour, 'Seascape'. Sandwich Auction Rooms, Kent. Jun 05. £50.

3325

Surrealist oil painting, signed by Gunter Maas, 1965. Sandwich Auction Rooms, Kent. Jun 05. £50.

3326

After Henri Matisse, 'Dessin en cinq couleurs', lithograph in colours, signed and dated 52 within the plate, Redfern Gallery label on reverse of mount, 55.7 x 50cm, unframed. Rosebery's, London. Jun 05. £48.

3327

Palmer Jones, charcoal and blue chalk heightened with white, Caudebec, Normandy. Gorringes, Bexhill On Sea. Dec 04. £45.

3328

Unsigned, a portrait of a late 18thC gentleman seated in a chair with coat, waistcoat and cravat, framed and glazed, 9 x 7in. Tring Market Auctions, Herts. Nov 02. £45.

3329

Chinese School, 20thC, Flower blossom, paint on tissue thin paper, signed and sealed, 39 x 30.3cm. Rosebery's, London. Sep 04. £45.

3330

June Metcalf, Woodland scene, black and coloured chalk, signed and dated '84, 72.5 x 51.7cm. Rosebery's, London. Mar 05. £45.

3331

French School, coloured lithograph, Girl with a songbird, oval, 8 x 6in. Gorringes, Lewes. Jul 04. £45.

3332

Henry Enson, (late 19thC) 'Summer river landscape', oil on board, signed but partially rubbed, 29 x 47cm. Hampton & Littlewood, Exeter. Jul 04. £45.

3333

Fred Rider, watercolour, Shepherd and flock in an open landscape, signed, 8 x 12in. Gorringes, Lewes. Jul 04. £45.

3334

Watercolour, signed Dees, 'Elterwater Lake District', 24.5 x 34cm. Boldon Auction Galleries, Tyne & Wear. Sep 04. £45.

3335

Pre-Raphaelite style, watercolour drawing, portrait of a young lady, 46 x 34cm, reframed. Thos Mawer & Son, Lincoln. Feb 03. £40.

3336

After Thoulow, 19thC French coloured print, winter river landscape, impressed gallery stamp RSS, no. 153, image 46 x 58cm. Thos Mawer & Son, Lincoln. Feb 03. £40.

3337

After Alken, set of six coloured hunting prints, 22 x 29cm, mounted, framed. T. Mawer & Son, Lincoln. Feb 03. £40.

3338

Oil on board, signed Duncan Fraser McLea, Scottish Scene, 18 x 14cm. Boldon Auction Galleries, Tyne & Wear. Sep 04. £40.

3339

Watercolour, Alf Cuthbert, 'The Langdales', 35 x 47cm. Boldon Auction Galleries, Tyne & Wear. Sep 04. £40.

3340

I Hassell after Thomas Bradley, (early 19thC), Barton Ferry, black/white mezzotint, with title & inscription, 16 x 21in, Hogarth frame. Dee Atkinson & Harrison, Driffield. Nov 04. £40.

3341

Late 20thC School, Warriors and nobles with a rearing horse, oil on canvas, 200 x 253cm. Rosebery's, London. Mar 05. £40.

3342

After Macdonald, Flirtation and The Quarrel, pair of colour reproductions, 13 x 8.25in, gilt frames. Dee Atkinson & Harrison, Driffield. Jul 04. £40.

3343

Roger Davies, Linton's homesteads, Summer in Wharfdale, & Grassington, signed pair, 7.75 x 11in, gilt frames. Dee Atkinson & Harrison, Driffield. Jul 04. £40.

3344

Robertson, Study of wooden fishing boats on the banks of an estuary at low tide, oil on canvas, signed, white moulded frame, 28.5 x 38.5cm. Locke & England, Leamington Spa. Mar 05. £40

3345

Early 20thC School, portrait of a seated Eastern European female wearing headscarf, unsigned, 18.25 x 13in, gilt frame. Dee Atkinson & Harrison, Driffield. Jul 04. £40.

3346

Continental School, (late 19thC) Portrait of a fisherman smoking a pipe, indistinctly signed, 29.5 x 24.5in, gilt frame. Dee, Atkinson & Harrison, Driffield. Feb 05. £40.

3347

William Lionel Wyllie, etching, Barges in docks, 5.25 x 7in. Gorringes, Lewes. Mar 04. £40.

3348

Birch, late 19thC watercolour, rowing and fishing boats at low tide with figures in attendance, 3.75 x 5.75in. Fieldings, West Hagley, Worcs. Jun 05. £40.

3349

Two Louis Wain coloured prints, depicting comical cats. Fellows, Brimingham. Oct 03. £38.

3350

18thC hand coloured black and white engraving, The Southwest Prospect of London, dated 1762, framed and glazed, 10 x 16in. Tring Market Auctions, Herts. May 02. £35.

3351

Oil on canvas, 'Durham Cathedral', 34 x 57cm. Boldon Auction Galleries, Tyne & Wear. Sep 04. £30.

3352

J Marshall, 20thC, 'Humber Dock Nostalgia', signed and dated '96, 11 x 14.25in, stained frame. Dee Atkinson & Harrison, Driffield. Nov 04. £30.

3353

Watson, Coastal Scene, with figures on a promenade, buildings beyond, signed, oil on canvas, 50 x 61cm. Henry Adams, Chichester. Jan 03. £30.

3354

Mary Wiles, 'The Beach, Las Palmas', pencil, water and bodycolour on buff paper, signed, inscribed on label attached to the reverse, 37 x 44.5cm. Rosebery's, London. Dec 04. £30.

3355

'Let there be lights', monoprint of a group of figures within lights, personal inscription to Shirley Bassey, dated 1975, signature to bottom right corner. Rosebery's, London. Jun 05. £30.

3356

Oval portrait miniature of an elegant lady, wearing a jewelled headdress adorned with flowers and feathers, a string of pearls around her neck, indistinct signature l.r., ebonised frame, (s.d), miniature height 3.25in. Fellows, Birmingham. Jul 03. £30.

3357

Manner of Andre Dunoyer de Segonzac, Landscape, pen, ink & wash, bears signature, 16 x 23.5cm. Rosebery's, London. Jun 05. £30.

3358

Daphne Reynolds, 'White & Black Sheep near Isfahan', 1977, gouache, signed, 14.5 x 18cm. Rosebery's, London. Jun 05. £30.

3359

Watercolour, signed J E Jamieson, Coastal scene with figure rowing toward land, 17 x 23.5cm. Boldon Auction Galleries, Tyne & Wear. Sep 04. £28.

3360

Honey, an abstract composition, oil on canvas, signed 'Honey 96', 166 x 103cm, and another similar, 89 x 31cm. (2) Rosebery's, London. Jun 05. £25.

3361

Harold Grimsdale, oil on artist's board, St Mary's Church, Beverley, before 1957, painted from Woodlands Garden, 12 x 14in. Dee, Atkinson & Harrison, Driffield. Apr 01. £25.

3362

Andrew Smith, 20thC, watercolour of Northgate, Walkington, signed and dated 1979, 12 x 16in. Dee, Atkinson & Harrison, Driffield. Apr 01. £25.

> Condiiton, rarity, provenance and fashion are the key market operators currently dictating values.

3363

John Austen, R.B.A., 'Centaur', wood engraving, signed, titled and numbered 1/50, 31.7 x 24.6cm. Rosebery's, London. Jun 05. £25.

3364

Pair of prints 'Faust and Margaret' and 'Romeo and Juliet'. Boldon Auction Galleries, Tyne & Wear. Sep 04. £20.

3365

Watercolour, signed J E Jamieson, Coastal scene with figures rowing, 17 x 24cm. Boldon Auction Galleries, Tyne & Wear. Sep 04. £20.

3366

John A Parkin, Figures beside the Humber Bridge, signed and dated '77, 11.5 x 9in, painted frame. Dee Atkinson & Harrison, Driffield. Nov 04. £20.

3367

Graham Aitchison, 20thC, City Hall, Hull, pen, wash and chalk drawing, signed and dated '96, 8.5 x 11.25in, stained frame. Dee Atkinson & Harrison, Driffield. Nov 04. £20.

3368

Graham Aitchison, 21stC, Street scene, Hull, signed & dated '01, 7.25 x 10in, stained frame. Dee Atkinson & Harrison, Driffield. Nov 04. £20.

3369

J Goddard, dockyard scene, signed and dated 1948, 7.75 x 12.75in, stained frame. Dee Atkinson & Harrison, Driffield. Jul 04. £20.

3370

English School (18thC) a miniature portrait of Thomas Guy, with brown flowing wig, paper laid onto panel, 15 x 10cm, inscribed on reverse, unframed. Hampton & Littlewood, Exeter. Jul 04. £20.

3371

Charcoal drawing, signed Franco Matania, 'Portrait of a nude', 35 x 27cm. Boldon Auction Galleries, Tyne & Wear. Sep 04. £16.

3372

English School, early 20thC watercolour, view of a watermill and meadow, marked in pencil 'Churchill 1903', 13.5 x 9in, framed. Fieldings, West Hagley, Worcs. Jun 05. £12.

3373

De Wint, A lake scene, with rainbow, watercolour, 7.5 x 12cm. Henry Adams, Chichester. Jan 03. £10.

3374

Modern oil on canvas of a Galleon in a Stormy Sea, rough pinewood frame, initials D C R. Kent Auction Galleries, Folkestone. May 05. £10.

Appendix 1

An explanation of Cataloguing Terms and Practices associated with the sale of drawings, paintings and watercolours at auction.

Readers should note that catalogue notes may be accompanied by a disclaimer which may state for example that '.... any statement as to authorship, attribution, origin, date, age, provenance, and condition, is a statement of opinion and is not to be taken as a statement or representation of fact'. Many auctions in reaching their opinions may rely on expert staff and/or they may also consult reliable experts or authorities outside of their jurisdiction. The following notes are typical of the terminology and practices associated with the sale of original pictures at auction.

Name of artist (date from-to) a work catalogued with the name(s) or recognised designation of an artist, without any qualification is, in the opinion of the auction, a work by the artist. In other cases the following expressions, with the following meanings are used.

Attributed to in the opinion of the auction, probably a work by the artist in whole or in part.

Studio of in the opinion of the auction a work executed in the studio or,

Workshop of workshop of the artist, possibly under his supervision.

Circle of in the opinion of the auction, of the period of the artist and showing his influence.

Style of in the opinion of the auction a work executed in the artist's style but of a later date.

Follower of in the opinion of the auction a work executed in the artist's style but not necessarily by a pupil.

Manner of in the opinion of the auction a work executed in the artist's style but of a later date.

After in the opinion of the auction a copy (of any date) of a work of the artist.

Signed/Dated/Inscribed in the opinion of the auction the work has been signed/dated/inscribed by the artist. Auctions may add a question mark indicating an element of doubt.

With signature, with date, with inscription in the opinion of the auction the signature/date/inscription is by a hand other than that of the artist.

English School Italian School etc (with or without indication of date) in the opinion of the auction a work not in any particular artist's style, which may or may not have been executed at a later date than the style might suggest.

The term 'bears a signature' and/or 'date' and/or 'inscription' means that in the opinion of the auction the signature and/or date and/or inscription have been added by another hand.

Measurements Auction convention is that the height precedes the width and is given in inches or centimetres.

Frames Pictures are usually presumed to be framed unless otherwise stated although some auctions provide detailed information on the frame as well as the picture.

Appendix 2
Abbreviations used in the text.
The following abbreviations are as up to date as possible but also include the changes and developments relating to the various institutions during the nineteenth and twentieth centuries.

A.	*Associate*
A.A.	*Associated Artists in Watercolours (1808-1812).*
A.A.A.	*Allied Artists' Association*
A.N.W.S.	*Associate of the New Society of Painters in Watercolours.*
A.O.W.S.	*Associate of the ('Old') Society of Painters in Watercolours*
A.R.A.	*Associate of the Royal Academy*
A.R.H.A.	*Associate of the Royal Hibernian Academy*
A.R.I.	*Associate of the Royal Institute of Painters in Watercolours*
A.R.S.A.	*Associate of the Royal Scottish Academy*
A.R.S.W.	*Associate of the Royal Scottish Society of Painters in Watercolours*
A.R.W.S.	*Associate of the Royal Society of Painters in Watercolours*
b.	*born*
B.I.	*British Institution (1806-1867)*
B.W.S.	*British Watercolour Society*
c.	*circa*
d.	*died*
fl.	*flourished*
F.R.S.	*Fellow of the Society of Antiquaries*
I.C.A.	*Institute of Contemporary Arts*
I.S.	*International Society of Sculptors, Painters and Engravers*
N.C.A.	*National College of Art, Dublin*
N.E.A.C.	*New English Art Club (1886-1917)*
N.S.A.	*New Society of Artists*
N.W.S.	*New Society of Painters in Watercolours. Founded in 1831, R.I. from 1881*
O.S.A.	*Ontario Society of Artists*
O.W.S.	*'Old' Society of Painters in Watercolours. Founded 1804. R.W.S. from 1881*

p.	*post*
P.S.	*Pastel Society*
P.R.S.A.	*President Royal Scottish Academy*
q.v. (qq.v.)	*quod vide (quae vide) which see*
R.A.	*Royal Academy, founded in 1768*
R.B.A.	*Royal Society of British Artists, 1824. Royal 1887*
R.B.C.	*Royal British Colonial Society of Artists*
R.B.S.A.	*Royal Birmingham Society of Artists*
R.C.A.	*Royal College of Art*
R.D.S.	*Royal Dublin Society. Founded 1731*
R.E.	*Royal Society of Painter Etchers, 1880. Royal 1888*
R.G.I.	*Royal Glasgow Institute*
R.H.A.	*Royal Hibernian Academy 1823*
R.I.	*Royal Institute of Painters in Watercolours 1881. Formerly N.W.S.*
R.I.A.	*Royal Irish Academy*
R.I.A.S.	*Royal Scottish Incorporation of Architects*
R.O.I.	*Royal Institute of Oil Painters*
R.P.	*Royal Society of Portrait Painters 1891*
R.S.A.	*Royal Scottish Academy*
R.S.M.A.	*Royal Society of Marine Artists*
R.S.W.	*Royal Scottish Society of Painters in Watercolours 1878*
R.U.A.	*Royal Ulster Academy of Arts*
R.W.A.	*Royal West of England Academy, Bristol*
R.W.S.	*Royal Society of Painters in Watercolours 1881. Formerly O.W.S.*
S.W.A.	*Society of Women Artists*
S.B.A.	*Society of British Artists. Founded 1824. Later Royal College of Art*
W.C.S.I.	*Watercolour Society of Ireland*
W.I.A.C.	*Women's International Art Club*

Appendix 3
Contributing Auctions

The Auctions listed below have contributed results and images for *Picture Prices at UK Auctions*. Many of them have also submitted invaluable analyses of the art market over the last 20 years and particularly in recent times.

Ambrose.
Loughton, Essex.

Amersham Auction Rooms.
Amersham, Bucks.

Andrew Hartley.
Ilkley, W Yorks.

Batemans.
Stamford, Lincs.

Bearne's.
Exeter, Devon.

Biddle & Webb.
Birmingham.

Bloomsbury Auctions.
London.

Bob Gowland International Golf Auctions.
Mickle Trafford, Chester.

Boldon Auction Galleries.
Boldon, Tyne & Wear.

Boulton & Cooper.
Malton, North Yorks.

Brettells Auctions.
Newport, Shropshire.

Bristol Auction Rooms.
Bristol.

Byrne's.
Chester.

Canterbury Auction Galleries.
Canterbury, Kent.

Charterhouse Auctioneers.
Sherborne, Dorset.

Cheffins.
Cambridge, Cambs.

Clarke Gammon Wellers.
Guildford, Surrey.

Clevedon Salerooms.
Bristol.

Crows.
Dorking, Surrey.

D M Nesbit & Company.
Southsea, Hants.

David Duggleby.
Scarborough, N Yorks.

Dee, Atkinson & Harrison.
Driffield, Yorks.

Denhams.
Warnham, West Sussex.

Desmond Judd.
Headcorn, Kent.

Diamond Mills & Co.
Felixstowe, Suffolk.

Dockree's.
Manchester.

Dreweatt Neate.
Newbury, Berks.

Dreweatt Neate.
Donnington, Berkshire.

Ewbank Auctioneers.
Send, Surrey.

Fellows & Sons.
Hockley, Birmingham.

Fieldings.
Stourbridge, West Midlands.

Fieldings.
West Hagley, Worcestershire.

Gorringes.
Bexhill On Sea, Sussex.

Gorringes.
Lewes, Sussex.

Great Western Auctions.
Glasgow.

Halls Fine Art Auctions.
Shrewsbury, Shropshire.

Hampton & Littlewood.
Exeter, Devon.

Henry Adams.
Chichester, West Sussex.

Hobbs Parker.
Ashford, Kent.

Hogben Auctioneers.
Folkestone, Kent.

Humberts inc Tayler & Fletcher.
Andoversford, Glos.

Hy. Duke & Son.
Dorchester, Dorset.

Hyperion Auctions.
St Ives, Huntingdon, Cambs.

John Taylors.
Louth, Lincs.

Kent Auction Galleries.
Folkestone, Kent.

Kivell & Sons.
Bude, Cornwall.

Lambert & Foster.
Tenterden, Kent.

Locke & England.
Leamington Spa, Warwicks.

Lots Road Auctions.
Chelsea, London.

Louis Taylor.
Stoke on Trent, Staffs.

Marilyn Swain Auctions.
Grantham, Lincs.

Maxwells.
Wilmslow, Cheshire.

Mellors & Kirk.
Nottingham, Notts.

Mervyn Carey.
Tenterden, Kent.

Morphets.
Harrogate, Yorkshire.

Neales.
Nottingham, Notts.

Peter Wilson.
Nantwich, Cheshire.

Richard Williams.
Pershore, Worcestershire.

Richard Winterton Auctioneers.
Burton on Trent, Staffs.

Rosebery's.
London.

Rupert Toovey & Co.
Washington, Sussex.

Sandwich Auction Rooms.
Sandwich, Kent.

Shanklin Auction Rooms.
Isle of Wight.

Simmons & Sons
Henley-on-Thames, Oxon

Smiths of Newent.
Newent, Glos.

Stride & Son.
Chichester, West Sussex.

Stroud Auctions Ltd
Stroud, Glos.

Sworders.
Stansted Mountfitchet, Essex.

Tennants Auctioneers
Leyburn, Yorkshire

Thos Mawer & Son.
Lincoln, Lincs.

Tring Market Auctions.
Tring, Herts.

W & H Peacock.
Bedford, Beds.

Wallis and Wallis.
Lewes, Sussex.

Wintertons Ltd.
Bakewell, Derbyshire.

Wintertons Ltd.
Lichfield, Staffs.

A

abstract Non-representational art or that which coverts forms into patterns to be interpreted by the spectator.

academy A group of artists who meet to share ideas and skills.

acrylic paint An emulsion using a synthetic medium as a quick drying substitute for oil paint.

aesthete Someone who puts artistic sensibility first in his or her life.

after See Appendix I.

all-over painting Usually abstracts after the Second World War which have no central focus.

Amelia A young ladies' hobby from the 18thC. A form of collage in relief made by pricking paper with various sized needles and gluing it to a picture.

antique Greek and Roman art after the 5thC AD from which academic painters from the renaissance onwards took their inspiration.

aquatint An acid etching taken from a copper plate, leaving a washed effect.

art unions A series of annual lotteries for works of art, originated on the Continent, became popular in Scotland in 1834, London in 1836 and gradually spread around the country.

artwork Drawings, photographs, typematter etc made into a form used for printing or reproduction.

Arundel prints Any of about 200 works published by the Arundel Society for Promoting Knowledge of Art (1848-97), including images of important sculpture, art work and architecture, named after Thomas Howard, Earl of Arundel.

attribution Considered to be by the artist named. See Appendix I.

B

back painting Painting done on the underside of glass and glassware.

baroque A capricious and florid western European art form c1580 to early 18thC.

Baxter print A process of full-colour oil printing of historical scenes etc, named after George Baxter (1804-67). Very popular around the end of the 18th century.

bitumen Unstable brown pigment which never dries out and becomes darker and more opaque with age. Used as an under paint, late 18th and early 19thC.

block A piece of wood or later metal engraved in relief and used to print an image onto a surface.

bloom Increasing opacity which develops on varnished surfaces, especially in damp conditions.

body In gouache, a white filler used to make paint opaque. In oil painting, the density of the pigment.

bodycolour See *gouache*.

Brooks, John London engraver, early 18th century. Connected to transfer printing on Birmingham and Battersea painted enamels and ceramics.

brushwork The paint 'handwriting' as expressed by the marks made by the brushes on the paint surface.

Byzantine Of the art of the East Roman Empire, from 5thC AD to the fall of Constantinople in 1453.

Byzantine art Art associated with Byzantium (later Constantinople, Istanbul). Exaggerated Oriental detail mixed with classical forms.

C

cabinet picture A small and almost perfectly executed picture which would have been on display in a cabinet of curiosities.

calligraphic painting 1. From late 1940s, art work which resembles eastern calligraphic writing. 2. Oriental painting in the style of calligraphic writing.

camaieu The term en camaieu refers to the method of painting in different tones of one colour.

Canton School Early 19thC, Chinese artists working in the European style.

cartoon 1. A full size early design for a painting. 2. A comic drawing.

cave art From the paleolithic, archaeological finds such as cave paintings, drawings and carvings.

Celtic art The art produced by the Celts, from c450BC to around 700AD.

Charles, A Georgian silhouette artist who invented the method of painting dark silhouettes on the inside of convex glass with translucent detail.

chiaroscuro A term given to print and other work displayed in varying tones based on one colour, usually dark such as black or sepia. From the Italian, meaning light-dark.

chromolithograph A form of lithograph printed in full colour using stones or metal sheets. Common from the mid 19th century.

circle of… Created by an artist close to the better known artist named in both time and place. See Appendix I.

classical Of the art work originating from ancient Rome and Greek empires.

collage A piece of work consisting of paper fragments stuck onto a background to make a picture.

collotype Process from the 1870s in which colour pictures were printed without producing the dotted effect seen in half-tone work.

coloured grey The resulting hue from mixing of primary colours.

commercial art Such art as used in advertising, where the work is not made for the sake of art, but in order to help sell something.

complementary colour Colours which when placed together appear stronger: blue and orange, yellow and purple, red and green.

composition A painting in relief containing a number of different elements or sections.

computer art Art work designed and executed with the aid of computer technology.

content The subject of a work of art.

copper plate The basis upon which etching and engraving is made to produce prints.

copyright Acts to control the rights to literary, artistic and musical works. The first Copyright Act, of 1735, gave 14 years protection from copying.

counterproof A mirror image reproduction. Counterproofs are created by wetting the etching and placing a sheet of paper on top.

crayon etching Etching on rough paper, being taken from a copper plate stippled with a roulette.

crayon manner An engraving technique used to reproduce drawings in chalk.

D

diorama Large painting using special effects so as to give the viewer impression that they are present in the depicted scene.

diptych A work folded so as to have two leaves, for example a pair of hinged paintings. See *triptych*.

distemper Water based paint using glue as a binder and chalk as a filler.

dotted print Engraving in which the dotted scene is produced by the depressions made by a punch.

drawing Art formed of a series of lines.

Drip painting Style of painting of Pollock et. al., involving dripping paint directly onto the canvas.

drypoint A print made by etching directly onto the surface of the plate or stone.

drypoint engraving A form of print producing a textured effect from drawing pointed tools across a copper plate.

E

easel picture A picture created on an easel of moderate size.

Edouart, Augustin (1789-1861) Prolific French silhouettist 1826-1838, much copied in the 19thC.

Edwards, George Artist famous for producing a quantity of line engravings of 'uncommon birds' in the mid 18thC.

encaustic An ancient form of painting using pigment mixed with wax.

engraving. line engraving A form of print taken by applying damp paper to an engraved and inked Copper Plate with pressure, to produce a slightly etched 'plate mark' with finely embossed ink.

etching. print Lines cut into wax varnish applied to a copper plate. Nitric acid was then applied to the etching, where it would bite into the exposed metal. Ink was then applied to the metal, onto which paper was pressed to form the print.

Etruscan art The art produced by the people of Etruria from the 7th to the 3rd century BC.

F

facsimile An exact reproduction or copy of an original print. See *fake*.

fake An item altered or manufactured in an attempt to deceive so as to increase its apparent value.

fancy picture 1. Art which depicts a fantasy rather than a realistic scene. 2. A portrait depicting the subject in fancy dress.

feminist art Movement from mid 20thC concerned with exploring women's perception of the world as opposed to that of men.

folk art Art supposedly originating from the collective awareness of simple people.

foreshortening Artist's technique of depicting objects in a distorted manner in such a way that the spectator's eye perceives it in its correct proportions.

forgery Anything made deliberately as a fraudulent imitation. See *fake*.

form In a work of art, referring to the manner in which individual shapes and volumes are depicted.

format Dimensions of a piece of paper, canvas, etc.

Foster, Edward (1761-1864) Silhouettist from early 19th century, painting on card, often in reddish-brown.

fox marks, foxing Rusty, brown coloured stains on paper produced by damp affecting traces of iron.

fresco An ancient technique for painting directly on to damp plaster.

Frith, Frederick Silhouettist from early 19th century. Often placed cut out figures against a sepia-wash background, sometimes against detailed drawings.

Frye, Thomas (1710-1762) Irish painter and mezzotint engraver.

G

genre In which scenes from every day life are depicted.

gesso A mix of gypsum and size used for some types of painting.

giclée, glycee A high-quality digital print imitating a watercolour.

glass prints 1. Mezzotint print placed on glass then wetted so as to leave trace marks for hand colouring from the other side. 2. A print on light sensitive paper taken from lines scratched by the artist through a light-resistant covering on a sheet of glass.

gouache A form of opaque painting in water colours fixed with gum and honey.

grisaille A painting executed entirely in grey monochrome.

grotesque Popular in the 16th and 17th centuries and ancient Rome, form of ornament depicting fantastical creatures amongst scrolling arabesques.

ground 1. Of a surface prepared for painting. 2. The canvas, paper, etc on which a piece is executed. 3. In etching, coating on the metal plate through which the point is drawn.

H

halftone Process of reproducing prints, since the late 19thC, in which shade was better depicted through the use of progressively light or dark / large or small dots.

history painting A form of picture depicting a famous scene or personage from history in an exaggerated manner.

I

icon A painting by a Greek or Russian Orthodox believer of a religious subject matter.

illumination Manuscript adorned with colour and ornamental detail using gold leaf and paint.

impression A print taken from a pre-prepared ink or paint-covered metal plate, wood block or stone.

Impressionism Art movement in France, 19thC, which sought to achieve a highly realistic representation of colour and tone.

incunabula Books and wood block prints from before 1500, when printing was still in its infancy.

India paper In the late 19th century, a tough, fine paper used for Intaglio printing.

inscriptions Latin abbreviations found on a print defining the contribution made by the author. For example, Ad viviam: taken from life; Imp.: printer; Indicit: carver / engraver. See *original engravings*.

intaglio A design cut into a hard surface, for example a copper plate etched or engraved for printing.

J

Japonisme Denoting the Japanese influence on European art.

K

Kit-cat A standard canvas size, 36x28 inches.

Kitchen Sink School A term given to the British art of the 1950s of a social realist style.

kitsch Mass produced works of art supposedly imitating higher, more exclusive forms of art.

L

laying in The process of painting the ground in one colour as a basis for the rest of the painting.

Le Blond prints Named after A. Le Blond in the 19th century, printing using plates and blocks to make full-colour prints.

line engraving See *engraving*.

linocut A design cut into a sheet of linoleum.

lithograph A print taken from stone or metal plate suggestive of a line drawing in which the artist would draw using a greasy substance. The stone, when wetted, would repel the applied printing ink and the oil would hold it thus producing a print more simply than through etching. Developed in the late 18th century by A. Senefelder, Munich.

lithotint Surface tone or wash effect achieved by preparing the stone with a powdered resin. See *chromolithograph*.

M

Mannerism Of European art of 1515-1610, typified by stylistic trickery and use of bizarre effects.

marine painting A work of art depicting the sea, often a naval battle or scene.

median price Not the average, but the middle figure of a range of auction results. More typical because it eliminates unexpected highs or lows. In the following range the median is emboldened. £50 £300 **£400** £600 £1800

medium 1. The substance from which any work of art is formed. 2. The base liquid with which pigment is mixed to make paint.

mezzotint Print taken from roughened copper plate, which the artist would smooth in places to create the desired tone and depth.

miniatures, painted A small picture painted on to various materials such as ceramics, enamels, card, ivory etc, often used as jewellery.

mixed media Denotes art executed with the use of a variety of materials or styles.

mixed method A form of painting in which the last application is in oil paint on a tempera base.

Modernism Denoting avant-garde styles in art prevalent throughout the 20thC.

mural Any wall painting other than a Fresco.

N

narrative painting A painting whose intention is to tell a story or part of a story.

naturalism Form of art common from the 19thC in which artists' subjects were the everyday tasks and objects of ordinary lives.

Norwich School School of English artists who specialised in depicting the landscapes of East Anglia.

O

oil Picture painted with an oil pigment which hardens on exposure to the air.

Old Master A painting of high quality executed before 1800.

oleograph Chromolithograph pre-varnished to suggest the texture of oil on canvas, popular late 19thC.

original engravings See *inscriptions*.

P

parchment An ancient material used for writing and painting, made from animal skin.

pastel Dry pigment bound with gum into stick form and used for drawing.

patina Denotes the slight discoloration to all works of art with age.

perspective The representation of a three dimensional image on a two dimensional ground.

pigment The colouring element of a paint, dye, etc.

polyptych A work folded so as to have a number of leaves, for example many-hinged paintings. See *diptych*.

Pop Art Form of art which uses images of mass-consumerism and pop culture as a subject.

Post-Impressionism Term for the loose group of artists who broke away from the traditions of Impressionism. See *Impressionism*.

Post-Modernism Movement representing a break from the traditions of Modernism. See *Modernism*.

pre-Raphaelites Described as a 'medieval artists' brotherhood', mid 19thC movement involving D.G Rosetti, John Millais et. al., in which artists would paint as seen, contrary to contemporary fashion.

pricked pictures Popular from the late 18thC to mid 19thC, portrait prints given relief by the application of needles to the reverse of the material then hand coloured.

proofs. states 1. *Artists' proof*: signed by the artist and likely numbered; 2. *Proof before letters*: includes the names of the artist, engraver and publisher, is untitled; 3. *Open letter proof*: includes the title in outline, before the printer issues a final, engraved title.

provenance Document proof of the source, and therefore authenticity, and history of an antique.

R

realism The style in which objects, people, etc are represented as they appear. i.e. without distortion or exaggeration.

recto Front face of a picture. See *verso*.

relief print Opposite of Intaglio. The protruding parts of a wood block were inked and pressed to form an impression on the paper. Cheaper than intaglio.

remarque proof A proof, usually of superior quality, carrying a mark to denote its higher quality.

Renaissance Classical revival of arts and literature in Europe from the 14thC.

S

School of… Work of art by an unknown painter whose style is influenced by an individual or group of artists. See Appendix I.

sepia 1. Brown pigment made from the ink of the cuttlefish. 2. Filter applied to art work, photography, etc, giving a light brown tint.

sgraffito Form of decoration applied to plaster, where the top layer is scratched away to reveal the different coloured layer below.

Shop Picture Used by art dealers, a term denoting a piece known to be made under the guidance of a known master.

silhouettes, shades, profiles Named after Etienne de Silhouette (1709-1767), for the extreme austerity of his financial programme for France: hence portraits reduced to minimal profile, usually in solid black.

silkscreen The process of printing using a fine mesh screen and stencils.

soft-ground etching Etching produced through the use of tallow, with the picture drawn on paper laid on the plate.

steel engraving From the early 19th century, a detailed print taken from steel instead of copper. Later, engravers would usually take fine prints from copper plates, then produce more cheaper prints of lower quality from steel plates.

still life A work of art composed of inanimate objects.

stipple engraving Print often in red and brown or blue, popular from 1760 for portraits. Associated with F. Bartolozzi, London, from 1764.

stopping out Part of the process of etching in which the parts of the design which the artist does not wish to darken are covered with varnish.

Stretcher the wooden framework to which the canvas is attached.

Studio of… Denotes a work of art by a probably unknown painter whose work has been produced under the guidance of a particular artist. See Appendix I.

surface prints Prints produced from plates which had been surface printed instead of being engraved. See *etching*.

Surrealism Art movement, early 20thC, involving representation of real objects or scenes in unreal situations, forms or circumstances.

T

tempera Base for adding pigment for painting, a mixture of eggs and water.

texture The feel or appearance of the surface upon which art is produced, or the look and feel of the finish of a work of art.

tint Colour most visible or closely represented in a mixture of colours.

tone The relative brightness or dullness of a colour.

townscape A painting, picture, print etc featuring a town or part thereof as its main focus.

triptych A work folded so as to have three leaves, for example three hinged paintings. See *diptych*.

V

vanishing point In pictures using perspective the point at which the scene disappears.

varnish Often clear liquid which dries to a hardened, protective surface. Includes shellac, linseed oil, various polishes.

verso The back of a picture.

W

wash A thin, protective sheen applied to the surface of art work.

watercolour Pigment mixed with water as opposed to oil.

watermarks Lettering embedded into the texture of paper, viewable when held up to the light. Can include makers' marks, symbols, lettering, numbers, dates, etc.

wood engraving A refinement of the woodcut using hard wood, allowing subtleties of tone and texture given the right tools and a skilled hand. One such being that of T. Bewick, 1753-1828.

woodblock print A print formed from the use of a number of differently coloured wood blocks which together form a picture.

woodcut Type of print effected using the side grain of wood. Used for cheap printing on rough paper.

Pictures Index

The Index is an integral part of this book and contains some 4,500 entries. References to all artists have been included, as have other areas of interest such as Schools. The entry '& assoc.' refers to the artist named and associates of that artist (manner of, circle of, etc).

AIS also publish

Antiques
INFO

The UK's Leading Guide to Prices and the Market

Antiques Info provides essential market information for the dealer, collector, auctioneer and investor.

With over 1000 colour images, 2500 fairs & auctions, multiple features and collectors' news, you can't afford not to invest in *Antiques Info!*

Subscribe to *Antiques Info* today and receive all this:

Market-led Features

Each edition has multiple market-led features written by industry experts

Price Guides

1000 images and descriptions, including where sold, when and how much for.

Fairs and Auctions Diaries

2500 colour coded 60 day Fairs and Auctions Dates in every edition

Free Written Valuations

2 Free written valuations for every six editions of subscription.

Ask about our Gift Service, telephone: 01843 862069

Direct e-mail link to our team

Write to our experts for a quick response to your information or research needs.

Internet Gold Services

Access our **FREE** internet services, including:
Searchable *Price Guide* database: *thousands of auctions sale images and prices.*
30 Day *Fairs and Auctions* database: *searchable by region and by date.*
3 other searchable databases of *Dealers, Services* and *Clubs etc.*
see *www.antiques-info.co.uk* for a courtesy preview of these *FREE* services.

To order your subscription,
call **(0044) 0 1843 862069**
visit **www.antiques-info.co.uk**
e-mail **enquiries@antiques-info.co.uk**
or ask your local newsagent.